Motion Design

MW01485404

This book offers a comprehensive overview of techniques, processes, and professional practices in the area of Motion Design, from fundamental building blocks of organizing time and space in production to managing workflow, budgets, and client relationships. The authors provide insight into the production process from concept through execution in areas as diverse as social media to large-scale projection mapping for events and festivals. Readers will learn through real-world examples, case studies, and interviews how to effectively use their skills in various areas of Motion Design. Industry professionals provide unique perspectives on different areas of Motion Design while showcasing their outstanding and inspiring work throughout. This is a valuable resource to students who aspire to work in a broad range of visual communication disciplines and expand their practice of Motion Design.

Austin Shaw is an assistant professor of design at Western Washington University. Previously, he taught at the Savannah College of Art and Design in Savannah, Georgia, where he was a professor in the motion media department for ten years, and at the School of Visual Arts in New York City for three years. For nearly 20 years, and in tandem with teaching, Austin has worked as a motion designer for clients including Target, Ferrari, FedEx, McGraw-Hill, Ralph Lauren, and VH1, and as a creative director, designer, and animator for companies such as Superfad, Digital Kitchen, Brand New School, and Curious Pictures.

John Colette is a professor of Motion Media Design at the Savannah College of Art and Design in Savannah, Georgia, where he previously served as department chair. As a professor, he has led collaborative industry research projects for external clients such as BMW Technology Group in Silicon Valley, Samsung, Microsoft, and Adobe Systems.

Motion Design Toolkit

Principles, Practice, and Techniques

Austin Shaw
John Colette
Edited by Danielle Shaw

Routledge
Taylor & Francis Group

NEW YORK AND LONDON

Cover image: Chrissy Eckman

First edition published 2023
by Routledge
605 Third Avenue, New York, NY 10158

and by Routledge
4 Park Square, Milton Park, Abingdon, Oxon, OX14 4RN

Routledge is an imprint of the Taylor & Francis Group, an informa business

ISBN: 978-1-032-06058-3 (hbk)
ISBN: 978-1-032-06057-6 (pbk)
ISBN: 978-1-003-20052-9 (ebk)

DOI: 10.4324/9781003200529

Typeset in Univers
by Apex CoVantage, LLC

This textbook is dedicated to the many generations of our students for pushing and inspiring us.

Contents

Acknowledgments

A monumental thank you to Danielle Shaw for editing this book.

We want to thank Patrick Clair for writing the foreword to this textbook and for inspiring the motion design community with his awesome work.

Thank you to Chrissy Eckman for designing the hero artwork for the cover of this textbook.

Thank you to all the industry contributors for sharing your time, insights, and examples of your work and process. Thank you, Wendy Eduarte Briceño, David Conklin, Ariel Costa, Jordan Lyle, Peter Pak, Mitch Paone, Erin Sarofsky, Orion Tait, and Boo Wong.

A big thank you to Michael Thomas Hill, Chace Hartman, and Erin Sarofsky for your insights and help throughout. Thank you to David Conklin and Nicole Colvin for additional editing support.

We would also like to thank the publishing team at Routledge for your patience and guidance throughout the process. Thank you to the interior design team for creating a beautiful book.

Contributors

PROFESSIONAL PERSPECTIVES—INDUSTRY CONTRIBUTORS

Wendy Eduarte Briceño
David Conklin
Ariel Costa
Jordan Lyle
Peter Pak
Mitch Paone
Erin Sarofsky
Orion Tait
Boo Wong

ADDITIONAL PROFESSIONAL CONTRIBUTORS

Hazel Baird
Peter Clark
Nando Costa
Chrissy Eckman
Madison Ellis
Michael Thomas Hill
Stephen Kelleher
Scholar
Kyle Shoup

STUDENT CONTRIBUTORS

Rita Albert
Nicole Colvin
Gabe Crown
Vero Gomez
Jayson Hahn
Oliver McCabe
Jessica Natasha

Meghan O'Brien
Nicole Pappas
Rosalinda Perez
Christopher Roberts
Mercedes Schrenkeisen
Jack Steadson
Yifan Sun
Akshay Tiwari
Samantha Wu
Phoebe Yost

Foreword

Patrick Clair

There's nothing more exciting than the prospect of a career in Motion Design, a field that is emerging, evolving, and fundamentally new.

I've spent 20 years practicing an art form that didn't exist just a generation before me. Of course, we could discuss the history of animation and the clunky text effects of optical printers; all this history is valuable and should be studied and venerated for where it got us. But, for practical purposes, the desktop computer revolution of the late '90s and early aughts gave birth to the modern "motion designer."

It's a hybrid task, and that's exactly what I love about it—part graphic designer, part editor/animator. To deploy a cliche: *storyteller*. I was attracted to it because of the sheer number of dimensions of thought it required. From art history to salesmanship, it promised new challenges every day. It was a frontier in a world where it felt there weren't many left.

I was a young film student in the early 2000s when pioneering shops like Psyop and MK-12 were posting wild new work that seemed to blend 3D animation, rotoscoping, and live-action into cheeky, playful—and strikingly cool—pieces of design filmmaking. Music video collectives like Shynola were inventing stunning new aesthetics with each project, never treading old ground. Lynn Foxx, from my understanding a group of architecture students, were bringing music to life with organic and mesmerizing films.

Meanwhile, I was stuck at home, staring vacantly at my "screen direction" degree, penniless and wondering what was next. Living in a city with no film industry and 60 film students graduating each year . . . where could I go? Without the money to go and shoot films, what would I do?

As I consumed vast amounts of inspirational new work, a new world unfolded before me. I had used After Effects to add defocus to a live action shot once. My friend and editor had used it to create the credit roller for our student film. Now, I started to see that it was a portal into a world where anything was possible. If I wanted to create the animated logo for an art nouveau biker gang, I could—but why? I could mash up my holiday footage of Banksy artworks with maps of the Berlin subway system in a lame attempt to recreate my favorite T-shirt designs in motion. I could create title sequences for films I could never afford to actually make!

It was all terrible of course, but it felt amazing. That's where it began for me. I enrolled in a "compositing and title design" post-grad and was off and running. Friends and relatives would ask what I would do after graduating, and I would say, "Title Design isn't a real job, this means I'll be making 'motion graphics for advertising.' " I loved those words— "motion graphics"—even as my aunts' and uncles' eyes glazed over with a mixture of

misunderstanding and disinterest. I'm still shocked today that professional title design ever became an option in my career, but that was a long, long time later.

It began with craft. And that's what this book can teach you. Every professional journey begins with long years of practice, imitation, and tutorials. I have a saying that I find useful: "don't be a thief, be a kleptomaniac." When you're new to a discipline, there is no choice but to be derivative. Look at the best work—the stuff you love, that makes you burn with jealousy inside. And slowly, over years, figure out how they did it. Copy them, until you know their tricks (just don't copy them on a paid job; that's not OK).

A wise lecturer of mine once posited an answer to an impossible question: what is creativity? He suggested it is nothing more than the combination of two previously uncombined elements. That's why I say be a kleptomaniac. Stealing from your favorite artist is derivative. Combining your two favorite artists in one aesthetic is being creative; it's making something new.

But first, do the work.

I've spent countless hours rotoscoping. I've spent three months doing nothing more than adjust the lens flare intensity on a football branding package between 9% and 13% (with a 45-second plus frame refresh rate—ah, the early days of HD!). Every formidable creative director I've encountered spent their time as a junior, learning their craft through experience and hard graft. Trust me, that experience will serve you well down the track.

I worked on lots of ugly stuff. I made so many, many mistakes. I worked on sketch comedy shows, where imitation and speed were the priorities over aesthetics. I worked with arrogant, low-end commercial clients that ruined projects with their poor choices. Oftentimes, I was able to ruin projects with my own poor choices. Over time, I think I got better. I've always had a chip on my shoulder that I went to film school and not proper design school. I'm terrified that all those design grads know all these secrets I don't—handshakes and code words. I think it helped me to want to learn from every job, to make up for this shameful inadequacy.

In the first ten years of my career, I watched every single piece of Motion Design I could find. On blogs like *Motionographer* and *Stash*, there was a torrent of new work every day, and I loved watching it—even as it bruised my ego. How could I ever make stuff this good? But honestly, I loved just being immersed in the work. Eventually, I started to find my own voice—clumsily at first (well, still clumsily today, if I'm honest). Finally, I could look beyond Motion Design and start to find inspiration in art, architecture, and the world.

Meanwhile, while I was lost in the layers, an entire industry flourished and matured. Obviously, Motion Design for commercial purposes absolutely exploded, becoming a legit and mainstream part of the design and communication industry—ubiquitous even.

The renaissance of title design that Kyle Cooper had kickstarted in the '90s with *Se7en* had flourished into ten-plus studios regularly turning out stunning title sequences for the best shows on TV (an industry undergoing its own technology-fueled revolution). Motion Design was spreading (literally) onto more and more surfaces. Today, these things we anachronistically call "phones" are portals to a billion sites and apps that call for the art of designing elements in motion. Car dashboards now need motion designers. So do tablet computers, smart surfaces, streaming platforms . . . the list is endless.

Meanwhile, as the potential for our output changed, the way we could make it changed as well. Of course, some of this is leaps forward in what a home system can do; it's a common truism to say that a contemporary bedroom setup can outperform a major studio

infrastructure. From GPU cards to cloud rendering and more, physical infrastructure is no longer a barrier to world-class work. When I graduated film school, the biggest barrier to starting a studio would be the $40,000 investment in a pro-level Betacam tape deck. A tape deck! Any student reading this doesn't even need to know what that means. When I started Antibody in 2013, all we needed was a few iMacs, some IKEA desks, and some space in a shared office. The barrier to entry is low.

Of course, the key is that you need clients—and that's where the most important revolution comes in.

Sometime in the late aughts, the internet made the world about the size of a city—and almost no one noticed. I didn't notice until 2012, when I simultaneously got clients in Montreal and Paris. I lived in Sydney, and the fact my work was on Vimeo meant that people who liked my style could find who I was and hire me. From then on, the physical reality of my life started to separate from the virtual spaces that connected my work. Ever since then, my life has been spread across at least the time zones of America, Australia, and Europe. Far from being a creep of work into life around the clock, it's been a relief—an opportunity to live life where I need to for my family and find the work that can sustain us.

With a global audience, you can go incredibly niche. This is the most important lesson I ever discovered. It promises a life of freedom, artistic satisfaction, and meaningful relationships.

Antibody has been using a "distributed workflow" model for years—just a fancy way of saying that we live near our family while we get to do work for clients from anywhere. These days I live in Sydney with my wife and son, while my closest collaborator lives on the far side of the country to me. My producer lives in Ohio, my visual researcher is in Colorado, my Houdini guy is in rural France. We live where we want to; we work hard. Sometimes job schedules demand a phone call early or late at night, but most days I walk my son to school and engage with work on my terms. The freedom is thrilling, and it's available to almost all of us in a post-pandemic world.

But it starts with foundations—and this book is the perfect way to build those. The journey is so, so much fun, and discovery is rewarding at every turn.

I've seen some things. I've met my heroes (some of them) and learned why you shouldn't). I've had a son and experienced the surreal thrill of gazing into the eyes of a brand new human life. I've realized my childhood dream of directing a car ad—with lights and sirens across L.A., blacked-out camera cars, and drone-covered stunts. But right up alongside these high points was the deep thrill I felt when I discovered that a "compound blur" with the right matte could imitate the aesthetic of a tilt-shift lens, and I could make my little AEFX (After Effects) comp look (a bit) like the one my design hero had just posted to *Tween* (that's right, I started reading *Motionographer* when it was still called *Tween*; color me old).

Motion Design will continue to change at a breakneck pace. Most people reading this book will, in a few years' time, have skills and technical capabilities that I'll never understand. The pace of this change is why I think a career in Motion Design is such an exciting prospect—and for those of you just dabbling, the editors and web designers, becoming that little bit more of a hybrid creative killing machine is not to be underestimated.

The future is hungry. Get devoured by it.

Patrick Clair

Introduction

This book grew slowly. We met over a decade ago at a Southern Art School, where we were both teaching. Austin was part of the faculty, having relocated from his career in Motion Design in New York City. John had arrived from Sydney, Australia, where he had most recently run a production studio, part of a long career in both teaching and industry.

As we became colleagues and friends, we watched the program where we worked grow and achieve a singular status in Motion Design education. We saw graduates leave to commence stellar careers, start studios, lead the design teams of major media companies, and work in a dazzling variety of new areas of creative practice.

The students we taught were not always majoring in Motion Design. In the early courses in our program, two-thirds of the students came from other areas of practice: graphic design, filmmaking, production design, user experience design, advertising, and illustration. Graduate students came from these disciplines, and many others, to add Motion Design skills to their professional offerings. We saw a generation of emerging creatives who not only saw Motion Design as part of their personal inventory of tools but also thrived once they had access to a foundation in this work.

We cultivated students to invent new and surprising work, as well as excel in their craft once they were given foundational skills in Motion Design. Each breakthrough felt like a key to a lock opening a door to an immense space of creative and professional possibility.

At the open-air tables of a coffee shop in Savannah, Georgia, we met for coffee after class, talked about the students we were working with, and shared stories of their progress and success. Talent was not something we dispensed from on high but something that seemed to bubble up inside the many creative people that surrounded us. We embraced our role as guides, signposting and sharing what we had learned in our own decades of practice, but always eager to see a student do something that surprised us, exceeding our own capacities in some way.

Over years, we discussed breakthroughs in the classroom, particularly the students who thought they were defined by a particular practice but found a new perspective or even a new calling through their progress in Motion Design. To our surprise, this process was not painstaking; it happened often in a matter of weeks, and usually in the very early stages of study.

This book evolved from those discussions and from those students. Over more than ten years, we wanted to see what moments in the classroom were those catalysts for change.

DOI: 10.4324/9781003200529-1

What transformed a graphic designer into a capable motion designer so quickly? What gave an advertising major the ability to make a compelling motion-based pitch after only a few weeks? What aspect of professional practice seemed hidden in plain sight? We wanted to find the essential toolkit for a motion designer—to give a clear orientation for the sounds, images, animations, installations, and practices that were expanding our students' creative horizons and professional opportunities. We wanted a toolkit for Motion Design, a map for the new skills that could open up creative practice.

No book is everything. There is an endless range of tutorials and specific information on technical practices and a stunning array of software and platforms for production. We have compiled our collective experience and knowledge on relevant tools and techniques. A book is not designed to be the end but the start. In this spirit, we have tried to make available a framework for the practical, technical, and professional aspects of this discipline to orient existing creatives in the practice of Motion Design.

Time does not stand still, and the work described in this book is part of a living process of change that shifts and morphs both media, its distribution, and its audiences. It is fair to say that Motion Design is a blend of animation, graphics, and filmmaking, with a side of interactivity if that is required. It is easy to see the origins of contemporary Motion Design in the painstaking animation done on Oxberry cameras and on optical printers. The techniques of paste-up and collage animation are visible in a lot of modern work, as is the laborious development of multi-plane animation to add depth to the frame.

The scope and range of digital systems has made Motion Design a hungry hybrid. Visual music, 2D and 3D animation, stop-motion animation, all forms of editing, cinematography, and graphic arrangement feed into a singular platform and develop new and surprising forms of mixed media. It is impossible to catalog the range of possibilities in this new world, and its products keep expanding into new relationships with audiences. What was once oriented to "broadcast design" finds its home today on cell phones, on public screens, projected into museums as sculpture, and displayed at massive scale on the sides of buildings.

In a previous age, every creative practice was discrete, its means of production complex, and it was often expensive and difficult to access. To use a sound studio was a world apart from working in a darkroom or with an optical printer. Each required what seemed like an apprenticeship and an understanding of the arcane and particular physical properties of the medium. Today, these practices not only sit adjacent to each other, but they inform one another and hybridize through the endless creative labor of the art and design communities.

This book is written with an embrace of that closeness, with a recognition that for many creatives, their practice is perhaps weeks away from embracing a new world of possibility that may sustain them for years to come. We hope they surprise themselves!

For our part, we have been sustained and nurtured by the kindness and care of people we have worked alongside, who shared their insights and experience, who subtly mentored us, and who were kind enough to be there for our journeys. We may be islands in the stream, but the stream touches us all.

Chapter 1
Focus and Flow

Motion Design works with both space and time. The *space* is usually a screen or frame that changes or animates over *time*. Motion Design is a uniquely flexible medium because it works with tools that integrate various media and technology extremely well.

Software such as Adobe After Effects is modeled on the traditional processes of optical printing in filmmaking and title design. In these analog processes, layers of imagery were printed onto a single piece of film, exposing multiple images together within that frame. The designer was deeply involved in the planning and layout of every element. For example, a piece of type would be exposed in one pass, and adding another element to the same sequence required the film to be precisely rewound in the camera. Then the new element was exposed in the desired place onto the same frame of film. After the different passes were exposed as planned, the film was processed in a lab; so, it could be days until the work was screened. Traditional Motion Design practices were extremely painstaking and drawn-out processes.

Digital tools give us instantaneous feedback on all aspects of a work, where visualization is an active process of experimentation with and refinement of a design. Historically, analog media involved multiple recording and display formats such as an audio recording, a photograph, or a moving image. The designer required very specific skill sets to work with each medium. Darkroom printing of a photograph was quite different from recording or editing an audio tape.

The shift to digital treats all media as files, and the computer becomes a universal platform for production, with different processes using the same metaphors: select, cut, copy, and paste. Learning to work with images in Photoshop or Illustrator, and extending this into After Effects, is a fluid and logical creative progression because of these affordances. New formats for media using 3D models, novel display technologies, and interactivity extend and challenge the boundaries of practice. But they are a progression of digital production, not entirely different mediums.

Today, there is a higher standard for design because of the vast pool of designers and artists now working digitally and pushing both creative and expressive possibilities across different channels. For all these new creative possibilities, persistent principles are part of the visual language inherited from previous mediums. The still image and the moving image continue to rely on the same formal foundations that have been developed over time.

DOI: 10.4324/9781003200529-2

Film-based Animation Rostrum

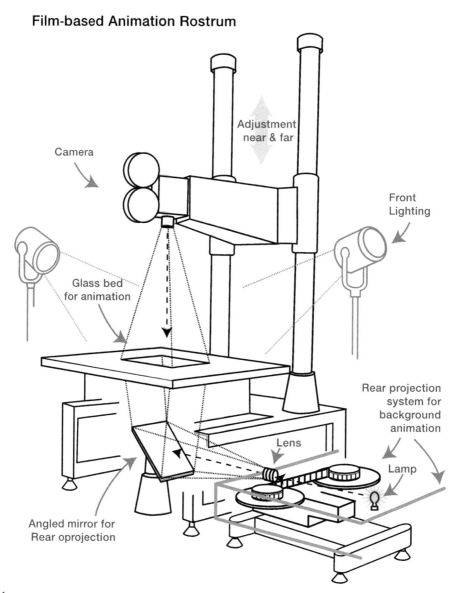

Adjustment near & far

Camera

Front Lighting

Glass bed for animation

Rear projection system for background animation

Lens

Lamp

Angled mirror for Rear oprojection

1.1
Illustration of film-based animation rostrum by John Colette.

The medium has a message: production is revolutionized through digital technology and its flexible capacity for handling and integrating media. As media evolves, the distribution platforms also expand the dimensions of practice. A social media video has very different requirements, because of its context, from a TV commercial or a documentary film. Yet the DNA of earlier practices is still written through into new and evolving forms, and the designer's awareness of this naturally changes with the times. The toolkit is grounded in a common understanding of how we create and experience the moving image, and as designers, how we make the familiar new again.

WORKING WITH SPACE

Since industrialization, the visual arts have responded to the times in which they are produced. The experimentation, ferment, and exploration that developed in the 20th century produced not only a reimagining of painting, sculpture, and other fine arts but also totally new categories of practice where art and design can be developed.

Motion Design can dynamically integrate a range of practices and mediums into new assemblies and new hybrid works. For example, a motion project that mixes photographic collage with animation and filmmaking creates an innovative style. Graphic design principles, animation techniques, and cinematic conventions all play a part in the design of the piece. Yet the principles of each practice must be understood and integrated thoughtfully to create successful work.

Peter Pak, the lead designer of the *Godfather of Harlem* title sequence, discusses the process behind this project.

> **While researching about the time period and characters in the show, I came across an image by Romare Bearden. The more I looked into this artist and the fact that he lived in Harlem during that time period, and his work and themes related to what the show was about, I thought there was an idea there. Another reason I thought this idea had potential was a lot of main titles at that time were really sleek 3D. I wanted to create something that would stand out. I started looking at types of collage animation that had already been done. I didn't find anything that quite hit the mark in what I was looking for. But it was still informative in getting a clear idea of what I wanted to do.**
>
> **When I was developing the style frames, I tried to make each frame cover a theme or topic. At this stage I am more concerned about the story and the concept. I figure out the animation transitions later. First, we need to sell the concept. The animation for this project was done in After Effects. Half the work was figuring out how we go from one shot to another. Because it was a one-minute and thirty second main title, it would have been a lot to be all animated collage. We integrated archival footage in between collage shots, which also helped to tie the concept into a historical time and place.**
>
> **Peter Pak, Designer/Director[1]**

In Motion Design, the designer creates and presents a space: the *focus*. This space, a frame or even a physical space in the world, alters over time: the *flow*. What we see, and how we see it, is open to boundless possibility and, at the same time, subject to very precise control.

Controlling space involves *composition*, the spatial arrangement of elements within the frame. It is not simply a two-dimensional process, where elements are laid out on something like a page. The screen itself is a frame, but also a window into a world we imagine extending beyond its edges. Elements within the screen have relationships and depth, and each of these relationships is open to change over time.

Introducing movement through animation inflects the composition with new values that can only be expressed in time. Rhythm, syntax, and the meanings created within a sequence or combination of shots all enhance the creative potentials of the static image.

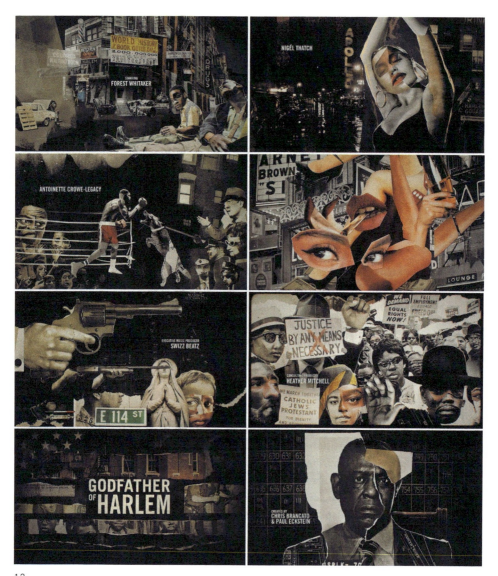

1.2

Godfather of Harlem, title sequence. Created by Digital Kitchen for EPIX and ABC Signature. Creative director: Mason Nicoll. Art director/designer: Peter Pak.

A good place to observe this style of sequence is in the presentation of short, graphic animations that end in a title or logotype. The resolve, or *lock up*, presents this last graphic as the final shot in the piece. The resolve is often introduced through a series of closely framed images where the final element is either in motion or rendered through a moving camera. These first shots introduce the color scheme, graphic style, and visual elements. The implied question of the piece is resolved in the last shot. This technique is used across corporate logos, news and sport openers, and different examples of main titles.

Figure 1.3 shows a title sequence that presents detailed vignettes of small dots interacting and weaving into a series of abstract depictions of workplace conflict, power

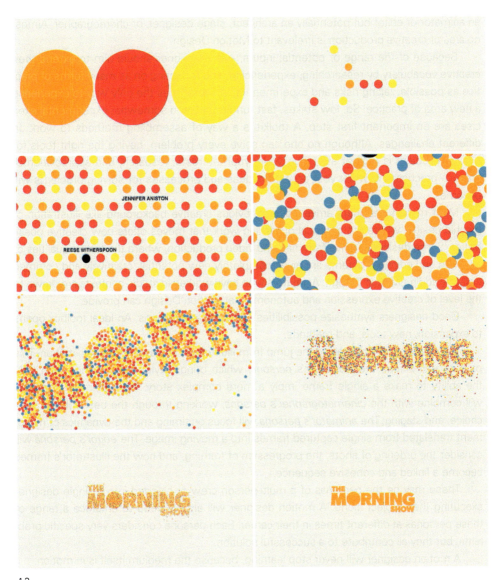

1.3
The Morning Show, title sequence by Elastic. Creative directors: Hazel Baird and Angus Wall.

struggles, and ambition. We pull back in the final frame to reveal an infinite field of these dots that become a pointillist rendering resolving into the Title Card. Each previous shot in the sequence is essentially presented as an extreme close-up of the final title.

The designer needs to think from different perspectives: the camera person, the editor, the animator, the graphic designer, and perhaps even a little bit like a musician or choreographer. These perspectives are *personas*, inhabited by the designer, sometimes in a rapid succession. Each has its own language, and each brings a particular type of thinking to the process.

The range of perspectives or personas needed depends on the project. Because Motion Design is a fluid hybrid of applications, you might need to think from not only the position of

an animator or editor but potentially an architect, stage designer, or choreographer. Almost no area of creative production is irrelevant to Motion Design.

Because of the range of potential inputs, every designer should aim to extend their creative vocabulary by researching, experiencing, and reflecting on as many forms of practice as possible. Taking risks and experimenting is sometimes the only way to experience a new area of practice. So, low stakes, fast turnaround, and somewhat experimental exercises are an important first step. A toolkit is a way of assembling methods to work on different challenges. Although no one can solve every problem, having the right tools for a given problem is a great start. The wider your interests, research, and appreciation of creative practice, the wider your access to ideas and processes for solving problems will become.

Most motion designers arrive from a previous creative background like illustration or graphic design, where the potential of making work that moves offers new creative possibilities. Some designers arrive from film and video production, where the formal qualities of shooting and editing programs are given completely new potential, creatively and commercially, by adding Motion Design. Animators who have worked in studio contexts are drawn to the level of creative expression and autonomy that Motion Design can provide.

Good designers synthesize possibilities into finished solutions. An ideal toolbox opens to expansion, new tools, and methods.

Take the example of making the jump from illustration into stop-motion animation. This process will extend the *illustrator's persona*, which brings style, color, composition, and the ability to make a single frame imply a more complex story. The illustrator's persona will combine with the *cinematographer's persona*, working through the best lighting, lens choice, and staging. The *animator's persona* will focus on timing and the dynamics of movement translated from single captured frames into a moving image. The *editor's persona* will consider the ordering of shots, the progression of framing, and how the illustrator's frames become a linked and cohesive sequence.

These may be the personas of a multi-person crew or blended into a single designer executing their project alone. A motion designer will always need to embrace a range of these personas at different times in their career. Each persona considers very specific problems, but they all contribute to a successful solution.

A motion designer will never stop learning, because the medium itself is in motion.

I was always interested in a lot of different things and ways of communicating visually. I started studying Graphic Design in school and ended up in Motion Design. I really enjoyed making things move, but more than anything, I liked solving problems and delivering messages.

I have learned that in the real world, being in Motion Design, as part of a creative agency really can mean so many different things. Sometimes, that is creating websites that move, or content for websites that move, presentations that are interactive, Apps . . . or content that goes into Apps. Sometimes it's video that stands alone but it's been fun to get to approach every project in such a new way and really find the path that makes the most sense, rather than just always being told "30 second spot; fill it with this story."

Chrissy Eckman, Associate Creative Director[2]

Changes in technology are providing new opportunities for alternative media presentations: projection mapping, virtual reality, and extended or augmented reality. These all expand and develop the existing space in which Motion Design takes place, so the designer needs to consider new relationships with their audience, who are no longer simply addressed by a screen. The media they develop may not be ordered by the boundaries of a frame, and the audience may have far more ability to interact with the work or to change their point of observation. If there is a frame in the work, it may be very fluid and subject to change.

Camera as Presence

The eye of the camera becomes, quite literally, the viewer's eye. The camera orients the viewer in space and limits what can be observed. Cameras give *presence* to the audience within a scene by establishing a sense of perspective and distance from subject matter. It is no accident that in French, the word for lens is *objectif*; the idea of the lens as an objective eye, framing the world for us. The camera is a proxy, a single point that focuses the image, standing in for the audience who "enter" the world presented to experience a scene, a story, or a journey.

The photographic image implicitly presents itself as a recording of something in the world. However, design and animation render spaces not bound by the laws of physics or optics and can choose to invoke realism or create entirely new representations. The realm of motion is fluid, with room for nearly any visual aesthetic.

For most designers learning to work with motion, it takes time to shift away from thinking about composition solely as an analog to the page—a flat, two-dimensional rectangle to contain imagery. The idea of the camera helps to start thinking about composition in terms of space that can be viewed and explored in three dimensions. In Figure 1.4, we see the idea of spatial composition. The image frame is defined by the camera's view. Visual elements are composed in space at varying depths, and the camera can be an active participant in the animation.

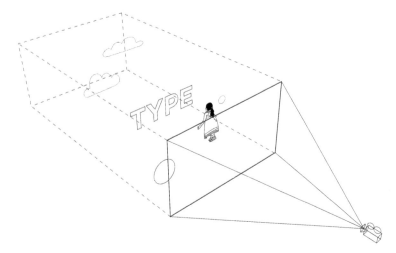

1.4
Infographic depicting the idea of spatial composition as seen through a camera lens.

1.5
A set of stills from different Motion Design projects created by students to showcase a range of visual styles.
Top left, Visual Effects Realism by Akshay Tiwari. Top right, Reduced Graphic Characters by Vero Gomez. Bottom
left, Photo-Real 3D combined with Typography by Gabe Crown, Jack Steadson, and Samantha Wu. Bottom right,
Papercraft Styled Animation by Yifan Sun.

Rather than being limited to creating just flat, animated drawings on a page, motion designers can construct spatial compositions in relation to a camera. When elements are layered and positioned at various depths, any camera movement produces the effect of *parallax*, where objects closer to the camera appear to move faster, whereas objects further from the camera appear to move slower. Again, this simulation of natural motion creates a more cinematic and engaging experience for the viewer. In addition to camera movement, elements can animate in the scene, appear from off-screen, or fly into the frame from behind the camera's position in space.

Representational Spaces

Compositions contain graphic *scenes* or *spaces*. Our presentation of the world in the frame can range from photo-real to completely abstract. Realism and abstraction are not fixed poles; they intersect and overlap in different ways to invoke different styles or presentations. The photographic image of a face is very different from the photo collage of a face, illustrated face, or any number of ways a face might be painted. Every style carries its own set of meanings, as well as its own set of visual pleasures, and the designer makes a clear choice as to which of these will suit their purpose.

A composition may range from utilitarian to expressive. A designer may develop a layout with the objective of communicating a specific idea or message, whereas an artist may work solely for the experience of creativity or self-discovery. Whatever the intent, the composition presents a boundary for the work.

WORKING WITH TIME

From calendars marking seasons changing to devices noting the hours and minutes of the day, we measure time to manage our lives. We understand time as sequences of related events, actions, or processes that have a specific order and duration. Rhythm, cause and effect, or other sequential relationships, in time, form an organizing principle for our experience of the world. These same principles establish the experience of Motion Design based on sequence, choreography, and editing.

Our interface for working with time in Motion Design is the *timeline*: a purely graphic representation of events occurring in a sequential or chronological order. The timeline cannot but help to reference film and video, as it is ordered in the same way: a sequence of frames that play back to produce a moving image. For motion designers, a timeline serves to define the essential parameters of a project such as the start point, end point, and overall length. Knowing the duration of an animation allows a designer to plan the narrative structure, rhythm, and cadence of a project.

Anatomy of a Timeline

A timeline provides a graphic user interface (GUI) to manage and compose audiovisual elements in time. Assets are placed in timelines as layers, tracks, or objects depending on the software. Regardless, a timeline offers an interface to display the sequence and the arrangement of visual elements across time and space, and to manage changes in how they appear and behave.

In animation software, the primary tool to navigate a timeline is the *current time indicator*. This interface graphic allows us to view and modify a composition at specific points in a time. With this tool, we can place time markers across a timeline to indicate audio cues, notes, or any relevant editorial information. Of course, a timeline also allows us to preview or render the entire edit, or any section of an edit.

Units of Time

A timeline contains a sequence of moments, or units of time: hours, minutes, seconds, and frames. *Frame rate* is the number of frames that are sequenced and displayed per second. Like a flip-book, the rapid changing of image content in a composition creates motion. Understanding frame rate is vital because it influences the stylistic quality of motion. Lower frame rates such as 12 frames per second (fps) work well for low-fi animation or a faux *stop-motion* feel. The standard for cinema, 24 fps, produces a life-like feel. Higher frame rates like 300 fps are used to capture slow motion, because they replay at a slower rate in a timeline—stretching the way we see time. Getting familiar with the various frame rates used in Motion Design is fundamental because different platforms have their own requirements.

Think of each frame as a frozen moment, and consider how they combine when played together to make images feel fluid and alive. This way of thinking translates across processes, between still and moving images, to become a foundation of creative practice. Learning how to manage time and the subtle variations of change over time is a constant practice for every motion designer.

Timing

For emerging motion designers, developing a sense of timing is a fundamental skill. For those who are new to working with timelines, it can be challenging to construct sequences that feel satisfying and have an organic flow in the movement. Observing nature and performative arts such as music and dance can help to improve one's sensibility for timing. However, becoming capable of translating this skill into finished work requires a solid foundation in the principles of motion, knowledge of how to interface with animation software, and frequent practice.

The core principle of timing is *rhythm*, "an ordered alternation of contrasting elements."[3] In Motion Design, rhythm is the contrast between slow and fast movement. Slower *hero* moments display key compositions that communicate information or elicit emotions. They also allow enough time for viewers to interpret what is happening on screen. Moments with faster motion capture attention, bring in new elements or information, or *transition*—the transformation of a scene or subject matter in a shot. The interplay between slow and fast creates an engaging rhythm for your audience.

The overall pacing of motion influences the emotional quality of a project. Faster rhythms are not only eye-catching but also stimulating. Slower rhythms feel calmer and more reflective. Like music, the tempo of a Motion Design project determines the sensibility of the piece.

GETTING STARTED IN MOTION DESIGN

Although it is important to have these broad-stroke frameworks in mind when working in Motion Design, it also helps to have a user-friendly entry into the practice. Motion Design can be intimidating for students and creatives from related professions—like graphic design, illustration, advertising, or film—interested in learning the craft. Getting started in a timeline can be challenging even for experienced users of digital design tools. The complexities of software workspaces that include a host of menus, panels, and GUIs can be overwhelming.

Rather than diving into purely technical learning, get excited about the medium. In a class setting, we show stellar examples of professional work to inspire creative possibility. Additionally, we present outstanding case studies of previous student work to motivate new learners by showing them what they can achieve. Remember, everyone starts in the same place—not knowing how to do something. Let go of trying to be perfect and take it a step at a time.

Low-Stakes Exercises

Through our collective experience, which includes decades of teaching Motion Design courses, we find an incremental approach works best. We start with a series of *low-stakes exercises* that encourage experimentation with basic motion principles while practicing foundational techniques. As exercises, these forays into the medium help develop and strengthen skills. Students feel less pressure when the stakes are low and the expectations are manageable.

Early explorations are iterative, with quick turnaround times. That means short deadlines with high outputs of bite-size exercises: for instance, a series of three distinct 5-second animations completed within two days. An assignment structured like this encourages risk-taking and experimentation. Also, a compressed schedule reduces procrastination and encourages students to avoid being overly precious. A few weeks of short, achievable exercises build skills and confidence.

Assignments that ask too much, too soon in the learning process overwhelm students and can leave them feeling anxious and defeated. A gentle approach affords an enjoyable experience while helping to build a solid Motion Design foundation. Gradually, as students gain agency throughout a course, we can present more complex lessons.

I see a lot of students biting off more than they can chew by creating 2-minute films, or even longer. In my opinion, they should be focusing on 5 and 10 second pieces. Motion Design students are not trained to make short films, so why are Professors letting them? If they are learning After Effects in a Motion Design department, then the presumption is that they are not becoming film makers. If they are talking about developing characters and narratives, that is called a short film, and they should transfer to the film department or find a way to bridge the knowledge gap by supplementing with proper coursework. In Motion Design classes, I believe students need to be focused on the tools and a different kind of storytelling that allows them to introduce a concept and articulate that as quickly as possible.

Erin Sarofsky, Executive Creative Director[1]

DESIGNING TIME AND SPACE

Basic Transformations

A motion designer works with space and time to direct change in a composition. We accomplish this task through controlling how visual elements transform. Learning to make changes happen over time can be quickly applied across different 2D and 3D animation software, because they use a similar set of basic transformation properties. This set of properties includes Position, Opacity, Scale, Rotation, and Anchor Point or Axis. There are far more attributes and effects that can be manipulated, but all visual layers or objects in software such as After Effects or Maxon Cinema 4D share these basic transformation properties. They are building blocks, and a solid understanding of each property is fundamental to the motion designer's toolkit.

Position

Position is the spatial location of visual elements in a composition. X, Y, and Z are the three *axes*, or reference lines of a coordinate system. The X axis refers to placement or movement on a horizontal plane, the Y axis refers to placement or movement on a vertical plane, and the Z axis refers to placement or movement on a depth plane—going forwards or backwards through space. The position of visual elements in an image is key to establishing effective composition and affecting a viewer's interpretation.

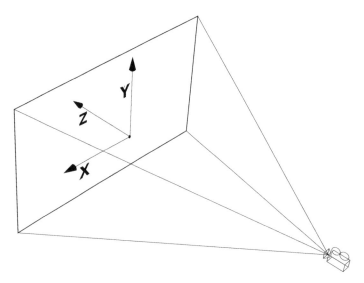

1.6
Graphic representing X, Y, and Z axes in space. In relation to a camera's view, X position and movement is horizontal, Y position and movement is vertical, and Z position and movement is forward or backward.

The process of constructing an image involves deciding where to place graphics or concentrate the focus of an image for maximum effect. The position of visual elements influences viewer engagement, visual flow, and the interpretation of a piece. Designers use their aesthetic sensibilities to create compositions that are compelling and informative. We also use grids and classic principles such as the rule of thirds to inform our layouts. This blend of intuition and graphic guidelines for image-making translates into motion as well. Animation of the position property shows changes in a visual element's placement in space. Learning how to effectively chart the movement of elements in Motion Design is a core skill that allows for the choreography of animation performance.

Opacity

Opacity refers to the degree to which a visual element is opaque or transparent. Digital programs designate a value of 100% opacity to a fully opaque asset, whereas a completely transparent asset would have an opacity value of 0%. We can set the opacity property to any value between 0% and 100%, such as 50%, where an asset is semi-transparent. The ability to control and alter visibility is useful for both spatial and temporal composing.

For spatial purposes, opacity is used for compositing and creating depth. Artful application of opacity creates a sense of layering in a composition. Variations in opacity mix visual qualities such as value, color, and texture between layers to create compelling aesthetics. Opacity is an effective tool for creating visual cohesion in an image when combined with *blending modes*, which are a function that mixes the appearance of layers.

Gradations of opacity over time are useful for the classic effect of fading visuals on or off. Film editing software offers this effect as a cross-dissolve between shots. Although we may use opacity as a broad stroke fade between shots, in Motion Design

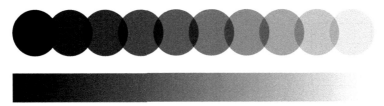

1.7
Graphic representing changes in Opacity, from fully opaque on the left to transparent on the right.

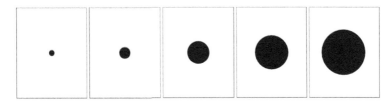

1.8
Graphic representing changes in Scale.

we often work in a more granular way. Each specific element or layer can be controlled with its own timing. Individual elements can appear and disappear in a choreographed sequence. In addition to purposeful fades, opacity can create flashing effects by turning layers on and off rapidly.

Scale

In Motion Design, the *scale* property represents the proportionate size of a layer or object in a composition. In other words, scale determines how big or small a visual element appears. X, Y, and Z (for 3D objects) are the values that can be adjusted to specify an asset's scale. The X value represents the horizontal size or width of an asset, the Y value represents the vertical size or height, and the Z value represents the depth or length of an asset. 2D layers in compositing tools such as After Effects do not have Z depth (most of the time.) However, 3D programs regularly use the Z value of scale to control the volume of objects in a scene.

Effective use of scale helps establish a composition's focal point, visual hierarchy, and depth. Scale is also a pivotal tool for controlling positive and negative space in an image. Contrasts in scale create tension and visual interest for a viewer. In motion, scale is used to grow or shrink layers or objects. Fast scale changes capture the viewer's attention and add drama to a project. Slow scale changes show the passage of time and/ or provide continuous secondary motion. Scaling effects are also used for transitions. Visual elements can fill the screen to change a background or reduce it to nothing to reveal a new scene.

Rotation

Rotation is a circular movement of a layer or object around an axis. For spatial arrangements, rotating visual assets creates dynamic angles or diagonals that direct the eye, break up

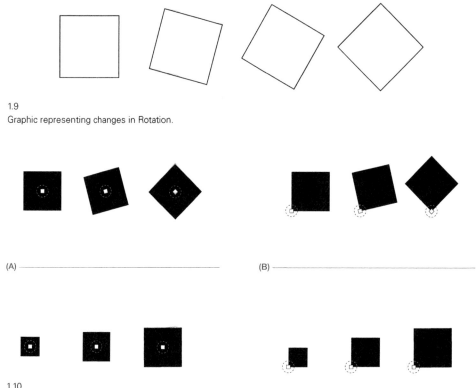

1.9
Graphic representing changes in Rotation.

(A) —————————————— (B) ——————————————

1.10
Graphic representing the role of the Anchor Point. (A) The Anchor Point is centered to the layer. (B) The Anchor Point is on the corner of the layer. The top picture shows changes in Rotation, and the bottom picture shows changes in Scale.

space, and produce compositional tension/interest. In motion, rotation is used to spin or flip assets and to change camera orientation. Rotation occurs up to 360 degrees or in numbers of full rotations. For 2D graphics, rotation is constrained to the Z axis. With 3D, rotation can occur on X, Y, or Z—meaning objects can appear to roll or flip over in space.

In the foundational text *The Illusion of Life*, by Frank Thomas and Ollie Johnston, one of the 12 principles of animation is *arcs*. "Most natural action tends to follow an arched trajectory, and animation should adhere to this principle by following implied 'arcs' for greater realism." In Motion Design, the rotation property emulates the feeling of arcs in traditional animation, adding dynamic qualities to movement.

Anchor Point/Axis

For Motion Design software, the *Anchor Point* or *Axis* is the point from which a layer or object scales and/or rotates. Learning how to manage the anchor point is essential to controlling your animations. In many instances, software will automatically place a layer or object's anchor point in the center of the content. When the anchor point is located in that central position, any scale or rotation will start from that center point, creating transformations that feel symmetrical. This default setting is typical for assets such as solids,

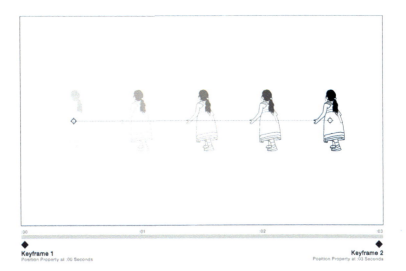

1.11
Infographic of the keyframe-based animation.

shape layers, text layers, and nulls generated in After Effects, as well as any type of object created in Cinema 4D.

There will be times you want to adjust the anchor point to not be centered on a layer. Perhaps you want typography to animate from the bottom of each letterform in a word, or you want a graphic to orbit from a point offset at a distance from the layer itself. The ability to adjust the location of a layer's anchor point or object's axis is a gatekeeper to being able to create a range of different types of animations. Therefore, learning how to comfortably interface with your creative tools is vital.

Keyframe-Based Animation
Keyframes are GUI devices that display and change the transformation properties of audiovisual elements on a timeline. A keyframe designates the distinct value of asset properties at a specific point in time. In Figure 1.11, adding a keyframe to the position property of a layer placed on the left side of a composition, at 0:00 seconds, marks the location of the layer at that moment on the project's timeline. Setting a second keyframe on the position property of the same layer, at a different location in space such as the right side of the composition, at 0:03 seconds in time establishes a new value for position.

The software interprets what happens between the keyframes, automating the process of animation to some extent. With traditional frame-by-frame animation, we would have to draw the asset at each distinct location, for every frame in the sequence. At 30 fps, that would be 90 drawings to create three seconds of animation. Keyframes exponentially increase efficiency for this kind of animation. Furthermore, digital tools afford the ability to non-destructively adjust the values on keyframed properties, as well as the locations of the keyframes themselves on a timeline.

Interfacing With Keyframes

Various software has different ways of setting and working with keyframes. For instance, in After Effects, we use the *time-vary stopwatch* to put the first keyframe on a transformation property. This tool "toggles a property's ability to change over time" as described in the After Effects interface. Once we activate the time-vary stopwatch and set the first keyframe, any changes made to that property at a different point in the timeline will automatically set a new keyframe to record that change.

Cinema 4D manages keyframes a little differently. In this 3D software, we use the *record active objects* button to set initial keyframes or a circular icon next to a keyframable property. In Cinema 4D, you need to record additional keyframes by hitting the record active objects button or clicking the icon next to a property (unless you enable *autokeying*, which is not advised as it records every action you take). This workflow is slightly different than After Effects, but the underlying principles and practices of keyframing are the same. Regardless of the software, you will need to learn and adapt to the platform's interface and methodology for managing keyframes. This principle of learning how to interface extends beyond keyframes, as this ability affords learning of all types of tools.

Duplicate and Offset

When we are satisfied with a sequence of motion on a layer or object, we can capitalize on one of the strengths of digital media, which is to easily duplicate. Duplication is an amazing affordance because it saves us from having to laboriously recreate complicated processes. Duplicating a layer in program like After Effects gives us an exact copy of the layer, including every keyframed property. When we offset the duplicated motion sequence in time and/or space, things can start to get interesting.

Offsetting in time involves moving duplicated layers down the timeline. Separating layers with identical keyframed animation by increments, as few as a single frame, creates consistent patterns of motion. Offsetting in space is adjusting duplicated layers spatially in a composition through position, scale, rotation, anchor point, or opacity. Effects or any keyframable property can be offset as well. Repetition on its own is a powerful rhetorical device for communicating information to viewers. Offsetting adds staggered variations of unified patterns and can quickly turn the ordinary into the extraordinary.

In Figure 1.12, we see an example of the *duplicate and offset* principle. Each layer in the project timeline has the same exact sequence of keyframes on the opacity transformation property: a quick flash on and off followed by an extended fade off. This set of keyframes is duplicated in this example, and the offsets are in both time and space. Temporally, each duplicated layer is slid one frame in time from the previous layer in succession. Spatially, each layer is offset in position, and some layers are also offset in scale.

When Figure 1.12 is played in motion, a captivating trail of movement is created solely from animation of the *opacity parameter* and purposeful offsets in time and space. We encourage you to rebuild a variation of this animation yourself, to experience this technique. Offsetting itself is a *rhetorical* device, meaning it communicates through the form of presentation; it operates through difference and repetition. Once this principle is practiced and understood, it can be applied to an endless variety of projects.

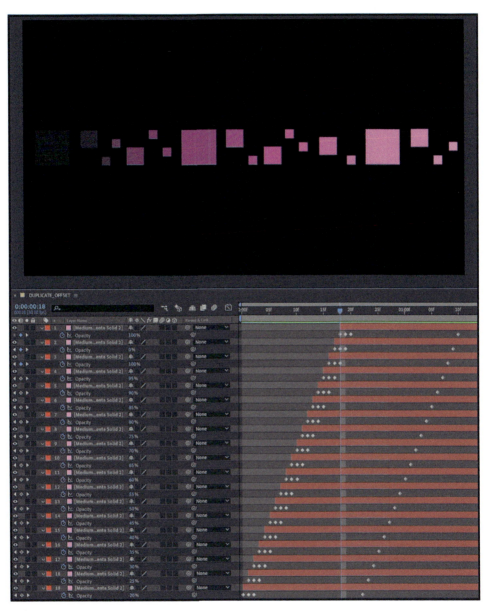

1.12
This screenshot from Adobe After Effects shows an example of the principle of *duplicate and offset*. We learned this specific technique from Carlo Vega, artist and director.

Creative Brief: Basic Transformations

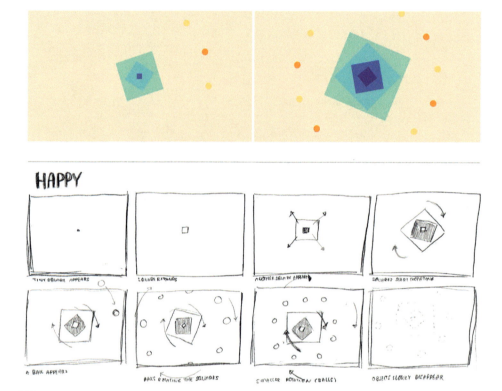

1.13
Example from Exercise 01—Emotion Graphics by Jessica Natasha. Top images are stills from the completed animation. Bottom shows pen and paper approach of storyboards prior to motion.

Description/Creative Needs

For this exercise, create (3) different animations using basic transformations.
Basic transformations include:

- Position
- Opacity
- Scale
- Rotation
- Anchor Point

Conceptual Prompt: E-Motion Graphics

Using only *simple shapes* and *motion*, practice using keyframes to express distinct emotions. Explore how variations in basic transformations can affect the emotional tone communicated to the viewer. Each animation should clearly portray a different emotion.

This exercise has both a design and motion component.

1 Design phase: Pen and paper approach. Work in a sketchbook to roughly draw out (1) storyboard for each of your motion exercises, for a total of (3) storyboards. The purpose of these storyboards is to map out the primary compositions for your Motion Design animations. Work in your sketchbook with pencils, pens, markers, and so on, or with your preferred digital drawing tool.

2 Motion phase: Use keyframe animation to create motion of your storyboards. *Restrict design assets to simple shapes such as Solids and/or Shape Layers in After Effects.* These restrictions will force you to be creative with how you approach your design solution. Simple can be quite beautiful and challenging. Consider using *contrast* in visual qualities such as *size, color*, and *value* to enhance overall screen composition.

Specifications and Constraints

- Suggested composition size(s): 1920 × 1080, 1080 × 1920, 1080 × 1080, or 1080 × 1350 pixels
- Duration: 5 seconds (per animation)
- Hand-drawn storyboards

Professional Perspectives
Orion Tait

Orion Tait is co-chief creative officer and partner at Buck, an integrated collective of designers, artists, and storytellers who believe in the power of collaboration. With a background in filmmaking, fine arts, and graphic design, his award-winning work spans a variety of disciplines, and his varied body of work is rooted in visual storytelling that continues to push the boundaries of innovation and quality in the creative arts.

Specializing in design-driven creative, Tait is an experienced and respected leader of teams that use animation, visual effects, and live action to collaborate with clients from concept to delivery to produce work that is visceral, innovative, and diverse. He has created content and experiences for a broad range of major brands from all over the world in the advertising, broadcast, film, and entertainment industries including Coke, Nike, Google, Amazon, Facebook, Apple, IBM, Mastercard, BBC2, and Sherwin-Williams. Tait has lectured at numerous schools and festivals around the globe and served and chaired on several juries, including the One Show, AICP, Clios, and the Art Directors Club.

Interview With Orion Tait

How did Buck get started?
It's a funny random story that involves Craigslist. One of my partners Ryan Honey and I met at a company called Heavy, who published a broadband website that was way ahead of its time called Heavy.com. Ryan hired me there as an art director and saved me from corporate drudgery. He and I became fast friends and met a lot of the Buck folks who we continue to work with today. Heavy was kind of this nexus during that time of the early 2000s at the start of what we call Motion Graphics now. It was this real creative hub in New York City.

Ryan and I both learned a lot from being there, in terms of what it means to run a creative company, and what it means to fail at that as well. There were a lot of long hours, a lot of insanity, and a lot of pursuit of something in the future, as opposed to embracing the now. At Buck we talk a lot about creating a *sustainable creative culture*. At Heavy, there was a lot of stuff that was not sustainable. There was a real separation between management and the makers and that has influenced the way we run our company now.

I ended up leaving New York after 9/11 and moved back home to Santa Barbara. I was working for Heavy, telecommuting. I was taking conference calls from the beach, which was great, but I knew that it was not going to last. So, I was scouring for my next thing and I came across this posting on Craigslist that looked kind of interesting. Someone wanted to

1.14

Beyond Magic: title sequence for David Blaine's ABC special. 2016 Emmy Winner for Outstanding Motion Design. Directed by Buck.

start a design and motion studio. I sent the listing to Ryan because he had just had a kid, living in New York, and struggling at Heavy. I was like, "Look, I am not ready for this . . . but if you don't apply to it, I might."

He applied and it was our other partner, Jeff Ellermeyer, who had posted the ad. Jeff was looking to build a creative services company out of a back-end web hosting company that he had. Jeff is about ten years older than Ryan and I and an entrepreneur who had built a few businesses. One of those was this web hosting business. Jeff comes from a computer systems background but is also a very creative person. He brought in Ryan because he

recognized that he needed a partner. So, they partnered up and started building out of this small Korea Town office. They lured me down to Los Angeles and I joined up and became a partner shortly thereafter.

Where did the name Buck come from?

Jeff's company that we grew out of was called Fullerene, which is the molecule named after Buckminster Fuller. Ryan and I were also fans of Buckminster Fuller and when we were kicking around names, we thought Buck was clever. There is a lot of what Buckminster Fuller represents and stands for that aligns with the way we work and the way we think about things.

Because Buck has become so associated with animation, do you still see yourselves in the creative services role?

We have changed a lot, but we also haven't. In the beginning, we were positioned right at this time where there was so much possibility. We could do the same thing with a laptop or a desktop that a million-dollar Flame suite was offering. There was this grittiness to it, and we didn't pigeonhole ourselves. My first job at Buck was creating a website for 50 Cent, but I was also directing an animated commercial at the same time.

We always thought of ourselves as partnering with our clients to make something interesting. But even more than that, it is the way that we work. We always directed under the name Buck, even after we became directors. We always worked like a design studio. *Get the people in the room that you need to solve a problem, whatever shape it is. If the shape is different, add a copywriter or add a strategist. Our flexibility and our fluidity helped us evolve in ways that I could not have imagined.*

We have called ourselves an animation studio in the past. We have called ourselves a production company. Lately, we call ourselves a creative company. Really, what it means is that we are thinkers and dreamers as well as makers. We don't dissociate those. We are learning to be more focused on strategy as we bring more strategists into our team, but we don't separate them. We are all doing it together. We might be prototyping, we are designing while strategizing, and checking our strategy during production.

What are your thoughts on the creative process?

We call it the "What If?" meeting, which is something that has always happened at Buck from the day I started working with these folks. But it's not something that happens everywhere. We are all getting in a room together, bouncing ideas in a collaborative ego-free environment where great ideas get thrown away because it's in pursuit of the *better idea*. You get inspired by each other in this way. I think there is an ego component that happens in other models where you don't allow for true listening, where you allow for "What if?" moments. Before you know it, we have built something none of us could have imagined singularly.

How do you approach studio culture?

We try to codify some of the things we did naturally when we were young and dumb, but also to try and hold onto some of that naivete. There is always going to be a balance and a tension between organization and freedom. How do we provide enough structure,

support, and organization to allow people to be successful without strangling their creativity in the process? How do we allow the freedom to express and break things and try new things? It is about who you hire. This is something my partner Jeff talks a lot about, is that we are really in the talent business more than anything. We have to be very intentional about being a values-driven organization.

What are the attributes of your favorite motion designers?

When we hire people, we recognize that soft skills are as much a marker of success in our organization as some of the hard skills. We have had folks come through Buck who are incredibly talented, insane portfolios, such great artists but their way of working is more like a solo-artist approach to things. They just aren't successful at Buck. Not because they are not amazing, gifted, kind, and talented people . . . it's just not their way of working.

The students who are coming out of schools these days and the access to information and teaching online, the level of polish is intimidating. I think it's even intimidating for students. The number one thing we hear from people is "I'm not good enough to be at Buck." I think that is not true. We are in the business of building, and supporting, and helping to grow talent.

The qualities we look for are curiosity, optimism, humility, vulnerability, and ambition. Animation is so difficult and process oriented that you need a certain level of attention to detail, but you also need the flip side of that, which is curiosity. The more you learn, the more you realize you don't know. I think animation is a great place for people who like to live in that space. There are so many incredibly talented people at Buck, but they are here to learn and to grow from the person next to them.

How does the studio balance passion projects with commercial projects?

We think of passion projects as creative opportunities. Intertwined within the phrase "passion projects" is the supposition that you are not really getting paid financially. We have learned that it pays dividends that are quantifiable, but maybe not in a spreadsheet. There is something about investing your creative capital into creative opportunity that for us has been a really positive feedback loop. We have learned over the years to do it sustainably.

Treating a passion project like a job is really important. There is a good balance of business and creativity that we inhabit. We recognize the value in some of the creative risks we have taken. We can see the dot from a project like Good Books to something like Apple Share Your Gifts, or some huge budget job—to be able to draw the line and what that has meant for us as a business to take those risks and invest in those creative opportunities.

More recently we have been asking, "How do we track creative opportunities?" There is a lot of software out there that tracks business metrics, but how do you generate creative opportunity? How do you track that and get data for it, to be able to see we got more creative opportunities this year, or we were able to spread that around, or this artist hasn't seen as much creative opportunity? Not just looking at business metrics, but how we look at creative metrics is a new and interesting challenge.

Do passion projects help lead clients into new creative possibilities?

A bigger mission of ours is to move the needle where creativity is really valued for the impact that it has. We would rather invest into something that has a good cause.

Some of the advice I give to students when they are building their portfolios is to *make the work that you want to make*. Put the stuff on your portfolio that is the stuff you want to do. Create that project if you are not given that brief or opportunity, and I think that is true for companies that are as big or established as ours.

The stakes are high at our level for some of the clients that we are working with and that can make them risk averse. So they want to see something that has been done or had that effect before. We never want to do the same thing again. Nobody here wants to pull out the same bag of tricks. But sometimes when you are in high-risk place where there is a small timeline or limited budgets, you can only do the thing that you have done before.

We have seen the dark side of that in our industry, chasing these trends that happen. As timelines shrink and stakes get higher, clients don't want to take those risks. Sometimes, it is unfair that it falls on the creative agencies to invest into pushing boundaries. I wish clients would invest more into taking those risks, rather than having studios do that. There is a real danger there, that studios feel like, in order to make a name for themselves, they have to invest hundreds of thousands of dollars into passion projects. For a smaller studio, it can break them, and they can't recover from that.

What are your thoughts on generalists *versus* specialists?

We have always talked about, pretty openly, that we favor generalists. Especially when we were a smaller group. It's probably not surprising since we are named after one of the most accomplished generalists out there. Buckminster Fuller coined the term *synergy*, and I think he was a strong proponent of generalists. I would use the term *polymaths*: people who are specialists in lots of different areas. Now, we have a mix of generalists and specialists, but even our specialists have curiosity to work on different things, and that's why they are at Buck.

I think as the projects we are tackling or the stories that we are telling get more complex, for them to resonate, it does favor the generalists who can connect the dots. I think that is where innovation happens. Specialists can push certainly, but the unexpected happens when folks have a wide range of interests.

What we do has become more and more technical, so it is important that we have really talented folks. But even a rigger at Buck is there because they love design. There is probably a wide range of interest that attracts them to a place like this.

Specializing can generate biases that can aggregate as discord, which in turn can lead to conflict. We've seen that as we've grown. We have had to break into departments at Buck to take care of people, but we like to think of the walls as membranes. If you are a 2D animator at Buck, you are going to be in the 2D animation department. But you might be one of our best designers. But you are not in the design department. So, how do we create processes that allow that amazing designer in the 2D animation department to have design opportunities? That is an example of specialization that starts to breed discord. Generalists can help breed empathy.

What are some of the challenges of growing as a studio?

We all really love and cherish this place that we have built. The number one fear is that we are going to somehow "fuck it up." That's the common story: "X company used to be amazing, they grew too big too fast, and now their work has plateaued or plummeted." How do

we make it the opposite story? How do we say, "Buck grew, and they got more diverse, and got more innovative and creative?"

The other fear that is inextricably tied to the first is the fear that we don't take advantage of what we built, for the fear of "fucking it up," we don't take advantage of this incredible creative engine that we built that is capable of so much. How do we continue innovating and taking risks? Those are the big challenges. But so far, we have taken these challenges head-on, and it has been really encouraging.

There is a lot of work that we have to do to be a more diverse and inclusive place. We are much more intentional to make sure our hiring practices are not ruled by our own biases,

1.15
The Road to Recovery: Film for Alcoholics Anonymous. Directed by Buck.

that we are not only bringing folks in who have benefited from an education that is guided by those biased networks. How can we continue to push and innovate? To be stronger, we need to be more diverse. We are constantly evolving. We are a chimeric, multi-headed beast.

What are your favorite projects?

I love animation that is about externalizing something internal. That is one of the things that I love about commercial animation. AA is one of those for me, just a personal and beautiful project that was about telling peoples' stories in a non-narrative and emotional way. I think animation is so well suited to that. If you tried to tell that story with live action, it could get maudlin or cheesy. To me, animation is the realm of dreams and emotions.

Along with that is the David Blaine piece, which is doing similar stuff. It's all about how you take something internal, trippy, weird, or hard to express and asking: how do we externalize that for a viewer to understand those feelings? When you tie that with sound, motion, and color, I think that is the sweet spot. I love the projects that do that.

What suggestions do you have for young designers?

Don't be afraid to put yourself out there, to be honest and take risks. We are always looking for that little kernel or little spark that shows possibility. When you look at the Instagram feed it can be paralyzing. It's hard advice to take, but: put yourself out there. Don't be afraid to be persistent. If you get a "no," keep trying. If there is a place or something that you want, don't be afraid to continue. If you are pursuing something that you are passionate about, someone else is going to see that. You don't need to have all the answers. The way that we work, we are looking for potential. We are looking for folks that have drive, curiosity, and the potential to learn and become great. We are not necessarily looking for someone who is great out the door.[5]

NOTES

1 Pak, Peter, Zoom interview with author, October 11, 2021.
2 Eckman, Chrissy, Zoom interview with author, September 8, 2021.
3 Rhythm. Encyclopaedia Britannica. Encyclopaedia Britannica, Inc. Accessed November 13, 2021. www.britannica.com/art/rhythm-music.
4 Sarofsky, Erin, Zoom interview with author, April 12, 2021.
5 Tait, Orion, Zoom interview with author, April 20, 2021.

Chapter 2
Between the Keyframes

KEYFRAME INTERPOLATION

Very complicated processes happen within software when we animate with keyframes. The good news is that you do not need to understand all the complex mathematics and programming at work when you keyframe a layer or object. Of course, you can learn as much about how software functions as you want. But, all you really need to learn is how to interface with your tools and their range of capabilities.

In mathematics, *interpolation* is "the process of determining the value of a function between two points at which it has prescribed values."[1] For some readers, this definition makes perfect sense. For those who may be scratching their heads, you can think of interpolation as *the change that happens between the keyframes*. Each keyframe stores two important pieces of data: a point in time and a value. Software knows how to "blend" or interpolate between these keyframes to create the illusion of a smooth transition. Adjusting the interpolation allows you to control the rate of change—or how to blend—between those fixed values and points in time. In other words, it is the way you get from point A to point B.

Two Types of Interpolation
Just like the two primary frameworks of Motion Design, the two types of interpolation are spatial and temporal. Each type of interpolation functions in two different ways: linear and non-linear. In relation to Motion Design, *linear* means straight line, or constant change. *Non-linear* is the opposite, meaning curved line, or variable change. Understanding how to adjust and control the two types of interpolation and their functions as linear and non-linear are fundamental to the motion designer's toolkit. To gain this understanding, a closer study of vector graphics and Bezier curves is needed.

Bezier Curves
Vector graphics are a type of digital media that use mathematics to generate shapes that are scalable without loss of edge or image quality. The term *Bezier curve* comes from Pierre Bézier, a French engineer who "led the transformation of industrial design and manufacturing, through mathematics and computing tools, into computer aided design and three-dimensional modeling."[2] While working for the French car manufacturer Renault, Pierre Bézier patented the Bezier curve, which we use to create vector graphics like fonts, logos, and shape layers. If you have ever used the pen tool inside of Photoshop or

DOI: 10.4324/9781003200529-3

Illustrator, you have been drawing Bezier curves! These same paths or splines are also used for a range of 3D modeling tools. Regarding Motion Design and interpolation, Bezier paths adjust both spatial and temporal interpolation. An examination of the anatomy of paths and how to work with them is also invaluable to the toolkit.

Points and Lines

The underlying structure of vector graphics are Bezier paths, and the building blocks of paths are *points* and *lines*. A Bezier path is made up of at least two points, each with a location and a tangent associated with it. The locations tell the curve where to start and end, whereas the tangents describe the shape of the curve as it goes from the starting location to the ending location.

Again, we find that there are two types of points and two types of lines. The first type of point is a *corner point*, which creates straight lines if two consecutive points are set to corner. The second type of point is a *smooth point*, that creates curved lines. In Figure 2.1, we see two simple parametric path shapes, a square and a circle. Both are composed of four points and four lines. For the square, we have four corner points that are each connected by straight lines. For the circle, we have four smooth points that are each connected by curved lines. The circle also has handles, which are manipulatable representations of the incoming and outgoing tangent lines.

With points, lines, and handles, we can design an unlimited array of graphic combinations. One crucial gatekeeper to success in this arena is learning how to effectively manage the handles of paths. Fortunately, path and handle behavior translates across software and function—meaning the same principles and techniques to control the path shape of an object in Adobe Illustrator are used to adjust the shape of a motion path in Adobe After Effects. In Figure 2.2, we see an infographic representing three different types of interpolation commonly used in Motion Design: Linear, Continuous Bezier, and Bezier.

When we make vectors using a parametric shape tool or a pen tool, we are using points and lines to define the vector path. Linear is rather straightforward (pun intended), and you do not need to worry about handles because there are none. To change the shape of a linear path, you simply need to select individual points and adjust them in space. Handles come into play with

2.1

A graphic representation of points and lines. The square has corner points and straight lines. The circle has smooth points and curved lines.

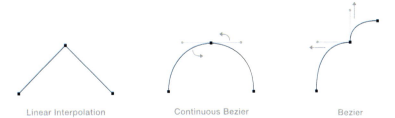

Linear Interpolation Continuous Bezier Bezier

2.2
Graphic representations of interpolation types: Linear, Continuous Bezier, and Bezier.

non-linear interpolation, and there are two ways to manage them: Continuous Bezier and Bezier. The direction and extent that a handle is moved influences the shape of the resulting curve(s).

Continuous Bezier means that adjusting a handle on either side of a point influences the shape of both lines connected to that point. More technically, a Bezier point set to "continuous" makes sure that the incoming tangent point, the point itself, and the outgoing tangent point are colinear—meaning they form a straight line. This setting is great when you want your paths to elegantly flow from point to point. However, Continuous Bezier will drive you crazy when you need a path to make a hard stop and change direction, if you do not know how to convert to the Bezier setting.

The *Bezier* setting uses handles, but they are not linked. That means an adjustment to a handle in this setting will only change the curve on the handle's side of the point. The handles on either side of a point are independent from each other. This setting allows you to make paths that are non-continuous. Learning how to convert path points from linear to non-linear, Continuous to Bezier, and to manage handles is vital. Software typically has interface controls and/or hot keys to accomplish this task.

Pen Tool

The pen is an amazing tool for creating freeform paths in digital programs. Learning how to interface with the pen tool and controlling Bezier paths takes some work, but the range of possibilities afforded by this tool are worth the effort. In Adobe Illustrator, the pen tool offers precise control to draw vector paths that are scalable without loss of edge quality. Once created, vector shapes are quite modular with easy access to features such as stroke width, fill, colors, and gradients. We can also easily duplicate paths, separate them into layers, and organize them by naming layers.

In Adobe Photoshop, the pen tool can draw vector shapes like Illustrator and can also draw a special type of path. When the pen tool is set to draw paths in Photoshop, we can draw a non-visible path composed of points and lines within a selected layer. The purpose of a path in Photoshop is to be converted into a selection. Selections are part of a Photoshop workflow that allows for precisely isolating parts of an image, such as "cutting" a figure out of a background in a photograph. When we draw a precise path using the pen tool in Photoshop and convert that path to a selection, we can copy and paste the selected part of an image or create a layer mask to control the visibility of a layer.

In Adobe After Effects, the pen tool is used for masking techniques, which are like Photoshop layer masks, except they can animate over time with keyframes. Open mask paths

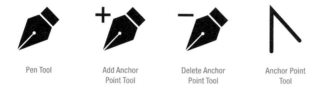

Pen Tool	Add Anchor Point Tool	Delete Anchor Point Tool	Anchor Point Tool

2.3

Pen tool options from Adobe Illustrator. The pen draws points and lines that compose paths. The Add Anchor Point Tool adds points to an existing path, the Delete Anchor Point Tool deletes points from an existing path, and the Anchor Point Tool converts points from linear to non-linear or vice versa.

drawn in After Effects with the pen tool can also be paired with effects to draw layers on and off screen. We will examine masking in After Effects later in this chapter. The After Effects pen tool can also create *shape layers*—vector layers that are like objects drawn in Illustrator but with keyframable properties that can animate on a timeline.

In 3D programs like Cinema 4D, the pen tool draws paths called splines that can be paired with modeling objects to generate 3D geometry. Extrudes, sweeps, lofts, and lathes are the basic modeling tools that combine with spline paths. We can create splines directly within Cinema 4D or import paths we draw in Illustrator. Furthermore, the pen tool and Bezier curves translate into Motion Design by controlling the spatial paths of motion for objects, layers, and cameras in both After Effects and Cinema 4D.

SPATIAL INTERPOLATION

Although Bezier curves are useful in creating shapes, they are also used to control motion. Bezier curves have two main roles in animation. The primary role is to control the rate of change between two keyframes. The secondary role is to control the path through space that spatial (position-based) properties take. In Figure 2.4, we see a simple diagram of a square moving on the X axis. The two points at the end of the line with the boxes around them signify our keyframes, where we explicitly set time and position values for our square. With two keyframes set up, the application automatically blends, or interpolates, between those points.

The line between our keyframes is a helpful GUI called a *motion path*. This graphic shows us the path through space that our square travels between keyframes. Furthermore, the small dots along the line show us where the anchor point of our square will be at each frame between the starting and ending keyframe. Looking at Figure 2.4, we can tell that the animation is 18 frames long (18 dots, not counting the one at Frame 0) and that we are currently viewing the position of the square on the 12th frame. Because our square is moving on a straight line through space between our keyframes, this diagram shows an example of Linear Spatial Interpolation.

2.4

Graphic representation of spatial interpolation in a linear motion path.

2.5
Graphic representation of spatial interpolation in a non-linear motion path.

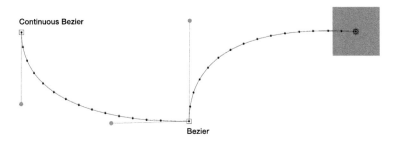

2.6
Graphic representation of the difference between Continuous Bezier, Bezier, and Corner.

Linear Spatial Interpolation is typically the default setting for Motion Design software. First, we set a keyframe for a layer's Position property. Then we navigate to another point in the timeline and change the layer's location to somewhere else in the composition. This action sets a second keyframe for the Position property, creating motion in a straight line. To make our path non-linear, we need to adjust the default tangent handles by clicking and dragging them to our desired shape. (If a linear path has no tangents, we need to convert the end points to smooth by using the Convert Vertex Tool.)

In Figure 2.5, we see an example of *Non-linear Spatial Interpolation.* The square is moving along a curved motion path through space. Also, notice the Bezier handles extending from the keyframes. The direction and extent that a handle is moved influences the shape of the resulting curve. This type of motion path creates a more organic movement than a linear path, as nothing in nature moves in perfectly straight lines.

Once we start creating motion paths with more than two keyframes for the Position property, it gets a little trickier, especially if we want our motion to make drastic changes in direction. In these instances, we need to adjust the spatial interpolation of the keyframe where we want these dramatic changes to occur. In Figure 2.6, the first keyframe is set to Continuous Bezier. The second keyframe is converted to Bezier, allowing for a radical change in path direction.

Interpolation Through Z Space

In Figure 2.7, we see a graphic representation of a motion path through Z space. Layers that are enabled to be composed in three dimensions can be animated forward or backward in space, in relation to a camera's view. Using handles, we create motion paths that

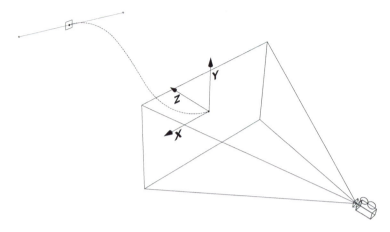

2.7
Graphic representation of non-linear interpolation through Z space.

can curve through X, Y, and Z space. We will examine Z space and cameras in greater depth in Chapter 5 of this textbook.

TECH TIP

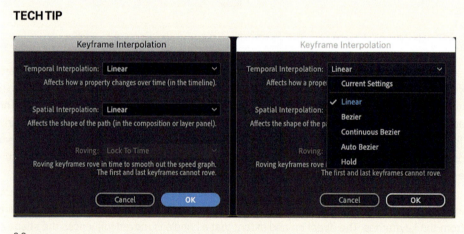

2.8
Screenshots of the Keyframe Interpolation panel in Adobe After Effects.

Adobe After Effects offers several ways to convert the interpolation of keyframes. The Keyframe Interpolation panel can be accessed through the Animation menu item or by right-clicking on a keyframe and selecting the keyframe interpolation option. Within this menu, you can change either the spatial or temporal interpolation of selected keyframes.

TEMPORAL INTERPOLATION

Just as we can manipulate how an object moves between two points in space by altering its spatial interpolation, we can also control how it moves between two points in time by modifying its Temporal Interpolation. *Temporal Interpolation* refers to the timing between

keyframes. Most objects in the real world do not move in a straight line from point A to B, and physical properties like friction prevent objects on Earth from moving at a constant speed.

> **Think about a car stopped at one end of a street, needing to travel down a straight, empty road with a stop sign at the end. The car does not go from stopped at the starting line to 60 MPH instantly, it must accelerate. Similarly, it cannot go from full speed to a stop instantly, but rather it must decelerate. Not only can the position of the car as it travels down the street be mapped to a Bezier curve, but so too can its speed over the course of its path. While the journey an object takes across the screen is easily visualized by altering a motion path, changing how it moves through time is slightly more abstract.**
>
> *David Conklin, Creative Technologist*[3]

When we set keyframes, we are designating the value of transformation properties at specific points in time. The default setting for temporal interpolation's rate of change is linear, which means animation moves at a consistent speed from keyframe 1 to keyframe 2. To go beyond the default setting of linear temporal interpolation, you will need to get comfortable with the *Graph Editor*.

GRAPH EDITOR

The Graph Editor is the primary tool to adjust temporal keyframe interpolation. This tool allows you to view and modify the values of transformation properties in between keyframes. When we enter the graph view in animation software, we see how keyframed properties change across a timeline. Keyframed properties are represented by curves, which are adjustable within the Graph Editor using Bezier handles. There are two primary types of graphs in Motion Design software: the Speed Graph and the Value Graph. The *Speed Graph* maps the rate of change a property experiences between two keyframes, whereas the *Value Graph* maps the change in value between two keyframes directly.

SIDE NOTE

This text is not a step-by-step tutorial on any specific software. The various infographics presented in this chapter are not meant to constitute an exhaustive representation of every possible interpolation. Rather, we strive to identify and examine the essential tools and principles used in Motion Design. We encourage you to explore online resources or software manuals to learn more.

In Figure 2.9, the two infographics show linear spatial interpolation in a composition and a simplified Speed Graph representing the velocity of the layer moving through space. It is important to observe that both diagrams describe the same motion. In the spatial composition (top), notice the dots along the motion path. These dots represent frames in time. Because the temporal interpolation is linear, the dots are evenly spaced throughout the

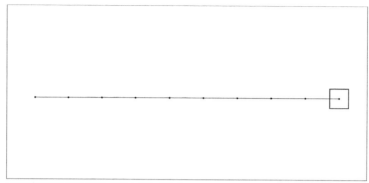

Linear Spatial Interpolation - Composition Window

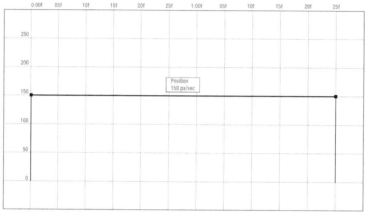

Linear Temporal Interpolation - Speed Graph View

2.9

Infographic representations of Linear Spatial Interpolation (top) and Linear Temporal Interpolation (bottom) as seen in a Speed Graph.

motion path. This graphic representation shows that the distance traveled from frame to frame, between the start and end keyframes, is exactly the same, thereby indicating that the square is moving at a constant velocity.

In a Graph Editor, properties that are *keyframed* and *selected* are displayed as curves. In the Speed Graph infographic (bottom), the two tiny squares on either end of the line represent keyframes. The curved shape is a horizontal straight line, indicating the temporal interpolation is linear, which also indicates the speed of the layer is constant throughout the animation. Both the spatial view and temporal view have infographic displays to communicate the same information.

The numbers running horizontally on the top of the graph represent the timeline, measured in seconds and frames. The numbers rising vertically on the left side of the graph show the speed of motion in pixels per second. The measurement of the left column is dependent on the type of property selected. Because the transformation property in this example is Position, the measurement is *pixels per second*—how many pixels traveled through space per second. If the property was scale or opacity, the measurement would be in percentages.

In the Speed Graph of Figure 2.8, we see the velocity of the layer is consistently 150 pixels per second between the two keyframes. Although the measurements of speed or degrees of change are important, *motion designers often pay close attention to the shape of the curve.* A horizontal line in a Speed Graph, no matter what measurement of pixels per second, will always move at a constant speed. As you become more comfortable with the Graph Editor, you will start to recognize the quality of motion based on the shape curves. The more dramatic the shape of the curve, the more variation in how a property transforms over time.

Now that we see a graphic representation of linear velocity, it is important to note that nothing in nature moves at the same constant speed. Throw a ball in the air, slide your phone across a tabletop, or watch leaves blowing in the wind. There is infinite variation in the speed of natural movement. The emotional quality of a Motion Design piece is highly dependent on the speed and tempo of animation. The ability to skillfully control Temporal Interpolation in Motion Design separates the junior from the senior animator.

In Figure 2.10, we see a representation of a layer moving in a linear spatial motion path through a composition and a representation of non-linear temporal interpolation in a Speed

Linear Spatial Interpolation - Composition Window

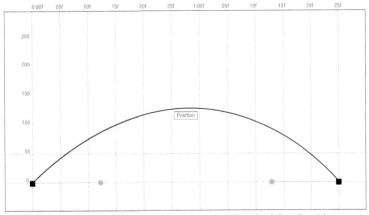

Non-Linear Temporal Interpolation - Speed Graph View (Easy Ease Out & Easy Ease In)

2.10
Infographic representations of Linear Spatial Interpolation (top) and Non-linear Temporal Interpolation (bottom) seen in a Speed Graph. *Ease-out and Ease-in.*

Graph view. In the spatial composition of Figure 2.9, notice the position of the dots (representing frames in time) along the motion path. At the start and finish, we see the distance between frames is smaller, indicating a slower speed. The distance between frames gets wider along the motion path as the velocity increases.

These graphics show a common Motion Design term known as *easing*—where movement starts or finishes slowly. An *ease-out* describes starting slow and then increasing speed. An *ease-in* describes the opposite, where speed slows down towards the end. The shape of the curve in Figure 2.10 is very important in learning how to interface with a Speed Graph. The animation begins easing out from the first keyframe on the left side of the graph. We start with very small movement and then gradually get faster. The fastest velocity of the animation happens at the highest elevation of the curve. As the curve starts to arc downwards, the speed of motion slows until it stops at the second keyframe. The Bezier handles on each keyframe allow you to adjust the shape of the curve, which adjusts the velocity of the animation.

Motion Design software often has automated *easy-ease* functions, which look like Figure 2.10. This type of subtle ease introduces a more organic feel to keyframed motion. Easy-ease is a great starting place to move beyond linear interpolation that tends to feel digital. The F9 key is the hot key that converts a keyframe to easy-ease in After Effects. However, more dramatic motion requires further adjustments to Graph Editor *curve shapes*.

In Figure 2.11, we see an example of extreme non-linear temporal interpolation in the Speed Graph. In this case, we have a dramatic and lengthy ease-out followed by a quick ease-in. The motion for a graph like this starts very slow, rapidly accelerates, then finishes slow. Again, in a Speed Graph, the shape of the curve represents velocity. The low points of the curve are the slowest moments, and the high points are the fastest. In the composition view, the dots along the motion path reflect the velocity displayed in the graph. Frames move gradually at first, then make huge movements in time during the fastest moments of animation.

In Figure 2.12, we see another type of extreme temporal interpolation with a slight ease-out followed by a heavy ease-in. This graph curve creates a very fast motion at the start of the animation that has a long smooth ease-in. In all instances of non-linear temporal interpolation, Bezier handles are used to adjust the shape of the curve and motion timing.

Although specific numeric values are important when keyframing, the shape of the curve indicates the type of motion produced. Essentially, the quality of motion is reflected by the shape of the graph curve. A flat line in a velocity graph has a consistent rate of change. A gentle ease-in and ease-out shows a gentle flow in the rate of change, whereas a dramatic shape to a curve in the graph shows dramatic contrast in motion.

The Journey

In Figure 2.13, we have another set of infographics showing both a spatial composition (top) and a Speed Graph view (bottom) of keyframed position properties. This infographic illustrates how easing the timing between keyframes controls the look and feel of motion. Even with parameters that are identical in terms of beginning, end, and distance, the shape of a property's curve determines how the animation plays.

In this animation, the three different layers *travel the exact same distance* and *start and finish at the same time*. However, each layer's journey is different based on its temporal

Linear Spatial Interpolation - Composition Window

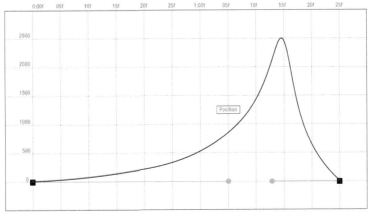

Non-Linear Temporal Interpolation - Speed Graph View (Strong Ease Out & Ease In)

2.11
Infographic representations of Linear Spatial Interpolation (top) and Non-linear Temporal Interpolation (bottom) seen in a Speed Graph: *Strong Ease-out.*

interpolation. Figure 2.13A is set to linear temporal interpolation and moves across the composition at a consistent speed. Figure 2.13B is easing-out and easing-in, starting with a gentle increase in speed and finishing with a gentle decrease in speed. Figure 2.13C begins with a dramatic ease-out, staying very slow, then going very fast before a quick ease-in at the end.

Easing Other Properties

The beauty of learning to animate with keyframes is these techniques translate to all types of transformations and effects. Any keyframed property can be adjusted in the Graph Editor to create variations in choreography and timing. That means once you understand how to keyframe and adjust interpolation with the Graph Editor, you can compose motion in unlimited fashions.

Easing Multiple Properties

Within the Graph Editor, multiple keyframed properties can be selected and adjusted simultaneously. This feature allows for precise and elegant synchronization of animation. In Figure 2.14, we see an infographic of a square animating across a composition with position,

Linear Spatial Interpolation - Composition Window

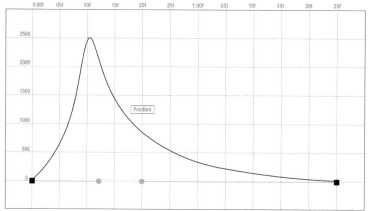

Non-Linear Temporal Interpolation - Speed Graph View (Ease Out & Strong Ease In)

2.12

Infographic representations of Linear Spatial Interpolation (top) and Non-linear Temporal Interpolation (bottom) seen in a Speed Graph: *Strong Ease-in.*

rotation, and scale all keyframed. The keyframes for all three transformation properties occur at the same start and end points in the timeline. The three transformation properties also share the same temporal interpolation—easing out and easing in—displayed in the shape of their respective curves.

In Figure 2.15, we see the same animation, but the temporal interpolation of each transformation property—position, rotation, and scale—has a dramatic ease-in. All selected properties are concurrently adjusted using Bezier handles in the Graph Editor. Although the properties are displayed at various heights (based on how their values are measured), the shapes of the curves are the same, indicating their movements are synchronized.

Negative Values

Most transformation properties can have both positive and negative values. Rotation, scale, position, anchor point, and many effects can be keyframed in positive and negative values. For instance, layers rotated in a clockwise direction display positive values of degrees and/ or full rotations. Layers rotated in a counterclockwise direction will display negative values of

3 Layers Animating the Same Distance, in the Same Amoiunt of Time - Composition Window

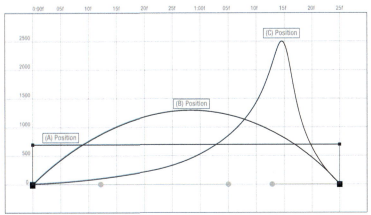

Multiple Layers' Position Property Displayed in Temporal Interpolation - Speed Graph View

2.13
Infographic representations of Linear Spatial Interpolation (top) and Multiple Temporal Interpolations (bottom) seen in a Speed Graph: (A) Linear, (B) Ease-out and Ease-in, and (C) Strong Ease-out.

degrees and/or full rotations. In Figure 2.16, we see spatial compositions and Speed Graphs that illustrate the difference between how positive and negative values are represented. The Speed Graphs in these infographics include values representing degrees of rotation running vertically on the left side and duration in time running horizontally across the top. For keyframes with positive values, the *curve shape* ascends. Keyframes with negative values display a curve shape that descends.

Multiple Keyframes in the Graph

So far, we have examined the speed Graph Editor in circumstances with two keyframes. What about when you have more than two keyframes on a layer? Managing interpolation within the Graph Editor is key to successfully controlling more complex animations. In Figure 2.17, we see two examples of the same motion path through space that uses three position keyframes. The example on the left has easy-ease temporal interpolation on each of the keyframes. When played down, this animation would start slow, then speed up, and then slow down again between keyframes 1 and 2. Then, we would see the same type of pacing between keyframes 2 and 3—easing out and easing in.

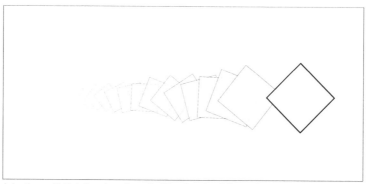

Animation on Multiple Transformations: Position, Rotation, & Scale - Composition Window

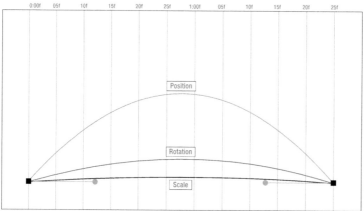

Multiple Transformations Displayed in Non-Linear Temporal Interpolation - Speed Graph View
Position, Rotation, & Scale

2.14
Infographic representations of multiple transformation properties seen in the Composition Window (top) and Graph Editor (bottom). The Graph Editor shows each property with gentle eases.

What if we want a smoother timing without so much starting and stopping between the keyframes? The Speed Graph on the right of Figure 2.17 shows a curve that eases out from keyframe 1, continues smoothly through keyframe 2, and eases in at keyframe 3. To achieve this type of fluid pacing, we need to adjust the shape of the curve at the second keyframe (P2). Each keyframe in the Speed Graph is composed of two separate points: an incoming and an outgoing. Each side of the keyframe has a Bezier handle that can be lifted to adjust the in and out points along with the tangent magnitude, thereby managing the shape of the curve.

If we want smooth motion between multiple keyframes, we need the overall shape of the curve to elegantly flow where intermediary keyframes meet. This technique takes time to master, so begin with simple animations of three or four keyframes flowing together. Essentially, the shape of the curve our keyframes make in the Graph Editor reflects the quality of our motion. Bumps or drastic changes in the curve shape result in abrupt or wobbly animation. Once you learn to control the interpolation of handles within the graph, you can apply this skill to more advanced animations.

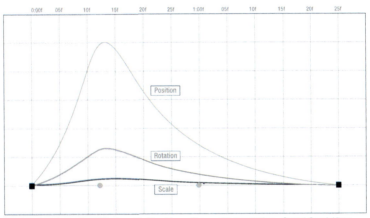

Animation on Multiple Transformations: Position, Rotation, & Scale - Composition Window

Multiple Transformations Displayed in Non-Linear Temporal Interpolation - Speed Graph View
Position, Rotation, & Scale: Easing adjusted simultaneously

2.15
Infographic representations of multiple transformation properties seen in the Composition Window (top) and Graph Editor (bottom). The Graph Editor shows each property with strong ease-in.

Value Graph

The other type of graph used to view and adjust interpolation is the Value Graph. Within this graph, changes in property values are displayed rather than velocity. Curve shapes show property values vertically and time horizontally. How values are expressed depends on the property being adjusted. Opacity is measured in percentages, Rotation is measured in degrees and full rotations, and Position is measured by pixel coordinate. "The *slope* of the line between keyframes represents the rate of change in units per second. Straight lines indicate a constant rate; curved lines indicate a changing rate, or acceleration."[4]

Using the Value Graph, the location of any given point along the curve directly correlates to the value of the property. In the Speed Graph, the location of a point along the curve represents its velocity. However, we can still infer the velocity at any given point of the Value Graph by analyzing the slope of the curve at that point.

In Figure 2.18, we see the same linear spatial interpolation of a layer (top) with a simplified representation of a Value Graph (bottom). In the Value Graph, the X and Y position properties are represented by two distinct lines. The X position value is changing over time

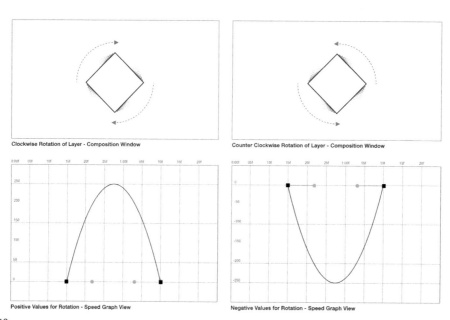

2.16

Infographics showing the difference between how the Graph Editor displays positive and negative values. Images on the left show clockwise rotation with positive change, or an increase in value in the Graph Editor. Images on the right show counterclockwise rotation with negative change, or a decrease in value in the Graph Editor.

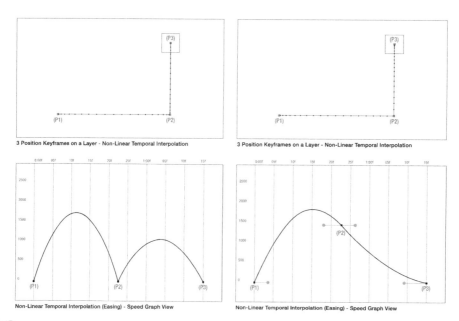

2.17

Infographics showing multiple keyframes in both spatial compositions and Speed Graph Editor views.

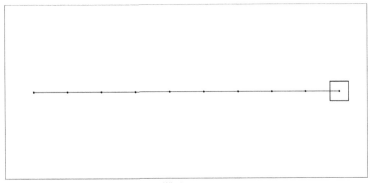

Linear Spatial Interpolation - Composition Window

Linear Temporal Interpolation - Value Graph View

2.18
Infographic representations of Linear Spatial Interpolation (top) and Linear Temporal Interpolation (bottom) seen in a Value Graph.

and seen in the Value Graph as the diagonal line. Because the temporal interpolation of this animation is linear, a straight diagonal line indicates a constant rate of change. In this animation, the Y position value does not change over time; so, we see that property as a straight horizontal line.

Easing in the Value Graph

In Figure 2.19, we see an example of non-linear temporal interpolation represented by a Value Graph. The motion path is still linear in the composition view, but the temporal interpolation eases out and eases in. In the graph view, the X position property is displayed as a curve, showing the gradation of changing value over time. The Y position property is still a straight line, as its value has not changed.

Adjusting Spatial Interpolation With the Value Graph

Within the Value Graph, we can change both temporal and spatial interpolation for properties. In Figure 2.20, the second keyframe for the Y position property is adjusted within

Linear Spatial Interpolation - Composition Window

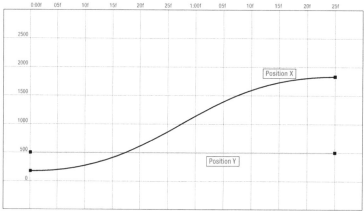

Non-Linear Temporal Interpolation - Value Graph View (Easy Ease Out & Easy Ease In)

2.19
Infographic representations of Linear Spatial Interpolation (top) and Non-linear Temporal Interpolation (bottom) seen in a Value Graph. *Ease-out and Ease-in.*

the Value Graph, causing a change in position within the spatial composition above. This affordance can be used on any of the basic transformation properties, as well as any effect or keyframable parameter that uses changes in value rather than velocity alone. It is also important to note that 3D programs such as Cinema 4D default to a Value Graph for adjusting interpolation.

Hold Keyframes
Another type of temporal interpolation is a *hold* keyframe. A hold keyframe "holds" the value of a keyframed property until the next keyframe in the timeline. This type of animation is great for creating faux stop-motion effects or for abrupt changes in space. Hold keyframes skillfully placed on transformation properties can simulate the organic feeling of classic animation that was created with practical methods. The strength of using hold keyframes is the efficiency of production relative to traditional stop-motion animation because you can create a similar look and feel in a fraction of the time.

Another strength of hold keyframes is the ability to make animation feel like editing. An editor cuts footage to create rhythmic timing. With hold keyframes, an animator can create

Linear Spatial Interpolation - Composition Window

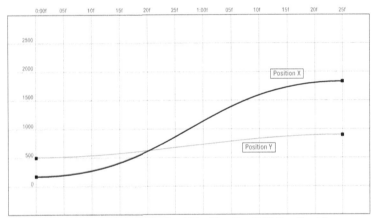

Non-Linear Temporal Interpolation - Value Graph View (Easy Ease Out & Easy Ease In)

2.20
Infographic representation of spatial transformation properties changing within the Value Graph Editor.

the same type of feeling, but rather than cutting an entire scene or shot, the "cut" can happen on an individual element in motion. For instance, a letterform or word can jump back in space on cuts rather than a smoothly interpolated movement. This type of motion adds an element of instability or disruption. Not every circumstance calls for hold keyframes, but they are an awesome affordance when you want to create change from one frame in time to the next.

Any layer that can be keyframed can be converted to a hold interpolation. Also, keyframed layers can have any mixture of interpolations. In Figure 2.21, our layer starts moving from keyframe (P1) at 0:00 seconds in time with linear temporal interpolation until it arrives at keyframe (P2), at 0:15 seconds. Because (P2) is a hold keyframe, the layer holds position until (P3), at 1:00 second in the timeline. The temporal interpolation between (P3) and (P4) in non-linear. The motion from 1:00 to 1:15 seconds has a strong ease-out followed by an ease-in.

In Figure 2.22, we see infographics comparing a layer's journey through space using the same motion path and the same number of keyframes over the same amount of time. However, the composition and Value Graph on the left are showing non-linear temporal

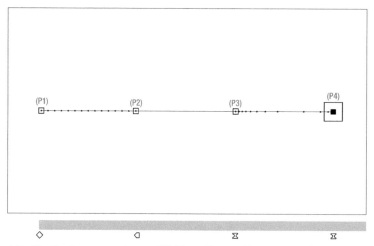

4 Position Keyframes on a Layer - (P1) Linear Temporal Interpolation, (P2) Hold, (P3) and (P4) Non-Linear Temporal Interpolation.

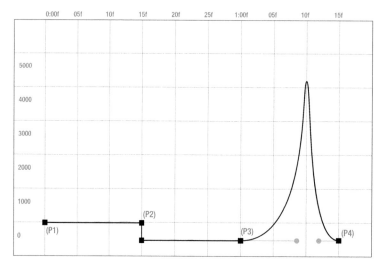

4 Position Keyframes on a Layer - (P1) Linear Temporal Interpolation, (P2) Hold, (P3) and (P4) Non-Linear Temporal Interpolation - Speed Graph View

2.21
Infographic representation of various keyframe interpolations within a single layer.

interpolation with easing, whereas the composition and Value Graph on the right are show-ing hold keyframe interpolation. The left composition displays dots along the motion path that signify where the layer is located at various frames in the timeline, with 15 frames between each keyframe. The shape of the Value Graph's curves for X and Y indicate a fluid rate of change.

The composition on the right shows four hold keyframes, with no dots along the motion path. When we use hold keyframes, there is no movement between keyframes. Rather, we have hard cuts or jumps to the next keyframe's property value(s). The layer in the right

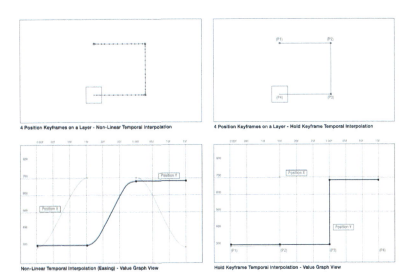

2.22
Infographics showing the differences between interpolation types. Images on the left show non-linear temporal interpolation, whereas images on the right show hold keyframes.

composition stays at keyframed position 1 (P1) for 15 frames until we arrive at the second keyframe. At this point in time, the layer jumps to position 2 (P2), where it stays for another 15 frames, then to position 3 (P3) for 15 frames, and finally to position 4 (P4).

Creative Brief: Audio and Non-Linear Interpolation

2.23

Example from *Synesthesia* exercise by Jessica Natasha. The top images include stills from the completed animation and a pen and paper approach of storyboards prior to motion. The bottom image is a screen capture showing an imported audio layer in After Effects. The layer is unfolded to display the audio's *waveform*, an infographic representation of audio levels across time. Using markers in tandem with audio waveforms informs when editorial cuts or animations should happen in a timeline.

Description/Creative Needs

For this exercise, create (1) animation using basic transformations, simple shapes, and audio. Practice using the Graph Editor to create non-linear interpolation in your animations.

Audio

When sound and motion are combined, there is a potential to create multisensory experiences that are evocative and impactful.

Conceptual Prompt—Synesthesia

Select a piece of music to which you can create a synchronized animation. You may also add sound effects.

Synesthesia as a Metaphor

Synesthesia is a neurological condition where "a subjective sensation or image of a sense (as of color) other than the one (as of sound) is being stimulated."[5] In other words, a person with synesthesia may hear colors or see sounds. In Motion Design, we use the idea of synesthesia metaphorically to represent the idea of synchronizing sounds and visuals. When audiovisual elements are skillfully synced, a satisfying multisensory experience is produced, and the individual parts amplify the effect of the whole.

This exercise has both a design and motion component.

1 Design phase: Listen to your audio sample, then create sketches that visualize the audio. Work with simple geometric forms that will be translated into After Effects Solids and/or Shape Layers.

Pen and paper approach: Work in a sketchbook to roughly draw out a sequence of sketches for your motion exercise. Create a hand-drawn storyboard prior to animation.

2 Motion phase: Use After Effects to create visual animations that synchronize with your audio sample. Create Motion Design that clearly relates and expresses particular sounds. Revealing an audio layer's waveform is helpful for both editing and synchronizing keyframe animations. For audio layers that contain music, the rhythm of a soundtrack is displayed through waveform. Spikes in the waveform show moments in time where the audio levels are high or intense, whereas dips show moments where the audio is softer. Matching cuts or movements to audio creates a synesthetic experience.

The objective is to learn to choreograph objects in response to a given sound structure; to produce simple shapes, movements, and colors that respond to and enhance the rhythms, tonalities, and dynamics of music.

Christopher Pullman, Yale University

Professional Perspectives
David Conklin

David Conklin is an Ohio-born motion designer and creative technologist currently based in Queens, New York. Over the past ten years, he's worked at a range of design and branding studios, agencies, and entertainment companies, building the visual and technical systems at the core of brands like Comedy Central, MTV, the Overwatch League, Rockstar Games, IBM, Showtime, and Disney. In his free time, David's a creative coder, exploring how emerging platforms and technologies help us understand, visualize, and interact with the world in new ways.

Interview With David Conklin, Creative Technologist

What is your background?

When I was young, I always thought I was going to go into tech or the sciences. In seventh or eighth grade, I wanted to go to MIT and be a programmer. I remember a conversation with my dad where he said, "You are going to end up in the arts." I was like, "No I'm not." I totally didn't believe him, but he ended up being spot on. I have always been a gamer, and back in 2007, I started playing more games online and spending time on forums. These forums had signatures at the bottom, where if you had a level 50 mage, you could make a banner that had your character in cool gear and a background. They had signature request threads where you could request an artist to make your signature for your character. You gave people the same information, and they came back with wildly different artwork. It was my introduction to briefs! What I was getting back was not exactly what I wanted, and I thought I could do something better—naively, in my 14-year-old brain.

I started learning Photoshop and tinkering around, following Deviant Art tutorials. I was fortunate that my high school had a class in Photoshop. I applied to a few different schools and ended up at SCAD (Savannah College of Art and Design). I thought I was going to be a graphic designer, but in my freshman orientation, they were playing reels of all the different departments. Here's the ceramics department—a bunch of cool vases. Here's the film department—a bunch of cool shots. When I saw the motion media design section, I was like, "This is a thing?! This is the thing that I actually want to do." I switched my major and got into studying Motion Design.

I was always interested in learning how to use the tools. To me, it was understanding how to make rigs and understand rendering technology. I am a designer, but I love engineering. I love building things, looking at something, plugging in all the right pieces, hitting play,

2.24
Selects from various projects *Overwatch League*, *SYFY*, *MTV News*, and *Comedy Central*. Projects completed at Loyalkaspar. Art and technical direction: David Conklin.

and seeing that it works. That has led to a career that I have been given room to explore how things work, and how to build things that are easy to use and update.

Can you tell us about your career path?
I started at Loyalkaspar as an intern and worked my way up to technical director and associate art director. My technical skill set is about workflow, how to manage complexity

at scale, and with branding—how to deliver a toolkit. I immediately realized that there would be a person downstream who would be using these files. Because I understood the software, I was able to take something from design boards, through animation, through the process of *toolkitting*—which is automation and streamlining—to delivery. I had a penchant for that kind of technical stuff. My mental model is very pipeline driven, collaborative, and how to make projects user-friendly.

After Loyalkaspar, I took a job at Rockstar Games as a motion designer. I had played their games since I was eight years old, I appreciated their sassiness, and it was right around the time that Red Dead Redemption 2 came out. I loved the work that I did there. After that, I went freelance for a while. I think everyone should try freelance because you learn so much from all the random people you work with. It was scary at first, but you put that call out to your network—"Hey, I need help." All these people that you have worked with, that you have made a good impression on, they rally. The confidence that comes from realizing you have a social safety net, mixed with the ability to experiment and figure out what you want, makes it feel good when you go back to a staff job.

I took a staff job at Trollback as a creative technologist because it aligned with my goals. It's the title I want because I can re-infuse with the creative energy that gets me out of bed in the morning and decouples me from the traditional technical director role, which is very pipeline driven. Creative technologist is a little more amorphous—you are creative with a technological bent.

What are your thoughts on learning design software?

We all use the software, and we all kind of describe it in our heads the way that makes sense to us. I'm a bit of a nerd for documentation, and so I like reading manuals so I can really understand how these things function and the terminology. But it also doesn't actually matter that much—if you understand what these things are doing, who cares what they are called.

Being someone who is more technical, there is a point where the technical knowledge makes you feel more proficient and effective—but it can become a hindrance. When you are too aware of what the constraints of the software are, you get boxed in. I have seen artists who are not as technically savvy, who do not abide by boundaries and figure out ways to do things. They do something that I would call "hacky" or not "semantic" or whatever developer-centric terms. But they end up making things that I didn't think was possible, because they are not so bound by the limitations of what they think can be done. In my technical career, the challenge is to not let guidelines or limitations stop me from making the things that I want.

How do you think motion fits into the traditional design disciplines?

Motion is a design principle. The reason why motion seems secondary to something like color, value, or scale is just because of the technological delay. We have not been able to communicate with motion until pretty recently. That does not mean motion is any less important than other visual principles. We have talked for a long time how color can communicate emotion—something blue might feel sad, something red might feel hot. Motion does exactly the same thing. How you move something; how lethargic, how snappy, how jiggly—you are communicating the

same things you do with color, value, texture, or lighting. We have not had screen-based media that was so accessible until the last few decades. We only had black-and-white film for a long time. That does not mean that color was not important.

What are your thoughts on procedural versus bespoke?

The various sectors within Motion Design make a big difference. I mostly do branding, toolkits, and iterative projects. The longer 30-, 45-, or 60-second spots, where every single frame is crafted, lends itself to the bespoke side of the spectrum. A brand is a system where nothing exists by itself. You have to be more agile and willing to address notes and have systems that work together. With the longer narrative animations, I always fawn over the amount of detail and custom care that goes into every single ease, and every single frame.

We use the term *Motion Design* that describes such a wide gamut of everything that can be done. I think the different sectors within the Motion Design world have different places on the spectrum where they succeed the most. An animator doing beautiful, stylized character work who is too enamored with the technical limitations—they may never get animation that looks that beautiful. On the other hand, if you have someone doing heavy branding for a news network, who is way too obsessed with making every frame perfect—they are going to get a system that doesn't function because everything is custom. It's figuring out what the right amount of procedural versus bespoke is based on the work that you are doing. There is no one size fits all.

What are your thoughts on branding in Motion Design?

Branding can be everything from network branding to live streams like Twitch, where streamers have brands; each component is a piece of a whole, whereas a monolithic spot can have something singular about it. Branding is not one element. When a Motion Design studio that specializes in branding presents a brand, it's a sizzle reel of hundreds of elements. A project in branding is made up of lots of different small parts versus a longer one-off piece. Procedural is another way of saying *algorithmic*, or a set of instructions. A brand is a set of instructions that generate a bunch of different assets. There is a set of instructions that says, "This is my color palette, this is my typeface, this is my motion language, etc." I can run an element through that procedure and get a lower third, an open, a button, or whatever. When you have a stand-alone spot, you can pay attention to each of those things on their own. That's different than a brand where all those things have to work together.

Do you think the duration/length of the deliverable makes a difference?

With longer durations, you have to think about multiple shots in a sequence. When you are building shorter stand-alone branding elements, how you get from one to another is not as important. In school, I was taught that Motion Design is *transitions*. How you get from one piece of graphic design to another piece of graphic design. We spent so much time stepping through transitions and how you get from A to B. The most clever motion projects really pull you from one scene to the next really fluidly. But that doesn't really exist in Motion Branding in the same way, and that is a function of the duration.

Transitions that I build for branding are 15 frames long—boom, done. That drastically changes the approach to animating. When you have a longer duration, 20 or 30 seconds,

your transitions become much more important. The transitions can be fluid, or they can be editorial, but I think that is an important piece of the longer Motion Design projects. When you are designing branding, you are working with a set of instructions that create cohesion. But when you are working on a longer narrative spot, you might be going from two drastically different shots. Those transitions are important in making those shots feel glued together.

What big changes have you seen in the Motion Design industries?

What studios and agencies are being asked for is different than it was ten years ago. Clients are not really looking for someone to run the job for them. They are looking for someone to scaffold it—to build the initial creative and tools that they are going to take in-house and expand upon. Even if you are delivering a one-off monolithic spot, these in-house places have gotten so strong and have so much talent now—whatever you deliver is just a starting point for them. For branding projects, the biggest deliverable we do is typically a style guide—the design and systematic thinking for the brand. We also deliver reference renders and toolkitted After Effects project files they can iterate from.

Do you have suggestions for young designers?

The places in your career or life that cause the most growth is where you commit to doing something that you don't know how to do, but you are confident you can figure out.

I think everyone should learn a little bit of code. If you work on a computer all day, everything you do is code, whether you know it or not. Once you have a little bit of coding knowledge, you start to understand that what is impressive about a computer is not the complexity of what it does, but how quickly it does simple things. Once you have that fundamental understanding, you can begin to look at the software we use in a different lens. It's not necessarily doing big, complicated things; it's breaking every task down into a multitude of sub-tasks—and doing those really quickly.[6]

NOTES

1 Interpolation. Dictionary.com. Dictionary.com. Accessed November 14, 2021. www.dictionary.com/browse/interpolation.
2 Bézier Award. Solid Modeling Association. Accessed November 14, 2021. http://solidmodeling.org/awards/bezier-award/.
3 Conklin, David, Zoom interview with author, September 18, 2021.
4 Peachpit. Accessed November 14, 2021. www.peachpit.com/articles/article.aspx?p=1327260&seqNum=6.
5 Synesthesia. Merriam-Webster. Merriam-Webster. Accessed November 14, 2021. www.merriam-webster.com/dictionary/synesthesia.
6 Conklin, David, Zoom interview with author, September 18, 2021.

Chapter 3
Masking, Type, and Project Structures

MASKING

Masking is a fundamental technique that allows motion designers to control the visibility of what appears on screen. Historically, masking was used in analog photography and post-processing to color correct and composite imagery. Today, we use masks for the same purposes, but with increased efficiency and non-destructive workflows afforded by digital software. In a program such as After Effects, masks are an essential feature for visible assets and are created by straight lines or Bezier paths. In other words, animated masks are paths—points and lines—in motion. They are modified and controlled by the same tools we use for other path-based processes. Parametric shapes, the pen tool, and handles are the interface and adjustment tools for masking. With keyframes, we can change the shape of mask paths over time, extending the utility of common animation principles not only to move elements but also precisely control the timing and transition of their masks as well.

Although we can control the visibility of layers with opacity, this transformation property affects the entire layer. With masks, we can isolate and control the visibility of specific parts of a layer. Skillful use of masks on imagery allows for more deliberate and purposeful compositing. In motion, masks animated with keyframes can reveal or conceal layers and aid in transitions. More advanced uses of masks include rotoscoping footage to separate visual elements from their backgrounds. Whatever the use, learning to interface and manipulate masks begins with understanding how to use paths.

Parametric Masks

A good place to start working with masks is with parametric shapes. Adobe After Effects offers a variety of shapes as Bezier paths—rectangles, rounded rectangles, ellipses, polygons, and stars. As vector paths, these shapes are composed of points and lines that can be modified after they are created. Parametric shapes are automatically *closed* paths, which is helpful when first learning to use masks because open and closed paths function differently. We will discuss uses for open paths later in this chapter.

In Figure 3.2, we see three instances of the same circle. In Figure 3.2A, the circle exists in the composition without any mask. When a shape is drawn on top of a selected layer in After Effects, a mask is automatically generated. In Figure 3.2B, we see a rectangular mask made up of points and lines covering the left side of the circle. The default mask type is an

DOI: 10.4324/9781003200529-4

3.1
Graphic representation of default parametric shapes found in design and animation software.

(A) No Mask (B) Add Mask (C) Subtract Mask

3.2
Masks can be applied to either make only the masked area visible or inverted to subtract the masked area from the element (making it invisible).

add mask, meaning that any part of the layer enclosed within the mask path is visible. Any part of the layer outside of the mask path is invisible. In Figure 3.2C, we have the same exact mask on the same exact circle; however, the mask is set to *subtract*. Subtractive masks hide any part of the layer within the mask path and show any part of the layer outside of the mask path. In Figure 3.2B and C, the invisible parts of the circle layer are represented by dashed lines. Masks are non-destructive, meaning the hidden parts of layers are not deleted. This non-destructive feature of masks is what affords their ability to animate the visibility of layers, changing what is hidden or revealed over time. The layer itself remains intact.

Once a mask is applied to a layer in After Effects, mask properties are automatically generated within the layer's properties. To animate a mask, we need to keyframe the *mask path* property. A mask path is literally the shape of the mask at any given moment in time. When we add a keyframe to this property, we record all points and lines at that specific moment in the timeline. Any changes made to the mask path at a different point in time will automatically generate a new keyframe, recording the mask path's new shape. After Effects will interpret changes to the mask path between keyframes.

This type of animation is known as *tweening*—when a path shape interpolates, or morphs between keyframes. In addition to adjusting the spatial shape of masks, we can

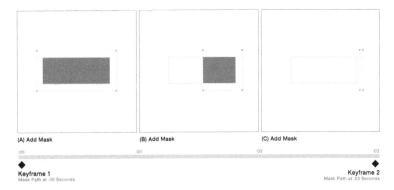

3.3
A rectangular additive mask animating its mask path to wipe away the visibility of a layer.

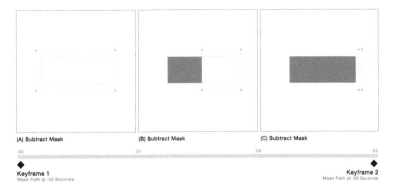

3.4
A rectangular subtractive mask animating its mask path to reveal the visibility of a layer.

also modify the timing of their animations. The temporal interpolation of keyframed mask paths can be adjusted within the Graph Editor. In other words, we can ease the timing of mask path animations in the same way as any keyframable property.

In Figure 3.3, we see a diagram of a mask path being animated over three seconds of time. In Figure 3.3A, the first keyframe designates the mask's shape as larger than the graphic rectangle. As an add mask, everything within the enclosed path is visible. Figure 3.3B shows the mask path animating to the right, hiding the parts of the rectangle outside of the mask. In Figure 3.3C, we arrive at the second keyframe for the mask path at three seconds. The mask path shape is completely off the rectangle, rendering it invisible. This infographic illustrates a simple "wipe-off" effect using an add mask with two keyframes on the mask path property, one at the beginning and one at the end of the transition.

Figure 3.4 shows the same animation of a mask path on a graphic rectangle, but with the mask set to subtract. In Figure 3.4A, the subtractive mask extends beyond the rectangle, rendering it invisible. Figure 3.4B shows the mask in motion revealing the rectangle as the path animates to the right. In Figure 3.4C, the rectangle becomes fully visible as the mask path animates off at the second keyframe. Mask types can be switched after a mask has been created on a layer.

Other Mask Modes

A mask can also be set to *none*, which will indicate the presence of a mask path on a selected layer, but this does not affect the layer's visibility. This setting is very useful when working on an animation because we can toggle the visibility of a mask on or off while assessing how a layer fits within a larger composition. Of course, the mask should be reset to its intended use before you render. There are a few other mask modes in addition to *none, add,* and *subtract.* These modes include *intersect, lighten, darken,* and *difference.* These settings determine how multiple masks on a layer behave when interacting with each other.

Multiple Masks

In After Effects, we can have multiple masks on a layer. From simple wiping on and wiping off layers to more complex processes like rotoscoping, there are many uses for combining masks. The non-destructive nature of masks naturally encourages experimentation. Get comfortable with mask animations and combining mask types. Duplicating and offsetting a mask path in time, creating multiple similar masks, and alternating these masks between add and subtract modes, can create interesting patterns of motion.

When working with multiple masks on a layer it can get complicated rather quickly, as they act like layers within the layer. After Effects allows you to select the color of individual masks—a helpful tool for organizing multiple masks. Changing the color of a mask can also enhance its visibility if the original color it appears in is too close to the hue of the element being masked.

Masks With the Pen Tool

Drawing on a selected layer with the pen tool also generates a mask path. There are a few key differences between drawing a mask on a layer with the pen tool versus a parametric shape. First, the pen tool affords more freedom in the form of path shapes, whereas parametric masks are constrained to simple shapes that can be modified. The pen tool can be used to adjust and segment more simple parametric mask paths.

In Figure 3.5, we see the pen tool as it is found in Adobe Illustrator. In After Effects, some names for similar tools are slightly different, although their functions and the working methods used are fundamentally the same. In addition to drawing paths with the pen tool, we can add points to a mask path with the Add Vertex Tool, delete points from a path with the Delete Vertex Tool, and toggle the interpolation of a point from linear to non-linear with

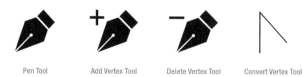

Pen Tool Add Vertex Tool Delete Vertex Tool Convert Vertex Tool

3.5

Pen tool options from Adobe After Effects. The pen draws points and lines that compose paths. The Add Vertex Tool adds points to an existing path, the Delete Vertex Tool deletes points from an existing path, and the Convert Vertex Tool converts points from linear to non-linear or vice versa.

3.6
Graphic representation of the pen tool symbol for closing a path. Close-up of the close path infographic on the left.

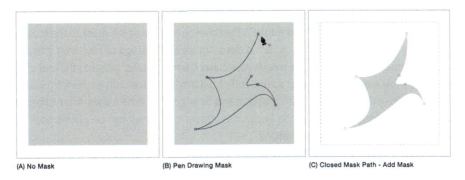

(A) No Mask (B) Pen Drawing Mask (C) Closed Mask Path - Add Mask

3.7
Graphic representation of the construction of an additive mask created with the pen tool in After Effects. (A) shows
a solid layer with no mask. (B) shows an open mask path being drawn with the close path icon on the pen tool. (C)
shows the closed additive mask, with the non-visible parts of the layer represented by the dashed line.

the Convert Vertex Tool. These features of the pen tool are extremely effective at modifying
simple mask path shapes or controlling very complex masks created with the pen.

The pen tool can also create an open or closed mask path. A *closed path* is created
when you click on the original point in a path shape with at least two points and two lines.
In Figure 3.6, we see a representation of the pen tool hovering over the first point in a path
shape (left side). When this happens, the pen tool displays a graphic circle on the bottom
right (close-up view, right side). This user interface element tells us that if we click on the
original point, we will close the path. It is vital to know how to properly shape and close mask
paths because After Effects will not generate a mask on an open path.

In Figure 3.7, we have an illustration of an additive mask path drawn with the pen tool
over a square-shaped layer. Figure 3.7A shows the square, and Figure 3.7B shows the mask
path drawn by the pen tool with various points and lines behaving in nonlinear fashion.
The pen tool hovers over the first point in the path, showing the close path infographic.
Figure 3.7C shows a closed mask path after the first/last point is clicked. The dashed line
in Figure 3.7C shows the invisible parts of the square-shaped layer. Once this mask path is
keyframed, we can animate a change in shape by moving to another location in the timeline
and adjusting the spatial location of the various points and the curves between them.

TIPS AND TRICKS

Rotoscoping with Masks

Rotoscoping footage involves a more complicated use of masks. An efficient rotoscoping technique for isolating a figure from a background is to create a separate mask for each body part, rather than one mask for the entire form—a common beginner's mistake. For instance, to rotoscope an arm, we would create a mask for the shoulder and upper arm, a mask for the forearm, a mask for the hand, and potentially a mask for each finger. This process is repeated throughout the form. Make no mistake, rotoscoping in this manner is a tedious and time-consuming process. However, understanding how to manage and interface with masks is essential.

Another tip for rotoscoping with masks is to strategically space the placement of the keyframes on your initial mask path. After setting a mask path keyframe in time, most beginners will advance to the next frame in the timeline and adjust the mask to the footage. Working in this linear manner is ok, but it does not take advantage of keyframe interpolation. A more efficient practice is to move your current time indicator either to the end of the sequence you are rotoscoping, or to the end of a dramatic movement of the form you are masking. Adjusting the mask path shape at this later point in time forces After Effects to interpret the changes between the keyframes. These keyframes can be played back and adjusted by eye for any major variations.

The software will not perfectly adjust the mask for every frame between the keyframes. However, it will interpret some of the changes and assist you in the process. In most cases, the next step is to adjust the mask and set the next keyframe approximately halfway between the first two. Continue to adjust the mask and make new keyframes in this halfway manner until your rotoscoping looks correct. You may still need to keyframe a mask path on every frame in the sequence. However, this technique gets After Effects to do some of the heavy lifting through spatial interpolation, leaving the artist to work on refining the feel of the work.

Paths From Illustrator

We can also copy and paste a Bezier path drawn in Adobe Illustrator onto a layer in Adobe After Effects. This function is context sensitive, meaning how the pasted path affects the layer depends on what is selected in After Effects. For example, pasting a Bezier path from Adobe Illustrator on a selected layer will generate a mask path on the After Effects layer. However, if a layer's Position property is selected when you paste a path from Illustrator, a motion path is generated that is defined by the shape of the Illustrator path.

Open Mask Paths

The pen tool can also create an *open mask path* on a selected layer in After Effects. An open path is a series of points and lines that do not close. Open paths on layers can be combined with effects that range from standard plugins that come with After Effects to third-party plugins that can be purchased and installed. An open path can also be used to direct the baseline of text into a novel shape by aligning text to a mask path drawn on a text layer.

The classic Stroke effect works with open mask paths by generating a stroke on a layer. This effect and variations such as Trim Paths (which allow you to animate a path using shape layers in After Effects) are tremendously useful. These effects work by animating the start and end parameters to draw on or off Bezier paths. Third-party plugins, such as Trapcode 3D Stroke, work in the same way, except you can also animate paths in Z space. These types of mask paths also work in 3D applications like Cinema 4D. Pairing *spline paths* (Bezier paths used in 3D software) with a Sweep object allows a similar type of path animation in 3D space.

A solid understanding and application of Bezier paths is the common tool in the examples above. Once you become familiar with how to create, modify, and control paths, you can translate that skill across platforms and uses. Effects and stylistic treatments can always be remixed for a variety of purposes. Points, lines, and pairing effects that generate forms on paths are fundamental building blocks of visually sophisticated compositions.

AUTHOR'S REFLECTION: AUSTIN SHAW

Shape Layers

Way back in 2007, Adobe introduced *shape layers* to After Effects with the release of Creative Suite 3. I had been working in After Effects daily starting around 2000, so at that time I thought shape layers were some new annoying feature. Basically, when I wanted to draw a mask on a layer but forgot to select it first, I would accidently create a shape layer. After muttering about how dumb shape layers were, I would delete the shape layer, then correctly create my mask and go about my business. Little did I know how powerful shape layers were.

Sometime in the mid 2010s, while I was teaching at the Savannah College of Art and Design, one of my students showed me a fun animation he was working on. I asked him how he made it, and he told me he used "trim paths" on a shape layer. Even though I had ignored shape layers for years, my curiosity was piqued. I started researching shape layers and was amazed at how versatile they were for Motion Design projects. I have since incorporated shape layers into all my introductory motion classes and use them regularly in my commercial practice.

Here are a few of the key strengths of shape layers and why you should become comfortable with them. First, they are vector graphics, which means they can be scaled without loss of edge quality. As vectors, they are composed of points, lines, and paths, which we have examined in depth throughout this chapter. You can create shape layers by using parametric shapes, drawing with the pen tool, or by converting Illustrator layers imported into After Effects. You can also convert text layers created in After Effects into shape layers.

Shape layers are procedural, meaning they have an array of built-in features and effects. Graphic properties such as *fill, color, stroke*, and *stroke width* are accessible through both the After Effects control panel and a shape layer's properties. Furthermore, these properties are keyframable, which offers easy access to animate them.

Because some of these features are shape sensitive, you should explore what is available based on the type of shape layer you create.

The other powerful aspect of shape layers are *operators*. Operators are like effects that are native to shape layers. Trim Paths, Wiggle Paths, and the Repeater are a few of the procedural operators that can rapidly add life to animations rather quickly. Not every operator will necessarily work with every shape layer you create, but embrace experimentation within the digital environment to discover what operators enhance your workflow.

PROJECT STRUCTURE AND ORGANIZATION

So far, we have examined basic Motion Design principles and techniques with simple shapes, geometry, and audio. This approach helps in the beginning because learning how to interface with animation software while learning motion skills is difficult enough. But Motion Design gets really exciting when we start to import assets created outside of After Effects, making the work a truly integrated and flexible production platform.

The importance of project structure and organization cannot be stressed enough. Any creative endeavor that requires planning, coordination, and usage of media will quickly fall apart without a system. The need for clear, consistent project structure and organization increases with larger productions in terms of scope and the number of people contributing. There is no "one way" to organize and structure a project. Each studio or individual motion designer will customize a system that works best for them. Although the specifics of project structures may change, they share a few common attributes. An effective project structure is accessible, easy to navigate, and supports opportunities to version.

For an individual motion designer, access may be as simple as having a project folder on a local hard drive. A large team working in-house or remotely requires access to network server or cloud-based system. Preserving source files and save paths in any project is important, but even more so with shared projects. Moving assets around indiscriminately or without communication can cause major problems, if there is no common understanding of where materials are located.

A useful project system is easy to navigate. Giving appropriate names to folders and subfolders is the first step in knowing where to save files and where to find them. Adhering to an established and legible naming and saving system requires discipline but allows for clear, common navigation. Too many folders or categories can become cumbersome.

!PROJECT_TEMPLATE	▶	DELIVERABLES	▶	3D	▶	JPEG	▶
		ELEMENTS	▶	AUDIO	▶	PSD	▶
		PRESENTATION	▶	FONTS	▶	TIFF	▶
		PROJECTS	▶	FOOTAGE			
		REFERENCE	▶	RASTER	▶		
		RENDERS	▶	VECTOR	▶		
		TO_POST	▶				

3.8
Example of a custom project structure.

So, a well-designed system needs to be user-friendly. Anyone in a studio should be able to see the project and locate not only an asset but also the latest version of that asset. A clear project structure also allows for portability. You can copy an entire project, with all source assets, if you need to work in different places, or transfer a project over the internet. It is literally a *filing system* for production files.

A critical aspect of any project is the ability to version and support redundancy. One of the strengths of contemporary digital media is the ease of saving and duplication. Storage has become exponentially cheaper over time; so, provided you have the storage space, there is no reason not to increment and save as you work. Saving by date and version number is a simple and effective way to back up your work, as it allows you to revert to an earlier version if needed. Many programs have auto-save features. However, seasoned veterans will advise you to back up your work manually as well.

Layer and File Naming

In creative production, devising and sticking to a naming system is critical to a project's success. We previously discussed the purpose of logical and consistent organization for project and folder structures. At the more granular levels of files and layers, this need is just as important. Assigning labels to individual layers while prepping assets and saving files with relevant names is an essential part of an overall design system.

A simple notation for a file might be YYMMDD_[filename]_version (year, month, day) and is the first part of the file. This naming will sequence files naturally in a list, so the latest versions can be clearly accessed. The name "210611_TOOLKIT_02.mov" tells us this file was the second one produced on the same day: June 11, 2021.

This naming system avoids the sometimes-seen file name "TOOLKIT_really_really_final_final_final_lastone_3.mov" placed in a random folder or on the desktop. Likewise, names like "cool background" or "animation_vector_test" tell another artist in a studio nothing about the files. Sometimes they do not even tell the artist who made them anything meaningful. Vague file names are the makings of a hot mess, but more critically, they waste production time.

PREPPING ASSETS

Although we can create a variety of design assets directly within software such as After Effects and Cinema 4D, Motion Design projects often require the creation of assets outside of the primary compositing or animation tool. Various combinations of photography, illustrations, video footage, logos, and typography are seen in most productions. The primary file types we use in Motion Design are vector, raster, footage, and audio. Understanding the strengths, weaknesses, and best practices for preparing these various file types contributes to a well-rounded toolkit.

Vector files are graphics that can be increased in scale or size without loss of edge quality. As discussed in Chapter 3, vector paths use complex mathematics to construct shapes. Fortunately, common user interface tools make these powerful file types accessible to designers. Vectors are extremely modular and excellent for flat graphics, stylized illustrations, logos, iconography, infographics, and typography.

Raster files are images that cannot be increased in scale or size without loss of edge or image quality because they arranged as a grid of pixels. They are resolution dependent, meaning their grid layout is fixed in scale, affecting the amount of detail and overall file size of the image. Images that are too small will break down in quality when scaled up, and images that are too large can unnecessarily tax a computer's processing power. Raster assets will typically include images with gradation and texture, such as photographs, digital illustrations, and composites, which need to show depth.

Footage files are sequences of images that are compiled into playable video formats. A footage asset may be recorded on a camera or rendered from software. These types of files have predetermined motion and duration. When imported into a compositing program like After Effects, footage files are placed into compositions as layers. Footage files can also contain audio, or we can work with stand-alone audio files. Audio assets could include pre-recorded music, voiceovers, or sound effects. Like footage, audio files have fixed durations and can be placed into Motion Design compositions as layer assets.

In any practice, analog or digital, it is incredibly difficult and frustrating to try and build something when you can't find your tools. When preparing assets for Motion Design production, every file and its subsequent layers are the raw materials used in the construction of the project. Just like tools in a toolkit, we need to know where to find our design assets.

When collaborating on a team, our co-workers need to be able to look at our project files and understand how to use them. When productions become more complex and assets are shared by teams who work on different aspects of a project, often in specialized roles, media stored on shared network storage will also need to provide clear visibility with a logical storage structure understood by all team members.

AUTHOR'S REFLECTION: AUSTIN SHAW

In the early 2000s I was a much better designer than animator. I was seriously debating if I should just focus on design and illustration for my career. Then, I got an opportunity to work as a junior animator on a project and I took it as a sign from the universe to keep pursuing motion. After a few days into this freelance booking, the lead compositor came by my workstation to talk. She called me out on my lack of organization in the After Effects projects I was passing to her. My project panels were basically a default list in alphabetical order that happens when you make comps and import assets without any structure or system for labeling; comp1, comp2, precomp1, untitled7, and so on.

Although I felt embarrassed and I am sure my face turned bright red, it was one of the most valuable experiences of my professional career. She sat with me for 20 minutes or so and showed me exactly how she organized her projects. She taught me how to make folders in the After Effects project panel and how to logically name and organize them. I was introduced to the basics of creating a nomenclature that was user-friendly and of value to a production team.

When I reflect on this experience, I am grateful she had the patience and willingness to teach me project structure and organization. She could have told the producer

of the project not to bother booking me again because I was too unorganized. As I continued to freelance at different studios and work with other motion designers, they showed me additional methods to achieve and maintain efficiency in my projects.

When preparing files for animation, I learned to always label my layers with a descriptive name that would be easy to identify and locate in a compositing software like After Effects. I learned to name my After Effects comps and pre-comps and keep them in their own folders. At first, it required discipline to stay organized, even when I just wanted to make things. But I discovered that a little discipline up front made me way more efficient throughout an entire project.

Working at different studios taught me how to organize entire projects and create a system for sorting my files. I created a blank project template that I duplicate and rename every time I start a new project. Rather than inventing a new structure with every project, using a template helps keep a consistent folder structure for saving and finding files while I work. Project files, renders, and versions are all saved by date with a consistent naming system. This practice helps to support an effective workflow while also maintaining a backup system.

From a technical standpoint, I think *After Effects* is the most important piece of software. For a graphic designer, year one—you have to get in there.[1]

Mitch Paone, Designer/Director, DIA

Linked Assets

When we import assets into a program like After Effects, they are linked to the project file. That means imported assets are not saved within After Effects itself. Rather, linked assets are referenced to the After Effects project by a *save path*, the location of the source file on a hard drive. Editing software like Adobe Premiere and layout software like Adobe InDesign work in a similar capacity. In these types of linked asset workflows, preserving the save paths and location of source assets is important for an efficient production. Breaking the link to a save path prompts a warning that an asset "could not be found." Fortunately, missing assets due to broken save paths can be relinked, which notes and updates their location.

Also, if we edit and save over the original file in a source application like Photoshop or Illustrator, the linked asset will update in After Effects. This can be very helpful to update a project with needed changes, or it can be extremely disruptive if done by accident. Digital media is very easy to iterate and save versions. Incrementally saving source files with version numbers when edits are made helps ensure you do not accidently save over an asset. Additionally, you will have the ability to revert to an earlier version if needed.

Importing Layered Files

Adobe Illustrator and Photoshop are fantastic tools for preparing vector and raster source assets. We have a few options for importing files into After Effects. We can import Photoshop or Illustrator assets as merged layers, individual layers, or as layered compositions.

Importing as merged layers can be helpful if you want to animate on a single asset or need a visual reference of flattened artwork. Sometimes we only need to import a single layer from a multi-layered source file. Importing layered compositions allows us to preserve the exact layout and layer order from the source application.

There are two options for importing layered files into After Effects: Composition and Composition—Retain Layer Sizes. Both choices will import all layers from Photoshop or Illustrator, preserve layer names, and automatically create an After Effects composition that matches the aspect ratio/pixel dimension of your source file. Grouped layers from Photoshop will automatically convert to *pre-compositions* in After Effects. Pre-compositions are layer comps that contain any number of layers, effects, and keyframes nested within a single layer composition.

The primary difference between importing a layered source asset as a Composition versus Composition—Retain Layer Size is the location of the anchor point on each layer. When importing as Composition, the anchor point of every layer in the automatically generated comp is centered to the composition itself. When we import as Composition—Retain Layer Size, each layer's anchor point is centered on that specific layer. Both options are useful depending on your intentions for your animation.

Importing as Composition works well for projects that require composing layers in Z space, while maintaining the layout from Photoshop or Illustrator. Composition—Retain Layer Size works great for any type of motion project that requires distinct animation on individual layers; for instance, animating each letterform and graphic element of an identity mark. Having the anchor point automatically centered to each layer can help when animating transformation properties. You should familiarize yourself with both types of multi-layer import options.

Putting It All Together

The final lesson in this chapter combines a variety of path-based techniques and other fundamental features in After Effects to demonstrate animation of typography. Most communication design projects incorporate some degree of type, making type animation a vital skill for motion designers. The approach is relatively custom, meaning it would be difficult to procedurally automate. However, once mastered, these techniques can be repurposed for a range of animated solutions.

In Figure 3.9, we have a sequence of images showing the effect of a letter "S" drawing on screen. Figure 3.9A shows a text layer of the letter in After Effects. In Figure 3.9B, a separate shape layer has been drawn with the pen tool on top of the text layer. *Remember, drawing with the pen tool while a layer is selected creates a mask. When we want to draw a Shape Layer, we need to make sure no layer is selected.* The path of the shape layer runs through the center of the "S" letterform. The shape layer is an open path set to display a Stroke, but without a Fill. Also, the shape layer's stroke width is slightly larger than the visible area of the text layer "S."

Figure 3.9C shows an in-progress animation of the shape layer with the Trim Paths operator applied. This function allows us to keyframe the start and/or end points of a path being drawn on or off. Because Trim Paths works with keyframes, the temporal interpolation can be adjusted within the Graph Editor to finesse the easing. In Figure 3.9D, we

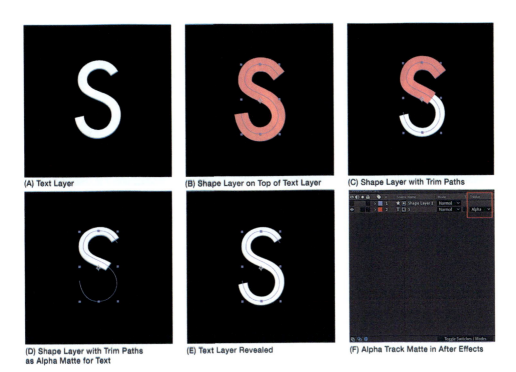

(A) Text Layer

(B) Shape Layer on Top of Text Layer

(C) Shape Layer with Trim Paths

(D) Shape Layer with Trim Paths as Alpha Matte for Text

(E) Text Layer Revealed

(F) Alpha Track Matte in After Effects

3.9
Screen captures of type animation that uses a Shape Layer with Trim Paths, as an Alpha Track Matte, to reveal a letterform.

see a more advanced technique called a Track Matte. In this case, an alpha track matte is applied to the text layer that references the alpha/visible information of the layer above. In other words, the Trim Paths effect on the shape layer above determines the visibility of the text layer below.

In Figure 3.9E, we see the completed animation of the Trim Paths on the top layer of the Matte, which fully reveals the text layer below. Figure 3.9F shows how the track matte pairing of the two layers looks in the After Effects timeline. Take note that the visibility of the shape layer, which is serving as a Matte in this instance, is turned off. After Effects automatically disables the visibility of the top layer when a Track Matte is selected. Track Mattes are incredibly powerful tools and offer a wide range of uses for animation and compositing. A deeper examination of Track Mattes can be found in Chapter 8. The letterform "S" does not have any crossbars or intersecting anatomy. Learning to animate simpler forms is a great place to start. Once you become comfortable with this technique, move on to more advanced letterforms.

Figure 3.10 shows a more complicated use of masks, paths, and typography. Because the letterform "A" has a crossbar that intersects with the diagonal strokes on either side, animating a single shape layer with Trim Paths will appear sloppy and amateurish. An elegant approach requires breaking more complex letterforms into multiple layers, using masks to isolate distinct or intersecting parts, and applying an Alpha Track Matte to each layer with offset timing.

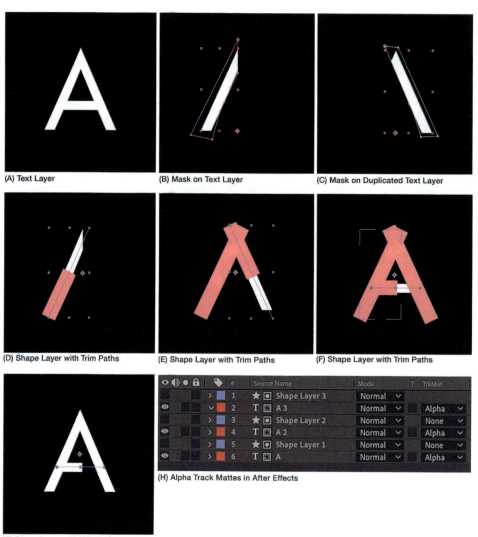

(A) Text Layer

(B) Mask on Text Layer

(C) Mask on Duplicated Text Layer

(D) Shape Layer with Trim Paths

(E) Shape Layer with Trim Paths

(F) Shape Layer with Trim Paths

(H) Alpha Track Mattes in After Effects

(G) Shape Layer with Trim Paths
& Alpha Matte for Text

3.10

Screen captures showing masks isolating distinct parts of a letterform, thus creating new layers, and Shape Layers with Trim Paths as Alpha Track Mattes to reveal each layer offset in time.

In Figure 3.10A, we see our text layer in After Effects. Figure 3.10B shows the diagonal stem of the letterform isolated by a mask. Figure 3.10C shows a duplicated layer of the letterform, with the other diagonal stem isolated with a mask. In Figure 3.10D, E, and F, we see the trim paths on a shape layer + alpha matte technique employed over each correlating layer. Figure 3.10G shows the crossbar of the letterform being revealed by the trim path shape layer. Because the diagonal strokes of the letter have already been revealed, a mask was not needed to isolate the crossbar on this layer.

Creative Brief: Type and Masks

3.11
Examples from this chapter's exercise, "Animate Your Name." The top example uses a handwritten typography treatment created by Meghan O'Brien. The bottom example uses a typeface created by Oliver McCabe. Both examples employ mask and matte techniques on imported assets created outside of After Effects.

Description/Creative Needs

For this exercise, create (1) animation using masks, paths, and typography.

Typography is the _number 1_ ingredient that is going to be in a graphic design project. If I am going to hire someone in the studio, it's the first thing I am going to look at. I am going to look at their resume and see if it's laid out well. If it's not, I am not even going to look at their website. If there is a sensibility and understanding of type to the page, the selection of the typefaces, that is equal to the sensibility of animation.

**Mitch Paone, Director/Designer, DIA**[2]

CONCEPT/DESIGN PROMPT—ANIMATE YOUR NAME

This exercise has both a design and motion component.

1 Design phase: Lay out typography in an aesthetically pleasing manner. Be sure to consider visual qualities such as color, value, scale, and texture during this phase of production.
Work with typography created in:

- Adobe Illustrator that is imported into After Effects

or

- Hand-drawn type made or scanned into Photoshop and then imported into After Effects.

You should also design background and textural elements during the design phase. Be sure to practice naming your layers and organizing your Motion Design project as you prep these assets.

2 Motion phase: Use masks, paths, and/or effects to animate typography. Consider motion qualities such as offset timing of your animation and linear and non-linear velocity.

Masks

Masks are a powerful tool because they determine what is visible versus what is invisible on layers. Furthermore, with keyframe-based animation, we can control the shape of masks as they change over time. You can create and control the shape of any path with a technical understanding of points and lines. Additionally, you can adjust the shape of paths over time with keyframes.

Specifications

- Suggested composition size: 1920 × 1080, 1080 × 1920, 1080 × 1350, or 1080 × 1080 pixels
- (1) animation
- Duration: 5–10 seconds
- Use masks, paths, and typography
- Animation—Your Name

Professional Perspectives
Jordan Lyle

Jordan Lyle is a multidisciplinary freelance designer and creative director from Kingston, Jamaica, based in Los Angeles, California. He graduated from SCAD with a BFA in broadcast design and motion graphics. Throughout his career, Jordan has been able to wear almost all hats in the design for motion and production process, from higher-level conceptualization to pitch development, direction to execution and production. Although he considers himself a jack-of-many trades technically, he is particularly adept at front-end creative problem-solving and strategic thinking in the development process. Jordan most recently founded and launched For the Culture Club—a lifestyle brand with an emphasis on thoughtful design from a Black perspective. He wants to create an often-missing link between traditional design and authentic Black culture using all the creative tools at his disposal.[3]

Interview With Jordan Lyle

What is your background?
I started at the Savannah College of Art and Design intending to study advertising because it seemed like a substantial career path. But I found the motion path was more suited to what I actually wanted to pursue. Everything I liked about advertising and commercials was the motion element of it, animation and bringing storytelling to life. I did my undergrad at SCAD studying broadcast design and motion graphics.

My first job was at Scholar in L.A., where I had interned as a student. It was such a young studio at that time. Everyone was on the same page; we were all one talented team working together. Because it was small, it was "all hands on deck" whenever applicable, which was a great experience for me, just leaving school. I got to learn very quickly, with firsthand experience, what it took to produce something and what really happens in order to get to the end result. As a student, all you tend to see is the end result and have no idea how they got there. It was cool to be integral in the process from concept to finish.

Why did you decide to go freelance?
After four years at Scholar, my priorities shifted. I worked up to being an art director, which had me handling multiple projects, clients, and teams at one time, but not as hands-on with the design process as I wanted to be. I just didn't have to be on the box and as "creative" as much I like to be. I decided to choose more flexibility with the kinds of projects I wanted to work on, flexibility with time, and being able to say "No" to things. When you are staff at a

3.12

Eyes on the Prize, titles created by Elastic. Designer: Jordan Lyle. Style frames and typography for For the Culture Club. Art direction and design: Jordan Lyle.

studio, there are not many opportunities to say "No." It was the right time for me and a good step career-wise to experiment and start something new.

What has your freelance evolution been like?

I've made my way onto the roster of a bunch of different amazing studios and production companies. I've had some visibility from the Justin Cone days of *Motionographer*, and

it hasn't really slowed down much. Part of that is continuing to maintain relationships, whether you are available for booking or not. Those relationships help to ensure you don't have too much of a lull in your freelance career, unless you choose to. Also, whenever you show up at a studio, try to "kill it" every time! Be nice to people; make sure that you are an asset.

I cherish moments where it has been slow as a freelancer because it allows me the flexibility that I had been asking for. Working on other things, taking downtime, and self-care by not stressing about what I can't control. It will pick back up, and "when it rains, it pours." Then I start complaining about too many emails.

What are some of those other things you like to work on?

I wanted to find something that I connected with, that exercised all the things that I am good at creatively. As an art director, it's about designing, writing, project management, organization, quality control, and having a point of view. I added photography to my skill set along the way, which came in handy in many ways. How could I make all these skills work for me? It turns out that it looked like creating a brand was a viable way forward.

So, I put my efforts and skills into a clothing and lifestyle brand called For the Culture Club. I feel like that was a meaningful avenue to have something physical; more shelf life than a commercial that only lasts for two weeks or so at a time. I am good at coming up with visuals and stories, but now there has to be a consumer element to it.

"For the Culture" has a specific meaning in Black culture—things that are important to Black people, created by Black people. A lot of American culture or "internet culture" that exists is co-opted from the Black community—music, art, food, language, style, dance, clothing, you name it. For the Culture Club is turning the lens back on us, highlighting Black culture through thoughtful design. Anyone else who derives anything from that process, perfect. It's made for a specific audience in mind, but it doesn't mean the message can't be received by many.

There is a lot of Black art, but not quite as much Black design, nice design with Black intention. So here comes FTCC with a blend of culture and my skill set, and how I can be a design voice in Black culture—specifically in clothing and physical products. It's something that is essential, because people need things to wear and like to look good wearing them. People also like to deliver a message, something they want to represent or to have represent them. Along with that, quality and craftsmanship are huge for me, having come up through art school. I take a step back periodically, to make sure these ingredients are still important to me. If not, how do I remix them so that my audience still gets what they need, but I creatively get what I need.

What are your thoughts on remote freelance?

I think what remote has done, it's forced people to let their portfolios speak for themselves. If my portfolio is what it is, and you need this kind of work from me, whether I am in-studio or at home, you will be able to get it. The shift has made people feel like they can still be valuable and have better work-life harmony without the pressures of physically being in a studio situation. I am proud of our industry for having really adapted quickly to it.

What do you think belongs in the motion designer's toolkit?

Solid work ethic and being a team player are very important. You don't have to be the nicest person, but you need to be a person that people want to work with. It doesn't matter what your skill set is or how good you are if no one wants to book you for a job. Know the basics—your Photoshop, Illustrator, and After Effects—whether you are a designer or animator. Continually brush up on what it takes to be in the spaces you are in, so you can be the best team player you can be.

Why does typography matter for motion designers?

Motion Design is about communication, and a big way we communicate is through words. The way words are presented can convey many different meanings. It's important for designers to understand how to use language and tell stories through typography. If you write one word in three different typefaces, then it has a whole different meaning, and the audience will perceive it in a different way. It's our job to understand how to communicate the correct message. That is what design is: problem-solving and communication. Typography is one of the best vehicles for that, and everyone should have their license before they start driving.

Know your different categories of type: serif, sans serif, handwritten, etc. All the different styles of type come with histories that mean different things. That is part of the psychology of typography. If you understand that, you can communicate a message easier. Know the areas of typesetting: kerning, tracking, leading, x-height, baseline, etc. Type has a lot of terminology, and it's important to have a basic understanding of those things. Someone is going to be asking you to edit typography according to one of those specific elements at some point in your design career.

Typography is really its own toolkit. What gave me a fundamental understanding of type for motion was working on kinetic typography projects, where the goal is to give type personality and to communicate effectively through animated type. It's an opportunity to understand how setting and moving type around works to deliver the right message. You have to have an understanding of the layout of the type, how many words should be on the screen at the same time, what's legible and illegible, and what's a good pace and cadence. For an animator, it's the same thing. How do I animate this type in a way that complements what's being said on-screen? What are ways I can punctuate and accentuate different elements of typography that bring out the story? Then, maybe to break those rules—you know, to make it feel cooler.

What are some of your favorite projects?

I recently worked on an HBO Max documentary called *Eyes on the Prize: Hallowed Ground*, which chronicles the civil rights movement. I worked on a type system to develop a new way of looking at lower thirds, title cards, and the title sequence. It was a project that was uniquely tied to my Black experience in America, and as a designer I was able to approach it with a particular perspective and vision alongside the team.

Do you have suggestions for young designers?

Early in my career, I was trying to compare myself to studios' work. That can be either very motivating or very disheartening for someone who doesn't know how that work gets

created. When you are in school, you are working on a project, you have two weeks to complete it, and you feel like you have to produce studio quality work, when the reality is there are ten professional people working on a commercial project, for a month, and getting paid. Be kind to yourself.[4]

NOTES

1 Paone, Mitch, Zoom interview with author, June 3, 2021.
2 Paone, Mitch, Zoom interview with author, June 3, 2021.
3 www.jordanlyle.com/contact-1.
4 Lyle, Jordan, Zoom interview with author, September 19, 2021.

Chapter 4
2D Character Rigging

As we become comfortable working with Motion Design techniques and principles, we can start to plan for more complex projects. In this chapter, we continue working with assets created outside of After Effects, importing them as layered compositions and then making them move. Character design and animation commonly appear in Motion Design projects as they express ideas and emotions. Although some projects use highly detailed characters and animation techniques, many motion designers employ simpler approaches.

Long-form animation projects such as episodic cartoons or feature films typically operate on an extended timeline, higher budget, and larger teams relative to Motion Design productions. Because of shorter deadlines and budgetary limits, the approach to characters in Motion Design is often more graphically oriented. These characters can still feel sophisticated, offering unique visual solutions to character-driven work. The constraints of brief-driven production pushes motion designers to adopt a punk-rock approach to solving a creative problem with characters.

Character design and animation are also fun. For designers who work with illustration, learning how to bring simple characters to life can be a great entry point into Motion Design. Motion Design projects that use characters include title sequences, TV commercials, explainer videos, and social media ads. We also see extensive character design and animation associated with large tech brands that have massive digital footprints. These simple moving characters serve as brand avatars that soften the optics of large corporations.

2D RIGGING

2D Rigging is a technique that involves connecting different parts of a character or design asset together for animation. There are many ways to set up a rig, and various software have their own specific methods for interfacing with assets. However, there are a few fundamental practices that translate across approaches: (1) separating a character or design asset into parts or layers for individual control; (2) properly organizing and naming your assets so they are easy to manage; (3) setting the location of the anchor point or axis on layers; (4) wiring layers together in a hierarchical structure.

Setting Up Your Rig

In Figure 4.1, we see the character "Cute Ogre" designed and prepped for animation in Adobe Illustrator. This process involves separating the various parts of the character into

DOI: 10.4324/9781003200529-5

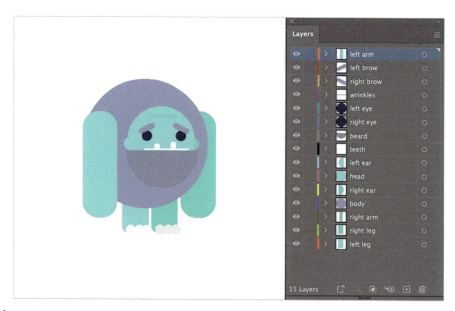

4.1
"Cute Ogre" character prepped for animation. Character design by Rita Albert.

individual layers. Any part of the character that we may want to animate independently is placed on its own layer and given a *logical name*. With these names, we can easily identify and locate specific parts of the character once we import the composition into After Effects. For instance, we have the *left arm* on its own layer, the *right arm* on its own layer, the *left eye* on its own layer, and so on. In Adobe Illustrator or Adobe Photoshop, the *stacking order* of layers is important because layers at the top of the stack will appear at the top of the image. In other words, if the *eye* layers were beneath the *head* layer, they would not be visible.

Working With Imported Assets

In Figure 4.2, we see how After Effects organizes an imported layered file from Adobe Illustrator. In Figure 4.2A, we see the Import Panel bringing our file in as a composition with footage dimensions set to Layer Size. This setting is the same as importing with Composition—Retain Layer Sizes. Each layer maintains the size at which it was created, and each layer's anchor point is automatically centered on itself. This option is helpful when we know there will be layers that we want to animate from their center, such as the Cute Ogre's eyes. A quick animation of the eye's Y scale property creates a blink, or a wink if just on one eye.

In Figure 4.2B, we see how After Effects automatically creates a composition with a name that matches the imported file: "CUTE_OGRE_01." When we import a layered file, the Project Panel also generates a folder that contains a reference to each layer in the source file. When we double click on the CUTE_OGRE_01 composition, we enter an After Effects comp with all our layers in their original stacking order and layout as

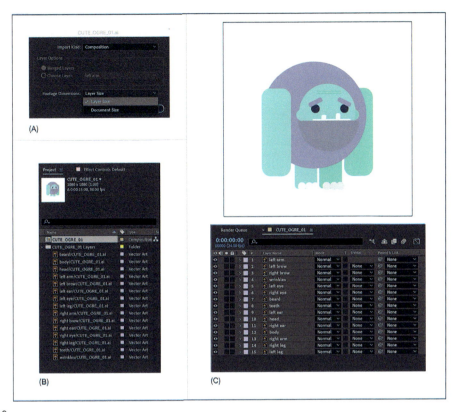

4.2
Screenshot of After Effects Import Composition Panel on the left, and the Project Panel on the right.

defined in Illustrator. Figure 4.2C shows how layered artwork from Illustrator is transported into After Effects. We can also import a layered Photoshop file into After Effects in the same way.

Anchor Point Adjustment

For the Cute Ogre, we will need to adjust the anchor point location for the arms and legs to create an efficient rig. In Figure 4.3, we see the process of adjusting layer anchor points as the first step. Figure 4.3A shows the default location of a layer's anchor point when imported as Retain Layer Sizes, which is centered on the layer content. If we were to rotate the *left arm* with its anchor point centered on the layer, it would look odd, moving a little like a spinning propellor around the default anchor point. Using either the Anchor Point transformation property or the Pan Behind (Anchor Point) Tool located in the After Effects control panel, we can change the location of the *left arm*'s anchor point.

In Figure 4.3B, we see the new location for the *left arm*'s anchor point where the arm meets the shoulder of our Cute Ogre character. When setting up a rig, we want to think about where to place our anchor points in order to rotate or scale from that point. Figure 4.3C shows the adjusted anchor point locations for the *left arm, right arm, left leg,*

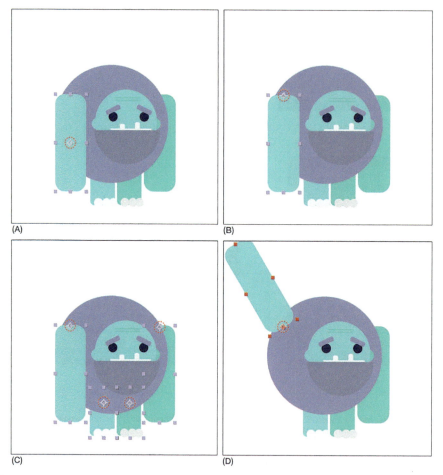

4.3
Screenshots showing the process of adjusting individual layer's anchor points for 2D character rigging.

and *right leg*. From here, we can rotate any of the limbs, and they would appear to move from the character's joints—shoulders or hips—as seen in Figure 4.3D.

Parenting Hierarchies

Parenting in After Effects is a function that allows us to link the properties of layers to one another. In Figure 4.4, we see how parenting establishes a hierarchy of links for our 2D character rig. Figure 4.4A shows the *left arm* layer being parented to the *body* layer by dragging the *parenting pick whip* from the child layer (*left arm*) to the parent layer (*body*). Once a layer is parented to another layer, any basic transformation made to the parent (except for opacity) will also be made to the child. So, changing the position of the parent layer also changes the position of the child, without adding any keyframes to the child layer. However, we can also add keyframes to the child layer that are independent of the parent. Parenting is an extremely powerful function not only for rigging 2D characters but also for improving overall workflow in many different situations. Complex arrangements of objects can be handled very simply and efficiently using parenting.

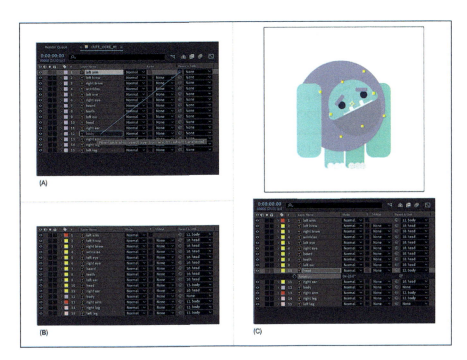

4.4
Screenshots of the process of setting up a hierarchal rig in After Effects using the parenting function.

SIDE NOTE

Sometimes, we need to adjust layers that already have extensive keyframing in place. Updating these types of animations, such as the motion path of a layer that has very specific Bezier curves and multiple keyframes, can be tedious. A useful method for making changes to layers whose transformation properties have already been keyframed is to parent these layers to a Null Object. A *Null Object* is a blank layer that will not show up in a render but still has basic transformation properties. When we parent a layer that has already been keyframed to a Null, we can use the Null to make changes without altering the existing keyframes. The Null functions like an invisible Parent. Using Nulls can maintain whatever animation has already been put in place, while still making global changes to the layer(s).

Complex choreography of animation that involves many layers can be easily adjusted by parenting to a Null. More in-depth workflows involve assigning sets of layers to their own parent Nulls to control incremental changes without affecting precise keyframing on individual layers. Another option is to arrange layers around a null in a radial fashion, as either 2D elements or even in Z space. This technique can produce very complex arrangements of images that can orbit around the Null Object.

In Figure 4.4B, we see the parenting hierarchy of the Cute Ogre rig worked out in the After Effects Layers Panel. The major limbs such as arms and legs are all parented to the *body* layer. All facial features such as the *eyes, ears, beard, teeth*, and so on are parented to

the *head* layer. In turn, the *head* is parented to the *body*, establishing primary and secondary hierarchies. We can rotate the head, and all the facial features parented to it follow. We can also move the body with a different set of keyframes, and the head will follow.

We can also color code our layers in After Effects to help organize our assets into categories for quick recognition. To change a layer's color, simply click on the colored square on the left side of the layer and select a color from the drop-down menu. In Figure 4.4B, the *arm* layers are red, the *leg* layers are pink, all layers associated with the *head* are yellow, and the *body* is lavender.

In this rig, the *body* is the root control layer that everything else is wired to. Figure 4.4C shows a *rotation* to the ogre's head in the Layers Panel, reflected in the rig pictured above in the Composition Panel. Because all the facial layers are parented to the *head* layer, they all rotate based on the *anchor point* of the *head*.

Animating a 2D Rig

In Figure 4.5, we see another simple 2D character rig that was prepped in Adobe Illustrator and imported into After Effects as a layered composition. The anchor points of layers are adjusted for pivots at joints, and the body parts are connected by parenting hierarchies. Once a rig is set up, the fun part begins! We can animate our characters or design assets like a choreographed actor. Unless additional character turnarounds are created, we are limited by the perspectives of our asset design. In this case, the Cute Cat can only work as a profile body and frontal head view. Adding a three-quarter or back view to the sequence of the character animation would allow us more flexibility.

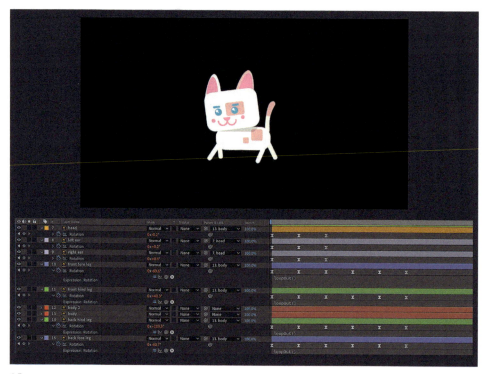

4.5
Screen capture of After Effects *Cute Cat* character, rigged and animated. Character design by Rita Albert.

Creating natural motion such as a walk-cycle can be challenging without visual reference. Fortunately, the internet is a great resource for finding references for all types of character movements. In addition to image and video searches for specific actions, we can always record our own reference. A video recording of a physical action made on a phone can serve as a starting point for character movement. Once we rough out the movement of individual layers in a character rig, we can start easing our keyframes. If natural motion is our aim, adjusting the interpolation of timing will add organic qualities to our animation.

To create repeating movement like a walk-cycle, a simple *loop expression* is very useful. For a seamless loop, the first and last keyframes in an animated sequence need to be identical. In Figure 4.5, the Cute Cat's legs are all set to loop. We see six keyframes on each of the leg layers, and Rotation values of keyframe 1 and keyframe 6 are the same. To set up a loop expression, simply option + click on the property you want to loop—in this case, Rotation. In the expression field of the Rotation property, enter the following:

loopOut()

With expressions, the syntax needs to be exact for it to work. When entered correctly, this expression tells After Effects to repeat the sequence of keyframed animation for the entire composition. We can speed up or slow down the animation by adjusting the space between keyframes without altering the loop expression.

Once a character rig is animated, it can be tricky to move, especially if the Position property has multiple keyframes. Parenting the various layers of a character rig to a Null Object is an efficient way to manage its overall movement. The Null serves as a controller for properties such as Position, Rotation, or Scale without affecting any of the keyframes on individual layers. For the Cute Cat in Figure 4.5, a Null can move the cat across the screen while individual layers are looping in a walk-cycle animation.

The Puppet Tool

Another fantastic tool that provides more elastic changes to design assets is the Puppet Position Pin Tool. This tool allows us to place pin markers on our layers that establish points from which we can bend or stretch artwork. When we pin a layer using this tool in After Effects, a mesh is automatically generated around the layer that lets us distort the asset. We can increase the size and complexity of that mesh to get more flexibility and detail in our puppet effects, but that does increase the processing demands on our computers.

In After Effects, as powerful as the puppet tool is at creating nonlinear adjustments to layers, it does have some constraints. The Continuous Rasterize option tells After Effects to treat artwork as vector (meaning scaling above 100% without loss of edge quality). Continuous Rasterize and the Puppet Tool do not work together. Scaling vector artwork up after setting puppet keyframes is very challenging. If you plan on using the puppet feature on vector assets, make sure you design and import them at the largest size you need.

Figure 4.6 shows the application of the Puppet Position Pin Tool in After Effects. In this example, the Jalapeno character riding a bicycle lends itself to the Puppet Tool. The character's limbs and body are designed to create flexible distortions. The bottom set of images show (2) Puppet Pins placed on one of the limbs. When we use the Puppet Position Pin Tool on a layer, After Effects automatically creates keyframes for Puppet Pins.

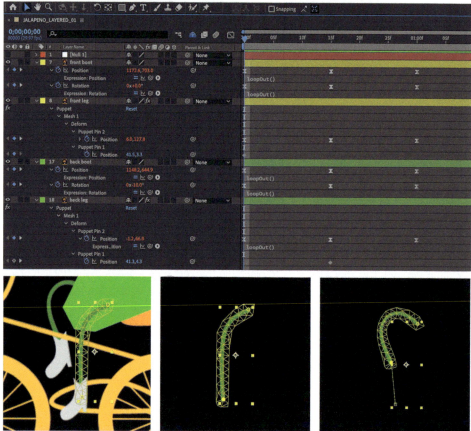

4.6
Screen capture of After Effects, Jalapeno character, rigged and animated with the Puppet Tool. Character design by Rosalinda Perez.

Figure 4.6A shows the mesh warp automatically generated around a layer when Puppet Pins are placed. In Figure 4.6B we see the leg layer *soloed*—a feature that allows us to hide all non-solo layers. The top pin in this example serves as an anchor to keep the limb in place, where the leg meets the body. Figure 4.6C shows the bottom pin is moved in space to create a motion path for the position of that pin, which creates the distortion in the limb. This tool works well for bending and stretching types of animation. When applied to both legs and offset in time, a simple loop expression creates the effect of the Jalapeno pedaling the bicycle.

Figure 4.7 shows an inventive use of 2D character rigging in the short film *Sins*, by Ariel Costa. This project reassembles photographic assets in a cut-and-paste collage style that

4.7
Sins, a short film by Ariel Costa.

takes the audience on a surreal journey. The characters stand out due to their strange combinations of human and animal parts, and their rich visual details against the stark graphic background.

It's a weird project for sure, but I like the weirdness of it. I worked at Buck for 2.5 years, and I got to a point where I wanted to pursue my own voice and do my own craft. It was a hard choice, but I decided to leave and go solo. I put together a portfolio and built my website, and I noticed that it was not really my work—it was Buck's work. I wanted to create a statement of my own voice and show the people what I am capable of. So, I decided to make a personal project. *Sins* is a very surrealistic world, based on the *Seven Deadly Sins*.

It was a great experience where I learned a lot in terms of animation and how I can make a photo-collage to feel organic. I was learning that I love collage and how powerful a photo can be integrated with 2D animation. *Sins* was the school that I didn't have in the past. I tried different techniques to learn to make animated collage figures feel organic, without feeling like stop motion. I wanted to put weight into the characters.

I use the basics, pivots, and parenting layers. When you learn the basics, there is no limitation because you have learned the hard way. If you learn the easy way, you are going to be limited. I don't like to use plugins in my characters, not because I am against them or anything; because when I use a plugin with a character, all the animation looks the same. I like my characters to feel organic and move in different ways. I don't want to put rules on my characters, that's why I don't use plugins. If you want to do it the best way, there is no easy way. If you want to create something unique, you have to put the work into it. I use all the After Effects tools, puppet, liquify, and mesh warp to give organic movement. Anything that gives a stop motion feeling is probably in my comp. Everything that gives a handmade feeling, I love.

Ariel Costa, Director/Designer, Blink My Brain[1]

Adobe After Effects is not the only software to set up 2D rigs, but it is a good place to start, especially if you are already familiar with Illustrator and Photoshop. Even within After Effects, there are a lot of options, including third-party plugins that specialize in creating rigs. We covered the essentials that work with the default After Effects settings. Once you become comfortable with these basics, it is always an option to explore more complex plugins for rigging.

Rigging Beyond Characters

The principle and practice of rigging goes beyond characters. We can wire any types of assets together through parenting hierarchies for more effective workflows. Typography, infographics, geometric shapes, and so on can be linked to create systems of motion. Again, this chapter covers the basics of rigging. Regardless of the method you use to rig 2D assets, you will most likely need to organize your layers into groups or *pre-compositions*. As any After Effects composition becomes more complex, pre-compositions are an integral part of maintaining project structure and efficiency.

AFTER EFFECTS COMPOSITIONS AND PRE-COMPOSITIONS

It takes time to get used to working with After Effects Compositions and Pre-compositions. An After Effects workspace contains several panels that display essential tools to compose motion. The Project Panel references all compositions and assets in a project. The more complex your project, the more the Project Panel fills with items. Therefore, it is vital you keep this panel organized if you want to maintain an efficient workflow and be a useful member of a team.

When we create a new Composition in After Effects, an infographic reference appears in the Project Panel with whatever name we designate for the *comp* (short for After Effects Composition). We also see a canvas or stage in what is called the Composition Panel, where visual assets are composed. This panel contains the Motion Design composition that ultimately gets rendered.

An After Effects composition also holds the Timeline Panel, where our layers are stacked and sequenced. This panel allows us to interface with layer properties, set and modify keyframes, access the Graph Editor, and use layer switches and modes. We can also navigate across a timeline with the Current Time Indicator, as well as zoom in to frame level or zoom out to see a comp's entire sequence.

When we pre-compose a selection of layers in the timeline panel, we create something called a *pre-composition* (pre-comp). Pre-comps are incredibly powerful for several reasons. First, they allow us to tidy up a Composition by nesting a selected group of layers into a single comp layer. A robust After Effects Composition may have hundreds of layers, which can be overwhelming. Creating pre-comps is a method of organizing multiple layers to simplify a project's workflow.

Once a group of layers is precomposed, the newly formed comp layer has all the basic transformation properties of any layer asset. In other words, a pre-comp that contains any number of animated layers nested inside can also be transformed with its own set of keyframes. Furthermore, pre-comps can be duplicated like any other asset. The principle of "duplicate and offset" can be applied to quickly create unified patterns of motion.

When a pre-comp is made, we see an infographic reference for it in the Project Panel. So, giving your pre-comps appropriate names and placing them in the proper place in the Project Panel is part of maintaining a design system. We can always enter a pre-comp, which is basically its own composition. Any changes we make inside will be updated in all instances of the pre-comp. This affordance is quite powerful but take care not to inadvertently make global changes that are meant to be specific. You can always duplicate a pre-comp in the Project Panel, rename it, make your edits, and then place the new pre-comp into a composition.

Another fundamental use of pre-comps is to organize sequences of animation, much like a traditional cinematic conform. Entire scenes that depict narrative moments in a project can be precomposed into shots. Shots are then appropriately labeled and arranged within an edit. When working in this capacity, a motion designer works like a film editor constructing a sequence with cuts and transitions. Of course, we also can dive into any precomposed shot and make changes within the scene (see Figure 4.8, bottom).

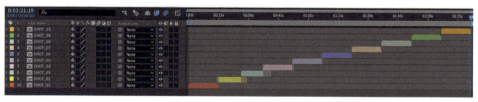

4.8
Screenshot of an organized After Effects Project Panel (top). Screenshot of pre-comps arranged as shots in an edit (bottom).

Experiments and Versions

The After Effects workspace is interesting because it allows us to create and work with multiple compositions. Again, the Project Panel serves as an excellent resource to duplicate and organize multiple comps for a variety of purposes. At the start of projects, motion designers will often work on several tests as they explore design solutions. Duplicating a comp allows us to experiment with variations on a direction without having to recreate everything from scratch. We can rapidly and efficiently prototype multiple options in this manner.

Versioning is an important term that refers to a similar idea of duplication but closer to the outcome stage of a production. A *main composition* is the primary comp that holds all pre-comps and shots that get rendered as deliverables. We may need to deliver a project

in a variety of sizes such as horizontal, vertical, portrait, and square. After we duplicate a main comp, we can rename and resize the comp to a different aspect ratio. Of course, we will need to recompose and update any shots within the duplicated comp to match the new size. Versioning in this way may require that we duplicate and update any pre-comps to match the new size. Although this process takes time and precision, it is far faster than having to recreate each main composition and all keyframed animations within.

Creative Brief: 2D Character Rig

4.9
Example of a multi-layered 2D character designed for motion. Character design by Madison Ellis.

Description/Creative Needs
For this exercise, you will create (1) animation using *multi-layered characters* and *2D character rigging techniques*.

2D Character Rigging
Working with multi-layered assets affords motion designers the ability to set up character rigs in compositing software. A rig allows us to manipulate individual parts of a character, such as the limbs and/or facial components. For this exercise, work with simple stylized characters.

Concept/Design Prompt—Gesture

This exercise has both a design and motion component.

1 Design phase: Create simple 2D characters that can express a recognizable gesture. Consider qualities that are contrasting, odd, or unexpected in your character design choices. Design environment and background elements as well.

Prep your artwork in layers to be imported as a composition into Adobe After Effects. Work with vector graphics created in Adobe Illustrator or raster graphics created in Adobe Photoshop (or comparable software).

2 Motion phase: Import layered assets into After Effects to setup simple 2D character rigs. The placement of layer Anchor Points and Parenting hierarchies will be integral to achieving control of your animation.

Create an animation that expresses the gestures of your characters.

Specifications
* Suggested composition size: 1920 × 1080, 1080 × 1920, 1080 × 1350, or 1080 × 1080 pixels
* (1) animation
* Duration: 5–10 seconds
* Use multi-layered files

Professional Perspectives
Wendy Eduarte Briceño

Wendy Eduarte Briceño's work focuses on storytelling via colorful design and art direction. She uses both 2D and 3D as complementary tools that translate the sensitivity, passion for language, and curiosity inherent in her into various mediums. Wendy graduated with honors in graphic design and photography in Costa Rica, where she worked creating print and digital graphics for advertising. Her love for design later led to a new passion for motion, as she graduated as an excelsus laureate as master of arts in motion media design at SCAD. Wendy has collaborated with the wonderful people at Toast Studio, Scholar, Sweden Unlimited, Bodily, and The Mill.[2]

Interview With Wendy Eduarte Briceño

What is your background?

I have always been fascinated by language. I was also curious about photography and wanted to pursue that. My parents suggested I study something that could be more applied, because there was not a lot of opportunity for a full-time photographer in Costa Rica. It was some of the best advice that I have ever been given. They said, "We will finance your photography career, but you have to double major in something that is more applied." I chose to study graphic design because it involves illustration, applied art, and advertising. I was spending most of my time with photography. But I made a lot of colorful vector illustrations and sort of fell in love with Beziers. That is how it started.

How has photography influenced your practice?

Now that I am mostly working in 3D, it informs so much of what the 3D tools have to offer. Coming into a program like Cinema 4D with just 2D or illustration can be overwhelming without knowing photographic terminology. Like lighting, how to set up light boxes? What's the difference between diffused and hard light? Someone who understands the basics of lighting or takes a class in photography, I believe those fundamentals will inform a greater perspective and creative freedom while using 3D tools.

My metaphor for creativity is like a set of drawers, you have all these little spaces in which you collect different things. You pull one or the other, depending on what you are searching for in that moment. My path in photography informs a lot of what I am doing right now, how I perceive volume, light, cameras, and lenses as much as my graphic design pulls towards my 2D side and illustration.

4.10

Pièce de résistance, by Wendy Eduarte Briceño (top). *Rethinking Flags*, by Wendy Eduarte Briceño and Marcus Bakke (bottom).

What about your background in Graphic Design?

I am very grateful for my background in Graphic Design because it informs how I use color, composition, contrast, and the basic principles of design. I definitely gravitate more towards design than animation. I animate every day, but I consider myself to be a stronger designer than animator. When I studied graphic design, there were all these rules, everything had to align, and everything was very rigid.

I worked as a graphic designer in Costa Rica for 2 or 3 years before studying at my grad program. I knew graphic design wasn't fulfilling everything that I wanted to do, but I wanted

to build on that career. I was searching for more freedom, and curious about what the realm of design had to offer in the United States. What else can I learn that will help me expand into 3D and Illustration?

Doing graduate studies at the Savannah College of Art and Design in Motion Design was liberating. I was thinking very 2D, where the frame begins and ends. I had to start thinking more like a camera or a window, how the composition can extend, and planning for what it could look like once it was in motion. That was very interesting but hard to translate in the beginning.

What has your career path been like?

I started as a mid-level designer at The Mill in New York City. I worked on a variety of different kinds of projects. I was hired with a strong 2D illustrative design portfolio. But whenever there was room for me to do some 3D, or frame by frame, they would throw me into that. It was a good first job in the sense of applying all the different tools I had and put them to use for quick turnarounds. I got a sense of industry standards, learned how to speak the lingo and understand how to collaborate with the team, and gained experience interacting with clients.

It was a very interesting journey for me. As a female creative, it definitely took speaking a lot about the things that I wanted, just because it's such a big company. I put in a lot of time and invested in self-education to level up with my 3D peers. There was a lot of cool stuff happening in terms of 3D, so I took advantage of being in that environment. I got very curious about where the illustrative design world that I love meet with 3D. How can I create beyond cute characters? How can I play with shapes, color, and abstraction to tie together 2D and 3D? How can I communicate stories and ideas with those tools? That is what I got most interested about.

The more I studied and got curious, the more opportunities came, because I was searching for them. I told the head of design that I wanted to learn, to put me on 3D jobs. I was lucky to get opportunity to art direct 3D jobs, which helped me learn from the peers I was working with. My strength is with the visuals, not necessarily the technical side. So, I would be paired up with someone more technical than I am, to back me up on that.

Was it difficult for you to be vocal about what you wanted in the workplace?

As an immigrant, I didn't leave everything in my country, and be far away from my family, to not have these conversations. I didn't allow myself to be scared, even though I was, because nobody else was going to advocate for me. I had worked so hard to graduate from SCAD and get where I was at The Mill, that I had to speak up for myself. If my fellow female creatives didn't see someone speaking up, how would they know if they could speak up too?

What was the motivation to make a move from advertising to tech?

I was at The Mill for four years. It was either move up in the post-production world or I can choose to learn how design can be applied for other things. At The Mill, I was working on visual effects and advertising projects all the time. I wanted to make a change in my career, to see what it would be like to work in a different environment. The move felt very organic, and I was excited about the new possibilities in expanding my knowledge and capabilities.

Currently, I am a 3D visual designer. I love thinking in a different way and how much it has shaken me from my prior work. I like being able to speak to a lot of different design considerations and to have the time to do so. For me, learning is the main motivation. It is something I will always gravitate towards in life.

How do you approach concept development?

Most projects start from a brief, for the most part ideas and treatments that are written down. For me, communication, language, and design are three things that are very important. I love the pitch process because of the problem-solving that comes with communication. I think a lot of people in Motion Design get caught up in the idea of "my style" and "my way of doing things." I am just doing my best to communicate what they client is trying to do. If my aesthetic translates well with that, that's cool. If not, I am happy we all reached the end goal, which is helping the client or service communicate. That is the goal.

When I work with a brief, I am looking for the loopholes within what people are trying to say and give meaning through my own experience. It's a play with language and visualizing metaphors. Gathering words and ideas into something and making it concrete allows me to have a better understanding of what the solution might look like. I don't fall in love with a Pinterest board or aesthetic and try to make it happen.

Does your love or words and language translate into typography as well?

When I studied graphic design, I focused my thesis on typography, understanding the different families and how people correlate different ideas or sentiments to typefaces. That is also why I have a bunch of tattoos that are type related. At that moment, I didn't understand that I was way more attached to language than I was to typography. In other words, I was attached to typography due to my love of language. Also, typography is shapes, and I really like how much rhetoric can be found in a few different shapes that make up a letter. I think that is why I like abstraction too. How many different meanings can you give to one thing, or how much can you reduce a shape to make a new metaphor?

What are your favorite projects?

Pièce de résistance started with writing that moved to graphics. I wanted to understand how to reduce this idea to oddly shaped forms that are not realistic but are stylized with contrasting colors. With all the social unrest that was happening last year, I wanted to speak about inequality and lack of freedom. Empathize with that feeling that you are trapped and correlate it to the visual metaphor of the finger trap in the visuals.

Rethinking Flags is a project I worked on with my partner. He did the 2D and I did the 3D. He also made the sound design. I wanted to do something in terms of the terrible situation for immigrants at the south border, and how there are so many people who do not get to be vocal or express who they want to vote for. I played with the idea of different places where two people could hold each other and help each other out, and how to abstract those into being flags. At the end of the day, what is a flag? For the most part, a flag is a symbol limits, boundaries, sometimes nationalism or being patriotic. But what if it was the symbol of two different people coming together, who might not even share those things?

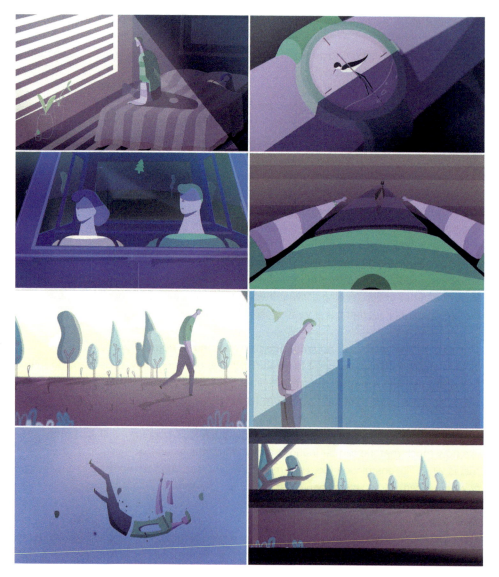

4.11
Precipicio, short film by Wendy Eduarte Briceño, et al.

Precipicio is based on the last day of somebody living, and how they reflect on that understanding. This project expresses my same love for poetry, language, and visual metaphors. I try to connect different moments of still life with the last day my grandfather lived. My brother helped me write this concept, and I worked on storyboards for a long time. For me, it is an honest type of storytelling. The project got a lot of attention, and I am very grateful for that. It got a Vimeo Staff Pick and was featured in a lot of places.

As your career develops, it is very easy to gravitate towards industry standards type of eye candy. Everything feels like an iteration of something. How do you take that noise out and reflect yourself in the work you are doing? With client work, we are always communicating

what the client wants to say. The reason why I do personal projects is because I have something I want to say and need a way to get that out. In the one moment that I can communicate something, what am I going to choose to communicate? What I have left of my own perspective and experience. I believe a lot in being vulnerable in the work that I make. I am strongly nostalgic and melancholic person. I find a lot of meaning and peace with expressing that. When you make something, you are learning a little bit about yourself.

What suggestions do you have for young designers?
Focus on the design fundamentals. Develop a love for composition and balance, understanding negative space, and how to lay out type are so important. They will always be beneficial, no matter what stage you are at in your career. Some people just want to jump into animating, but it is extremely valuable to understand why you are adding motion to this design first and developing a nice style frame as a guide.

The more you put yourself out there and show the kind of work you want to do, the more people will understand your passion for it, and you will get other opportunities. You always want to stick with a studio that sees and understands your potential, beyond of what your skill set is at the moment, you want to sit at the table with peers that can visualize your growth as your talent will only keep developing as you go.[3]

NOTES
1 Costa, Ariel, Zoom interview with author, August 26, 2021.
2 www.wendyeduarte.com/about.
3 Eduarte Briceño, Wendy, Zoom interview with author, September 20, 2021.

Chapter 5
Z Space and Virtual Cameras

Z SPACE

Z space is the shorthand that motion designers use to describe the third dimension in After Effects. Most design applications have a horizontal (X) axis and a vertical (Y) axis, but After Effects also allows users to access the depth (Z) axis. Working with Z space in After Effects gets exciting because we can do more than just create an animated picture—we can create scenes that we can move through. When we make an image on a flat surface, we often try to produce the illusion of depth. Skillful use of visual principles like overlap, scale, perspective, and value, as well as more advanced techniques like atmospheric perspective and depth of field, aid in this task. These tools and principles translate into motion, but with Z space, we can actually layer our assets at varying distances creating foreground, middle ground, and background planes in relation to the camera's view.

3D-Enabled Layers

When we enable layers to be 3D in After Effects, they can be transformed in three dimensions. All visible layers in After Effects have a 3D switch, which is shaped like a cube (see Figure 5.2). When this 3D switch is clicked, the layer automatically gains additional transformation properties. Also, as soon as a layer is 3D enabled, the After Effects default camera view becomes active, which allows the viewport to display layers in a perspective view in three dimensions. Although the default camera view allows us to compose layers in Z space, we need to create a camera layer if we want to move the audience through the scene.

With 3D-enabled layers, a third field appears in the Position transformation property, highlighted in red in Figure 5.2. Increasing the value of the Z Position moves the layer further back in space, away from the default camera view of the scene. Decreasing the value of the Z position moves the layer forward in space, towards the default camera. Working in Z space is more than just position; it is rotation too.

3D-enabled layers also have additional transformations that include *Orientation*, *X Rotation*, and *Y Rotation*. In addition to side-to-side Z rotations, we can have our layers flip over on the X or Y axes when they are 3D enabled (see Figure 5.3). Orientation allows for adjustments to X, Y, and Z rotations of a layer up to 360 degrees. If we want to animate full or multiple rotations of our layers, the X, Y, and Z Rotation properties allow us to do that.

DOI: 10.4324/9781003200529-6

5.1
Illustration of the text "Z Space" moving through Z space.

5.2
Screenshot of an After Effects layer with 3D switch enabled (cube icon on top right). Additional transformation properties—*Z Position*, *Orientation*, *X Rotation*, and *Y Rotation*—automatically appear when a layer is 3D enabled.

X Rotation in Z Space

Y Rotation in Z Space

5.3
Graphic illustrating how 3D-enabled layers can rotate on the Y and X axes.

VIRTUAL CAMERAS

Virtual cameras place the audience within a Motion Design project in the same way physical cameras place the audience within a film. The camera's view is ultimately what the audience sees. So, you want to think about your Motion Design composition the way a director considers a film set. Of course, it is a stylized representation of a film production—instead of actors, we have graphics (although we can composite live-action footage). However, many of the same principles and practices apply.

> **The camera is the eyes of the audience. The more dynamic the camera is, the more fun the audience will have.**[1]
>
> *Ariel Costa, Director/Designer, Blink My Brain*

When working with cameras in Motion Design, we need to think like a director. How far should the camera be placed from the subject matter? A tight shot feels very different than a wide shot. Learning the basics of camera distances and angles is imperative. Fortunately, we have the entire history of cinematic techniques and language at our disposal. Even better, we are not constrained by the laws of physics like traditional filmmakers. Motion designers work like cinematographers, constructing graphic worlds to communicate messages and tell stories, and the camera is the device that places and moves the audience through these worlds.

Anatomy of an After Effects Camera

When we create an After Effects camera, it appears in our timeline panel as a layer. Like other layers, a camera has several properties that can be keyframed. However, cameras do not have all the basic transformation properties of visible layers. The properties of an After Effects camera include *Point of Interest*, *Position*, *Orientation*, *X Rotation*, *Y Rotation*, and *Z Rotation*. The Point of Interest is like an anchor point target that tells the camera where to point (similar to a Target Tag in Cinema 4D).

Position works in the same way for an After Effects camera as it does for any visible layer. We can keyframe this property to animate a camera's position through space and time, which in turn controls what the audience sees and experiences. As a 3D-enabled layer, a camera can also rotate to change the perspective of a scene. After Effects cameras only work with 3D-enabled layer assets and always have access to the X, Y, and Z parameters of the Position and Rotation properties.

Composing in Z Space

In Figure 5.4, we see an example of layers composited in Z space. We have an illustrated bottle centered in the foreground, two bottles further back in space in the middle ground, and two more bottles even further away from the camera, in the background. If we were solely creating a still image, we could create the composition on the left by duplicating layers, adjusting the stacking order, scaling the bottles down in size, and changing their positions. However, in our After Effects composition seen here, all the bottle layers are the exact same scale. The appearance of the bottles, in the middle ground and background, getting smaller is due to their Z positions being further back in space in relation to the camera.

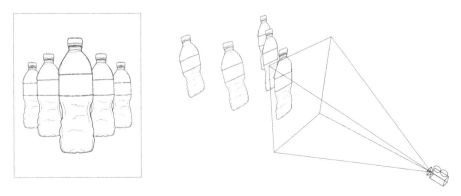

5.4
Layers composed at varying Z depths. The left image shows the camera's view, whereas the right image shows a three-quarter view of the scene.

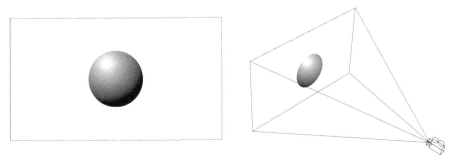

5.5
Camera view of an After Effects 3D-enabled layer on the left. Custom three-quarter view of the same 3D-enabled layer on the right. Although the shading of the layer looks three-dimensional, the layer has no depth.

The ability to compose elements in Z space makes Motion Design an expansive medium. Projects become representational worlds in space rather than simply animated images on a page. Compositions can be as simple as a few layers at slightly different Z depths or quite elaborate with many layers positioned very far apart in space. In addition to the classic foreground, middle ground, and background planes, we can also position assets in Z space to create extreme foreground or background elements. With motion, layers can travel through space towards or away from the camera.

2.5 and 3D
After Effects has some 3D capability. However, 3D-enabled layers are treated as *2.5-dimensional* assets. When we make a vector graphic in Illustrator or create a raster graphic in Photoshop, they do not inherently possess volume. So, when we import these types of 2D artwork into After Effects and enable them as 3D layers, they can be composed and moved through Z space; but they have no depth. They are essentially flat layers in space (see Figure 5.5). Rotating a 3D-enabled After Effects layer on the X or Y axes will reveal a lack of Z depth. For some projects, a flat style is fine. However, for projects where the illusion of depth is important, we need to work within this constraint. There are some plugins that can emulate more robust 3D effects, but there are limitations to what can be achieved in 2.5D.

Programs like Cinema 4D, Blender, Maya, or Houdini show volume or depth in 3D models and geometry. Also, in 3D programs the scene is enabled to compose and move elements through Z space by default. Regardless of 2.5D or 3D, the ability to move forwards or backwards in space allows motion designers to create cinematic experiences. Again, a motion designer needs to think like a filmmaker in addition to thinking like a designer, animator, and editor. A filmmaker crafts composition through the view of a camera.

MULTI-VIEW LAYOUTS

When we begin working with Z space and cameras, sometimes we may want to look at our scene from a different angle than we want our camera to capture, just as a director may walk around the set before calling action. When working in After Effects, the primary view is the *Active Camera View* (the equivalent in Cinema 4D is the *Perspective View*). The Active Camera View is what the camera sees and what After Effects will actually render. Multi-view layouts allow us to look at our compositions from a variety of different perspectives. These additional views make it much easier to both adjust how elements are composed at various Z depths and also visualize how layers and cameras animate through space.

When we select a multi-view layout in After Effects, we are shown our active camera view and a variety of other views of the scene. The default views include *Top*, *Right*, and *Front*. These multi-views are *orthographic*, meaning they show the scene without depth. The Top View shows our composition as if we were looking straight down at the scene. The Right View shows our composition as if we were looking from the right side of our scene. The Front View is a little different, as it shows our scene flattened out, without any spatial depth.

In a true 3D program like Cinema 4D, the Front View is incredibly useful for adjusting point-based splines and models as well as precise alignments of objects. In After Effects, a *Custom View* showing a three-quarter view of the scene is often a more helpful selection because it helps to visualize your scene in a more effective way. In addition to a variety of Custom Views, we can also select *Left* or *Bottom* to view our scenes from the left side or from underneath looking up.

In Figure 5.6, we return to our composition of the bottles arranged in space to examine a 4-view layout in After Effects. The Active Camera View shows the camera's view of the scene, which is essentially our visual layout. In the *Top View*, we see the camera and layer's location in Z space. This view is somewhat abstract because 3D-enabled layers have no depth or volume. The layers simply look like lines arranged in space. The numbers on the bottles in the active camera view correlate with each layer's position in space in the top view.

The *Custom View* in Figure 5.6 is a little easier to understand because the shapes of the bottles are recognizable. Again, the numbers on the bottles in the Active Camera View correlate with the numbers of the bottles in the Custom View. In the *Right View*, the camera and bottle layers are visible but in a more abstract manner, like the Top View. Also, layers 2 and 3 are at the same exact Z depth, so we only see a single line for both layers in the Right View. This representation holds true for layers 4 and 5 as well.

Another major benefit of working with multi-views is the ability to adjust motion paths through Z space. Using Bezier handles, we can make curving paths through X, Y, and Z space for our visual elements and/or our cameras. It does take time and effort to get used to

5.6
Illustration of a multi-view layout in After Effects.

working with the way After Effects displays 2.5D/3D. But once you understand how to work with Z space and cameras, the possibilities are endless.

Nuts and Bolts—One-Node and Two-Node Cameras

Learning to work with cameras in After Effects can be a little challenging if you do not understand the difference between a One-Node and Two-Node camera. Fortunately, it is rather simple to select either type in the Camera Settings Panel (see Figure 5.7). The main difference between a One-Node and Two-Node camera is the Point of Interest. A One-Node camera does not have the Point of Interest property that a Two-Node camera does.

In Figure 5.8, we see an illustration of how a One-Node camera moves horizontally through space, from the Top View of a scene. Both the position of the camera and where the camera lens is pointing are linked. This feature makes working with One-Node cameras in After Effects relatively easy to manage. For 2.5D scenes, One-Node cameras help to maintain the illusion of depth created by flat layers composed in multiple planes in Z space.

In Figure 5.9, we see the same horizontal movement of a Two-Node camera through space, from the Top View. Because we have Two Nodes, the camera also orients to keep aiming its lens towards the Point of Interest. In other words, the camera is *auto-orienting* towards the Point of Interest. In a program like Cinema 4D, we have a similar function called a Target Tag. In a true

5.7

Camera Settings Panel in After Effects, with camera type selection highlighted in red.

5.8

Example of a One-Node Camera in After Effects moving horizontally, Top View.

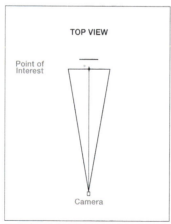

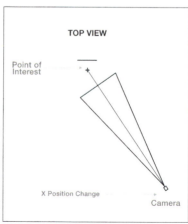

5.9

Example of a Two-Node Camera in After Effects moving horizontally, Top View.

3D program, a Target Tag is great when you want to orbit your camera around an object. In After Effects, this function of Two-Node cameras is also very helpful. However, it can quickly wreck the illusion of depth by revealing that After Effects 3D–enabled layers have no volume.

Of course, you can always keyframe the Point of Interest property to match the values of your camera's Position. But unless you plan on taking advantage of auto-orienting where a camera is pointing, working with a One-Node camera is far easier. Alternatively, a classic work-around for this challenge is to parent an After Effects camera to a 3D-enabled Null Object. This technique works fine, but it does limit a motion designer from working with the super-useful *Camera Controls*.

After Effects Camera Controls

After Effects Camera Controls can be found in the control panel of the software's workspace. A major advantage of using the Camera Controls is they offer a tactile option for interfacing with cameras. In addition to adjusting camera movement through entering numeric values in a layer's transformation properties, or moving a camera by grabbing an axis in a multi-view layout, we can use Camera Controls to travel through our compositions by clicking and dragging in the Active Camera View.

The *Pan Camera* tool allows us to change the X and Y values of a camera. Essentially, we can change the horizontal and vertical Position of the camera by clicking and dragging in the Active Camera View. Adjusting the camera in this way instantly shows how a composition changes based on the camera's Position. Although we are working in a digital space, our sense of touch is active in this workflow, which feels quite natural.

The *Dolly to Camera* tool tracks the Z position of a camera when used in the Active Camera View. We can move our camera forwards or backwards through space by clicking and dragging. Again, this tool feels very tactile because gestures with our hands effect the camera's journey through space. Using the Dolly to Camera or Pan Camera tools in the multi-views such as Top, Custom, or Right changes our position of the selected view—without affecting our main composition or Active Camera View. For example, we can zoom out in our Top View for a wider perspective of how our composition is layered in space.

The *Orbit Around* tool allows us to change a camera's angle when used in the Active Camera View. With a One-Node camera, using the Orbit Around tool changes the Orientation property—rotating the X, Y, and Z axes of a camera's view based on the layer's Anchor Point. With a Two-Node camera, the Orbit Around tool changes the camera's Position and Point

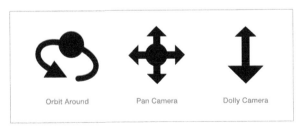

Orbit Around Pan Camera Dolly Camera

5.10
After Effects Camera Controls.

of Interest properties to orbit around where the camera is pointing. This tool is great when maintaining the illusion of true 3D depth is not required.

When used in a Custom View, the Orbit Around tool allows us to adjust how we view the scene from a multi-view, without changing how the camera sees or renders the scene. This feature is useful for composing layers in Z space and understanding how the camera is working within a composition. The Orbit Around tool does not function in the Top, Bottom, Right, or Left multi-views. You do not have to use the camera controls to animate your cameras in After Effects. However, moving a camera with a mouse or Wacom pen is fun because it feels more hands-on.

CAMERA MOVEMENT

How we layer assets in space and where we place our camera establishes composition. Once we determine the position of our elements and initial placement of the camera, we want to start thinking about how the camera will move. Just like any layer or object, a camera can travel through space. Figure 5.11 shows the range of directions we can move our cameras: forward, backward, horizontally, or vertically. Our paths through space can also move diagonally or in non-linear sweeps or curves. Moving a camera through a space with layers at varying depths is one way to create the effect of parallax, making it more realistic.

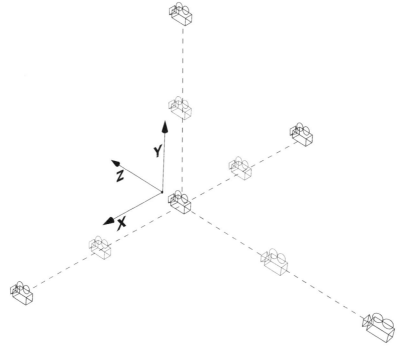

5.11
Infographic representing how a virtual camera can move through X, Y, and Z space.

AUTHOR'S REFLECTION: AUSTIN SHAW

I started working in After Effects in the year 2000, and the program did not have Z space or camera capabilities yet. If I wanted to create the effect of parallax, I had to fake it by parenting layers to null objects. I would move the background nulls much less than the foreground nulls to simulate the natural feel of parallax. Other effects like depth of field or rack focus would also have to be faked using blur effects.

The introduction of Z space and cameras to After Effects was revolutionary. I could break my images or compositions into layers, arrange them in space, and travel through them using cameras like a virtual cinematographer. I absolutely fell in love with this process and rarely work in After Effects without a camera in my comp. Sometimes the camera is the main driver of motion in a piece, and sometimes the camera is doing something simple, like slightly drifting forwards or backwards. For more narrative pieces, I often use a back-and-forth rhythm between the camera being active and the camera being subtle.

Primary and Secondary Motion

In Motion Design, cameras are not only the eyes of the audience but also can be active participants in a scene. The speed of a camera and how far it moves impacts the overall feel of a shot. For instance, a dramatic camera move in a short amount of time feels dynamic. Alternatively, subtle camera movement over a longer period of time produces secondary motion. This dance between fast and slow camera movement creates a compelling rhythm to structure the timing of projects.

When the goal is to capture attention quickly, opening a piece with a big camera move is an excellent way to draw in the audience. However, if we just keep moving the camera around quickly, that can get over-stimulating. On the flip side, if the camera is totally static, that feels boring. But a slowly drifting camera can add a layer of motion to a shot while allowing the audience to absorb pertinent information. An effective approach to working with cameras is to alternate between primary (fast) and secondary (slow) camera movements.

Typically, faster camera moves work well to transition between shots and to re-engage the audience's attention. Slower camera movement adds realistic presence to hero moments. Commercial Motion Design projects often follow this pacing of fast/slow/fast/slow to engage and inform throughout a piece. Faster camera moves during the open and transitions, then slower camera moves on the hero moments where the audience needs to read information or visually digest what is happening on screen.

Camera Rotation

In addition to moving our camera through Z space with position, we can also rotate our camera to change the view of our scenes. Again, we have a robust history of cinematic techniques that we can use, such as Dutch camera angles, where we slightly rotate the camera to create compositional diagonals. Additionally, we can use rotation to completely shift the perspective of our scenes in a way that feels more like a dream. Motion Design is

5.12
Graphic showing how a camera can also rotate in space to create dynamic angles and/or surprising transitions.

not constrained in the same way as film or live performance. For instance, a well-crafted camera rotation can seamlessly transform a close-up profile view into an overhead shot. The same principles of fast and slow motion apply to camera rotation. Faster camera rotations are dynamic and work well in transitions, whereas slower camera rolls feel more atmospheric and add secondary movement to a shot.

Handheld Feel

Keyframes help to easily create smooth motion, but sometimes a less perfect feel is desired. Giving camera movement a handheld quality is a great way to add an organic feeling to a shot. We can always keyframe sporadic changes in position or rotation, but that can be tedious and often does not achieve a natural effect. A simple but effective technique is adding a basic *wiggle* expression to a camera's position and/or rotation properties. The wiggle expression will randomize changes to the property based on the values you input for frequency and amplitude.

To apply a wiggle expression, you need to option + click the *Time-Vary Stopwatch* corresponding to the property you want to randomize. In the expression dialogue field of the property, type the following:

wiggle(x, y)

The x value stands for the frequency: how many times per second the property should randomly change. The y value stands for amplitude: the amount you want your property to change. So, a wiggle expression applied to the position property of a camera, written as

wiggle(3,50)

will randomly change the position value three times per second up to a value of 50. Unless specified in the expression, this randomization will apply to the X, Y, and Z parameters of position. Like all expressions in After Effects, the spelling and syntax need to be exact for it to work. Fortunately, there are multitudes of resources online for creative use of coding and expressions that are easily copied, pasted, and modified as needed.

Multiple Cameras

Using multiple camera shots in filmmaking was a revolutionary technique that evolved the medium beyond being a simple recording of a theatrical play. It heralded the invention of visual editing, visual effects, and the cinematic language that we continue to practice in Motion Design today. Another layer of visual storytelling involves building rhythmic edits based on camera distances and angles, in addition to what is happening on screen.

We can use multiple cameras to cut between shots in Motion Design projects. In After Effects, stacking order of camera layers determines what camera is active in the composition. The camera layer at the highest place in the stacking order takes priority. By trimming camera layers, we can effectively cut between cameras that are viewing the same composition, but from different distances and/or angles. Alternatively, we can use cameras to cut to different scenes entirely within an edit, provided our content—layers and/or pre-comps—are timed with our camera layers.

In Cinema 4D, we can also cut between multiple cameras in a scene using a tool called a Stage Object. The *Stage Object* allows us to keyframe which camera is active in a timeline. For instance, we may have a 3D scene composed of models, textures, lights, and animation that has three different cameras. Camera 1 is set to a close-up distance from the subject matter, camera 2 is set at a medium distance, and camera 3 is set as a wide/long shot. We may start our animation viewing the scene from camera 1 (close-up), then use a Stage Object to cut to camera 2 (medium) midway through our timeline, and then close with a cut to camera 3 (wide shot). When we start moving and editing between cameras in a scene, we can achieve cinematic Motion Design within a 3D space.

AUTHOR'S REFLECTION: AUSTIN SHAW

Splitting Camera Layers

Camera moves that transition seamlessly through a variety of different setups, speeds, and camera distances can be very satisfying. However, setting up seamless moves can be extremely difficult with a single camera layer. I used to spend entire workdays noodling and perfecting my After Effects camera to contain a series of keyframes alternating between fast and slow movements that radically changed direction, all with different types of interpolation. I spent so much time in the multi-views, pulling handles to adjust the Bezier motion paths between keyframes to make everything perfect. But it was a precarious setup ready to topple if anything needed adjustment.

I would present this epic, seamless camera move to my creative director or directly to a client, and they would love it. But like most commercial projects, there would always be feedback: a change to timing, adding or taking away a moment, or switching the order of an edit. Even minor changes would wreck the fine-tuned choreography of my camera, forcing me to start the process over. It was not the most efficient or ideal way to work. I loved seamless camera moves, but I was frustrated with how difficult it was to apply changes.

Then an idea occurred to me. Why not split the camera layer where a keyframe marked the completion of a move? When you split any layer (including camera layers),

you preserve all the keyframes on both layers; they are just trimmed on either end of the split. The original layer trims everything to the right of the current time indicator, whereas the new layer trims everything to the left of the current time indicator.

The next step in this technique is to clear all the keyframes and their interpolation on the newly created camera (after the split) by hitting the time-vary stopwatch. Then, with the time indicator at the exact moment where the cameras were split, apply a new transformation (position and/or rotation) keyframe to the new camera. This new keyframe is free of the interpolation and influence from the previous camera movement. If the transformation values of the last keyframe of camera 1 and the first keyframe of the newly formed camera 2 are the same, the camera movement appears seamless.

This technique makes updating seamless camera moves much easier in After Effects. I may end up with a lot of camera layers in a composition, but I will have more control to address feedback and make dramatic changes in direction with my cameras. Following the rhythm of faster camera moves for transitions and slower camera moves for hero moments, many of my projects look like Figure 5.13.

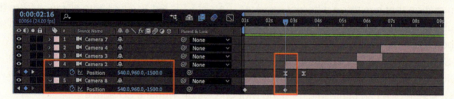

5.13
Despite the number of cameras in this composition, the camera movement appears seamless. Split camera layers offer flexibility to dramatically alter speed, whereas keeping all keyframes on a single camera layer presents challenges due to interpolation and influence.

Exporting and Importing Camera Data

As working with cameras becomes a regular part of your process, the ability to both export and import camera information between programs is powerful. Programs like After Effects can analyze captured footage and create tracking markers and a virtual camera to match the physical camera's movements. This track camera information is useful not only within compositing software but also when exported to a 3D program like Cinema 4D. From here, 3D geometry can be composed to work with the camera data from After Effects.

Alternatively, footage can also be tracked in Cinema 4D and then exported for use in After Effects, or another compositing software. Exchange plugins like Cineware allow Cinema 4D project files to be imported directly into After Effects, where 3D camera data is easily extracted for use in an After Effects composition. There are many options for passing camera information between software.

Camera Options

In animation software like After Effects and Cinema 4D, camera options can add even more realistic qualities to our Motion Design projects. Depth of field, aperture, focus distance, and

shutter duration are a few of the analog functions of actual cameras that can be simulated in software. Because camera options are virtual translations of analog tools, understanding how physical cameras and lenses function is helpful. When applied to graphics, these options add a cinematic feel to the work. Typography, illustrations, 3D geometry, or simple shapes can exist in cinematic spaces with realistic lighting and atmosphere, viewed through a camera lens.

Creative Brief: Z Space

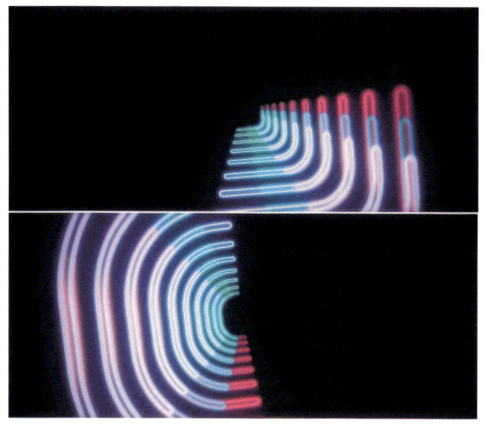

5.14

Example of the *Shapes in Space* exercise by Christopher Roberts. Stills from completed animation of simple shapes composed in Z space.

Description/Creative Needs

For this exercise, create (3) different animations using Z space in After Effects.

So far, we have worked with X and Y positions and movements that are horizontal and vertical.

Now, we will add position and movement that travels forwards or recedes backwards in space.

2.5 Dimensions

After Effects has been referred to as being able to produce 2.5D animation as opposed to full 3D. This description is due to After Effects' handling of 2D layers in a virtual 3D space.

Imported 2D assets such as Photoshop or Illustrator files do not inherently possess Z depth, or volume. They are flat layers that can be positioned or moved within a simulated 3D space. However, if they are rotated in 3D, their two-dimensional nature is revealed.

Postcards in Space

A helpful metaphor is to think of imported 2D layers in After Effects as postcards in space. When viewed from the front, they appear to possess depth. When viewed from overhead or from the side, they will appear flat.

After Effects Cameras

One of the most dynamic aspects of working in After Effects is the ability to use cameras. These virtual cameras allow you to navigate the viewer's eye through a scene. Cameras can serve to produce either primary or secondary motion in a composition. Often, you will want to transition the camera between these roles.

Conceptual Prompt—Shapes in Space

These exercises will be reminiscent of our first exercises from Chapter 1. However, you will move your shapes through Z space as well as X and Y. Use these exercises as an opportunity to get well acquainted with how After Effects handles 2D assets in a 3D space.

Specifications

- Suggested composition size(s): **1920 × 1080**, **1080 × 1920**, **1080 × 1080**, or **1080 × 1350**
- (3) different animations
- Duration: 5 seconds each
- Use 3D-enabled layers composed in Z space
- Start with After Effects Solids, Shape Layers, and/or vectors from Illustrator

Creative Brief: Stills in Motion

5.15
Four-frame design board for *Stills in Motion* exercise (top). Photographic assets for exercise (bottom). Design and photography by Austin Shaw.

Description/Creative Needs

For this exercise, you will create (1) animation using photographic stills, scanned elements, and cameras in After Effects.

Photographic Elements

Use a camera and/or scanner to capture elements, and then use Photoshop to isolate and prep your assets for design and animation.

The purpose of this exercise is to practice compositing photographic stills in a representational space in a cohesive style. Additionally, you will practice using After Effects cameras to create cinematic motion.

Conceptual Prompt: Juxtaposing Symbols

Create an interesting juxtaposition of symbols that have contrasting meanings.

This exercise has both a design and motion component.

1 Design phase: Create a *design board*, a visual sequence of style frames that communicates the narrative of a project. Use at least (3) style frames that convey a journey through space that requires After Effects camera moves. Use your photographic assets to suggest depth in your compositions, clearly defining foreground, middle ground, and background elements.
2 Motion phase: Use After Effects camera moves to take the viewer through your Z space composition. Add secondary animation to enhance the overall quality of your piece.

Specifications and Constraints

* Composition size: 1920 × 1080, 1080 × 1920, 1080 × 1080, or 1080 × 1350 pixels
* Animation
* Duration: 10 seconds
* Include audio (audio makes things better)

Professional Perspectives
Ariel Costa

Interview With Ariel Costa

What is your creative background?

I am from Brazil, and my first plan was to become a live action director. At the time that I was studying and looking for a college degree, Brazil didn't have a lot of schools or places to get the practice that I wanted. So, I went to school for media arts. I took classes in communication and arts that involved cameras and lighting. While working on my thesis, a short film, I found myself accidently learning After Effects, just to pull off the VFX for my short. I wanted to be close to the university equipment, so I got a job at the university. My job was to take care of the visual identities for the school TV station. I had no idea what motion graphics were at the time, so I had to learn just to make it work. I browsed different references and came across the website Xplv.tv, and that completely changed my mind. When I was a kid, I always loved to draw things, and when I was introduced to the motion graphics world, I thought, "Oh my god, maybe I can make my ideas in the animation world." I found this path, where I was forgetting about live action, and here I am, 18 years later doing this for a living.

Do you still think of yourself as a filmmaker?

In a way, I think Motion Design is more than just moving graphics. You are telling a story and you are telling a message. It's just like design—without the concept behind it, it's nothing. It's just a bunch of abstract nonsense. You need to have a meaning behind your craft, otherwise it's pointless. So, in this way, I feel like we are very much connected to not just live action, but any other form of art that wants to express a message. I turn the photographic into the cinematic with my work. Maybe it's that deeper feeling of my younger self wanting to be a filmmaker. Using photos, I try to fulfill this younger self.

Working with Motion Design has created a sense of fulfillment in my soul. I don't feel like I want to go back to live action. I can express my ideas through my graphics and characters. I just want to send a message and tell a story, and I think I can do that with Motion Design.

What do you enjoy about collage?

The thing that I love the most about collage is the contrast—the contrast between the old and the modern. Putting these two worlds together to create a new surrealistic world is very appealing to me. I like these odd combinations, and I think that can bring something new to

5.16
Marni, brand film. Design and animation: Ariel Costa.

the table. I love doing the research for the right photo, because I feel every photo has a story behind it. It's fun for me. It's two different worlds that aren't meant to mix, but when we create this clash—it's like an explosion of flavors. That's what Motion Design is all about, it's the exploration. It's not just the final result.

What are some of your influences?

Terry Gilliam is one of my biggest references. I love the way he created his unique world. There is this fun, saucy irony that you can see in his work. It's a weird world, but I like to embrace weird in a good way. What I like to do in my work, I try to play around with the

perspectives of my characters. Although they are realistic, they have different proportions, different sizes of heads. It's what everyone is doing with illustrations these days, but I am using photos to create weird shapes and characters. We can create different worlds and have fun with it.

How do digital tools effect your process of exploration?

When we go analog, we have certain limitations. But once we have the digital world, the explorations become faster. You have more time to play around with characters, color, with whatever you want. It's easier because the only thing you need to do is control + Z or command + Z and you are back to your initial point, and you can start exploring again.

The first character that I create for a project is not the character that goes to the final piece. I create at least two or three different characters. Then I combine what I think is working the best from each character. Sometimes it works, sometimes it doesn't. But it's based on these explorations that I create something I was not expecting. We have to embrace the imperfections. The explorations are like stretching before an exercise workout. You have to try different passes to find the thing that you are comfortable with. If it is not working, you can apply different techniques from different projects.

There are some projects where I really want to achieve some level of texture, and I cannot do that only shooting stuff on my iPhone and putting that in my computer. I have to print it out and scan it back, so it can have that paper texture that is very beautiful. When I have time, I love to do passes back and forth from analog to digital. I do see a lot of charm in the analog world, but it is not very practical when you have tight deadlines. These days I am doing more digital stuff, because I want to have more time to explore. I have been working for years to find the best way to create organic halftone textures in a digital world—trying to make things more realistic so I can do things more efficiently in the computer.

A lot of students struggle with allowing themselves to experiment in their process. Have you always been comfortable embracing creative exploration?

I relate 100% with the students. I see myself when I was very young and learning this craft. We have two problems with the young minds. One, they are afraid to try different things because they think that what they are consuming on the internet is the right way to do it. They are too naïve, but in a good way because everything demands experience. They are in a process of learning. The other bad aspect is the rush—younger minds are in a rush to be in a position that they don't have to be. They have time to learn and to enjoy the tools, the failures, and to embrace different techniques. When I was young, I was trying to learn everything at once and trying to be the best. From my perspective now, I see myself in my 20s like a dog chasing its own tail. The information and references can be overwhelming. We have a lot of social media today, and the content can be a little bit scary for students because there is so much out there. It's hard to stay focused.

Are you comfortable with failure?

Failure is part of life. You don't have to succeed all the time. People put a lot of negativities into the word failure, but I think failure is an opportunity for you to grow. It's important for you to fail, because you learn that a path you took is not working. That path can lead you to something else.

What are some of your favorite projects?

One project I am really proud of, that came out 100% the way that I intended, was for a fashion brand called *Marni* (see Figure 5.16). It's a black-and-white project, very noir, full of fashion, abstract shapes, and a surreal character. I had a lot of fun doing that, and there is storytelling in there too. I feel like this project is personally and technically the project I am most proud of.

Can you talk about how you work with cameras in After Effects?

The camera is the eyes of the audience. The more dynamic the camera is, the more fun the audience will have. We are taking them on a journey, just like a rollercoaster. I try to bring a little bit of cinematography to my vision. It's about the storytelling, I am just using a different technique. At the end of the day, we are like magicians. We don't need to show behind the scenes. The audience just needs to see what we want them to see.

My camera is not physical, it's digital, but the theory is the same—the perspective, the framing I want to show, the moments that I want to create tension here or there. At some points, I might have the camera a little shaky, to make the sensation that the audience is part of this in a live way. I love the 3D environment and the parallax effect because it feels more natural.

You describe your Hasselblad piece as a super short film. How do you think of it as a film?

It's like an open title for a movie. I am trying different things, but also keeping my soul in there. We don't have any physical characters in this piece, so I try to use the elements as our characters. We are talking about a lens with this project, and lenses are in a round shape. I created this sphere to represent the lenses, which is our character and helps us to conduct our journey through the history of Hasselblad. We see different techniques like exposure, and the elements that you see inside of an actual camera like the aperture, to help tell the story and reveal photos or moments of history. We wanted it to feel very classic with little to no color, but also to highlight the quality of the camera as well. I gave small pinches of color here and there. When we introduce features of the camera, we bring in some colors like a revelation. It's where the past meets the future.

Where do you find inspiration?

It's not about the reference; it's about how you see the reference and how you take that to the next level. I believe everything had an inspiration prior to the happening. But be smart about where your references come from. It's a very dangerous path to start to replicate people's work. For example, if your only source of inspiration is Vimeo or Instagram, you only create content that is like those references. I love Pinterest because it gives you several different worlds—you see tattoo artists, architecture, illustration for kids, you see whatever. It's a wide net. You don't only have to seek reference within the design industry. Go outside, explore, and live your life. That will give you inspiration for sure.

What belongs in the motion designer's toolkit?

That is a good question, which demands a very relative answer because sometimes people feel more comfortable doing animation in a different software. People need to understand there are no rules. What is the best tool for you? It's always about your mind, and what you are going to do with the tool. But of course, I am comfortable with After Effects, and I think After Effects is the most complete tool for motion designers out there.

5.17
OnePlus x Hasselblad, commercial. Design and direction: Ariel Costa.

What suggestions do you have for young designers?
Enjoy the time learning and exploring. Don't rush yourself. In this industry, you are going to be learning for the rest of your life.[2]

NOTES

1 Costa, Ariel, Zoom interview with author, August 26, 2021.
2 Costa, Ariel, Zoom interview with author, August 26, 2021.

Chapter 6
Physical Cameras

For the motion designer, the physical camera is an indispensable tool that allows an expansion of practice into cinematography while using it in new and very *motion-specific* ways. Cameras are the basis of cinematography and, by extension, the entire language of traditional cinema. Motion Design transcends traditional cinematic uses of the camera, placing the filmed image into a naturally hybrid environment where animation, graphics, and other media forms influence its use.

Working with the physical camera has a number of advantages for every motion designer. In the first instance, we can create either still or moving assets very quickly in a studio setting or in the field. Various types of shots can be quickly incorporated into a project if the designer has some basic comfort with capturing their own images.

The camera enables motion designers to undertake different projects with more flexibility in creative execution. Cameras can produce media that simply cannot be developed otherwise. These assets include simple photographs, longer filmed sequences, composited elements, background plates for commercials, or highly creative work developed with macro and close-up lenses that provide very different views of the world.

The first thing to consider with every project is its intended purpose and scope. It may be possible to use a smartphone to capture imagery for a personal project, or even to quickly grab a still or moving texture element. As projects become more sophisticated, the cameras required for their execution can also become more complex. At some point, it is important to cede control of the process of cinematography to a professional, whose expertise in the area will be crucial to get the right result. Through this range of possibilities, it is important for a designer to consider what their needs and budget might dictate for a project and how their particular skills mesh with the production requirements.

THE IMAGE REVOLUTION

Capturing work with a physical camera has become increasingly important for designers. Today, individuals have more capacity than at any point in history to capture effective and even outstanding imagery. Creative control of the image is within reach as never before. The introduction of digital video cameras and the further development of digital SLR cameras for photography—which also enabled high-resolution video capture—completely changed the game for image-making during the first decade of the 21st century. Suddenly, it was possible for a relatively affordable camera to not only take wonderful still images but also make very effective moving images as

DOI: 10.4324/9781003200529-7

well. The number of high-quality programs, short films, and documentaries that are being produced today, along with the exceptional quality of self-initiated "creator" programs on platforms such as YouTube, is a testament to the wide availability of exceptional camera systems.

The development of these capacities has not slowed, and in many ways, it has accelerated. A dizzying array of cameras, lenses, support systems, and associated lighting and rigging setups has effectively made the process of quality cinematography accessible to almost anyone who is sufficiently passionate in exploring this work.

With this variety of options comes the potential for confusion. What is the best option for image capture? What sort of image quality is acceptable for the kind of work I want to undertake? How do I pick the right kind of lenses, recording systems, and lighting options?

It is safe to say that there will always be something a little bit better just around the corner. There is always another feature for a little bit more money. Although this fact may be true, there are general principles we can consider in deciding what makes sense to bring into the studio. What sort of work do we undertake ourselves, and what sort of work should involve a dedicated, professional cinematographer? The image revolution has unquestionably deepened people's expertise and understanding of how to use and benefit from these new digital tools, but it has not removed the value of deep expertise where it is needed.

What Do I Want From a Camera?

For each of us, there is something we *need* from a camera, and this consideration really comes down to expertise and budget. Anything that an artist or designer does to develop their work from a portfolio point of view or to show proof of concept can usually be done with tools that they may have fairly close at hand. Most modern cell phones have excellent cameras, and these are improving with every new model that is released. So, using a cell phone, perhaps with an accessory lens kit for some options in image capture, is incredibly practical, and for most of us, it is just as simple. It makes sense to start here.

For detailed client-based work that requires post-production, it is worth thinking about having a dedicated camera in your studio. This kind of camera may be a functional DSLR or *mirrorless* camera that shoots both stills and videos. For some designers, it might be worth considering a more cinema-oriented camera, but this choice does not have to be wildly expensive. There are incredible options for recording very high-resolution and high-quality images at price points that were completely unimaginable a decade ago.

Projects that involve high budgets and elaborate lighting setups, a specific requirement for the "look" of the cinematography, or a process like extreme slow motion or advanced green screen work will require a specialist cinematographer and particular camera equipment. Starting a project by looking at your needs, budget, and intended outcomes is a great way to identify which of these pathways is appropriate.

So, let us take a look at the camera and its common functions.

CAMERA BASICS

Every camera has three basic processes that inform the decisions we make about the way we work with it: (1) the lens or optical system; (2) the sensor or capture system; and (3) the recording or media system.

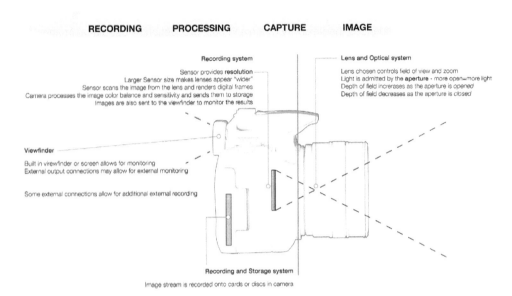

RECORDING PROCESSING CAPTURE IMAGE

Recording system
Sensor provides **resolution**
Larger Sensor size makes lenses appear "wider"
Sensor scans the image from the lens and renders digital frames
Camera processes the image color balance and sensitivity and sends them to storage
Images are also sent to the viewfinder to monitor the results

Lens and Optical system
Lens chosen controls field of view and zoom
Light is admitted by the **aperture** - more open=more light
Depth of field increrases as the aperture is *opened*
Depth of field decreases as the aperture is *closed*

Viewfinder
Built in viewfinder or screen allows for monitoring
External output connections may allow for external monitoring

Some external connections allow for additional external recording

Recording and Storage system
Image stream is recorded onto cards or discs in camera

6.1
Every camera is a *system* designed to turn light into images. An image of the world is focused, framed, and directed to the sensor by the *lens*. The lens will determine the field of view (framing) and the focus of the image. The *sensor* is the engine of the camera, turning light into pixels and sending the image to be processed and recorded as a file. The sensitivity of the sensor will make a difference in how it reacts to light, particularly in low lighting conditions. The image is processed and recorded into a file, with color information and resolution set by the capabilities of the camera and user preferences. From here, the image is sent to some form of *storage*, where it is stored as a file, as well as to a *viewfinder*, to provide real-time feedback on the framing and exposure of the image.

For a motion designer, it is good to work backwards through the system, starting with the media. Every image we record to the camera is going to be stored as a file that has three fundamental characteristics: resolution, bitrate, and color space.

Resolution is easy to decide upon because the pixel dimensions of a file, particularly a moving image file, influences a lot of what we can do with it in post-production. Given that a standard mastering format today might be 4K or Ultra High Definition (UHD), we are looking at a final canvas of 3840 × 2160 pixels, so that is the first consideration. A lot of social media work is only a fraction of this resolution, but a lot of public space, out-of-home work, such as LED billboards, may be a much higher resolution. However, the practical limits of vision mean that we cannot resolve all the individual pixels in this extremely dense image, so the basic UHD camera is probably adaptable to most work that designers need to undertake. Cameras that create imagery at this resolution or higher are useful benchmarks. Even a modern cell phone is a starting point for capturing high-quality images. Higher resolutions than basic 4K provide the opportunity to pan or crop an image without losing resolution at all—another important consideration.

No moving image is stored at these high resolutions without some degree of compression. This factor seems to be a contradiction: having high resolution but also compression in the image. However, many forms of compression are perceptually invisible in a moving image. So, every camera will have a particular *bitrate* that it can capture and store media within—a measure of how much data is stored or replayed in the file, every second. A higher bitrate is better because there is more information and less compression in the file.

Color space refers to the amount of color information stored in every pixel of an image, which massively influences the flexibility of a file in post-production. Most digital images are stored with eight bits of information in each channel: red, green, and blue. But color correction can quickly reveal the underlying compression used in an image. For example, if the deep shadows in an image are lifted with a levels adjustment, it might reveal blocky aliased artifacts that were almost invisible in the untreated file.

It is important to understand that many more basic cameras, including cell phones, tend to immediately compress the image in a format such as MP4. Although this formatting creates a great-looking compact image, the amount of color that is stored can produce serious issues with post-production or color correction. So, this consideration should go into your basic evaluation of a camera.

Sophisticated cameras or those developed specifically for moving image applications allow for more information per pixel to be stored in what is usually called a "cine" *gamma*, the way luminance is handled within the image recording. Quite often, this setting has ten bits of information in each pixel, sometimes more, and it behaves a bit like RAW image files in photography. When you import the clip into a post-production environment, there is usually a first option to *grade* the file and give it a specific set of tonal and color qualities that are extremely flexible, without losing quality. At this stage, color balance, exposure, highlight, shadow detail, and other aspects of the image are all adjustable. So, the availability of this type of file format is an important part of considering how color and image adjustment play into your workflow.

Being aware of the options for what kind of files a camera might record allows a designer to make a more informed choice regarding what suits a given project.

One factor to consider is that larger, more "professional" image types that use higher bitrates also require specialist storage media to record and store the image. Although many accessible and very affordable cameras might use a standard Secure Digital (SD) storage card, the much faster transfers required for larger files usually need a more "boutique" type of storage media that can cost five to ten times the cost of a standard storage card. It pays to look at the entire system of a camera you are considering, including weight, lens options, and storage formats.

Recording the Image: The Sensor

Whereas traditional cinematography recorded everything on grains of photosensitive chemicals in an emulsion applied to the clear base of the film, digital images seem to just "appear." It is important to recognize that the light entering a camera through the lens is recorded as an image on a *sensor*, a highly detailed and sensitive device that essentially represents the pixel count of the image as a light-sensitive digitizing plane in the heart of a camera. Sensors come in different resolutions, expressed as megapixels (MP) for photographic sensors, and these are often several times the resolution of the video image that they will also record.

So, the resolution of the sensor can be important if you need to take still photographs, but from a practical point of view, it is only the resolution of the video capture that is important for moving images. Larger sensors, often described as *full frame* or greater, have the photosensitive elements spaced a little further apart, which can noticeably enhance the image quality. The largest of these sensors will also record an image using all the available light from a lens and enhancing some qualities of an image, such as *depth of field*, which give it a cinematic look.

Many very functional cameras use smaller sensors often in the MFT (Micro Four Thirds) category, which are usually less expensive and require different lenses or an adjustment in the way that a full-frame lens is used. Sometimes, the mounting standards for these lenses are different, and so it is good to beware of what type of camera lenses you are using for a project.

The way light is recorded is moderated by the ISO setting on the camera, an adjustable setting that is passed on from film cameras. Originally, ISO referred to the light sensitivity of film: lower numbers had more detail, and higher numbers, which could expose more clearly in low lighting, had more grain. In film cameras, a range from 64 to about 800 was normal, although 800 ISO film had quite visible grain artifacts in the emulsion. Digital cameras have adapted this system to indicate how sensitive the sensor is to light.

Modern digital cameras can sometimes go over 100,000 ISO in their sensitivity, although most work best somewhere in the 320–6000 range. As the sensitivity of the sensor is increased, it simply boosts the information recorded by each pixel. This amplification of the signal creates a visible noise, not unlike an electronic "grain" that becomes very noticeable in low light. Smaller sensors will also have more noise on their adjacent recording elements, and the influence of compression can further complicate the look of the image. A 4K cell phone recording in very low light will suffer from all these issues at the same time, whereas a high-resolution still camera that also captures video, with a large sensor size, and higher compression headroom will make these artifacts less visible.

Setting ISO should be one of the first adjustments to a camera in any shooting situation.

Every image captured will need some form of *color balancing*, to account for the variations in the color tone of the available light. All light is made up of a visible spectrum of electromagnetic waves that are only visible in a very narrow band of frequencies. White light,

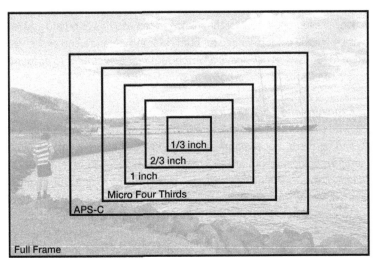

6.2

Sensors range in size, and this image shows the way a given lens (e.g., 50 mm) would translate to a range of different sensors. Sizes vary from *full-frame* sensors that have a very large capture area to the small one-third-inch sensors on cell phones. Older broadcast cameras were often two-thirds of an inch, but even the popular Micro Four Thirds size is far larger in its surface area. The larger area not only allows for more pixels and captures a wider field of view with a given lens, but it also increases the sensitivity of the sensor in low light conditions.

split into a rainbow, shows the range of colors in light—from red, a low frequency, to violet, the highest frequency. Below our range of vision at the red end of the spectrum, there is infrared, and just out of our vision at the top end is ultraviolet.

Light we see from the sun, various types of bulbs, and other artificially lit settings all have some type of bias towards a different part of the spectrum. In our work, light has a range of what is referred to as *color temperature*. This temperature is described in a measurement called the kelvin (K). Color temperature ranges from low, very orange light such as a candle, which is around 1900 K, to blue sky, which is around 10,000 K. Halogen lights and incandescent lights are typically described as "warm" and are around 3200 K, and open daylight, often referred to as "cold" light, is around 5500–6000 K.

Our eyes tend to read white in different lighting conditions as "white," with rapid adjustments in our perception to compensate for the color temperature. However, the sensor in a camera will record the image as it is, so the lighting can be very yellowish in the warmer colors, quite green under industrial fluorescent lamps, and very blueish under sunlight.

To work around these possibilities, every camera will allow for *white balancing*, a quick adjustment to set the white point of the camera to the correct place for the color temperature of the scene. There are usually simple settings for "daylight" or "indoor" lighting, but a user-set white balance works best. This setting is as simple as getting a white sheet of paper or card and putting it in front of the lens of the camera, filling the field of view with a white reference in the current lighting conditions. The camera's white balance can be "set" to this value, thus a baseline for how color should appear is established. The camera will adjust the image accordingly.

For a more robust reference, a "gray card" (at 18% gray) can be purchased, and this *midtone* reference—with equal parts of red, green, and blue—will also work to color balance an image. It is possible to white balance an image, and then at the start of a shot, put the gray card in front of the subject, and capture a few frames of gray. When images are imported for post-production, an eyedropper tool for the midtones can use this gray card as a reference, and the image will be quickly color balanced for both color temperature and exposure.

In addition to ISO, white balance is an important first adjustment to account for the light levels and color conditions as you prepare to shoot.

The Image: Exposure and Lens Choice

Getting light onto a sensor needs, of course, a lens. Two key factors affect lens operation: focal length and aperture. Focal length refers to the field of vision of the lens: whether it covers a wide field of view or presents a more narrowly focused perspective on the scene. The *focal length* of the lens is usually expressed in terms of a measurement in millimeters, and so a lens with a *wide-angle* field of view has a lower focal length than a lens with a *telephoto* or more directed field of view. As a common point of reference, a camera that covers a typical high-resolution sensor area will usually see a 50-mm lens as either wide or telephoto, which is close to the "natural" field of view. A 35-mm lens will be somewhat wider, and 28-, 24-, or 21-mm lenses are progressively wider still. Lenses in the teens will be ultra-wide angle. Once a lens focal length is in the single digits, it frequently registers as *fish-eye*, creating a circular image in the center of the frame. This focal length works well for fulldome and planetarium production, or as a particular optical effect, but the image is not usable in a conventional sense.

6.3
Shallow depth of field can produce evocative effects with light sources that sit outside the focal plane of the lens. In this twilight shot, the bokeh of the distant lights forms a soft series of bright shapes beyond the ladybug in the foreground. Lighting effects of this type, particularly combined with movement, are a quick way to introduce abstraction to the image using just the camera.

Taking the focal length higher, the 75- to 85-mm range is often used for portrait images, as it takes a slightly narrower field of view and flattens the image very slightly, bringing foreground and background elements into a closer relationship. This effect increases as lens "lengths" go up, with longer telephoto lenses of over 200 mm offering light telescopic effects with a corresponding *flattening* of background and foreground elements.

The real influence on the areas of the image that are in focus is the *aperture* of the lens. Aperture is usually expressed in f-stops, and these measurements indicate the *speed* of the lens: a fast lens can have a very open f-stop and admit more light than a slower lens. Lenses of f2.8 and lower are usually described as *fast* lenses.

When the aperture of a lens is open, the depth of field in the image decreases, meaning the area of the scene that is in focus becomes more *shallow*. This can have the pleasing effect of framing a subject against a background in soft focus, creating a more graphic sensibility for the image. Using wider apertures brings in more available light, and at nighttime, background lighting in an image with a wider aperture and shallow depth of field accentuates this effect, which is termed *bokeh*, a Japanese word meaning "blur" or "haze."

More subtle choice of lenses will help to place the subject within the field of view. A wide lens can make the subject sit within an expansive world surrounding it. A telephoto lens will frame the subject with the background working as a graphic layer in the frame. These choices closely mirror the way that Z space is used in motion with the virtual camera, and the mechanics of the physical camera translate directly to 3D scenography and animation. Developing a critical eye for the use of the camera, watching films and TV programs, occasionally with the mechanics of the camera in mind can expand a designer's

6.4

Images captured with different lens lengths (left to right): 24 mm, 50 mm, 80 mm, 135 mm, 210 mm. Note the spacious "feel" of the wider-angle lens on the left, and the gradual flattening of different elements at varying distances as the lens length increases.

fluency with the language of the camera and its many touchpoints in different aspects of Motion Design.

Camera Support

The camera offers a wealth of possibilities in exposure, framing, and capture of images, but how the camera sits in place and moves in space depends upon its *support system*. The simplest style of camera support is the tripod, and the basic movements of pan and tilt are based on the affordances that the fixed tripod offers. Cheaper photographic tripods will not pan as well as a *fluid head* tripod, which is designed for video work and has a special damping fluid in its mechanism.

Most motion work calls for fairly simple and often static use of a tripod. In these cases, standard photographic styles may be more appropriate, as these have the advantage of frequently offering boom arms, so that tabletop shooting, from above, is more easily set up in a small studio.

Camera weight also plays a role in support, and although it produces a less robust image for extensive post-production, a smartphone with a good camera is both very mobile and easy to mount—both arguments in its favor—for many practical uses.

Today, moving images that track the camera or follow a figure can be undertaken in vastly different ways because of the relatively light weight of modern cameras. Small tabletop "skater" dollies or rail systems can transform a tabletop shoot, adding movement around objects. Handheld *gimbal* mounts can effectively remove vibration from a moving shot, steadying the camera and providing a smooth tracking motion with what is essentially a handheld system. These setups range from elaborate semi-professional rigs to simple cell phone gimbals that can effortlessly mount a smartphone for one-handed tracking, floating, or even circular, rolling shots.

Specialist Lenses

Motion Design can accentuate the graphic qualities of the image, and this graphic sensibility can take many forms. The simple addition of close-up and macro photography lenses to the toolkit can offer completely new ways of originating material, with the capacity to transform everyday objects into new and visually arresting source material.

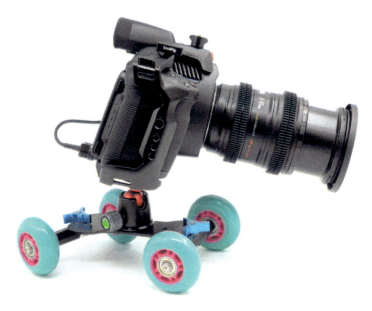

6.5
The variety of support systems rewards the more curious designer who might explore motion in very physical forms. Here a cinema camera is mounted on an inexpensive tabletop dolly that uses skate wheels to provide fluid motion on a smooth surface. The axles can be locked in place to allow for repeatable, curved movements, and the camera is tilted with a locking ball head.

Macro lenses divide into three basic types, each with different applications depending on the designer's requirements. The simplest style of macro lens is a clip-on or screw-on lens that basically sits on top of the existing camera lens. Most lenses have a "filter thread" at the end of the lens, indicated by a number showing the thread's diameter. Although they are a simple and very inexpensive solution, they typically suffer from blurring and image artifacts away from the center of the image. Low cost, clip-on adapters do the same thing with smartphone cameras, and these make a useful quick-fix solution for capturing some macro imagery quickly.

The second solution for close-up work is an *extension tube* or *bellows* unit that goes between the lens and the camera body on a DSLR camera, or a cine camera with interchangeable lenses. These push the lens out and away from the sensor, in effect taking a much smaller "slice" of the image, and reducing the distance required for focus. So, in practice, any standard lens can become a close-up, macro lens using this type of attachment. These are relatively inexpensive additions to a lens kit, and they offer a very accessible pathway to macro photography, expanding the range of a camera and lens that are already in use.

The two things to consider in using macro extensions, either tubes or bellows, is the loss of light that happens, because only a small part of the lens is now active in capturing the image, and so only a portion of the light hitting the front of the lens is passed through to the sensor. The second consideration is that the focal depth becomes *extremely* shallow using this technique. Focus becomes much harder to find, and camera placement in relation to the subject is more critical. This constraint can in turn become a very useful creative consideration, allowing for striking depth of field effects if it is used creatively.

6.6

A cinema-style camera mounted with a bellows extension and standard lens (left) and a specialist Super Macro lens (right). Both of these allow for extreme close-up imaging, with the bellows converting a standard 50-mm lens for this purpose. As an alternative, a set of rigid tubes ("macro tubes") can support the lens at a similar distance from the camera. These attachments have standard lens fittings at each end, and so they simply click into place.

The third type of lens option is a specialist super macro lens, which replaces the existing lens on the camera and can do nothing but extreme close-up work. These lenses often have built-in LED lighting to compensate for the slightly darker image they capture, and using them can produce striking details, turning the most everyday objects into highly detailed close-ups or creating unusual and unique abstractions if used on the right source material.

Alternative Visions

Taking the image beyond the range of normal vision, specialist lenses can also offer unique framing for physical sets or staging. Arthroscopic lenses that sit at the end of flexible cables are usually self-contained micro camera units, but these can be adapted to motion work depending on what type of recording device they are attached to. Cheap versions of these can be purchased for smartphones, and they will capture an image anywhere that their flexible cable can reach. Snorkel lenses can shoot in tight 90-degree angles, or they can extend into deep and narrow spaces, taking an audience with them through the imagery they capture.

Extreme wide-angle lenses are able to capture 180-degree fish-eye viewpoints that can be used in fulldome production, as they translate immediately to the immersive projection environment. Newer cameras that extend the action camera philosophy to the capture of immersive images will sometimes allow specialist 360-degree image capture, and these images can be integrated into immersive production for projection or through the creation of 360-degree video that can be shared on popular streaming platforms such as YouTube.

The physical camera is an essential tool, in some form, for every motion designer, touching everything from simple still image capture to the most avant-garde and experimental forms of moving image creation.

Chapter 7
Editing for Motion

EDITING

Because editing is so diverse in both practice and application, we will not address specific software here, but there are many other books that do. Editing within Motion Design is really about the way the designer integrates the tools of editing and its processes within their work.

Editing is one of the most essential skills to build a tight and coherent production in any time-based media. Because Motion Design attracts such a wide variety of practitioners, many designers bring backgrounds from areas such as illustration or graphic design who have less experience working with timelines. Time is, however, the foundation of all Motion Design because the very process of motion requires a change in time.

In our imagination, we take something from previous media, which then frames how we think of media now. Very few mainstream movies are shot on film today, but we still refer to them as "films." Photography has roots in photochemical processes, but today's digital photos are more properly just described as "images." However, we still talk about a *photo* when we want to describe a digital image or its uses.

Motion designers will often refer to narrative works that they produce as a short film. In this sense, much of the language and process of production is borrowed, or at least adapted from traditional filmmaking. However, Motion Design represents a different set of potentials, extending its roots in cinematic and televisual forms into new creative possibilities. A general understanding of editing in its traditional form is important, because these principles underpin the basis of Motion Design's capacity to communicate and connect with its audience. We already have a language for understanding the moving image.

Motion Design offers a departure from traditional forms because of its hybrid nature, implicitly allowing the combination of multiple types of media with multiple communication styles. An image can be combined with type. Two images can be combined and transitioned without a hard cut defining the edit. Animated and "filmed" elements can coexist fluidly in the same space. These possibilities are all natural affordances of Motion Design because it is by nature an integrative and flexible practice.

Film, on the other hand, was naturally defined by two elements, both related to the frame. In its basic form, the view of the camera is what is recorded *within* the frame, and so most of the language of traditional cinema developed through using the photographed or

DOI: 10.4324/9781003200529-8

recorded image as its basic unit of meaning. Just like the old historical examples at the dawn of cinema, which were often just single shots (essentially moving photographs), the view captured by the camera is a base unit of film language.

The second important element is the single frame itself. A strip of film was made of multiple images, and editing was a process of cutting strips of film into particular links and joining them to other pieces of film. This process is not to be underestimated, as it was incredibly difficult to integrate multiple shots into a logical and coherent finished product. What is important is that the frame itself was a natural dividing line and the easiest form of assembly was to cut on the frame. So, the *cut* is a foundational element of cinematic language that translates to motion work, but it is not central to the way Motion Design is practiced. In motion, the starting point might be the frame, which could operate like a theatrical stage, where elements enter and exit from the offscreen space. It is also easy to perform transformations in scale and visibility so the need to cut is not as central to Motion Design. The motion sequence can be composed of different approaches to the presentation of time, which becomes the basis for a new language of the moving image.

As we extend this idea of language, the sequence—the second important element in traditional cinematic editing—relies on structuring basic units of meaning (shots) into larger articulated arrangements that have their own language and specific grammar. We could say that film is a way of *speaking with sound and images*, and the images are structured like sentences; each shot forms part of a much longer set of connections and relationships that we experience in time.

With the development of specifically digital motion tools, the capacity to assemble elements not only in time but also within the frame, is the central quality of difference in motion work. A single frame may have one or two images, some text, a graphic, and even another animated element. A frame may be a collage with multiple photographic images—still or moving—recombining in a new space, with a life of its own.

For the motion designer, editing takes place not only in time and in the context of the sequence, but also in the frame and in the context of the space of the frame. In this way, a motion work must address both time and space as dimensions of editing.

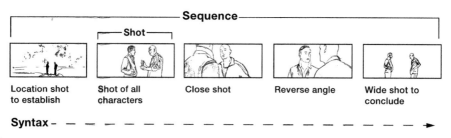

7.1

The single shot is part of a larger sequence that conveys a more complex meaning. Images form a language that we can understand from previous experience. The progression of shots is like the progression of words in a sentence: each has a specific purpose, and their placement is specific to the words or shots that come before and after them. The rules of this arrangement, the *grammar* of the language, are open to individual expressive arrangements, their *syntax*.

7.2

In this storyboard example, the voiceover is supplemented by multiple elements. (1) The map with striped texture and the words "ALL ACROSS." These both fade and blur with the addition in (2) of the word "CRISIS." (3) The zoom transition into the map graphic and the addition of a radar button slowly zooms in to (4) and the map turns to slats, which transition into the ground plane in (5) with the addition of two 3D houses. Each frame is a composite of multiple elements at once—some emphasizing the audio, some adding visual focus—all within a sequence that happens in a short period of time.

Motion Editing: Meaning in Space/Meaning in Time

The other edited element in cinema is sound, which includes dialogue, location sound, voice-over, sound effects, music, and other sonic elements, is similarly edited within a production. It is important to note that the term *sound designer* (as opposed to *sound editor*) was developed in response to the very sophisticated layering of sonic elements that took place in films, and it is interesting that we heard in a layered and multifaceted manner before we commonly saw in the same way. Sound is, by its nature, never absent from editing, and in many ways it offers an entirely different dimension with which to consider the total experience of Motion Design.

As we approach Motion Design from so many backgrounds and with such a range of experience, there are some common processes in editing that are worth thinking about as components of a rounded toolkit.

Editing Elements: The Sequence and Continuity

How we structure the range of shots within a sequence has very specific ways of being read by the audience. Most narrative work operates through *continuity-based* editing, meaning that shots are created and combined to present the experience of a continuous uninterrupted flow of action.

The role of continuity is particularly evident in narrative work, where the interaction of characters has to produce both dramatic interest and focus without being too logical, but *natural* to the audience. There are certain familiar rules in continuity-based work that allow an

audience to read the sequence in the way it is intended. These rules are combined with performance, direction of the camera, and art direction to produce the total effect of the work.

The most familiar elements of continuity-based production are the following:

1 The use of establishing shots and editing with closer shots within a sequence to focus the audience's attention.
2 The position of actors involved in dialogue in a fixed relationship to the camera to maintain their relative positions within the edit—the 180-degree rule, where the camera stays to one side of an imaginary line between speaking characters.
3 Consideration of *eye line* within shooting and editing to make the relationships of characters feel natural during cuts.
4 The overlapping of sound and image to allow for *cutaways*.
5 The maintenance of a consistent arrangement of elements within the scene to allow shots filmed at different times to cut together without an obvious change.

Continuity-based work typically structures a scene to frame its dramatic purpose, usually within a larger set of sequences (scenes), to be understood by the audience. Shorter motion-based works can also employ this structure to create a sense of rising drama leading to resolution.

Continuity structure will typically use what is called a "circle of action" to define the dramatic intent of the scene and the audience's relationship to it. In a dialogue-based scene, the circle of action is between the speaking actors. The camera will typically follow dialogue from a little outside the circle, perhaps using over the shoulder cross-cutting. When there is a rise in dramatic intensity, it is common to use close-ups from inside the circle and then release the framing to wider shots as a means of finishing the scene. Within a single scene, multiple takes with different framing and emphasis are captured to allow for wider choice in the editing process. Overlapping action, cutaways, and reverse angles or reaction shots are usually shot multiple times to allow for multiple possibilities in the edit.

The use of circle of action is not confined to filmed drama with actors. This principle extends to understanding the point of focus in *any* work. Motion pieces with multiple graphic elements can just as easily benefit from awareness of when to cut closer and

7.3
Continuity-based editing will typically establish the scene, in this case using a two-shot (top left), before moving to intercutting dialogue (top center/top right). The top row is edited from over the shoulder, keeping the audience just outside the circle of action. As dramatic intensity escalates, the camera works inside the circle of action with close shots between the characters (bottom row).

7.4

Camera positions and their relationship to the circle of action. A motion designer will need to think as both cinematographer and editor because they are usually in complete control over what appears, and when, in the work they produce. Modulation of sequence intensity should always be thought through as a key component of directing a project.

when to use wider shots, based on how elements relate in the frame. Identifying the circle of action allows the designer to inhabit the editor's persona, cutting a sequence to control focus and intensity by structuring the audience's point of view, and position in the scene, over time.

Editing Elements: The Sequence as Montage

Montage is the other important organizing schema to consider when thinking about editing. In simplest terms, montage is editing in its basic form: a sequence of shots that can vary widely depending on how it is used. Montage can describe a sequence of shots of a scene edited in order to compress time. In many motion examples, this compression is often used as a series of close shots producing the general impression of a sequence and then a resolution shot that provides a visual overview to conclude the scene. The early shots are not necessarily linked in time as a sequence; they serve more as a visual summary or question that is resolved in the final shots. Sports openers in broadcasting often use this technique where a collage of sports highlights is resolved with the wide view of the program's title card.

Other forms of montage can be purely rhythmic or may cut together elements that collage visually from different sources. Montage-based editing does not have to conform to the conventions that are used in continuity-based sequences, and so a more natural and open play of rhythm, in both space and time, is possible. Think of a series of shots that might use a central, circular visual composition. This sequence could intercut, for example, a piece of fruit with a petri dish, perhaps a round dial, and a wide shot of the planet. All these shots might be matched for a visual similarity based on the central circular motif. The viewing of this sequence invites a free ranging visual comparison by collecting disparate elements within the unifying visual theme.

7.5

A storyboard sequence that uses consistent similarity of *form* to visually link images within montage: fruit–petri dish–dial–Earth.

Some montages can simply sequence shots in a very strict temporal rhythm. For example, a half second, or one-second edits that are organized in the first instance first by rhythm before content is considered. The audience may recognize this rhythm, even to the point of anticipating each cut, as the form of the edit becomes self-defined. Visual rhythm might be further emphasized by music or other structured audio cues.

So, a sequence in montage can be *additive*, building different elements from a scene into a single focused impression. It can be *comparative*, assembling different places and ideas into a linked sequence of impressions, so the audience will ideally resolve the contrast. As previously noted, montage can also be purely *rhythmic*, bringing elements together under a fixed duration to emphasize the edit as a semi-musical composition.

In every case, the images are arranged through *juxtaposition*, which does not require the presentation of a continuous sense of time and place, as is the case with continuity-based editing. Any leap in space, time scale, and the content of a shot is possible without the requirement for sequence continuity.

SPATIAL EDITING

Just as we edit images in time, Motion Design is almost always based on the addition of elements in space. Even the creation of a single scene in an illustrative style will require consideration of the space of the frame. Working in illustrative motion, with background and foreground elements intended to produce a narrative-based work using the principles of continuity, a designer will need to consider the staging and placement of *everything* in front of the camera. So, to make any scene is always an act of assemblage, with choices far more open than they are in cinematic production. The camera will be the starting point for the image in traditional filmmaking. In Motion Design, the scene is defined by whatever a designer chooses to bring in front of the camera. Comparison, juxtaposition, and

composition all happen in the space of the frame before a single element is put into motion.

The *visual edit* happens naturally within Motion Design.

This arrangement of elements is something much closer to production design, where the art direction of a film is considered at every level of production. In Motion Design, this form of art direction is an active process of *spatial editing*. The creation of a unified final frame is based on a set of decisions that are always made by the designer.

Motion work that integrates multiple forms—animation, live action, and graphics—in a frame highlights this question of spatial editing. This consideration is because multiple forms of decision-making come into play—the framing of the cinematographer, the layout of the graphic designer, the motion created by the animator, and the intentional assembly process of the collage artist. The designer needs to inhabit these different personas at different times during production. Thinking through possibilities is a seamless process. These personas may be switched out in rapid succession or even brought into a dialogue as work evolves.

It is Important that the assembly of elements within the frame invokes the same processes as editing in time: *addition* to amplify elements, *comparison* to contrast them, and *rhythm* to develop a tightly defined visual order. These questions are the same that a graphic designer might consider when laying out a poster, a social media post, or a page. The position of elements in a motion piece makes each frame, each shot, a unique assembly of meaning. Add to this assembly the flow of time, and the movement of elements within the frame, and the possibilities expand exponentially.

7.6
The previous storyboard example is extended with the use of type. Some type elements are persistent in the frame, the word LIFE in the first two frames. Some add over time, the addition of the word EVERYWHERE. These additions adapt the strict montage of the first example into a more layered spatial composition, where type *anchors* the reading and meaning of the images. Now the type provides *continuity* with a consistent voice, and the cuts in the images are mixed with type elements that do not follow the same cutting rhythm. This layering allows for multiple editing styles in time to be mixed with multiple approaches in space, layering the frame's message.

V	shot one	shot two		
A	shot one audio		shot two audio	**L Cut**

V	shot one		shot two	
A	shot one audio		shot two audio	**J Cut**

7.7

L and J cuts. The L cut (top) extends the audio under the image cut to let the audio linger in time, whereas the J cut (bottom) introduces the next image with sound. These techniques can be applied in scenes, where we might cut to a reaction shot while dialogue continues from the previous shot. These cuts can also smooth transitions between whole scenes, where a new scene is introduced with sound before we see its image. These techniques are equally applicable to sound design for motion work.

Thinking spatially can also translate into time. Several elements in a frame can form a compound image, yet the hard cut is not a given or natural aspect of motion work. Elements can remain in the frame as others change, a kind of partial edit that may visually smooth a transition, add emphasis to a particular element that stays on screen, or provide a rhythmically gentle sense of transition.

It is worth considering the similarities to music here as well. A piece of music that has different instrument parts will seldom cut between moods abruptly, and layers of instrumentation work together at any moment in a musical composition. Motion Design invites this sense of musical editing naturally, from improvisational jazz to tightly scored orchestral moods; motion has the capacity to create visual sequences that place the designer in the role of both composer and conductor of a unique ensemble.

Audio and Editing

It is important to look at audio as a partner to editing work, as the audio in a project can have the same cuts, layers, and sequencing practices as images. Making the best use of audio while editing rounds out a designer's process more completely.

The simplest edit for audio is the cut, which might be likened to a continuity-based conversation where dialogue cuts back and forth between people. The variations on this idea are the *J cut* and the *L cut*, where audio might be introduced a little *before* an image it is linked to, or it may be extended a little *after* the image has been cut. These types of cuts are effective tools in making dialogue feel more natural, but they are also a means of transitioning into and out of scenes. Undercutting sound in this way might typically be used in a monologue, where someone describes a situation and we cut to what is being described, so the dialogue becomes voiceover. In the same way, a voiceover underneath a sequence might resolve with a shot of the narrator switching from voiceover to first-person dialogue.

Using audio to underpin transitions is incredibly effective across a range of motion work that might not use the spoken word at all. Music or sound effects cut to precede a shot can provide a subtle cue to the audience about what to expect, and sounds that linger can leave a sense of connection to a previous shot by simply using audio. Consider the last frame of a TV commercial, where an audio element such as music or dialogue from the main sequence is reprised over the last shot. This gentle addition of the audio cue can be a reminder of the

previous scene or a means of extending the scene, or it can be used simply to enhance the cohesion and continuity of the work.

Audio Edits/Cuts

Think of the layering of sound as a means of supporting, in every sense, what is seen on screen. Good design considers the *total* experience of the work. Leaving sound as an afterthought is ignoring the potential of this aspect of your design.

Even a work using a musical background can have audio added in post-production to enhance the impact of visual movements, or to add presence. Music in cinema often plays alongside sound that occurs in the events being seen on screen. Sound within a scene is referred to as *diegetic* sound, meaning it occurs naturally within the world seen on screen. Music, because it is added later in editing, is referred to as *non-diegetic* sound. In Motion Design, effects and sounds within a sequence must be consciously considered as part of the design process, and even the subtlest use of supplemental audio can transform a work so that a musical track, for example, does not totally overpower it. Think of these simple elements as sonic textures that enhance the feeling of realism and presence in even the most stylized work.

Where and How to Edit

Editing with non-linear software allows multiple pieces of footage, in multiple layers, to be cut, combined, and transitioned in real time. There is a dizzying array of choices for the editor, but all of the platforms are designed to allow for quick decision-making while editing with real-time previews of the results. This speed in assembly makes editing a very fast and intuitive process where decisions can be made with fairly instant feedback. For the motion designer, this process marks an important point of difference in workflow because layering, sequencing, and compositing in Motion Design software requires either very short playblast previews or more deliberate renders for evaluation of progress. Using editing software as

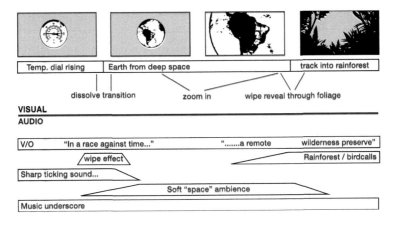

7.8

Just as the image is planned in sequence and transitions, spot audio to emphasize what is happening on screen can be planned to layer audio into the final production. Between the voiceover and the musical score, spot effects of a ticking clock, the sound of transitions, and the rainforest are all faded in and out to amplify the sense of presence in what are otherwise silent graphic images.

part of your workflow makes the assembly and decision-making process far quicker. So, it is important to consider where working with an editing focus can offer advantages in production.

Most larger studio projects will end up in an editing session because all the different elements can be treated as shots, and people across a team can be working on different parts of the finished piece. For this reason, final decisions and even iterative rough cuts will be completed in an edit suite with the media stored on the edit machine and then adjusted in the cut very quickly.

Editing is also important in longer-form projects, where a motion designer is integrating elements within a large program that may have quite a lot of camera-acquired media. This type of program is particularly true in broadcasting, where on-screen graphics, lower thirds, and other graphic elements produced as motion work will be used in the larger system. Combining motion in this way can even be true of shorter pieces, where an extensive graphic treatment or overlay is added to shots acquired with a camera, or perhaps longer sequences of rendered 3D animation. In each of these cases, the base edit is completed before the sequence is taken into motion-specific software.

So, every project needs to be approached with the attitude of "what makes sense" for its particular workflow and the type of media being managed. Software families, such as the Adobe Suite of products, allow for some integration between editing and motion. An After Effects project can be opened in Premiere, and although detailed effects work is not transferred, shot sequences, audio placement, shot lengths, and some transitions will all transfer

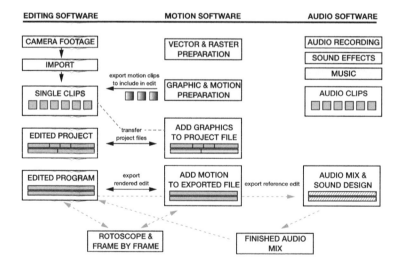

7.9

There are multiple entry points to move from original camera files to editing or motion production. Single shots can go straight to motion, possibly after some editing for length. A base edit can be moved into motion as a project file, or as a rendered movie file. A reference render can also be sent to audio software for audio treatment, with a mix exported and used to *restripe*, or replace the original raw sound. Other processes, such as frame-by-frame overlays or rotoscoping can move media back and forth to edit or motion processes as needed. When and where media is transitioned between processes will usually be based on the type of program, its duration, and the type of media involved.

across projects. In the same way, a "base" cut can be done in Premiere and exported to After Effects for more detailed motion treatment.

Working across applications is not too different, except that project structures, layers, and links to original media are not supported; but with the right approach, the formatting should only be a minor issue. Exporting an edited and rendered sequence and then refining it—by adding animation or additional graphic elements—is really a process of project planning during the early stages of the design.

Two further things are important when thinking of a more integrated workflow that combines editing and motion. The first is the way media is stored and handed across different applications. Many designers render work for personal presentation or social media delivery in a compressed format (e.g., H.264) in order to save space, upload media quickly, and achieve fast playback of the file on different computers. Although this format makes sense for a final copy intended for distribution, the format that media is stored in is very important during the production process.

Try to keep work in progress at as high a resolution and with as much information in the file as possible, ideally as uncompressed media or a high-quality ProRes compression format. Higher-quality formats are more suitable for storing and reworking media files during production. If a file has too little information because of compression, and it is copied or processed several times, the small artifacts that are inherent in compressed media will become amplified with each generation. Avoiding compression issues by using larger files with more information maintains quality, resolution, and color information through the production process.

Maintaining file information at higher resolutions in this way comes at the cost of larger file sizes, and most simple, desktop-level hard drives are not suitable for replaying large media files. So, working at a professional level with quality media requires a little more investment in storage and replay than working exclusively with still images, for instance. It is often a good idea to have a single drive, which is optimized for video files attached to your editing system purely as a *scratch drive*, to store media files and working components of

7.10
System design for editing should make provision for not only a drive to store working documents and images, but a high-speed drive that can store all the working media for edits in progress. These scratch files should be part of a backup strategy that allows for a separate copy of all current documents, storage, and scratch disks, that can recover files in case of a disk failure. The backup process can usually be automated to run overnight, only updating files that changed during each day's work. If you are working with higher budgets, then an offsite, cloud-based backup might also be a good idea.

an edit. Any solid production system used for editing should take the need for high-speed storage into consideration.

A further consideration is that complex layering, transitions, and graphics can all be undertaken in editing software, but as we move closer to pure motion work, with multiple layers in a timeline, the capacity for a system to access and display all these media elements at the same time is reduced. Complex transitions or overlays produced in an editing application will require a particular type of "scratch" render, where the preview file is committed to disk as a new mini sequence at the full resolution of the project, with all elements embedded into a single stream of media. These renders will replace the multiple elements they were produced from and allow for real-time replay, at full resolution, after they are rendered. There is no need to set up a timeline or a render queue to make these renders; a selection in your timeline or the entire program can be set to render, which becomes immediately available to the editing session, replacing the other media files for the duration of the rendered element. It is good to be aware of these processes as you develop longer edited programs.

Editing is an expressive process. With great precision, it controls the way work presents ideas, the way we experience a project in time. In Motion Design, editing explores the complex relationship between images in time and the additional possibilities of images in space. Making the most of both creative and practical tools for editing sits at the core of a developed Motion Design toolkit, as we are always, in some sense, editors by nature.

Chapter 8
Animation Techniques

Anima—(Latin) soul or life.

Modern Motion Design emerged from the combination of traditional animation, film, visual effects compositing, and graphic design. As trends in both styles and techniques rise and fall, we see the re-emergence of past forms, born anew in cycles. Over the last decades, digital affordances have ushered in renewed enthusiasm for frame-by-frame animation. A new generation of designers have been enticed by Wacom Cintiqs, tablets, and styluses equipped with libraries of brushes that respond like analog pens and pencils.

Frame-by-frame animation can be used in any type of Motion Design project, from longer-format title sequences to short and snackable social media posts. Sometimes this animation technique is used to enhance other types of media, such as accent lines that exaggerate movement over footage. Other projects use frame by frame as the primary method of creating motion. But, even the most dedicated frame-by-frame animation projects require some level of compositing, editing, and color correction or grading.

EARLY OPTICAL INVENTIONS

The very earliest novelties devoted to bringing images to life were based on hand-drawn animation. Usually, no more than a dozen frames arranged in a loop invited the onlooker to peer through a slit that revealed the images on a spinning disk or drum. These images, changing as they revolved, relied on the *persistence of vision* to blend the impression of each still frame into a convincing moving image. From as early as the 1830s, devices like the zoetrope and phenakistiskope, and later the praxinoscope, brought simple images to life much like the frames of a GIF image today. The capture and replay of serial photographic images by Eadweard Muybridge in the 1870s were originally intended to study animal locomotion, but they soon developed into a range of human motion studies. Muybridge invented the zoopraxiscope in the late 1870s, another early projection system, and his influence on Thomas Edison, whose Kinetoscope was able to play a consistent film loop of about 50 feet, is well documented.

Every slow, experimental movement towards what would ultimately become cinema was built upon the ideas, techniques, and processes of the field it advanced. Today, the progress of digital tools and their creation of images is perhaps no different than these early incremental developments in the possibilities of the moving image.

DOI: 10.4324/9781003200529-9 **145** ☐

What is fascinating to consider is that before the world could be captured as a sequence of photographic images, it could be rendered for movement as a sequence of drawings. Animation was in this sense the original and essential process for creating a moving image.

Cel Animation

Traditional frame-by-frame animation is one of the pillars Motion Design is built upon. Like optical printing and other forms of pre-digital production, it was very labor intensive. With this technique, every movement in an animation is a new drawing or image. Individual frames were drawn or painted on transparent sheets of plastic called celluloid. These sheets were physically composited on top of painted background plates and then photographed. Each change to a pose was its own image on a separate piece of celluloid. The photographed artwork was then sequenced together to produce motion. The term *cel animation* emerged from the medium from which it was produced.

Today, the name persists, although it has evolved to be known as digital cel animation, or *digi cel*. Even digital frame-by-frame animation is time-consuming relative to keyframe-based motion. Although working digitally removes the need to photograph and develop each drawing or image as film to be composited, we still need to create each frame in a sequence. The benefit of working frame by frame is the ability to produce animation that is not achievable by keyframes alone.

In Figure 8.1, we see process examples for a Motion Design project that heavily uses cel animation, by the studio Buck. The images in Figure 8.1A show the key moments and compositions in a fluid transition. These frames are rendered in black and white for the initial blocking of movement, then colored after the timing is established. In Figure 8.1B, we see the progression from looser drawing tests to the refined art direction of the visual style of the piece. This compilation of images is a fantastic snapshot of not only the process of frame-by-frame animation but also the general approach to creative production. We follow an iterative path that begins with low-fidelity sketches or tests and then gradually revise and polish our work towards completion. Figure 8.1C shows a style frame, which serves to define the visual aesthetic of the project.

The project *Good Books* is a great example of traditional animation techniques used in a Motion Design pipeline. The art direction in terms of illustration style, color palette, use of positive and negative space, textures, dynamic compositions, and surprising transitions all relate to the filter of Motion Design. However, the principles and techniques of classic frame-by-frame animation are also evident in this piece. In many ways, a project like *Good Books* demonstrates the possibilities of remixing the modern with the historic, at least in terms of production. A brief examination of the fundamentals of traditional animation and how they pertain to Motion Design can illuminate how a project like *Good Books* gets created.

TWELVE BASIC PRINCIPLES OF ANIMATION FOR MOTION DESIGNERS

The *12 basic principles of animation* were introduced by Disney animators Frank Thomas and Ollie Johnston in the book *The Illusion of Life: Disney Animation*. Their book outlines the essential principles used in classic Disney films to give life or breath to animation. These

8.1

Examples of cel animation process from *Good Books*, by Buck.

basic principles are still widely in use today, taught in traditional animation programs, and extend into other forms of media such as Motion Design and user experience (UX) design.

Although the basic principles were developed with character animation in mind, they are applicable for any design element in motion. Typography, simple shapes or 3D geometry can all benefit from these techniques. Below is a summary of the 12 principles of animation as outlined by Disney,[1] and their applications through the Motion Design perspective.

1 *Squash and stretch*: This principle shows the effects of weight and velocity on forms in motion. In frame-by-frame animation, we draw a shape stretching as it increases in speed and squashing as it makes impact on a surface, like a bouncing ball. This example is a classic introductory exercise to learn how to endow animations with a sense

of physical presence. We can also use this principle with keyframes by animating the X or Y values of the Scale property, managing the location of a layer's Anchor Point, or keyframing a path shape of a mask or shape layer.

2 *Anticipation*: This principle is used to prepare or setup an action. Physical gestures often require a preparatory movement before the primary action. In frame-by-frame animation, we draw the setup to build a sense of expectation for the audience about what is going to happen next. Again, this principle translates well into Motion Design and keyframe-based animation. We can keyframe transformation properties to have a sense of anticipation, such as the moment before a shape falls off an edge or slides down a ramp.

3 *Staging*: This principle relates to composition and how to focus the eye of the viewer: "the presentation of any idea so that it is completely and unmistakably clear."[2] In Motion Design, we use art direction including lighting, color, value, and saturation combined with camera framing to control the staging and attention of the audience.

4 *Straight ahead and pose to pose*: This principle describes two different approaches to the drawing process for traditional animation. With straight ahead, we draw one frame after another, from the start to finish. Pose to pose is a technique that plans the key positions of an animation. In-between drawings are filled in after the key poses are established.

5 *Follow-through and overlapping action*: This principle helps to add realism to animation through adding extra motion after an object has stopped moving, to account for physics. Although this technique was developed for figurative characters, it works well for any graphic element. A simple shape scaling up quickly can overshoot—grow bigger than its final size for a quick moment—or a line of type may slide on screen and have a slight extra movement before it stops.

6 *Slow in and slow out*: This principle relates to easing, with objects starting slow and building speed, and then slowing down at the conclusion of an action. Nothing in nature moves at a constant speed, so easing is a fundamental principle for motion designers.

7 *Arcs*: This principle is built upon the idea that natural movements travel in arcs. In traditional animation, character gestures often follow this principle. In Motion Design, arcing motion paths and the Rotation property can bring a sense of natural movement, even with graphic forms.

8 *Secondary action*: This principle advises creating secondary, supporting actions to the main character or focus in a composition. In Motion Design, this principle is extremely helpful to enrich a scene. Secondary motion can be created in any number of ways, from keyframing movements of visual assets to subtle camera drifts.

9 *Timing*: This principle relates to the speed of an action. In frame-by-frame animation, the length of time for an action directly impacts the number of frames needed to be drawn. With Motion Design, timing is important because fast or slow movements affect the sensibility or tone of a project.

10 *Exaggeration*: This principle suggests making the qualities and movements of traditional character animation bigger than life. How much bigger depends on the goals and intentions of the animator. *Hyperbole* is a technique also employed in Advertising and Motion Design to emphasize concepts and capture the interest of viewers.

11 *Solid drawing*: This principle relates to the idea of forms existing in a 3D space. In traditional animation, the ability to render perspective, light, and shadow help to create the illusion of three dimensions on a two-dimensional surface. In Motion Design, we can use these same techniques to give solid form to our visual assets. Furthermore, 3D programs are designed to render dimensional spaces.

12 *Appeal*: This principle speaks to the idea of giving charm to a character in a traditional animation. Although we may not work with characters at all in a Motion Design project, we can still bring a level of visual appeal to our design elements through art direction and choreography of movement.

Our summation of the 12 principles is brief and meant to be viewed through the lens of Motion Design. In addition to *The Illusion of Life: Disney Animation*, there is a multitude of resources that explore traditional animation in far greater detail. As part of the toolkit, we encourage a basic competency in this animation technique, or at the least knowledge of how frame-by-frame animation is made. One of the first steps is to understand how frame rate works with traditional animation.

UNDERSTANDING FRAME RATE

With frame-by-frame animation, frame rate determines how many drawings are needed per second. For beginners, it is highly recommended that you work at a lower frame rate while you learn the basics. Starting at 12 frames per second (fps) in your animation software is a gentle introduction to traditional animation. When you import a 12-fps animated sequence into a compositing software like After Effects and place it into a 24-fps composition, it will automatically *animate on 2s*: each drawing from the 12-fps animation will hold for two frames in this scenario. An experienced animator may *animate on 1s* at 24 fps, which requires 24 drawings for every second of animation.

Keyframes are fantastic tools to automate the heavy lifting involved in animating basic transformation properties and effects. However, they can be limited at producing certain types of liquid motion, perspective changes, foreshortening, and dynamic figurative animation. These types of animations often require a more traditional approach. Having frame-by-frame animation techniques in your toolkit expands the range of your creative potential. Furthermore, learning the basics of traditional animation will deepen your appreciation of keyframes.

EASING WITH FRAME BY FRAME

With keyframes, adding an organic ease is as simple as selecting a hotkey or dragging a Bezier handle in the Graph Editor. But when you are working with frame-by-frame animation, you need to draw your eases. Figure 8.2 shows the process of charting the path of easing a circle in a frame-by-frame animation. This drawing is a like a storyboard in a single frame for a 12-fps composition. The line underneath the circles shows a series of numbers that represent the location of the drawings at every frame in our 12-frame sequence. To ease-out, our drawings at the start of the movement are close together. We see more drawings with small changes

Ease-out and Ease in - Drawn in a linear motion path.

8.2
Graphic showing how easing is drawn in frame-by-frame animation.

Ease-out and Ease in - Drawn in a nonlinear motion path.

8.3
Graphic showing a simple plan for frame-by-frame animation in an arcing path.

in distance in frames 1, 2, 3, and 4. As we pick up speed, the distance between drawings grows, as seen in frames 5, 6, 7, and 8. Easing-in returns to more drawings closer together with frames 9, 10, 11, and 12.

In Figure 8.3, we see another simple chart for a frame-by-frame animation. In this example, our motion follows a more natural arcing path across a 12-fps composition. Again, we see both an ease-out and an ease-in, with shorter distances at the start and end of the animation. Another organic element drawn into this example is the stretching effect that happens to objects as they move faster. Starting at frame 4, where the animation starts to increase in speed, we draw our shape with a slight elongation. This distortion increases with frames 5, 6, and 7 as the shape reaches its fastest speeds. As we slow down for the ease-in from frames 8, 9, and 10, the stretching distortion reduces until it is gone entirely by frames 11 and 12. When we play this animation down over the course of one second, the stretch effect—in sync with the distance between frames—adds realistic qualities to the movement.

EXTENDING FRAME-BY-FRAME ANIMATION

Figure 8.4 shows an extended use of the arcing circle frame-by-frame animation. Figure 8.4A shows a storyboard sketch serving as a simple pose-to-pose reference on the left. Having a chart for the main poses in a sequence works as a guide and is especially helpful for more complex animations. The right side shows an individual frame being drawn in the sequence with *onion skinning* options turned on. Onion skinning is a great feature that shows the previous

8.4

Example of extending frame-by-frame animation by importing into After Effects and using the duplicate and offset principle, composing in Z space, and camera movement.

drawings in a frame-by-frame animation at a lower opacity. These onion skins work like registration marks or references to synchronize the current frame being drawn with previous frames.

In Figure 8.4B, we see the frame-by-frame animation imported into After Effects as a layer asset. The layer is duplicated and offset around its anchor point, located at the center of the composition, to create a kaleidoscopic pattern. Subsequent images in Figure 8.4B show the duplicated layers precomposed, and then the pre-comp is duplicated and offset to create a more elaborate pattern. Figure 8.4C shows further enhancements to the original animation with pre-comps changed to different colors and offset at varying depths in Z space. This example illustrates how the combination of frame-by-frame animation with After Effects allows for new and unexpected results.

MAKING FRAME-BY-FRAME ANIMATION

Regarding digital techniques, there are several software options for creating frame-by-frame animation. Some tools have been used in productions for decades, and some are quite new. Deciding which tool works best for you depends on your level of interest in using this animation

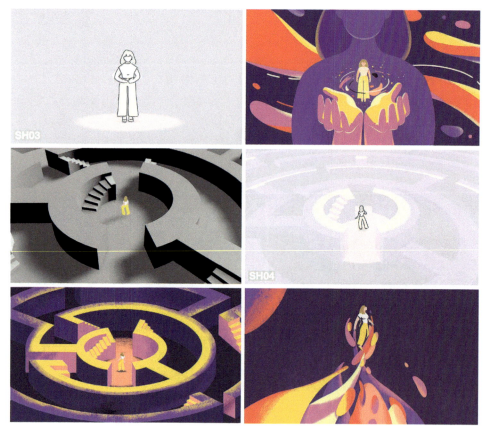

8.5
CDC Ana and Linda, Awareness Testimonials Campaign. Created by Scholar. This layout illustrates the process of 3D renders used as reference for cel animation.

process. For a more punk rock approach to cel animation, software such as Photoshop and Pro-create work well. The learning curve is not too steep, the programs are relatively accessible, and exporting animations for compositing in other programs like After Effects is easy. If you envision working on frame-by-frame animation in a larger studio pipeline, learning software such as Toon Boom, Adobe Animate, or TV Paint might be of interest. These programs have dedicated work-flows for cel animation production. Animators who work in these programs typically specialize in frame-by-frame animation.

In all instances of digital cel animation, a Cintiq or equivalent screen that works with a stylus such as a Cintiq Pen or Apple Pencil offers clear advantages. The ability to draw directly on your screen affords precise control of line quality and maximum efficiency in production speed. A Wacom tablet that sits on a desk is OK for frame-by-frame animation but will not equal the advantages of a stylus sensitive screen. A mouse or touchpad is usable for exper-imentation or just getting started, but extremely limited in terms of precise drawing control needed for professional productions.

For work that employs forced perspective, strong camera angles, camera tracking with a subject, or changes in perspective around a figure, 3D software can be a very useful tool. Making a scene in 3D as a simple grayscale render first, then rotoscoping over it to add line, color, and hand-drawn detail, gives the feel of cel-animated work. Additionally, we gain the guidance of the 3D camera for what are sometimes challenging shots or movements to draw. 3D can solve spatial problems with camera movement, perspective, and lens framing that are difficult to resolve through imagination alone. Mixing a 3D shot into an otherwise hand-drawn sequence or using 3D to create a key element or background can make a subtle difference to the feel of a production without overpowering an otherwise hand drawn feel.

STOP-MOTION ANIMATION

Another classic form of frame-by-frame animation is *stop motion*. Again, prior to digital pro-duction, this medium required a scene to be photographed one frame at a time, film to be developed, and then composited together in an analog manner. Digital cameras and soft-ware have greatly increased the speed of production. However, like cel animation, even with digital affordances stop motion can be very time-consuming because each motion is a change in a practical set up with physical assets.

The benefits of stop motion include bringing tactile sensibilities into a Motion Design project.

Small-scale projects created with this technique are called *tabletop productions*, because they are often constructed on table-sized sets. Just like cel animation, stop-motion elements might be used as assets in a mixed media project, or it may be the primary approach to a pro-duction. Studios or motion designers who specialize in this technique develop highly refined skills in areas such as fabrication, creating physical models, and production design for asset creation. Capturing footage requires sophisticated understanding of lighting, cameras, lenses, and software to manage the cinematography and sequencing of stills.

For beginners, the most important first step is to work with a stabilized camera. Use a tri-pod to make sure your camera does not move while capturing stills. Ideally, you have a shutter release separate from your camera—either a cable or software that enables the camera to take

8.6
The simple soft box surrounds the light with a reflective box, which opens in flexible spines a little like an umbrella. This will direct light from only the front face of the box, to avoid reflections or bounced light. A soft fabric can be applied to the front of the box, essentially turning the entire front face into a large, soft panel of light. This setup allows the light, which is now coming from a wider surface to "wrap" around objects, avoiding hard shadows, making it an ideal light source for close stop-motion work.

a picture without being physically touched. Even the slightest movements to the camera can cause the animation to feel jittery.

The next step is to make sure you have consistent lighting. Lighting is thankfully relatively cheap and easily found in online marketplaces, so establishing a small studio or tabletop setup is quite straightforward. Start with two small "soft boxes" designed for video production. These fittings will usually come with stands and simple soft boxes to direct the light out of the front of the box. The light is diffused through a heat-friendly fabric that will turn the entire front surface of the box into a diffuse (soft) light source.

There are several phone apps that do a decent job of capturing and creating stop-motion sequences, and even provide onion-skinning options. However, if you want to develop this animation technique as part of your toolkit, you will want to work with more robust software such as Dragonframe. This software is designed to work with the leading digital camera manufacturers and offers a comprehensive workspace to control both the camera controls and sequencing of captured frames.

DOPE SHEETS

It is probably not too much of a stretch to say that Motion Design is a little like music, with multiple parts coming together to make a finished composition. With this idea in mind, it is useful to adapt a classic animation tool, the dope sheet, into motion production. A *dope sheet* is a paper plan that outlines movement, dialogue, and very granular details of an animated scene to give an animator the opportunity to draw frames that would synchronize with dialogue, or to plan movement in a scene that would relate to the intended direction of characters.

FRAME-BY-FRAME TECHNIQUES

In Figure 8.8, we see selections from student projects that use frame-by-frame animation to varying degrees. Figure 8.8A shows a digi cel approach to traditional animation, where assets were drawn frame by frame in Procreate on an iPad and then composited together in After Effects. Initial style frame development established the art direction, color palette, texture, typography, and line quality of animation. A design storyboard served as a pose-to-pose guide for key compositions in the project. Additional camera movement, track mattes to control texture, and color grading were added in After Effects.

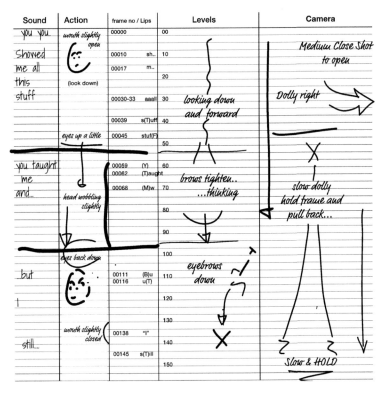

8.7

A dope sheet breaks down an animated sequence into frame-based cues for gestures, camera movements, and lip position to synchronize with recorded dialogue. The same principles can be expanded to plan motion projects movement, flow from scene to scene, and even the color story that develops during a piece.

8.8
Collection of different student projects using frame-by-frame animation techniques: (A) created by Mercedes Schrenkeisen; (B) created by Phoebe Yost; (C) created by Madison Ellis; (D) created by Nicole Colvin, Jayson Hahn, and Nicole Pappas.

Figure 8.8B shows a project that was created with a *rotoscoping* animation technique, where video footage is shot and used as a base to draw over. This approach requires cinematic planning to choreograph and capture the movement of actors. In this project, the student imported video footage that she shot into Adobe Photoshop and used it as a visual reference to create frame-by-frame line work and color passes. The Photoshop animation was imported into After Effects and composited over background plates illustrated in the same style as the figurative animation. Additional camera movement and light effects were added using After Effects.

In Figure 8.8C, we have a combination of frame-by-frame animation techniques including stop motion and digi cel. The stop-motion animation was first carefully planned through storyboarding. Assets were designed digitally and then cut and assembled by hand. Stop-motion frames were captured in camera in a controlled lighting setup, then sequenced in After Effects for motion. Additional frame-by-frame accent lines were added to accentuate gestures. Additional track matte compositing and color grading were performed in After Effects.

Figure 8.8D shows frame by frame as an accent to a primarily 3D animation project. Digi cel assets were created in Photoshop and added to Cinema 4D as animated textures. The project was rendered out of Cinema 4D and composited in After Effects. Although frame by frame was not the primary technique for this project, the moments of traditional animation add an unexpected highlight to computer-generated scenes. A fusion of graphic 3D geometry and more bespoke animated elements creates a dynamic visual piece.

Although this chapter focuses on traditional animation, we rarely call our work finished once the frame-by-frame process is complete. In the examples above, notice each project integrated a variety of techniques. Much like the idea of the personas of Motion Design introduced in Chapter 1, the ability to transition between tools is a key aspect of the toolkit. Knowing a variety of animation techniques is indispensable to expanding your range as a creative problem solver.

NOTES

1 Thomas, Frank and Ollie Johnston (1997) [1981]. *The Illusion of Life: Disney Animation.* Hyperion.
2 Thomas and Johnston (1981), p. 53.

Chapter 9
Compositing

COMPOSITING

In Motion Design, *compositing* is often the glue that holds a style together. Compositing is the process of combining elements from different sources to create a new and unified whole. It has roots in analog photography, collage, and visual effects that have translated into digital production processes. Compositing requires skills to select, blend, adjust, and integrate disparate elements into new combinations. The first step in effective compositing is having assets separated into distinct parts or layers.

Layering offers flexibility to compose, rearrange, and mix visual qualities in either static or motion projects. When prepping assets in Photoshop, we can create selections using tools such as the lasso, magic wand, pen, quick masks, channels, and color range. Once we have a selection, we can isolate parts of an image by using layer masks and/or copying and pasting to create new layers. Although we can accomplish a significant amount of compositing in the design phase of a project, we often continue the process once we import a multi-layered file into After Effects.

In After Effects, masks are a powerful tool for compositing. If an imported asset needs to be divided into parts for greater control, we can quickly duplicate that layer and use masks to isolate the different elements. When used in this capacity, masks serve as a layering device, much like they do in Photoshop. However, we can also animate these masks using keyframes. Ultimately, masks and other tools that help to control the visibility of layer assets work to distinguish between opacity and transparency.

Alpha Channels

The ability to isolate parts of an image is a critical component of compositing, and understanding *alpha channels* helps to accomplish this task. An alpha channel is a way to define and look at a layer's opacity. In Figure 9.1, we see an example of images in both their RGB color spaces and their alpha channels. Figure 9.1A shows a photograph of a flower with a transparent background. Figure 9.1B shows the same image but displayed through its alpha channel. In the alpha channel view, black represents 100% transparency and white represents 100% opaqueness. Alpha information is displayed in values ranging from black to white, with gradations in opacity seen as variations of gray.

In Figure 9.1C, we have a photograph of a tulip repeated at different opacities. The layer on the far left is 100% opaque, the next layer in the sequence is 75%, followed by

DOI: 10.4324/9781003200529-10

(A) RGB (Red, Green, Blue) Color Space (B) Alpha Channel

(C) RGB (Red, Green, Blue) Color Space (D) Alpha Channel

(E) RGB (Red, Green, Blue) Color Space (F) Alpha Channel

9.1

Example of images on transparent backgrounds and their respective views as alpha channels. Photography by Austin Shaw.

50%, and the final layer on the right is 25%. Figure 9.1D shows the alpha channel view of the four layers and their corresponding opacities. Gradations of gray represent the different degrees of opacity: lighter grays are more opaque and darker grays are more transparent. The final set of images in Figure 9.1, E and F, show the RGB and alpha channel views of clouds on a transparent background. This example shows an image that has a mix of fully visible and semi-transparent pixels. Gradations of opacity will appear with variations of light and dark values in a layer's alpha channel.

TRACK MATTES

Track Mattes use information from one layer to control the alpha channel of another layer. They are like Masks because they allow us to define and animate the visibility of layers. They differ from Masks because Track Mattes work in independent layer pairs. One layer is the

Matte layer and one layer is the fill layer. They are incredibly powerful tools for Motion Design because the separation of Matte and fill layers allows very precise and independent control of animation and compositing. There are two different types of Mattes: an *Alpha Track Matte* and a *Luma Track Matte*. Each type of matte has two settings: regular or inverted.

Alpha Matte

An *Alpha Matte* uses the alpha channel—opaque information—of one layer to define the visibility of the layer directly beneath it. In Figure 9.2, we see the source layers and settings for an Alpha Track Matte. Figure 9.2A shows a photographic layer of fire, which serves as the "fill." Figure 9.2B shows a text layer that says the word "FIRE," which serves as the Matte. In Figure 9.2C, we have a screenshot of the Layers Panel in After Effects. The text layer is placed on top of the photo layer of fire. In the *TrkMat* (short for Track Matte) column, we see the fire photo layer is set to "Alpha." In Figure 9.2D, we see the result of the Alpha Matte: the fire imagery isolated to the alpha channel of the text layer. When we choose the selection of Alpha Matte, the visibility of the text layer automatically turns off. After Effects also displays infographics on both layers to the left of their names to show a Matte has been applied.

Any kind of visible layer asset can be used in a Matte: footage, stills, precomposed animation, shape layers, and so on. A huge advantage of Mattes is the ability to animate the Matte and fill layers separately. The text layer can start scaled up so much, it fills the entire screen, showing the entire layer of fire footage. We could scale the text layer down in size without affecting the scale property of the fire layer, or we could do the opposite, where the text scales up to reveal footage within the Matte. This type of Alpha Matte animation is often used as a transitional device in Motion Design projects.

An Inverted Alpha Matte is set up in the same way, with the Matte layer on top and the fill layer directly beneath. However, the alpha information of the Matte layer subtracts from the fill while preserving everything outside of the Matte layer's alpha channel. The Inverted Alpha Matte creates a window or die-cut in the fill layer, allowing us to see what is behind in the layer stack or transition through the transparent space.

Luma Track Matte

A *Luma Matte* uses the luminance—light and dark information—of one layer to control the visibility of another layer. Again, the setup of a Luma Matte is the same as any matte pair, with the matte layer on top and the fill layer on the bottom. In a regular Luma Matte, the light values of the matte preserve the visibility of the fill, and the dark values of the matte hide the fill. In Figure 9.2, we have an *Inverted Luma Matte*, which shows the dark values of the matte and hides its light values. The source image in Figure 9.2E serves as the fill, and the ink footage in Figure 9.2F is the Matte. Because the Luma Matte is set to inverted in Figure 9.2G, the result shows the source footage visible in the dark values from the Matte layer in Figure 9.2H.

Luma Mattes work well when the Matte layer has high contrast between dark and light values, such as shooting smoke on a dark background or dark ink on a light background. Other instances for a Luma Matte include making a piece of footage high contrast using color correction tools like curves, levels, and hue/saturation. This technique works well when duplicating

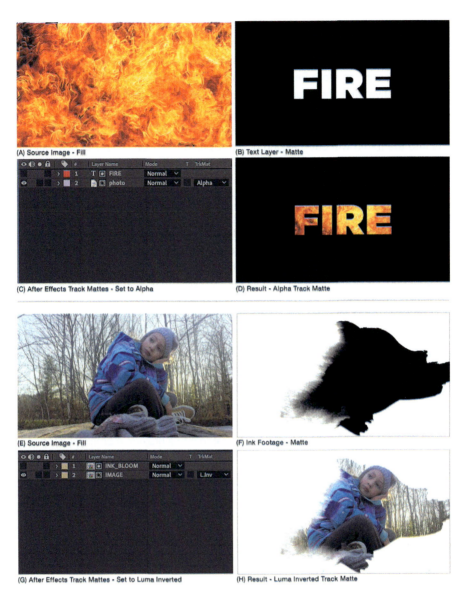

(A) Source Image - Fill

(B) Text Layer - Matte

(C) After Effects Track Mattes - Set to Alpha

(D) Result - Alpha Track Matte

(E) Source Image - Fill

(F) Ink Footage - Matte

(G) After Effects Track Mattes - Set to Luma Inverted

(H) Result - Luma Inverted Track Matte

9.2
Examples of Track Mattes in After Effects. Fire photography by Fluke Samed/Shutterstock.com. Portrait and ink photography by Austin Shaw.

an asset, making the duplicate high contrast, then setting a Luma Matte to isolate parts of the source image.

GREEN SCREEN

Green screen production uses a uniformly colored background to create alpha channels, which are attached to images for compositing operations. It is sometimes just referred to as keying or color keying an image. Although the color green is frequently associated with

this type of work, any of the three RGB primaries can be used. A Blue Screen, or even a Red Screen, works using the same principle, because this type of keying operation is based on color differencing. Green is popular because people have a certain amount of redness in their skin tones, and therefore Red Screens are not a good choice as they do not create a clear and distinctive separation from the background. Blue, although originally used for these processes, is more inclined to affect the color balance of a shot if it is removed.

So, shooting with a uniformly colored background gives a designer the capacity to place objects into the frame without masking or rotoscoping the edges. The key generated by a well-shot green screen will provide all the required detail if handled properly.

It is important to grasp the mechanics of color differencing to effectively plan and produce material for compositing through using these types of keys. We could start with the pixel.

Every pixel in an image is based on additive colors—red, green, and blue—in different values that produce the millions of shades we can work with on screen. Running an eyedropper over an image in Photoshop, and reading the RGB values in the Info Panel, reveals how very different the ratios are for pixels that sit next to each other in an apparently evenly toned image. For the purpose of keying, we need pixels that are sufficiently different from the rest of the image in color so that they can define our keyed areas based on difference. No image has perfectly even tones—there is always a mix of red and green in any photographed or filmed image—but if pixels have a high enough amount of green information, and a low enough amount of red and blue information, they will be sufficiently different from other pixels in the captured image to allow for a key to be extracted.

Green screen is not only for capturing people in elaborate studio shoots. It can work very effectively in smaller desktop situations where graphic elements, stop-motion media, or other smaller physical images can be incorporated into a project. A small tabletop or floor setup can be arranged using a glass sheet and boxes to provide a stable surface for green screen shooting and a little separation between the green backing and the elements placed on the glass.

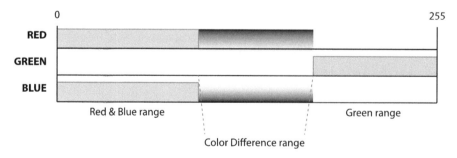

9.3
Green screen capture is not designed to capture precisely green pixels, but a range of pixels that have high green light energy and lower red and blue light energy as they are captured. In this representation of an 8-bit pixel, with 256 values of red, green, and blue, the color difference means that even if an area is not perfectly green, so long as it has high enough green and low enough blue and red, there will be a difference in the middle, and it will enable a key. Standard keying plugins, like Keylight in After Effects, will translate these values almost immediately into an effective key.

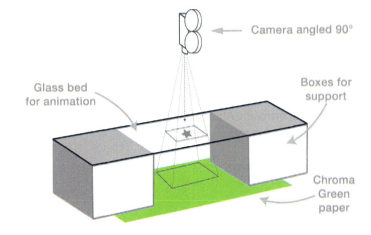

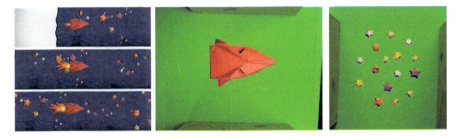

9.4
A simple stop-motion animation where the different paper elements, rocket, stars, and flames were all shot on a glass sheet for compositing. This technique allows every element in a stop-motion setup to move separately, and to be controlled individually, providing tremendous control over the final animation.

This principle of *separation* between the foreground elements and the green screen background is important to keep in mind for two reasons. Moving the foreground and background into different *zones* allows for lighting to be separated and the mood of the foreground lighting to be controlled. Green screen backings work best with softer, even illumination, so even a tabletop setup can benefit from lighting the backing evenly and allowing a little more light and shadow to play on the foreground elements. This setup prevents the elements intended for stop motion from being lit with a flat and shadowless lighting.

In any green screen setup, tabletop or studio, separation also reduces unwanted spill. If we think of the backdrop as reflecting the green wavelengths of light and subtracting the red and blue from the "white" light illuminating the backdrop, the whole backing can be thought of as a large, green light source. Reflecting light back to the camera with a high amount of green is good, but green spill wrapping around the foreground subject is not. Being too close to the background makes the subject of the shoot pick up all the green light from the screen, and this spill can make the edges of the subject a little too green to key properly. The spill from a backdrop also introduces a green cast to the subject's lighting, which can require additional color correction in post-production to compensate.

Creating distance between the subject and the background will help make a key more defined in post-production, again saving time on additional color correction.

Simple Key Processing

The basic stages of keying in post-production are as follows (Figure 9.5):

1 Top left: Footage is imported into After Effects, placed in a composition, and the Keylight effect is added to the footage layer.

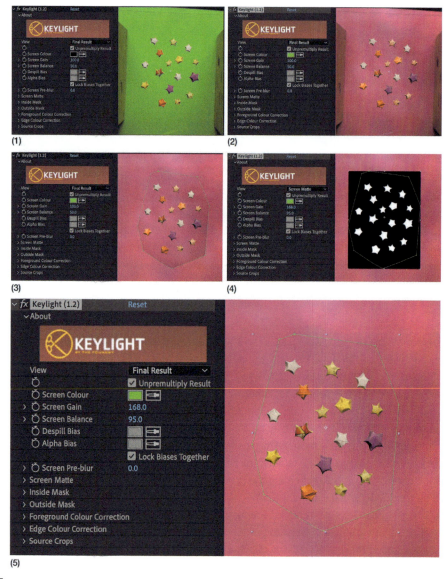

9.5
The basic stages of keying in post-production.

2 Top Right: The eyedropper selects the Screen Color, sampled from the raw image's green areas, which immediately removes the green color.

3 Center Left: The boxes that have not keyed out of the background are removed with a rough Bezier mask, often referred to as a *junk matte* because it does not need to be precisely drawn.

4 The Screen Matte is selected in the key software, which shows the footage in alpha channel view. The white areas indicate what areas of the layer are visible and the black areas indicate what has become transparent or been keyed out. The Screen Balance is lifted to 95%, making the Matte (which creates the key) crisper. This technique is referred to as *crushing the Matte*.

5 The final result (lower) shows clear separation of the foreground elements and a clean key.

It is important to note that this footage, shot on glass, began with good separation from the backing. Footage clips with green spill from the background will usually require spill suppression, which removes any green color cast in the image, but in doing so reduces the saturation of the foreground image slightly. Having a clean and defined base image, with foreground separation, is always preferable.

BLENDING

Another vital aspect of compositing is *blending*, the purposeful mixing of visual qualities between the layers in a composition. Blending can help integrate layer elements from different sources, as well as more robust multi-pass rendering of 3D assets. One fundamental tool of blending is Opacity. Simply adjusting a layer's Opacity mixes its appearance with the layer or layers beneath. When combined with other compositing techniques like Masks or Mattes, this effect can resemble double exposure photography. More subtle uses of Opacity help to reduce the visual intensity of layer qualities that may appear heavy-handed or distracting from a composition's focal point.

Blending Modes

In addition to Opacity, Blending Modes are tools in Adobe software that integrate visual properties of layers. We can create unique aesthetic styles by combining layer qualities with Blending Modes. *Multiply, Add, Screen, Overlay*, and *Soft Light* are a few of the most commonly used, but we encourage you to explore them all. Bending Modes use math to manage the combination of colors and values and are separated into groups of similar functions. Some of these modes are easy to "work out in your head," whereas others can be harder to visualize.

Modes like *lighten* are easy to understand. When the layer on top in the composition has the lighten mode applied to it, pixels anywhere in the image that are lighter than the layers below are applied to the image. If a given pixel is not lighter, it will not be included in the image. Darken uses the same principle, in reverse. These modes can be a quick way of adding something to an image without complex masking. For example, adding black text on a white background to a composition might use the darken blending mode, and the black

text is applied with all the white areas removed, as those pixels will *not* "darken" the image below. For more complex modes, it is good to experiment and get a feel for the kind of results they produce.

COLOR CORRECTION

Learning to control color is another foundational tool for compositing. Motion Design projects often use assets from a variety of sources, sometimes with vastly different color spaces. A motion designer needs a solid understanding of how to adjust colors to make all assets in a project feel like they belong in the same space. Additionally, color is a powerful tool to both capture attention and evoke emotional qualities in the audience. Like many of the areas of the toolkit, working with color can be a specialized role with sophisticated software. We are covering the essential principles and tools motion designers should know for both color correction and color grading.

Adjusting Color

Programs like Photoshop and After Effects offer a range of tools for image adjustment. In terms of controlling color, the *Hue/Saturation* tool is fundamental because it offers the ability to change an image's hue (or color), increase or decrease saturation (or color intensity), and increase or decrease the lightness or darkness of an image. Another great tool is *Color Balance*, which allows us to make adjustments using color channels and their complementary colors in either Shadows, Midtones, or Highlights. In After Effects, these properties can be applied as Effects and animated over time using keyframes. Although Hue/Saturation and Color Balance are basic tools, they are incredibly effective when used with skill.

Controlling color is important for motion designers because we can use it to direct the eye, unify a composition, and evoke emotional responses in the audience. Our eyes are naturally drawn to areas of high contrast and high saturation. The technique of *selective saturation* specifies what parts of an image have high saturation and what parts of the image are more muted, which influences the visual focal point. *Colorizing* an image through effects or Blend Modes can tint an entire composition to a single hue, which creates visual cohesion through color. From both cultural and psychological perspectives, different colors produce various emotions. The ability to skillfully work with color allows us to purposefully communicate our intentions in creative projects.

Adjusting Value

Adjusting value—the dark and light intensities of images—is a key aspect of controlling the focal point of compositions and hierarchy of visual information. *Levels* and *Curves* are two of the most useful ways of balancing an image's tones and adjusting its values. Every digital image has a range of values expressed as numbers. Most simple digital images have 256 shades, from 0 to 255, and these represent dark to light values in the image, or *intensities* of luminance. Color images add red, green, and blue together, but each of these values is also a range of intensities from 0 to 255. A 100% red pixel will have a red value of 255 and green and blue values of 0. A white pixel is a mix of all three colors, and they are all at the highest

9.6
An image with Curves (left) and Levels (right) palettes displayed. The histogram is displayed in each indicating the distribution of luminance values in the underlying image. Not only do these offer the capacity to adjust the tone of the image, but each has output controls to further restrict what tones will be output with the image, essentially setting a starting point for the image *above black or below white* if required.

value (255R + 255G + 255B). This mix of all colors added together will render white; in the same way, the absence of all values is a black pixel (0R + 0G + 0B).

Each pixel in an image has a unique value, which is the *average* of the three color values in the pixel (R + G + B, divided by 3). In a *black and white* or grayscale image, it is simply the values from dark to light. The mix of these values in an image can be seen in a *histogram*, which is a small graph showing the distribution of values from 0 to 255.

Levels adjustments are common across digital imaging applications and offer a view of the image's histogram and its distribution of values. We can quickly adjust an image's Shadows, Midtones, and Highlights using sliders. Increasing the Shadows, for example, will make every value below its new position darker. Increasing the Highlights will make values lighter. Moving the Midtones up or down will adjust the tonal values of the image in either direction. The same adjustment can be applied to individual color channels, affecting the color balance by raising or lowering the value of red, green, or blue in the image independently.

Curves operate in a similar fashion, by showing a straight line progressing from dark to light and allowing this progression to be adjusted with a user-defined curve. This curve essentially transforms the midpoint function into one or more points of influence (which are not necessarily set at the midpoint). Curves work well when used to make a simple adjustment but can quickly become complex and difficult to manage with multiple points in play.

Compositing is one of the most creative and intensive forms of spatial editing. We can combine multiple images into highly controllable compositions. Making the image feel integrated and complete requires a solid approach to the capture and collection of images, effective use of alpha channels, keying, blending, and color correction. Once we gain competency in these skills, we are ready for more robust Motion Design productions.

Chapter 10
Motion Design Production

PRODUCTION

This chapter explores the fundamental tools for Motion Design production. Although every project is unique, there are common patterns that can orient the designer and their commercial clients within the production process. For projects with a very specific creative brief, an initial kickoff meeting is followed by a period of research and ideation that clarifies an appropriate design direction and creative solution. Once the design direction or pre-visualization is approved, a project transitions into animation production. How this stage of a project begins will vary depending on the scope, team, and creative techniques employed.

Not every tool or stage described in this chapter will be used in every Motion Design production. However, having competency with these tools and knowledge of these production stages is vital for any motion designer. Productions often have a lot of moving parts in addition to multiple stakeholders. Learning to effectively navigate a project from kickoff to delivery takes time and experience. Furthermore, knowing when to use the appropriate tool is just as important as knowing how to use it.

For the motion designer, what is on screen is uniquely within their control. There is the potential to define every element that appears in a piece. To assist with decision-making as a project develops, these tools for refining and developing the choreography and movement of a work are valuable aids in the process of moving from idea to finished work.

Motion Tests

Motion tests are an incredibly important tool in the motion designer's toolkit. At some point in the production process, every Motion Design project begins to *move*. Although motion tests are the pivotal first steps in animation, they are typically granular moments in relation to the entire project. For example, a motion test may be a highly refined two- or three-second animated shot, in a longer 15-second piece, or it may resemble a low-fidelity moving sketch that blocks out one specific scene or action.

Motion tests may be created in a linear fashion, starting with the opening shot in a project, or a motion test may be non-linear in relation to the broader timeline. Which shot or scene to begin animating depends on the creative needs of the project. Often, a series of motion tests are sequenced together to create an animatic or a rough cut. In this way, motion tests are part of an incremental approach to building a series of animated shots on a timeline. Motion tests are the essential transition from design into motion.

DOI: 10.4324/9781003200529-11

Why Do Motion Tests Matter?

Motion tests afford a designer or studio opportunities to explore the personality of animation for a project. They help set the tone and stylistic guidelines for how a project happens in time. In other words, motion tests establish the *pattern of motion* for a piece. A pattern of motion can clarify qualities such as overall timing, camera movement, editing style, easing, rhythm, transitions, and secondary motion. Early tests will improve the consistency of animation, creating overall cohesion for a viewer or user.

For productions with multiple animators on a team, it is vital that each animator has a common point of reference for the project. Motion tests serve to keep all artists on the same page with respect to animation as a production moves forward. In this age of remote working, motion tests can be shared easily across vast distances and quickly brief a new member of a team with the stylistic needs and expectations of a project.

All traditionally drawn 2D animation used *pencil tests* to feel out and refine movement in time before transitioning to the tedious process of ink and paint. The pencil test allows for movement to be assessed as it is being developed. For anyone working in *any* style of animation, this movement from simpler more basic rendering towards refined final work is how the ideas of audition, blocking, and rehearsal are translated from other styles of performance into animation. This process makes work tangible as it develops. Although contemporary production allows for a range of different techniques, the same principle of moving from rough to refined applies.

Efficiency of Production

From a commercial standpoint, motion tests save time and money. Rather than spending resources to produce an entire polished animation for what may only be an initial presentation to a client, a motion designer or studio can produce motion tests to indicate the larger animation plan. With a single motion test, a dialogue for development, revisions, or refinement can happen immediately between project stakeholders. Client collaboration at the early stages of animation will benefit any production, as this gradual approach invites participation in a project's development. From a motion designer or studio's perspective, gaining step-by-step approval from a client ensures resources are being efficiently allocated throughout a production.

Low-Fidelity to High-Fidelity

Motion tests range from low-fidelity moving sketches to highly refined animations that feel like shots pulled from a finished piece. The degree of polish depends on how the motion test is being used, and what mediums or techniques are employed. For internal development or review, a low-fi motion sketch can quickly communicate essential qualities such as pacing, asset choreography, or camera movement. Revisions can also be quickly implemented as iterative motion sketches, reducing ambiguity in "describing" nonverbal aspects of a work and contributing to a productive workflow.

When working with savvy clients, low-fi motion sketches can be very effective for establishing a visual reference for dialogue. However, presenting a motion sketch to a client who does not understand what they are looking at, or how it fits into the production process, can cause confusion. In some cases, they may think the low-fi motion sketch is an indication of the

final look of the piece. Educating your client about the production process may be necessary. It can also be helpful to set the terms for feedback, saying "here we are looking to establish X," so that the conversation is structured and the client feels supported.

More refined motion tests are used for both internal and external reviews. Internally, polished tests often reflect the organic process of building shots for a project. There will be any number of creative reviews within a studio's hierarchy. An animator presents and receives feedback from their creative lead throughout the development of a scene. A shot will be revised and tweaked until the creative lead is satisfied or a deadline is reached. The refined motion test is then presented for external review. Feedback received from the client is then negotiated and implemented into the shot. This type of highly refined motion test is like a style frame in motion, meant to communicate how the final project will appear in that moment.

Pitching Versus Production

Motion tests are used throughout the Motion Design creative process. However, it is important to note that motion test usage can vary between pitching and production. For instance, a motion test may be employed to elevate the quality of a creative pitch prior to a project being awarded to a designer or studio. In a competitive pitch against other creatives, a highly refined motion test may be the difference between winning or losing a job.

A project may be *single bid*, meaning it is awarded to a designer or studio. However, there may be a round or multiple rounds of motion tests presented to the client to gain their approval prior to advancing into more comprehensive production. Motion tests in this scenario are used to define the pattern of motion in a step-by-step manner. Once the designer or studio and client agree on a motion test, all relevant shots in the project can be developed in that treatment or direction. Again, this approach brings everyone together as a project develops.

TYPES OF MOTION TESTS

Playblasts A *playblast* is a low-resolution CG/3D render that communicates essential scene qualities such as composition, camera placement, camera movement, animation, and timing. Rendering fully lit and textured animated scenes from 3D can be very time-consuming. Additional finishing effects such as ambient occlusion, global illumination, motion blur, and camera depth of field can exponentially increase render time. Errors in timing, animation, or camera movement in a highly refined render are incredibly frustrating. Playblasts allow the choreography of elements to be developed as a project takes shape.

Playblasts provide opportunities to review progress very quickly rather than investing precious time rendering polished 3D before broad-stroke qualities are worked out. A shot or scene can be drafted through a software's editor view and then rendered as a preview or wireframe. An animator or a creative team can then review playblasts and revise as needed. This process can be iterated until the creative team is satisfied, and then CG can be rendered at the highest quality.

Playblasts can also be shared with clients during the production process. However, if a client does not understand that a playblast is a low-fi render, the designer or studio will need to explain that you are showing them a test for timing, camera, and so on—not the final look and feel. This type of dialogue can be valuable, because you can gain sign-off prior to investing in refined render time while keeping your client engaged in the process.

(A)

(B)

10.1

(A) Examples of low-fidelity playblast frames and final composites from "2025" by Sarofsky; (B) example of low-fidelity digital cel animation juxtaposed with refined cel animation, "Spectacle of the Real" animation for David Blaine by Buck.

Cel Blocking

Traditional frame-by-frame or cel animation can be extremely tedious and time-consuming to produce. Fortunately, the historical framework to produce cel animation is quite robust relative to newer forms of Motion Design, so the pipeline for translating storyboards into refined animation is well established. From the motion designer's perspective, integrating traditional animation techniques into their toolkit affords opportunities for more fluid motion and hybrid production techniques.

Motion tests for cel animation in a Motion Design pipeline may start with bringing a single-style frame to life or blocking out a transition between style frames. Cel motion tests may start with sketchy line work at a low frame rate to block out key poses and timing. Shots can then be composed into a cel animatic for review of overall timing and the emerging

"feel" of the work. From this point, additional in-between frames are drawn to smooth out transitions. Finally, color is added, and shots are composited into a project.

Using 3D renders as reference for cel animation is a useful tool for scenes with dramatic perspectives or camera rotations. Quickly rendered playblasts from 3D can serve as reference for cel animation, bringing the dimensionality of 3D into a 2D frame. This technique can also serve to help integrate mixed media in Motion Design. Transitions from cel animation to 3D or live action can be blocked out and created using rotoscoping techniques and gradually refining in-between frames.

Highly Refined

Once a design direction is approved by a client, it is quite common to create a highly refined motion test of a single scene or shot for the next round of presentation. Highly refined motion tests can be made in any medium, but they are easily created in keyframe-based 2D animation programs. A designer can produce a motion test relatively quickly that feels like an actual shot from a project in compositing programs like After Effects or Nuke. Of course, factors such as stylistic complexity and the designer's experience will affect turnaround time. However, highly refined motion tests are very useful to show single shots from a larger sequence. Successful motion tests can transition to being used as final shots within a project.

Practical Effects

Practical effects are another area of Motion Design that use motion tests with analog techniques. Traditionally, all visual effects were created via practical methods. These processes were very time-consuming and unforgiving when mistakes were made. However, practical effects afford very organic sensibilities that are extremely difficult, if not impossible to replicate in a purely digital workspace. Today, designers can combine practical production practices to capture footage with digital post-production methods to efficiently edit, enhance, and composite effects.

For practical effects, a motion test can serve as a proof of concept to communicate how something that is "hard to describe" might look. This test will assist in gaining client approval and moving a production forward. However, the final look and feel of practical effects can be difficult to predict and control. Therefore, it is important to be clear with a client that a motion test informs the general treatment or direction for the practical effect.

Boardomatics

For projects that require previsualization through hand-drawn storyboards and/or style frames, a boardomatic is an effective tool to begin a conversation with a timeline. A *boardomatic* is a low-fidelity production tool used to visualize storytelling through the key beats or moments in a project. They are often made with music or voiceover to help refine the synchronization of audio and visual cues for a project.

Timing

By exploring the overall timing of a project, a boardomatic rapidly drafts an entire sequence in a rough and loose manner. An editor or animator can quickly create a boardomatic by

10.2

(A) Examples of highly refined motion tests from Traditional Medicinals commercial by Scholar. (B) "Thump" logo animation by GMUNK and Peter Clark. Examples of a motion test for experimental practical effects using cymatics with gallium (top). Stills from the final practical effect (bottom).

dropping frames into a timeline and working out the various in-and-out points for shots. In this way, a boardomatic is like a gesture drawing, constructing a project's narrative in broad strokes. Editing decisions at this stage are not particularly precious or set in stone. Because boardomatics are rough, changes and revisions are easily implemented without wasting time or resources.

Each storyboard frame or style frame represents a single shot or a key moment in a Motion Design project. The boardomatic allows an editor or animator to figure out how much time each shot needs to be on screen in order to communicate pertinent information, to create an emotional impact for the viewer, and to contribute to the overall flow of the story. This approach is very helpful when a creative brief asks for a specific duration, has a script with a defined narrative, includes voiceover, and/or includes on-screen copy. A boardomatic can demonstrate how all the elements fit into a timeline or if adjustments are needed.

Editing

Boardomatics lean heavily into the skill set of editing and thus use many of the same tools and techniques as traditional film editors. A few of the practices employed when making boardomatics include timeline markers, synching cuts to musical cues, and matching voice-over to on-screen content. When constructing a visual narrative, cinematic considerations relating to camera position, distance, and movement are vital. General camera movements such as zooms or dollies can be conveyed with basic scale and position changes.

Usage

Once the pacing of a boardomatic is approved, a production can transition into replacing low-fi hand-drawn frames or static style frames with animated shots. For larger productions with multiple animators, a boardomatic helps determine the division of labor. Boardomatics unify a creative team's efforts as they transition into more refined animation.

Animatics

An *animatic* is a sequence of low-fidelity animations that seeks to lock down the timing of individual shots as well as the overall piece. For productions that require CG, cel anima-tion, or integration of mixed media, an animatic can be very helpful. Animated shots that require heavy investments of time—either in 3D rendering, frame-by-frame animation, or fluid transitions between mediums—can first be developed as low-fi motion tests that are assembled into a larger edit. Each shot in an animatic can be reviewed and refined towards the desired look and timing. Additionally, the entire project can be viewed to ensure each shot feels cohesive.

Editor + Animator

Animatics are like boardomatics because they help to convey the narrative of an entire piece through timing and editing. However, animatics take a step further into the realm of motion, as actual animated shots are included in the timeline. The skill sets of both editor and anima-tor are needed most when constructing an animatic. The animator is focused on making sure each shot is moving as intended, including the animation of individual elements and camera. The editor's job is to make sure all shots in the project flow in a compelling way while com-municating the essential narrative.

 The size of a production team largely depends on the complexity of project scope and budget. It is important to note that the editor and animator of an animatic may be the same person, switching between skill sets while working. Alternatively, there may be a dedicated editor working with an animator or team of animators who are supplying the editor with shots. Regardless, a blending of skills is required for successful implementation of Motion Design production tools.

Digital Animatics for Tabletop Productions

Another type of animatic is the sequencing of low-fi digital shots to block-out timing for tac-tile tabletop productions. Stop-motion and live action that uses graphic sets and props can be extremely tedious to produce. Often, changes in tactile characters and physical camera position are done in small deliberate increments. Revisions for tabletop productions may

need to be recreated, which are very costly. Working out the timing for each shot in relation to the entire piece beforehand, through a CG or After Effects animatic, can help alleviate this laborious process.

Temporary

Although an animatic's purpose is to define the timing of an entire project and specific length and pacing of each shot, the look and feel of an animatic is not meant to be final. The shots included in an animatic are *temporary placeholders* destined to be replaced by more refined animations. Highly polished 3D can take a significant amount of time to render. Similarly, detailed cel animation is very time-consuming to produce. Working with CG playblasts or low-frame-rate cel is an efficient way to perfect the timing of a piece. Once an animatic is approved, the project transitions into the development of rough cuts.

Rough Cuts

A *rough cut* in Motion Design is a first pass of an entire edit of a project. This draft is important because it is a culmination of all the research, planning, pre-visualization, and motion development that has been previously completed. Because Motion Design incorporates a variety of techniques, an edit may include any combination of animated shots, live action, or other forms of mixed media. Therefore, the rough cut represents the overall style, pattern of motion, and narrative of a work. Although a rough cut is not a polished final version of the project, the drafted piece should feel cohesive and consistent in communicating the project's final form.

Rough cuts provide opportunities to present work in progress and receive feedback. Initially, on a larger studio project, rough cuts might only be viewed and assessed by an internal creative team. Creative leads will give feedback and expect revisions from motion designers until they are satisfied that a rough cut is ready for presentation to an external client. In relation to external reviews with clients, rough cuts represent a significant mid-point in a project's development.

A rough cut gives the client an opportunity to view the entire project, evaluate progress, and request changes. There is an implicit understanding between the creative team and the client that a rough cut is not a finished product, but it should be a strong indication of progress. A creative team seeks assurance that their efforts are advancing in the right direction, while the client wants to know that their needs are being met and that they are receiving quality work.

Presenting Rough Cuts

The presentation of rough cuts can range from in-person meetings to sending a client a link to a video posted on the internet. Ideally, presenting a rough cut is a dialogue between the stakeholders to identify what is working and what should be edited or revised. Motion designers must be prepared to articulate how the rough cut effectively addresses a project's needs regarding narrative, design, messaging, and strategy.

Interpersonal communication skills are essential for presentations. The ability to talk through a rough cut and speak to a client's concerns helps solve problems and advance a project towards completion. Confidence, clarity, patience, and diplomacy all go a long way

during creative presentations. For beginners, the urge to apologize or make disclaimers is very common when presenting work in progress. When presenting rough cuts, there is an expectation that the project still has room for improvement.

Receiving Feedback

From the designer's point of view, there is a balance between fighting for a vision and setting aside ego to hear the needs of the client. The ability to listen is essential, particularly when someone else is paying for the work. Hearing and taking note of specific requests from a client provides clarity when making revisions. It is a professional expectation that a motion designer or studio implements a client's requests and specific notes in future rounds of rough cut presentations. Failure to address client revisions demonstrates an inability to listen or an inflexible attitude. Neither scenario promotes return business or lasting client relations.

Remember, the only projects you will have complete creative control over will be the ones you do "for yourself" as a passion project or artist's project.

From the perspective of collaboration, listening closely to client concerns provides clear instructions for changes to a project and helps to build a healthy relationship of trust and respect. In other words, the idea of "I hear you" is another way of saying "I see you." When all parties feel included in the project's development, there is less chance of friction, bruised egos, and power struggles. Rather, the creative problem is being solved together.

What about tough feedback? Inevitably, there will be projects that receive disappointing if not brutal feedback. This circumstance can happen for a variety of reasons, from miscommunication between the client and creative team to strategic changes at the client level. Regardless, it can be a huge hit to morale when a project's creative direction is dramatically altered. How does a designer successfully pivot when a promising idea gets killed and passion instantly drains?

Always be professional by setting aside personal feelings about how a project should proceed. Clients engage a creative firm to help them problem solve. Changes in project style can also impact project budgets. So, if significant and perhaps unforeseen adjustments are affecting the project, it is important to lay out the need for additional work and a new agreement on increased scope.

With projects that change from your original creative vision, there may be an opportunity to showcase or create a director's cut—a version of the project that exists outside the chain of client revisions, which can be used for portfolio purposes.

It is rare for a project to be dramatically redesigned at the stage of a rough cut, but it does happen. Similarly, a project may get approved on the first presentation of a rough cut. But most of the time, there are a series of rough cuts that gradually get refined until a project gets delivered. Most often, commercial Motion Design projects are completed through a process of revision and iteration.

Revision and Iteration

Motion Design is an *iterative* process. There may be many rounds of rough cuts before a project is approved and delivered. Revisions require organization and close attention to detail. To identify and correct problems with timing, storytelling, or design, we need to be able to watch a few frames, a single shot, or an entire edit repeatedly.

When receiving feedback from a client or creative lead, it is vital to accurately take clear and detailed notes. If feedback is unclear, ask questions to clarify exactly what is being requested. The same is true when revisions are sent via email or text, which should always be followed up with a simple confirmation of receipt. Successful productions are dependent upon the efficiency of each contributor. Studios cannot afford motion designers who consistently forget to address client notes or perform revisions in a sloppy manner.

Adjustments to Timing

A crucial skill for motion designers refining rough cuts is the ability to adjust timing. Often, client revisions include adding elements to a piece. These additions can include extra copy, new visuals, or replacements of existing assets. Motion designers spend a lot of time crafting timelines to not only look good but also flow. What happens when revisions alter the balance of timing in specific shots and/or the entire edit?

A Motion Design timeline is like other creative compositions, where a change to any section affects the entire piece. When a revision requires compressing or expanding the amount of time on any given shot, adjustments must be made to the whole timeline. It is important to effectively update animated shots while maintaining the pacing and flow of a project. A clear project structure, logical file naming, and timeline markers all assist with making these adjustments effectively. Staying nimble while implementing client changes and keeping a positive attitude throughout are professional qualities to cultivate.

FINISHING

The deliverable is the result of all the various production tools and revisions in a Motion Design production. Depending on project scope, deliverables can range from a single animated spot to a host of versions, animated toolkits, or multi-platform placements. Regardless of the deliverables list, the final pass of refinement requires focus, precision, and accuracy.

Specifications

Before shipping or uploading a finished piece to a client, always do a final check that the work you are sending meets the required specifications. Was it rendered at the correct frame rate? Is the duration correct? Is the deliverable required in a particular codec? These specs are just a few of the nuts and bolts to verify before delivering. This checklist becomes more important when there are multiple deliverables in different formats for various platforms. Although double-checking seems self-evident, the reality of deadlines, stress, and fatigue increases the chances of human error. A standard checklist can help prevent embarrassing mistakes.

Copy

When working with projects with a substantial amount of copy, a proofread is invaluable. Copying and pasting text supplied by a client can reduce typographical errors, unless there are errors in the source document. Sometimes a motion designer who has spent countless hours working in a composition will gloss over the granular details and overlook spelling errors. A fresh set of eyes is helpful to review spelling, punctuation, and grammar before shipping final deliverables.

10.3
Example of a color correction and finishing effects used to create a cohesive look and feel for the collage style used in the title sequence "Godfather of Harlem." Created by Digital Kitchen for EPIX and ABC Signature. Creative director: Mason Nicoll. Art director/designer: Peter Pak.

Color Grading and Finishing Effects

Prior to delivery, Motion Design projects often have a final pass of color grading and/or effects to help unify shots. Additionally, color and effects afford opportunities to address any final concerns for aesthetic enhancements. Although this stage of a production is both technical and detail oriented, artists who work with color and finishing also need a good eye and understanding of color space.

Colorists are specialized artists who work in film and video projects during post-production. Color grading defines the mood and tone for a piece and must be handled with craft and care. Although motion designers may not be specialists with color, they should be competent with the basic principles and tools of color grading and finishing. A motion designer responsible for finishing and delivery needs proficiency with adjustments to hue, saturation, and value, as well as how to control the application of color throughout a project's timeline.

Versioning

Versioning is a vital aspect of finishing as many projects need to be delivered in several iterations or versions. Versions can include an assortment of sizes for social channels, OOH (out-of-home) digital billboards and signage, video platform pre-rolls, different durations, or various languages. In each of these circumstances, the ability to quickly and precisely produce versions specified in a deliverables list is an area where pre-planning and effective workflow can produce real efficiencies in the production process. Does the design allow for the possible range of screen formats? Is the story or narrative of the piece able to be simplified into an abbreviated form for an online pre-roll? From a business perspective, versioning can be quite lucrative for a studio or motion designer that can handle this iterative process.

Social Channels

With the rise of social and digital platforms, the need for versions to work across multiple platforms has become an industry standard. In addition to the traditional horizontal 16 × 9 aspect ratio, motion designers need to be fluent working with square, vertical, and portrait sizes. Adjustments to scale, positive and negative space, and typography all need to be considered when adapting a project to different aspect ratios. Motion designers must train their eye to quickly assess how to implement necessary changes to a composition.

OOH—Out of Home

Creative briefs often contain deliverable lists with versions for both social media platforms and OOH. Out-of-home placements for Motion Design projects include digital billboards seen on locations such as buildings, stadiums, buses, subways, and store interiors. Some digital billboards adhere to standard aspect ratios such as vertical 1080 × 1920. However, all kinds of sizes can be created through combining 9 × 16 screens into ultra-wide arrays or through the construction of custom screens at extraordinary sizes. Radically different aspect ratios require dramatic redesigns to composition.

Cut-Downs and Remixes

In addition to different sizes and aspect ratios, deliverables may need to be versioned at various durations. Traditionally, versions for 60-second and 30-second TV commercials were

delivered as 15-second, 10-second, and 5-second cut-downs. Social channels and OOH placements usually have specific requirements regarding duration. Larger billboards may only run for a few seconds and the audience may only see it briefly in passing. When creating a version that is a cut-down in time, a motion designer must tap into their editor skill set to communicate relevant information while maintaining a project's narrative and graphic sensibility.

Clients often repurpose or remix Motion Design projects to maximize their messaging across platforms. A series of seconds-long GIFs may be created from a longer Motion Design project, with similar considerations to a larger billboard execution. A 30-second spot may be used for traditional TV, web, OOH, and across all social channels, adapting to the time constraints of each media platform.

Translations

For projects with international distribution, creating versions for multiple languages is sometimes necessary. A motion designer does not have to be fluent in a variety of languages. But, if they are responsible for creating versions with foreign languages, they need to accurately update compositions with translations of copy. In the best case, text documents with correct translations supplied by clients can be copied and pasted directly into compositions. Even so, each version should be double- and triple-checked prior to final delivery.

Professional Perspectives

Boo Wong

I feel that the best producers have a deep respect for the people on the team and the art. Otherwise, go work in a different industry.

Boo Wong, Executive Producer

A strategic futurist thinker with exceptional tactical execution, Boo has a track record of leading global multifunctional and motivated teams forging industry-bending emergent technologies and experience design into new business lines and products for the most prominent brands and companies in the world. With a 20-year history in the worlds of media and entertainment, interactive and experience design, film and animation, she excels in building organizations fueled by innovation, speed, and creativity.

Boo is the co-inventor of real-time AR reflection/lighting production tool Mill Cyclops, co-founder of Mill Experience and a member of the Forbes Technology Council. She is a frequent speaker and contributor to industry publications on the topics of innovation, creativity, technology, VR/AR/MR/XR, virtual production, and the future of human interactions and marketing. Boo has judged leading industry festivals, and her work has earned numerous awards including a personal distinction through the Advanced Imaging Society's Distinguished Leadership Award in 2019.

Boo joined Unity Technologies as the director of live entertainment in 2021, and is working to forge the game-changing future of live experiences in the convergence of physical and contextually aware virtual worlds.

What is your background?

I grew up on the island of Singapore, spending my days out in the sand and sea, waterskiing, studying ballet, and enjoying math and art as my fave subjects in school. I left for university in the US and studied electrical engineering. Before returning to Asia, I decided to indulge in a brief NYC "hiatus" to pick up on the thread of my past interest in dance before settling into working life. What I thought was a temporary distraction in modern ballet turned into bookings as both a performer and a choreographer, and the weeks turned into months and, before I knew it, nine years had passed.

I decided that it was time to switch on the left side of my brain again, and considered going back to school for computer graphics and animation, a relatively nascent field at that time. A good friend of mine made the astute recommendation to do an internship first this time around, to see if this was actually a field I'd end up wanting to work in. The internship

really caught. This was at production company Curious Pictures, and after several 100+ hour weeks of assisting and self-training. . . . I was offered a job and never ended up going back to school. I became a compositor, ran the department as head of CG, directed and executive produced animation, VFX, filmmaking and then moved into experience design, AR, VR, virtual events, virtual production and characters, and game development.

Throughout my career I've worn creative, technical, and production hats. It's from that baseline place of understanding that I've always aimed to lead successful multidisciplinary teams. It's important to look at a project from as comprehensive a point of view as possible, in order to understand its purpose and how it can best come together in production. The design of a thing, when you talk about it broadly, is not just about how it looks, but it's about how it feels, and how it fits into the end user's personal experience.

How did your start in the performing arts affect working in creative production?

I think perhaps by instilling a sense of discipline and getting a really good eye for things. And, of course, an innate sense of timing and animation. I *feel* it if something isn't animated right, if your keyframe hasn't been eased, or the angles are wrong. I might also have an inordinate tolerance for pain.

What is a producer?

The producer's job is to understand the project, to have its scope and goals in mind. You put together the best team possible to sit down and figure out "what is the problem" and then answer that ask. As your team works through a project, along the different stages that will vary depending on what it is—a film, print campaign, wayfinding system, mobile game—it's the producer's job is to keep progressing towards the project's goals, while the rest of the team lean as hard as they can in the areas that they are expert in. It's the push and pull of best ideas that a producer needs to manage, while guiding the way to the finish line.

What are some of the attributes of your favorite producers?

They can see the future! They're good crystal ball readers. They anticipate. They are not just sitting around making sure everyone is in the room. They're not just time and money people. They are part of the team, part of the problem-solving. And they anticipate the future, so as your designers are working, and your coders are coding, good producers are already thinking about how it all fits into the main goal. They're thinking about achieving alignment with internal stakeholders and external clients and about how they can best nudge, influence, guide everyone to arrive at the same finish line, on time and in budget.

Producers need to be completely aware of all their team members, where their challenges lie, and how to draw the best out of them. They are cheerleaders and organizers. They are constantly thinking about what their crew needs next—can I find them more reference, line up more resources, what can I do to help unlock them? You understand enough about each aspect of the job and team expertise—design, animation, cinematography, software development, etc. . . . to speak in the various languages of your subject matter experts and align their priorities.

Managing scope, time, and money is also solely the producer's job. That aspect of any project can be "invisible" to the majority of your team, but a good producer will know how to convey it in different yet impactful ways. You define milestones, and you don't let your team or the project fall down because you're the one who's watching the timeline.

At the end of the day a good producer is like that swan that's paddling really hard, but you'd never know it from how gracefully it glides above water. You're working really hard for the team because you're looking out for them. And you're looking out for the client because you have their goals in mind as well. But nobody needs to know how challenging it is.

What are the attributes of your least favorite producers?

There's no single answer for this since production requirements vary depending on what is being produced, and at what types of companies. But there are some core requirements that can get missed, like producers who don't realize they are there to *actively* manage a project and team. They are not just there to call a meeting and sit in a room and track no outcomes. Producers should be there to listen and guide, and be unafraid to ask questions in order to then figure out the next steps with their team to achieve the best outcome.

Does it help when a producer also has creative skills?

I've often thought that the best producers are the ones that are failed artists or coders because, in a way, you're coming from a place of common understanding. I like to think that I wasn't a failed artist and that I intentionally chose to become a manager! But the fact is, I've often connected best with my teams because I have some real sense of what it takes to do what they do.

So yes, I think that it does help to have some background in what you're producing. And if you don't have direct experience, then it's good to have that enormous amount of respect for the work, and the willingness to learn.

What suggestions do you have for people interested in becoming a producer?

Should you still be safely nestled within school, take classes outside of your major. Always keep learning, and keep experiencing things that you're interested in and, once in a while, stretch outside of your assumed areas of interest. Get out there and go to museums, read books, travel, and try new things. You may be inspired to work in a way that you've never done before. Because it's how you connect the dots that makes you unique, and that is something that I would recommend to both producers and to artists.

Do you have any favorite projects?

My favorite projects are the ones that find novel ways to use emergent technologies in ways that are highly designed and considerate of users' experience. I love pushing the envelope of what's possible.[1]

NOTE

1 Wong, Boo, Zoom interview with author, March 24, 2021.

Chapter 11
Audio and Motion

We hear as much as we see.

CREATIVE WORK WITH SOUND

Since the late 1800s, when the earliest work in *color organs* linked the idea of sound and color together, we have creatively explored sounds and images in tandem. This exploration expanded throughout the 20th century with the work of Oskar Fischinger, Len Lye, Mary Ellen Bute, and Norman McClaren. These artists made visual instruments and integrated abstract animation and electronic signals into the process of making images linked to sound.

The creative synchronization of images matching sounds in *music videos* further pushed the techniques and experimentation associated with audiovisual production. Music videos fluidly adapted techniques from artistic avant-gardes and introduced these to mainstream audiences. More recently, this relationship between music and visuals has blended with sophisticated software and production tools. The modern VJ, who often spontaneously creates visuals to accompany musical performances, arose out of this advancement. In most of these areas, sound, usually music, is the original element driving a production. Moving images are produced to accompany the sound. This dynamic suggests a more sound-driven style of work, or even the use of sound as a metaphor for thinking about images.

The way Motion Design is taught, practiced, and consumed is largely focused on images. Yet sound, specifically sound design, is an integral part of any motion work. Although it is not essential to be an expert in audio production, audio is just as important as visual in the Motion Design toolkit. Having a thoughtful and informed approach to sound is essential to maximize the creative and commercial potentials of Motion Design work, and understanding the possibilities of audio will inform a good designer's practical approach to project development, production, and collaboration.

The flow and feel of a work can take its inspiration from music. This synchronization extends the relationship between what we hear and what we see in the same way that dance extends and interprets music through choreography. Although working with audio is clearly a career in its own right, the flexible qualities of Motion Design, with its capacity to combine different types of media, allows audio to become an integral part of this production landscape. A motion designer will need to work with audio at some level in their process. Although there are no fixed boundaries, this table offers a guide that can help you decide where audio fits into your practice.

DOI: 10.4324/9781003200529-12

Level 1: Audio Essentials	• Importing and managing audio within motion productions. • Setting levels and making sure that sound is not distorted or too soft. • Basic file formatting and the capacity to collaborate with a sound designer.
Level 2: Audio Exploration	• Basic editing and mixing in Audition, Audacity, or a similar audio software. • Matching audio effects and cues to moving images. • Producing simple sound beds and music stems using iPad or desktop software. • Recording sound on set or elsewhere and integrating it into production. • Making useful voiceover recordings. • Using simple plugins to adjust tone, depth, or compression of audio elements.
Level 3: Audio Extension	• Using a dedicated digital audio workstation (DAW) software to arrange and integrate complex multitrack projects. (Logic Pro, ProTools, Ableton Live, Reaper, or similar software). • Using MIDI systems and virtual instruments to creatively produce music or sound effects. • Integrating sequencers, external audio hardware, or control surfaces to extend the capacity of audio software. • Stereo recording and mixing.
Level 4: Audio Specialization	• Having expert familiarity with DAW software and processes. • Composing original musical scores. • Multitrack recording and tracking. • Extensive familiarity with software and hardware instruments. • Studio recording, microphone setup, and placement. • Mixing and mastering complex soundtracks and multitrack recordings with dedicated equalization, loudness setting, and compression. • Multichannel, production surround (Dolby) or Ambisonic (multi-microphone immersive) sound recording and production

Most motion designers should aim to work in the first two levels with some degree of comfort. However, one should be aware of when the work is best handed over to an expert.

ENTRY POINTS

We could define motion as "change in an object or image through space, over time." Although this definition easily applies to images, "change over time" and "space" also applies to sounds. Audio can have depth, space, texture, tone, timing, and rhythm. Once we start to classify its qualities, the parallels between images and sounds become more obvious.

Motion Design requires observation of form, composition, and change. These principles also apply to audio. A designer's approach to audio should be grounded in listening—using this sense to consider the way audio expresses and communicates within time.

TIME IS THE LINK BETWEEN MOTION AND AUDIO

Motion is *not a still* because the image moves; it changes in time. Likewise, sound is *only* experienced in time. The interplay between the moving image and audio is integral to realizing the full expressive potential of Motion Design.

Not all work requires a sonic masterpiece to accompany it. Small social media projects, many explainer videos, and other short-form pieces may only require a clear understanding of how to add music or a recorded voiceover at the correct level, with basic mixing.

Many projects have audio supplied to the motion designer, so it is simply a process of working to the supplied soundtrack. Other projects may extend the use of audio as a key creative element within a production, requiring an audio technician, sound recordist, a musician, sound designer, or specialist studio to work on the audio aspect of the project. In between these areas, there is a range of practice the designer can consider and potentially adapt into their production toolkit. Think of this chapter as an introduction to working with sound.

SOUND AND IMAGE HIERARCHIES

Although we think of the quality of motion in terms of an image, audio may sometimes be the dominant aspect of an audiovisual work. This tendency becomes clear in pieces driven by voiceover, such as explainer videos, some types of infographic work, and persuasive television campaigns. If you close your eyes and all the key information in the work still makes sense, it's probably *audio dominant*, and the images are there to "illustrate" the soundtrack.

Image dominant pieces are more likely to use audio to enhance or amplify what is seen on screen through music, sound effects, or atmospheric audio. It is important to understand that there is no value attached to these hierarchies. One is not better than the other; they are simply different approaches and will often be included together in varying degrees to produce the overall effect of a finished piece.

Sound in this sense can be broken into *diegetic* and *non-diegetic*. *Diegetic* sound originates in the world of the piece itself. So, we can consider elements like whooshes, or impacts that are "produced" by the images, as diegetic sounds. Music that is *added* to the work is a non-diegetic sound.

By using images to amplify and illustrate a soundtrack or voiceover, audio dominant work makes something purely factual into a visually evocative and compelling experience. Persuasive voiceovers use imagery, which can even be somewhat abstract to visually amplify ideas to bring the soundtrack to life. In these instances, the *image illustrates the sound*.

By comparison, work that uses images as its primary means of presenting its meaning will use sound to heighten and enhance movement. A subtle swishing sound as an element moves through space, the sound of friction as elements come into contact, or the ambience

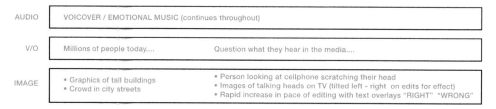

11.1
Audio dominant. This layout of elements is typical of voiceover-driven work, where the *audio* is the dominant aspect of a piece.

AUDIO	Sweeping musical chords		Music fades on swoosh to deep pulsing ambience
F/X	Airy ambiance fading up city noises		"Swoosh" as cars pass - rising sound of heartbeat..
IMAGE	• 2-shots sweeping across apartment buildings • Long shot of city with crowd in streets		• Pan down to shot of traffic POV across city street • Cut to tighter shot - several car's movement across screen • Cut to closer shot - car passes to reveal standing figure

11.2

Image dominant: In this layout, the *image* is the main element developing the meaning of the work, and audio is added to accentuate the image or to provide a sonic backdrop.

of the screen space itself are all ways to elevate the effect of movement or to enhance the sense of the viewer's presence within the world created visually by an artist or designer. In these cases, we *enhance and extend the world of the image with audio.*

It is worth noting that many projects may sit in a fine balance between the sound and the image. When a song becomes a music video, there is often an equal sense of the music and the image in the final work. The two go together. Artistic and creative pieces may also strike a balance between sound and image. One may be used to generate or even modify the other. For example, sound can provide cues for keyframes, or an image may respond to sound by being made audio reactive. In other cases, both sound and image can relate to or modify another external source, either through data visualization or interactive participation by the audience. The creative possibilities of audio extend those of motion alone.

SOUND-OFF ENVIRONMENTS

Many social media platforms and out-of-home (OOH) placements are considered *sound-off.* This term describes environments where audio is not enabled. Most audiences on social media watch video content without sound, and digital billboards or in-store screens are typically sound-off as well. Just because we may need to deliver with sound-off in these circumstances does not mean we should create our projects without sound. Using a music track to synchronize visuals with the audio cues helps a Motion Design project with timing. Even when experienced without sound, the project will still feel like it moves to a rhythm.

THE AURA OF SOUND

Sound is expressive and persuasive because it is *natural.* It occurs in every aspect of life, and every moment is linked to its sound. Sitting on a beach, walking through a forest, a city, a subway, an empty corridor—every space will have some associated sound, a kind of sonic imprint and mood.

Structuring sound as music brings in completely new dimensions, partly because the very structure of music will introduce a trace of authorship into sound. Music is consciously structured, or at least consciously understood, because it divides sound into different tones and durations on purpose. So, mixing natural or ambient sound with music is a conscious decision by a designer to create a specific mood or atmosphere within a project.

The use of sound within media brings up the term *sound design*. Sound as a designed medium is consciously recorded, played back and layered, with all the intention of a musical performance or recording. However, the result may not be as musical as it is evocative, like an abstract painting rendered as sound.

Sound design has no formal requirements. It mixes sounds that occur naturally, processed recordings, or digitally generated elements, often with more formally produced musical components, to create a sonic experience for the audience. Adding sound design to a well-crafted visual experience can make both more memorable. Sound becomes a vital consideration when designing motion works for installations, museums, or experiential spaces.

> **For visitor installations, audio, of course, is great to create atmospheres and to extend the boundaries of a small screen or a smallish screen. Some museum spaces are huge, we did four, 4-meter-wide screens for the *Royal Flying Doctor Service*, but in an aircraft hangar. It looks tiny when you walk in, but when you walk up to it and sit down . . . its massive again. So, to extend the size of it, we used a multi speaker array and it filled the whole space. To get that sense of "wow"; to get that sense of inclusion from a long, long distance, audio can do that. To change atmosphere, and especially to change the character of a space, to create some dynamism—audio is terrific!**
>
> **_Michael Thomas Hill, Creative Director and Studio Principal, Lightwell_**

THE MATERIAL OF SOUND

The raw material of sound is *vibration*. Sound is the perception of different intensities and frequencies of *sound waves*, which are simply waves of pressure in the air, caused by the vibration of objects. Music is created by the vibration of strings, skins, reeds, metal, and air within instruments. Voice is the vibration of vocal cords in the throat and the passage and shaping of this vibration from the mouth. Ambient sounds, splashes, scrapes, hits, rustles, and whooshes are all created by friction between objects that encounter each other.

So, vibration is important for designers, as it forms the basis of all natural sounds, and the way that we hear sounds after we have recorded and manipulated them. Speakers and headphones are a means of reproducing a recorded sound wave, stored as information, into new sound waves as needed. Microphones in the same way convert sound waves and variations in air pressure into an electronic signal that can be recorded and encoded.

Speakers, or headphones, produce sound by converting an electrical signal to a magnetic pulse, which is used to produce vibrations in the air. The cone of a speaker is connected to a magnet, which translates the recorded waveform to physical movement in the air.

Sound can be recorded in many different mediums and formats. Grooves in a record, early engravings in a wax cylinder, or magnetic particles on a strip of audio tape were all traditional *analog* means of recording the variations in sound waves so they could be replayed later. For our purposes, digital technology has simplified the capture, creation, and manipulation of sound as much as it has done for images. Today, our raw material for audio in Motion Design will be a digital waveform where sound waves have been converted into a digital file.

Digital audio has two key components: a sample rate and a bit depth. The *sample rate* describes how frequently the sound wave is sampled in time and recorded as values. The *bit depth* is a measure of how much information is in each of these samples.

In the same way as it applies to images, having more information in the source audio allows the original to be adjusted and manipulated without *artifacts* in post-production. Sound with higher sample rates can be slowed and adjusted without the introduction of noticeable issues. Again, as with images, a final sound can be compressed to reduce file size for distribution.

For most post-production, the standard format is 48 kHz (sample rate)/16 bits (sample depth). Although compact discs use a 44.1 kHz sample rate, some audio workstations are often capable of using 192 kHz/32 bits. These are usually appropriate for highly specialized recordings and sounds at (or beyond) the limits of human hearing; so, they do not cross over to post-production very often.

As a rule of thumb, master projects at 48/16 and compress your distribution media from there. Social media deliverables will usually have compressed audio to allow for speed of access on phones and network devices.

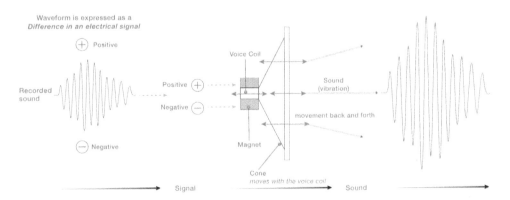

11.3
The process of soundwaves being converted into a voltage and reproduced as soundwaves by a speaker.

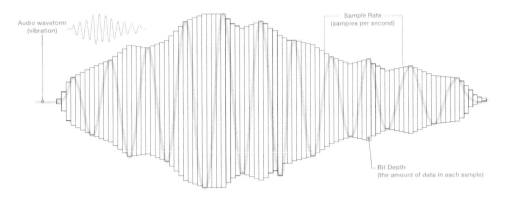

11.4
The vibrations of an audio waveform being converted into digital samples, a process known as *quantization*—literally, to "make into a number."

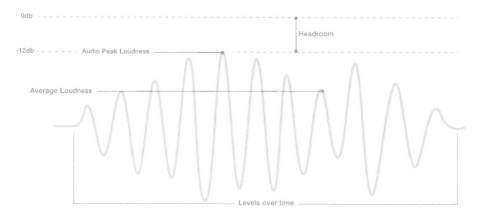

11.5
Loudness is not simply the "peaks" in audio but the *perceived* average loudness over a period of time.

You will also want to watch the *loudness* of your production. Every recording has a "level" where the peak loudness is reached at a value of 0. This level is usually indicated by meters in editing, motion graphics, and audio software. If the level is lower than this point, there is a little bit of headroom in the audio. If this value is exceeded, the audio will distort and sound like it has been compressed and mixed with static. If the level is too low, the sound will not have enough dynamics (the range between loud and soft sounds). Low levels can also make any noise in a recording or replay system more apparent; so, it is good to work in a set range.

Most broadcasters have a set of requirements ("spec sheets") that they publish to provide details on all aspects of how media should be delivered to the station. They have requirements regarding audio, the peak loudness, and average loudness. Good sound studios are aware of these requirements. However, if audio is not your specialty, specifications can be a surprise.

For best practices, work with slightly lower peaks in your audio, with the higher peaks in sound happening at −12 dB on the meters. This range will allow for adjustments if there is mixing to be done, once the master is being finalized. This allowance is referred to as *headroom*, meaning some room to raise the top level, rather than to have a track's levels saturated and potentially distorted during peaks.

RECORDING SOUND

Audio can be sourced from almost anywhere, yet many projects benefit from some audio that you have recorded specifically for the work. Music, sound design, and other specialized production will usually require the expertise of someone who works in these areas most of the time. Smaller or simpler recordings, such as voiceovers or interviews, can often be done in-house, or in a rented voice booth as part of a production, depending on the complexity and the designer's level of comfort in working with sound.

The good news is that today, portable audio recorders are cheaper and more powerful than they have ever been. So, it is quite easy to record sound in different situations. Some

recorders have built-in microphones for recording field audio and atmospheres, but in most cases a specialist microphone is advisable, as it will enhance the quality of recordings. Many portable recorders can both record from a microphone to a removable card and work as an interface while connected to a computer.

Any serious production work with sound should be done through an *audio interface*, which connects to a computer and provides both microphone and instrument inputs and proper balanced outputs for speakers. These interfaces range from simple single input/stereo speaker and headphones output units, with a simple volume knob, to studio-level devices that can input dozens of sources at a time. Quality powered speakers (usually referred to, a little confusingly, as "monitors") are also important to get an accurate sense of the range of audio with which you are working. The best choice for most production work is *nearfield* monitors, which provide optimal reproduction when the user is in close proximity. So, they are designed to sit on either side of your monitor.

For some work, a desktop USB microphone that interfaces directly with a computer may be a suitable choice. Small, portable sound absorbers that sit behind the microphone are easily purchased to create a simple "voice booth" effect in any quiet room, which can make simple voiceover work quite cost-effective.

More precise recording will benefit from a specialist microphone running into an audio interface. It is important to know that most professional microphones require what is known as *phantom power*. Because professional microphones use a three-pin plug called an XLR connector, they send audio to the recording source and take power from that source instead of being powered by batteries. The cable sends power to the microphone and takes the recorded information at the same time; however, the recording device needs to have phantom power available to power the microphone. This feature is a fairly standard of three-pin XLR devices, including basic audio recorders and interfaces.

It is also possible to use a smartphone as a recording device, either by using a dedicated microphone attachment or using an audio interface that allows a quality microphone to be connected to the device. There is a vast range of different voice recording and audio recording software available today, so designers have a range of options to choose from.

RECORDING VOICE

Two important techniques are central to getting good sound from a portable recorder. The first allows for noise reduction, and the second is providing for location ambience. Every location has some ambient noise, which we might refer to as the *noise floor* of the space. This noise might be a low hum from an air conditioner, a light wind in the trees, filtered sound from an adjacent room, or noises from the world outside. The point is that no place is silent. So, when recording anywhere, a recordist needs to get at least 30 seconds of *room tone*. This recording captures the sound of the location with no talking or other outside sounds. Room tone is recorded in silence, simply to get a base recording of the location's noise floor.

In the first case, this room tone can be added to any audio produced later, to smooth over cuts or silences by using the audio "feel" of the location as a base. This technique maintains a sense of presence and consistency in a production. It is surprising how useful this recorded background ambience can be in later audio production and editing.

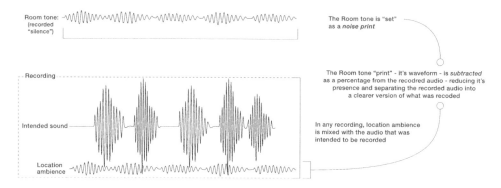

11.6
Noise reduction "subtracts" the unwanted vibrations from the overall waveform. However, it does produce some audible artifacts when used excessively. It is a useful tool for balancing the clarity of a recording, not a magic "fix it in post" technique!

In the second situation, where the noise floor is a little loud, possibly intruding on the recording, a room tone can also be used to assist with noise reduction in post-production. In this case, a section of the room tone is set as a "noise print" and can be used to filter out the same sound frequencies from the full recording. This process of *subtracting* literally removes the ambience. Software will take an average of the ambience and reduce that average within the recording. Only a user-specified percentage is removed to allow for the fact that it is not exactly the sound of the location, but a digital average of what the location's ambience is adding to the full recording. Even a small amount of noise reduction can have a noticeable effect on the clarity and presence of recorded sound.

These techniques are essential in post-production. Even if you work with a professional sound recordist, the recordings they supply will often need to be processed in this manner. A professional location recordist will always record and supply room tone and recorded ambience for each location.

EDITING AND USING SOUND

Individual sounds, or *tracks*, are edited together for length, tone, and texture. Sounds are combined, or mixed, into projects. In this sense, sound editing and mixing extends the familiar processes of editing and combining images in motion work into a similar software metaphor. Thinking about how to edit, arrange, and mix sounds is really a process of adaptation for a motion designer.

Working with basic audio software is a surprisingly quick learning curve. Every audio software will have a media bin, a series of tracks, a range of effects, which are specific to audio, and usually a mixer panel for adjusting the levels of the different sounds in a production.

Multiple tracks are arranged and layered in a timeline, and sounds can be cut, mixed, and faded to align accurately with an image. There is always a video preview window available, where a reference clip can be imported to allow for the audio production to be matched accurately to events in the associated video. This reference copy plays back

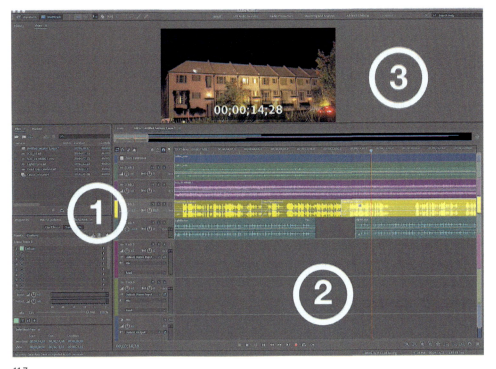

11.7

The Adobe Audition Interface showing common elements from time-based software. (1) A *Media Bin* with Audio, Movie, and Project files. (2) A *Timeline* with a number of active sounds, edited and faded where appropriate, in a multitrack arrangement. (3) An open *Video window* displaying timecode allowing for sound to be matched to the moving image.

smoothly because it is a compressed edit of a finished production. A motion project can be completed with an audio guide track in place, which can be replaced or added to in dedicated audio software.

CREATIVE CONSIDERATIONS

How much should a designer incorporate audio into their practice? How much should it influence their thinking, their studio design, and their workflow?

Sound is part of Motion Design practically and conceptually. From a practical perspective, deeper exploration of audio requires time and dedication. For some designers, sound and music are part of their background; so, audio might be more attractive to them than to a designer who has a background in commercial illustration. It is a good idea to think about where your work sits, and how important audio might be for your development.

There is a range of course, which is what makes Motion Design so flexible and diverse. The designer is free to choose exactly how to pursue solutions across many possibilities. Audio work ranges from simple skills that are inescapable to an immersion that becomes a completely specialist practice.

SIMPLE AUDIO PROCESSING

Even "entry level" software will offer a range of quite sophisticated filters and effects that can be applied to audio, usually as a suite of plugins. These plugins account for the variations in audio sources by managing tone, volume, audio dynamics, timing, and the audio's presence.

It is a good idea to familiarize yourself with the various functions of these effects, as they can help with noise reduction and removing clicks and pops in a recording. Effects can also remove unwanted frequencies through *equalization*, create a more evenly balanced sound using *compression*, make a sound feel deeper or more spacious through *reverb*, or even stretch a sound a little without changing its pitch.

To understand how various effects work, try to record some basic audio, perhaps using a smartphone or other available device. Then test all the key effects available, to get a sense of what they add or subtract to the audio.

In the same way that you can add more effects to most visual software, additional audio processing effects are available as plugins for your audio toolkit. These are usually system-wide plugins, so they can be accessed by almost any audio software.

SIMPLE INSTRUMENTS

Although the leap to using complex electronic instruments may seem intimidating, there are many small steps that can help you become acquainted with the process of doing your own audio production for simple motion projects.

There are dozens of professional level audio tools developed for tablets today, so an iPad is often a great starting point to explore different audio production and instrument possibilities.

Full soundtrack and scoring tools are available that can modulate an original musical piece based on touch and gesture. There are also software-based drum machines, synthesizers, and soundscape creation programs that can record individual tracks, and these can later be mixed on the desktop. Software can also provide dozens of options for sequencers to program notes and how they are played.

PROFESSIONAL AUDIO PRODUCTION

> **Every designer should affiliate with a really talented sound person—a composer or sound engineer—because audio is so important.**
> *Erin Sarofsky, Executive Creative Director*

A professional audio collaborator who is deeply knowledgeable about audio production and has the tools to manage audio professionally is an essential resource for a motion designer or larger design studio. Using a true professional for accurate mixing, mastering, and preparation of files will always yield a superior result. Try to develop a relationship with an audio specialist you trust and can work with as the need arises. Solid, long-term relationships of this type are often developed early in a designer's career. However, if an audio collaborator is not in your professional network, start looking for the right relationship to cultivate in this area of production.

Having a highly professional approach to audio avoids costly mistakes, particularly where mixing for a master and setting levels and loudness for broadcast is concerned. Finishing the sound for a social media campaign is probably an acceptable in-house task, until the budget and expectations drift higher. Look to your budget for guidance.

Just as a relationship with an excellent professional cinematographer is important for certain areas of production, having the right collaborators for audio allows a higher-value production to be executed properly, which always saves money in the end. It is important to develop a level of comfort working with audio, which will vary for each designer and is different for every production.

Creative Brief: "Everyday" Sounds and Images

Singing Bowl

Typing on Keyboard

Spray Bottle

Snapping a Book Shut

11.8
Examples of everyday objects to make and capture sounds. Photography by John Colette.

"Everyday" Sounds and Images

This is an exercise in edited abstraction to get you thinking about sound and image as rhythmic elements and to start experimenting with the use of time, editing, and audio as layered arrangements.

Method

Collect a number of clips of things making sound, as videos. The quality does not have to be pristine. Recording these on a cell phone should work perfectly.

Think in terms of actions and events that mimic the various parts of a musical piece. Some elements should be short and rhythmically oriented—perhaps an impact. Other elements can have a textural quality, whereas others may produce a long-sustained note—a hum or other consistent tone.

11.9
Laying out the edited clips to create visual space and audible rhythm.

An example might start with:

Singing bowl: A longer tone produced by the singing bowl, by having a mallet roll around it.
Typing: A consistent sound of fingers typing on a keyboard.
Spray: A spray bottle making a gentle "hiss" as it is squeezed.
Book: A book being "snapped" shut.

Import the raw footage into software and edit the clips so that the sound produced is the focus of a single sub-clip. For example, if the time base of your composition is 24 frames per second (fps), make your edits into divisions of this frame rate: several seconds, 24 frames, 12 frames, even 6 or less.

A good frame rate to work with is 24 fps because the single second is equally divisible into 12, 6, 4, or even 2 frames.

For each element, make a set of copies where the edited element repeats to create a rhythm.

Lay the various elements out at different places on screen to separate them visually. You can pre-compose the edits if needed.

Play the sequence back with audio previews enabled and adjust audio levels to get the balance feeling right. Pre-composing helps with this process as you can adjust all the clips in the sequence.

Let the sequence play, and perhaps make a copy of it to paste later into the timeline and slip the layers a little. For example, each element in a sequence has the same duration, but of a slightly *different* section of the raw footage.

You can vary the effect by using different sounds, mixing the range of sources, making some sounds into a series of even shorter edits in the timeline. Try making fade ups or downs for clips using keyframes or replacing existing clips in place with totally new ones. Select a group of clips in the timeline and drag a new clip onto them while they are selected holding the Option key (Mac) or Alt key (Windows) to change their content, without changing their edited length or position in the timeline. *Time-Reverse* clips to "flip" the sound. These options are all about adjusting the feel of the piece and trying different sounds in the edit.

If you are happy, save your project and render an edit!

Professional Perspectives
Mitch Paone

WHAT IS YOUR BACKGROUND?

Before even getting into school, I was trying to find a place where I could study graphic design and study music at the same place. Loyola University was the only place that let me do it. Having come from a music background, that is very central to all the work that I do. Especially with animation, editing, and film, having a music background really lines up with that.

I studied graphic design and jazz performance in New Orleans. I trained as a traditional graphic designer and graduated in 2005. I immediately went to work in motion graphics and film. I started freelancing in Los Angeles, at Logan, and then moved to New York. I was particularly interested in film titles because there is a typographic position in that kind of work. Over the last ten years I have done more traditional branding and visual identities. Branding work tends to command more of the work we do, but motion is very central to that, but in a different context than it was when I was working at places like Brand New School and Shilo.

How did DIA get started?

Typography has always been a strong interest for us. Around 2012, motion graphics kind of lost its graphic design touch. Everybody wanted to be a live-action director or a VFX guy. I was like, I don't like either of those things. I don't like being on sets and I don't like CG pipelines. So, let's go mess with fonts. We were doing a lot of experimentation and a lot of traditional print-based branding. We were like, "What's up with this? There is something here. Can we find a way for them to come together?" Around 2012–2013, things started to shift. The current team of four has been together since 2016.

When *A-Trak* happened, it was like, boom. They came to us because they saw our weird typographic experiments. They were the first to dig into this area of this generative typographic stuff we were doing. That project blew up a little bit, then Nike got on and it started to trickle out. Since 2015 we have been fusing motion and typography, and now we have really ingrained and perfected a clear process.

Can you talk about how audio fits into your Motion Design process?

I think it is pretty clear once you start to break it down. When we are in a feedback session with an animator or an editor, we talk about everything in a sense of rhythm or sound. This motion needs to make a "whoosh" or a "tack" or a "bop." That is how we describe to move

11.10
Squarespace, brand film for Squarespace by DIA. Creative director: Mitch Paone.

something. We intrinsically use sound effects and audio in a way to describe the visual form that we are dealing with. I see these things as really connected, almost impossible to break apart.

With motion graphics and editing, we think about rhythm and time in the same way we think about music composition, once you start to understand how our body reacts to rhythm, that we feel different rhythms in different ways. With a good edit, I am feeling the edit because the placement of the cuts or the placement of the transitions are landing at really good moments—that I am still reacting to in my body. There is this sense of rhythmic

understanding and choreography that as an animator comes together in the same way as music.

I have spent a lot of time thinking about this from a theoretical point of view. How we make decisions as animators, editors, or when we are dealing with time—we are responding to a feeling of "this is a little too fast" or "this is a little too slow" or "this is just right." These aren't really concrete things; it just feels good. That is exactly how we describe the musical experience. We are activating an emotional or visceral response out of the work that feels really good. When I see an animation by Buck and I am like "Oh my god!" It made me feel good.

If you start to look at choreography and dance, that's kind of the intersection between that. If we look at ballet or hip-hop dance, the movement and expression of what people do there can be direct references to how I would place keyframes. My easing and keyframing are part of the same gestures. It's a fascinating territory that overlaps.

For myself when I am editing or dealing with a linear piece of motion, especially when I have to cut to music, I am listening to the phrasing of the music. I am listening to the bridge section, the A section, the B section, knowing when the "1" comes in—when you start to lock up the visual that edits into the sequence of how the music is composed, it feels really good because it becomes tightly connected. I feel like I have an advantage because I come from a music theoretical background. When I hear music, I deconstruct it and match visual to it. This intersection is important to think about.

Especially with the kind of work we are doing in branding, where it's not always a linear motion graphics piece like a one-minute animation. Maybe it's a three-second thing on social media, or just animation behavior. We are still trying to find that emotional response in the movement. Using music composition principles to build an animation that makes people feel a certain way. There is still a sensitive to that choreography of things, like typography as a ballet dancing group.

What's crazy about it is, if you look at basic music theory—if I am playing rock and roll versus swing, they both have two different feels—but it's the same if you look at the sheet music. Your body feels differently in relation to the sound. So, if I am animating, I can play off that same gesture. I can be very mechanical and straight, or I can be choreographed and bouncy. Even with walk-cycles and character animators, they can take on the same stuff. Even very basic music theory principles can be activated with animation principles.

With teaching, I have my students dance so they can understand and feel these things. Because if you are going to animate, that is how you are going to be able to judge if your animation is doing the right thing, if it is making you feel a certain way. It's a more abstract and artistic approach, but for me that is very central to the comparison of animation specifically.

Take rhythm aside, if you look at music composition and compare that to a design system, it's the exact same. If we look at a *Kind of Blue* chart, a Miles Davis chart, that has the core progressions, all the time there, and you look at a brand identity guideline—it's the same. You get this guide that allows you to do certain things. You have these certain ingredients, like drums, sax, keyboards, whatever. . . . This is the color, this is the font, the font size, these are the elements that create the aesthetic of this work. The elements that build a system for a visual identity can be thought about musically. We can fuse animation and

movement within a branding context because we are looking at a formula or sequence that comes together to generate the aesthetic of the identity.

How we approach the composition of design at our studio is very similar to a music composer creating a beat, a rhythm, or writing a song. If we can evoke the same kind of emotional response that we get from using music, then we are hedging a bet that this is going to be a much more powerful piece of design or animation on a visceral level. That is the ticket to grab someone in. We are curating something that makes us feel good that isn't imposing formal restrictions that suck the soul out of it.

How does improvisation play into your work?

We use the word *generative* in a bastardized way because it doesn't need to be coded. You just need to set up a system that can generate a certain thing for you. Once you have the stability of those elements working, then you can mess with it. But it still maintains relatively consistency. That is why I compare it to Miles Davis versus a piece of Bach, because there is always some looseness. There is an unexpected quality in the work we create, where every composition is going to have a different output. But the underlying system is going to keep the consistency there. I see it as a lead sheet for a jazz group where the song is played differently every time, but you know it's the same song. It makes it fun.

Can you tell us about the MOMA "It Wasn't Written" project?

The traditional approach to visual identity and branding work was the mentality of "we have the typeface, the logotype, and the color." The MOMA project leads with a prototype for motion: the very first thing is a generative system of motion. That is the leading position of all the work. From there, we can export for print and create consistency through all the exported assets that become static.

When creating an identity system that is going to work on screen, on printed material, and interactive material—if I come in with a poster design first, I will have to create transitions and animated qualities that deteriorate the design because you need to add motion to it. But if you have considered something that is fluid, constant, or generative, then the design system maintains consistency and quality through all aspects. Once you have this system set up, from a production standpoint, it's like "export, boom!" It becomes super-fast and very efficient.

What are your favorite projects?

Squarespace

Squarespace is probably my favorite project that we have done because it is so encompassing to everything. It is motion driven but also very systematic, with straightforward toolkits and communication design and with experimental stuff. From Times Square billboards to social posts, to a custom typeface, to product design—it hit every possible skill set that studio had to offer.

I think Squarespace will be a seminal project for us. The whole motion is developed by the idea of squares in space. François Rappo designed the typeface. He is a super old school Swiss type designer. He doesn't believe in variable fonts, he does it all by hand—he's as traditional

as it gets. Something I can't stress enough is the danger of teaching technological driven stuff, it comes at a sacrifice of the traditional understanding of basic typesetting principles, how we look at hierarchy, text, and legibility—we still need to have a fluent understanding of how that stuff works, before we can wreck it.

If you dissect a lot of our work, there is a sensitivity to baseline grids, scale, and layout that comes from a traditional understanding of design that is the underpinning of why it

11.11
It Wasn't Written, symposium for the MOMA (Museum of Modern Art) by DIA (top). *A-Trak,* live visuals by DIA (bottom). Creative director: Mitch Paone.

works. If you don't have that, it becomes messy, and the aesthetic is lost. There is a technique that needs to be ingrained. When you start to feel comfortable with your fundamentals, then you can start rocking in After Effects and Cinema 4D.

So, we went on a 1-year journey with Squarespace, and they were really willing to go for it. Seeing that work being produced now, their internal team really embraced and elevated it. It makes me happy to see the work improve and expand beyond our system.

What do you think belongs in the motion designer's toolkit?

From a technical standpoint, I think After Effects is the most important piece of software. For a graphic designer, year 1—you have to get in there. Working with Cinema 4D, that is such a ridiculous software. What you can do in there as a graphic designer is insane. Those two pieces of software from a hard-learning perspective are super-valuable.

Typography is the number one ingredient that is going to be in a graphic design project. If I am going to hire someone in the studio, it's the first thing I am going to look at. I am going to look at their resume and see if it's laid out well. If it's not, I am not even going to look at their website. If there is a sensibility and understanding of type to the page, the selection of the typefaces, that is equal to the sensibility of animation.

The ability to be creative in conceptual thinking and how you do research. Also, if you love doing other things like photography or drawing, integrate that within your design skills. Find a way to marry your other artistic craft, and that is how you develop your signature way of doing things.

What suggestions do you have for young designers?

There is always some parallel or unexpected interest that you can lock into design. It makes design fun. It helps to define your path when you can marry it with personal interest. From a creativity standpoint, it is really important. For me, music is my fuel and design is the work. I have an endless load of energy coming through a different passion that keeps me moving. If you can find that with anything else, it makes the work a bit easier.[1]

NOTE

1 Paone, Mitch, Zoom interview with author, June 3, 2021.

Chapter 12
Motion Design Systems

PRODUCTION SYSTEMS

Production starts with inspiration, but it requires effective execution to reach completion. As artists and designers, we are inspired by ideas and ways of representing them. However, to realize these ideas through complex software, often in team situations, requires planning, structure, and process. All production takes us from an *idea*, which is conceptual, to the realization and the refinement of that idea by making it visible and giving it a finished form and expression. Sketches, style frames, design boards, and schedules are all production assets that help to make the idea concrete.

Production as a word has overtones of manufacturing, and this term is important, because the movement from "this could be anything" to a finished piece requires not only the initial creative inspiration, but also the focus on process and efficiency, particularly in commercial settings. Production in this way is a form of creative manufacturing that takes ideas and turns them into finished work.

As the scale of production increases, particularly as budgets rise, the pressures on delivery and schedule become more pressing. Larger teams, specialist skill sets, the use of freelancers, and external contractors all increase the need for both production management and an organized, efficient "factory floor."

Because of this complexity, organization, file naming, file storage, and consistent project structures are essential because they allow for assets to be located by anyone, anywhere within a project team. If a team member is away from their desk, or key production elements are part of a shared storage system, anyone should be able to access any part of a given project quickly and effectively.

As previously examined in Chapter 3, a system of storage and naming should replace the somewhat idiosyncratic naming structures that an individual might develop on their own. Likewise, the names "final.final.render" or "really final render" are not useful within a shared naming system, so dates, version, and other attributes have to be part of the system.

The second area in production that can benefit from systems thinking is the automation of persistent processes. Multiple lower thirds, for example, could be versioned, using an import process linked to a spreadsheet. This spreadsheet with multiple text elements could be updated by clients remotely. For example, the process could be further automated by having an After Effects Solid, underneath the text, adjust its width dynamically based on the

DOI: 10.4324/9781003200529-13

text import. These simple procedural elements might be facilitated with a spreadsheet, or they may be custom scripted into a project using expressions.

Other types of information can be imported into After Effects using common data formats, such as. json or, csv, and these can be custom scripted to produce variations in a given animation. After Effects projects can be then saved to a folder on a local network, or even to a remote folder on a cloud service, like Google Drive. Rendering these files can be automated, by having Adobe Media Encoder watch a given folder and render any new media, or project files stored in that folder. These rendered files can also be stored anywhere on a network, or even in the cloud. Files could be automatically published to one of a number of popular video sharing platforms or sent via FTP to a remote folder where they can also be included, automatically, in other programming. So, the options for automating production processes not only allow for versioning of media at scale, but these versions can increase the profitability of a project by automating work that is still billable.

The lessons in complex productions also apply to a designer who is working alone. So, production is very much about designing not only motion work, but also the tools and processes to make it happen.

One of the interesting shifts for us has been the move away from deliverables and towards systems. It has been a response to peak content with screens everywhere, but also that brands need to show up everywhere in lots of different ways to lots of different types of people. Their customers are so varied and so targeted that the shift towards thinking about systems as opposed to a :30 second or even a :05 second thing.

12.1

In a sample process, text for new interstitials can be updated (1) in a remote document and imported automatically into After Effects (2). The updated project can be saved, even remotely, on the cloud (3), with the required image assets stored with the project files. The save folder is "watched" by Media Encoder (4), and any new files are rendered with a saved template and specifications. Finished media can be delivered remotely (5) to a client, automatically as it is rendered. This media update process is almost entirely automated.

How do we create a system that allows you to create infinite things? We very regularly now deliver *After Effects* as software. Which is the way it used to be, where you deliver the toolkit. It's like some After Effects toolkit on steroids, where you plug in something and spit it out across multiple formats.

Orion Tate, Buck

SOFTWARE SYSTEMS

Working with media is increasingly about defining a system to produce an image, as opposed to simply "making" an image. Thinking through the process of designing typical motion *Projects* that combine *Assets*, often in multiple *Compositions*, we find any of these elements can be modified to create a different version of a working project. Most Motion Design projects involve thinking about how images work together as part of this complete process.

Motion Design is still somewhat focused on producing a moving image that is *rendered*. Rendering is a final, committed edit, the last part of the production process. Tools within a project can be modified and parameters can be changed, but the idea is still focused towards the "right" version of the work, a final "master."

Different approaches to software open this process to design a system to create an image rather than a single project and timeline with a single output.

3D software such as SideFX Houdini takes a different approach because it is based on a *procedural* model of animation. A 3D scene is not strictly made up of objects, textures, lighting, and cameras, but rather a series of nodes, which define a process that *describes* a 3D image. This type of *node-based* approach gives rise to new possibilities because it treats the work as a flow of changes through a network. Changing one aspect of the network will change the flow of information, so new processes can be almost immediately introduced into the network, which might markedly change the final result.

For example, we might start with a cube that has movement, shading, lighting, particle systems, and other processes applied to it. In traditional software, deleting the cube would lose later elements added to it. Starting with a sphere is a little like beginning again. In a procedural system, replacing the node that makes the cube with a node that instead makes a sphere instantly updates that part of the system. The new geometry immediately inherits the entire workflow previously applied to the cube. Elements that modify any part of the process can be added at any time, making a 3D scene simply a set of variables in a network.

This node-based style of production is found in many different applications today. Instead of offering a set interface for working with media, a node-based system will link what are often processes in code, to form complex yet flexible procedural "trees." The average person can use these systems with a little practice and with no need to define everything in complex, handwritten code. A process is then based on creating software out of ready-made blocks, and this approach is even being used in systems like Scratch, the MIT-developed open-source project that teaches node-based programming to elementary school children.

The node-based model has given rise to a new generation of software like TouchDesigner, which allows a vast and expanding range of processes to be applied with multiple

inputs and multiple outputs. If we wanted to use a depth sensing camera like a Microsoft Kinect with After Effects, there is no easy way to do so, and no way at all to make the project respond to inputs in real time. After Effects sets up a system of relationships with media elements in order to render the result. In a node-based system, we can simply drop a Kinect *input node* onto our project, connect the Kinect's reading of human gestures to a *variable* within the project, and these variables will update in real time. Waving your arm might trigger a change in the way an image is rendered, for example. The Kinect, in a few simple steps, can be introduced or removed from a project without complex coding.

This same flexibility can apply to a range of inputs—which can be images, 3D objects, or signals from other software, or hardware devices—from cameras or keyboards to depth-sensing LIDAR (light detection and ranging) scanners, which can produce a real-time dimensional "scan" of a scene. Inputs can be mixed with each other, can pass data within the network of nodes, and can be rendered in 3D in real time or produce other images or moving images. These mixes can be mapped to a screen or projector, or sent on a network or to another software process as a data output.

Software can also output musical notes, commands for LED lighting, 3D model data, or instructions for robotic devices and motors. With these tools, motion designers can create completely novel applications. For example, the Kinect might drive a robotically positioned array of LED lights that change color based on a particular image, user input, or other information fed into the software's mesh of nodes and their relationships.

It is not surprising to see these tools in heavy demand for public installations and detailed interactive projects where an array of screens, user inputs, projections, and other interactions may work together as part of a constantly changing network of media and data, accessing multiple inputs, and producing multiple outputs. So, things can get complex quickly!

> **As soon as something is interactive, now you're opening up a lot of possibility to how the user can experience, whatever you're creating, in ways that you can't do if it's just simply on rails, like, if I'm showing them a commercial. In the commercial, I can really guide that journey pretty easily. Once it's interactive, you have to really plan for all the contingencies of how they can approach and experience whatever story you're telling. It's all storytelling, but now there's a more freeform dimension to it, where they can go off and explore it in their own way. You have to be really careful with these possibilities, that it's all still ladders back to whatever messaging you're trying to get across.**
>
> **Kyle Shoop, Executive Creative Director, LVTHN Chicago**[1]

New software systems for Motion Design have also developed, in parallel, out of *game engines*. Game engines were designed to provide a flexible and modular structure to develop interactive experiences based on a range of user inputs within the software. As games have become more visually complex and increasingly use the rendering power of modern computers' GPUs (graphics processing units), the software in game systems has developed to offload quite simple scene descriptions to the GPU, which can render these into visually complex spaces on screen. Unreal Engine and Unity are two leading game engines, which combine real-time rendering with complex interactive frameworks

12.2

This node-based project in TouchDesigner uses a series of *processes*, connected left to right (pictured top) to create an interactive particle field (bottom). The nodes, left to right, (1) connect a Kinect azure, (2) to a transform node and successive operations, (3) to make an image threshold, (4) blur the output, (5) create an optical flow effect, (6) blur the output of this, (7) send the result to a GPU rendered particle tool, (8) key the output, and (9) create a null object to view the result onscreen. Moving in front of the Kinect, or for example, waving your hand in front of it, sends depth information from the Kinect's depth camera through the network to move the onscreen particle field in real time.

to program game behavior and increasingly, to address external media devices and inputs. These game engines are increasingly being used not only for game development but also for the design of real-time, responsive motion assets, which can be changed on the fly, just as they would in a game.

The stronger that these tools are, they are going to hit a broader market. I think this kind of real-time, procedural, data-driven, and smart logic allows you to blueprint and code dependencies. You're going to be using game engines more than these kind of, in a way, somewhat dumb tools, where it's very locked and it doesn't get iterated the same way that a game engine does. The game engines really give you a lot of flexibility, so I feel like the designers that are going to be doing a lot of interesting work are looking at these procedural tools.

There are people in the physical space, where they use Cinder, they use Touch Designer, these are all kind of in the same kit. That is where the exciting things come in now. If you already have that sensibility, you're ready to kick ass designer, you already know how to work with type, shapes, colors, whatever—and then you're basically opening up all these new tools that superpower you in many ways and actually allow you to work faster.

The thing that's cool about these real time tools is the sense of iteration as well. As artists, when the tool is slowing down, that is your worst enemy. Whereas sometimes with these real time tools, it moves at the speed at which you're thinking. You're like "pink shade or green shade, or more reflection less bump," and it's right there.
Boo Wong, Director of Live Entertainment, Unity Technologies[2]

In this workflow, a motion designer is essentially designing a playable graphic as opposed to a rendered graphic. These changes are offering completely new ways of thinking and designing workflow for animation and production.

GPU-based systems are also influencing 3D production, with new rendering and game engines allowing for the *render* of a scene to be completed in real time by the GPU instead of calculating every pixel's position, color, and relationships with appropriate lighting in the scene. To give a few examples, IRay, Arnold, Redshift, and VRay all speed up 3D rendering using this technique. Game development platforms such as Unreal Engine have complex rendering built in to their real-time rendering capabilities.

It is also worth noting that the traditional process of set design for Broadcast is increasingly being done within 3D software, where a "virtual" set is developed. This set is matched with the moves of studio cameras filming talent, whose "set" is a green screen. The studio talent is *live keyed* into the "virtual" set. The design of these sets can incorporate complex graphics and animations, and many motion designers adapt easily to this style of work.

This technique is also being extended into dramatic production using XR (extended reality) stages. In these setups, a massive LED screen behind the talent can display landscapes or other backgrounds in context, matched to the actual camera and lens being used and updated in real time to camera movement and changes in perspective.

DESIGN SYSTEMS

Motion designers may need to think in systems to develop new work or to extend their design into new territories. The traditional idea of a *system* in design is similar to the "Grid System," the Swiss style of modernist graphic arrangement based on dividing a graphic space into a grid, using guidelines, and arranging elements in a clear and systematic way based on this structural principle.

This emphasis on arrangement and legibility extends into other graphic systems such as wayfinding systems, where common, repeatable typographic and graphic elements are used to orient visitors in a complex and diverse space. The classic example is the Swiss-inspired systems used in airports all over the world, with their clear, Helvetica typeface and their common icons for bathrooms, luggage facilities, and boarding gates.

Increasingly, wayfinding systems are no longer static, and the development of everything from public signage systems to the instrument clusters in cars require the development of Motion Design elements. Most UX systems, from smartphones to fitness trackers, all employ motion elements in their interfaces and the many movement cues that UX systems typically integrate. This integrative process is a subset of Motion Design that is highly structured by the requirements of hardware, software, and users in their development. There is information in motion everywhere we experience it.

12.3
DIA Studio's interactive system for SPACE10 enables real-time experimentation with type and layouts, allowing for the immediate production of generative work with type and image for a range of output formats.

Some designers may develop a system that can produce continued variations of design. DIA's work in generative typography is a great example of this approach. Their work frequently sets up a project that can output an array of both still and moving media. DIA's development of a generative tool for Space10 in Copenhagen, for example, is a software tool that can output 4k video, print layouts, GIFs,. pngs, and High-Res images for print from a flexible, user controllable interface. With definite constraints within the system, it is not open to unintended variation within the design. But within the tool itself, there is no prescribed way to work. *It is a set of potentials for the output of design.* The process of design here is not an image, layout, or video but the design of a process for making images, layouts, and videos within a considered framework.

MEDIA SYSTEMS

Motion Design is open to new ways of working with and incorporating media as never before. The range of tools, systems, and processes that can be connected to form a final work not only touches traditional desktop media production but also expands production to offer new user inputs, new ways of working with media, new methods of creating or modifying images, and vastly expanded display and output possibilities.

A software like After Effects was introduced in the mid 1990s, at a time when the desktop rendering of 3D in games was defined by the early versions of DOOM. TV commercials involving motion work were completed on very expensive dedicated hardware, and the possibilities of desktop editing were only beginning to emerge. Over the next quarter of a century, hardware and software developed to offer robust desktop production with tightly integrated tools sharing data between them. Additionally, smartphones found their way into everyone's pockets, with literally more computing power than a computer from 25 years earlier. Commercial VR re-emerged, game engines and game hardware became spectacularly capable, and an explosion of software developed to fit every niche of practice.

With these advancements, Motion Design will frequently involve designing media *workflows* within media systems. This evolution is what we might refer to as a *meta practice*— designing the flow of media and a framework within which the eventual form of the motion work takes shape.

Media in production opens workflows to new possibilities. Files in the digital space can be processed and reprocessed, but they can also be translated to other practical formats; for example, printed and modified by hand. Every designer should be open to the integration of new processes within their production workflow.

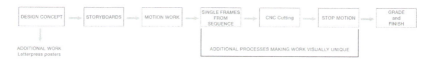

12.4
The workflow for *The New America* takes standard Motion Design and diverts it into a unique physical process that gives the finished work a highly unique visual signature.

12.5
A finished frame, number 320, rendered as computer cut wood, from *The New America*, by Nando Costa.

Nando Costa's *The New America* is an artwork that takes a vector-based motion project and inscribes every frame into a piece of wood. Each frame is engraved by a computer controlled milling machine, which translates the vectors into precise cuts into the surface of the wood. Each piece of wood is then reanimated using a simple stop-motion process, to reintroduce the original motion into the work.

It is worth noting that one part of the production of *The New America* involved the printing of letterpress posters using similar computer cutting techniques. The active exploration of new processes in this way not only offers new possibilities for creative production but also stimulates a designer's thinking through a breadth of artistic practice. Non-commercial

12.6
Tinder: The Invention of Together, commercial created by Buck.

work can inspire new and unexpected possibilities for commercial commissions. Most clients will come to you based on what you have already done, so working in new ways artistically may raise new conversations for commercial work as well. The asset created in a vector-based software can be used as an image in After Effects, or its path can be used to define a motion path. The vector information can be sent to other devices, laser cutters, engraving, or sign-making equipment, and even to laser projectors that will trace the outline using laser beams. The digital image or the vector path no longer need to remain inside a single computer; they are flexible bases for design across a vast range of outputs. As production of all types uses the same kinds of information to generate both images and physical

12.7
Tinder: The Invention of Together, commercial created by Buck.

outputs, Motion Design can happily traverse a variety of disciplines if a designer is open to the possibilities.

Media may require a great deal of thought to design its integration, particularly when different source media is composited into a single finished production. In Buck's *Tinder: The Invention of Together*, 3D animation is composited into practical backgrounds with detailed sets. This highly unique look for the piece is the result of carefully blending two media types. This type of bespoke workflow requires careful pre-planning to maximize the visual coherence of the final integration. Each project that takes on this type of unique composited "look" is a media system with different inputs merging into the final product.

It is useful to think about this process as a set of stages based on:

Inputs > Processes > Outputs

Breaking the system into these stages helps to identify the possible options during the design and production process. Some systems are designed to pass media through a *series* of processes. So, designing a motion piece may sit within a larger design system that manages this flow of media in real time.

For example, take the development of a projection work for use at a music festival. Individual motion pieces are developed to sit within a larger media system that provides the right functionality for a VJ at the event. So, an individual element in After Effects may be developed and mixed in a VJ software with other images, and the output of this process sent to a projection mapping software where the result is mapped, and the entire process is controlled by an external controller to switch clips, sequences, and mapping setups at the press of a button.

The *VJ software* is linked to a MIDI controller, which has a keypad mapped to key software controls of the VJ system. The *Mapping software* is linked, over Wi-Fi, to a custom iPad

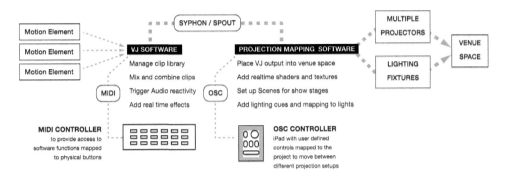

12.8
In this example of a VJ workflow, Motion Design produces individual elements, which can be stored in a library in a specialist VJ software project. Here they can be mixed, keyed and sequenced, or have effects applied to them. The output of this is sent in real time into a mapping software through *Syphon* (on a Mac) or *Spout* (on a PC), which allow for real-time passing of moving images between applications. The mapping software sees the processed VJ images as an input and sends these images to multiple projectors as mapped outputs, and to stage lighting or LED lighting arrays. It might also stage the program into scenes, that can offer different, predetermined setups of mapped elements, lights, and source material.

interface through OSC (Open Sound Control) allowing for a user-defined interface to move through scenes and turn lighting fixtures on or off. All the software and hardware to develop this workflow is freely available, off the shelf, so this is an *open system* approach.

Interactive Work

Experiential works, along with interactive elements, are expanding in importance as the tools to develop it become more widely used. Advertising and communications profession-als are looking to "cut through" the array of existing and expanding media platforms, and so site-specific work with a more expansive presence is an attractive option.

In much the same way, traditional collecting organizations like museums are pushing towards interpretation as opposed to simple display, particularly in organizations with a con-temporary focus or those that engage younger audiences. This expansion has led to a vast range of new, media-based programs and installations that incorporate Motion Design as part of an evolving, hybrid practice.

When approaching interactive work, thinking in terms of inputs, processes, and outputs always applies, but the level of investigation into the specifics of each stage is important. There is a much wider range of possibilities and techniques that can be brought to bear on an interactive project, and so there should be a wide-ranging investigation of options during the scope stage.

In addition to the possibilities of interaction, there is also an increasing opportunity to develop work that is generative and will take external inputs and transform them into Motion Design that is designed, but not defined, by the artist or designer.

An example of this style of generative work is the *High Water* installation, commis-sioned by the City of Sydney for the Green Square precinct, which creates a generative watercolor image that evolves in relation to live data feeds.

The installation uses live temperature data to modify the display of color, whereas humidity affects the size of the blooms. Wind direction is represented by the movement and velocity of the animation as it tracks across the screen, and rainfall becomes water droplets

1. INPUTS	2. PROCESSES	3. OUTPUTS
What data comes into the system?	What is displayed in the work?	What data is produced by the application?
Can a user interact with media?	How is this affected by the user?	How are the results displayed?
What is their input?	How is media moved?	Are outputs translated for different devices?
Can multiple users interact?	Where is media stored?	Is there data passed to a remote location?
How is this achieved?	Is there image processing involved?	Are some results stored for later recall?
Is the interface discrete? [fixed controls]	What links different parts of the system?	How does the system physically connect?
Is the interface open? [via user movement?]	Does media pass between softwares?	Is there an audio component?
Can media be updated?	Are there curatorial requirements?	What audio format is appropriate?
Does the system record local data for its use?	Are there commercial requirements?	How do displays address physical space?
Is there access to a remote database?	Does data arrive from multiple places?	Is there a need for remote access?
How is user data passed to the application?	Are there multiple points of input?	What are the site's sightlines and acoustics?

12.9

Typically, at the start of an interactive project, a number of questions will be asked about the basic functions of the work, broken into Inputs/Processes/Outputs. These questions should take in the widest range of possibilities to develop a suitable scope. This scope should align users, clients, and designers with the range of requirements before things like a specific software approach is developed as part of a functional specification. For example, a project might make use of any one of several software platforms to manage interactivity. However, this selection should be considered *after* the project requirements and key functions are established. In some cases, the development of a new process or the development of a specific platform for the project will require some additional research on the part of the development team.

12.10
High Water, public art installation in Green Square, Sydney. A 9-meter-high, two-sided LED screen that continually monitors tidal and atmospheric data and transforms it into an evolving, watercolor like image. Artists: Indigo Hanlee, Michael Thomas Hill/Lightwell.

that run down the screen. The sea level is shown slowly rising and falling from low tide to high tide, with its color also reflecting the temperature throughout the year. The data comes from a range of sources; Willy Weather, the Bureau of Meteorology (BoM), the National Oceanic and Atmospheric Administration (NOAA), and local weather sensors installed at Green Square Plaza.

This work also posts sequential image captures each day to the website (www.high-water.sydney). Here, the flow of patterns over months and even years can be viewed as a

linear sequence, adding other levels of visibility, interpretation, and access to the design of the system.

There is no way to predetermine exactly how a work like this should develop. Beginning a project of this sort requires a very detailed development of scope that should in turn investigate a range of possibilities for the physical and technical realization of the finished piece. In essence, High Water is a complete system for representing a range of climate data in a specific setting, rendering it visible to different audiences in different contexts. The work is a perfect blending of art and science that is realized through complex system design and detailed project management during production.

For a motion designer developing work in a systems context, the range of possibilities transcend the direct production of linear images. Expanded work that embraces the full range of possibility is in part UX design because the way an audience experiences work will be written into the design and development of a project, often in its early stages. A motion designer working in this setting is more concerned with the activation of possibility and potential through their design, as opposed to its finished visual form alone.

NOTES

1 Shoop, Kyle, Zoom interview with author, January 13, 2021.
2 Wong, Boo, Zoom interview with author, March 24, 2021.

Chapter 13
Projection Mapping and Immersive Media

THE SPACE AROUND US

Motion Design adapts naturally to a range of possibilities, integrating different media types and production processes, at different scales and resolutions. Along with this natural flexibility, the emergence of new technologies for media display and production have expanded the options for Motion Design in very diverse situations. Outdoor screens and billboards, projection systems, and other forms of public media display have introduced Motion Design into a new range of artistic practices, communication platforms, and public settings for education and visitor experience. Motion Design is everywhere from moving signage on subways, and museum exhibits to massive projections shows and rides at theme parks.

Images designed for public display involve very different ways of working with media and thinking about the design process. When we design for a screen, there is an assumed position for the audience, where the screen itself forms a natural frame that constrains the point of view. We can control the image and its composition, the pacing of shots, and the orientation of the audience within the world we create.

Public work, in all its settings, loses the fixed relationship with the audience. Media is one part of a larger space; it is situated in a location that may serve another function altogether. Public media appears in leisure spaces and in city streets; it is woven into retail and hospitality venues and is part of mass transit infrastructure. In every instance, the media becomes part of a larger system of use, of visitor circulation. The attention of the audience is not assured. For example, billboard signage in cities need to deliver a message immediately, as they are part of a much larger context for the public audience. Wording, timing, and editing are all constrained by the need to create impact within the space of what may be a passing glance.

A larger installation, like a media work commissioned for a building foyer, can usually operate with a different set of assumptions. In the first viewing, it may have all the formal qualities of a painting, making considered use of color, tonality, and subtle movement. It functions in this way as "art on the wall." Yet, its movement over time, or some other layer of interpretation, may allow for more considered storytelling. The work itself may present a constantly changing image to the frequent visitor, allowing it to be appreciated at very different viewing intervals.

Public Screen Spaces

In the 1970s, the first moving images appeared on buildings in major cities around the world. These early displays were simply "televisions on a building," and they served as carriers for a fairly rigid production industry that worked within fixed dimensions and formats. Today,

the development of flexible LED systems has allowed for screens in very diverse formats and shapes: curved façades, long vertical pillar box displays, and even the narrow bands of screen that circle sports stadiums. These displays all require different media for display, and a designer will have to start with the canvas first, thinking about the dimensions of the screen and where it is situated. The wide strip of an LED screen spanning the seating of a sports stadium may require vertical transitions, rather than long movements across the vast horizontal space of this type of screen.

For motion designers, these concerns are simply a process of adaptation to the new template that a different screen requires, and a thoughtful consideration of how a given design, its layout, and timing will work in the particular space for which they are designing.

Most permanent public display surfaces are managed as a piece of media infrastructure, either by a business that aggregates the programming on the space and sells time on the display, or in the case of architectural and retail installations by the building owner or tenant who operates the attached space. In every case, the media formats for delivery and display are documented and available to give the designer the exact specifications of the display.

Other types of work, particularly temporary installations such as media for performances, projection installations, and gallery work will need a designer to not only work through the production process, but also define the display process as well. Although these types of work involve some additional considerations, the creative flexibility that is offered by open systems can produce truly remarkable and creatively rewarding outlets for Motion Design.

Projection, Screen, and Surface

There are a number of different ways that projection can be formatted and presented, with different software pathways, image production pathways, and mapping and replay options. The best way to simplify this process is to think of the workflow as inputs, transformations, and outputs. For a designer approaching this work there are two ways to think about the process: "What *can* I do?" and "What do I *want* to do?" In design for a fixed screen, the emphasis is on what a designer *wants* to have happen. Because the frame is set, everything else is a creative decision to give the work its final form.

In design for space, the final scale, format, and placement of the image are part of the design process, as are any other ways the scene might be modified. A VJ set may involve several different pieces of media, and these may be arranged in different ways to provide control over an image at different times during a performance. Some aspects of an image might be modified to respond to audio, or there might be another input, such as a body sensing camera like a Kinect, which could influence the image in real time. Design in this sense needs to explore not only the process of image media creation, but also the integration of these additional possibilities.

So, let us start with projecting and mapping an image into space. Because projectors vary in resolution and light output—measured in *lumens*—we need to find something that fits the purpose of the media we make and the space with which we are working. An indoor venue with dim lighting might be very well lit by a 3000-lumen projector, but a building outdoors may need 10,000 lumens or even more, requiring a larger, heavier projector and some scaffolding to support it. The kinds of spectacular "projection mapping" shows that are seen on public landmarks may use multiple arrays of very powerful projectors. A small retail

display might use projection mapping to augment a space, which could be done with a palm-sized "pico projector" that produces less than 1000 lumens. So, the choices for a designer are really driven by the intended use.

Once we have a projector that works for our space, it needs to be fixed in place so that it is not moved or bumped. If we use mapping software, a projector needs to be connected to the computer we are working with and set as a *second screen*, or external display. The projector is then set as a display surface in our software. For the purposes of illustration, we can use MadMapper, a software developed by Garagecube, a group spread across Western Europe. The same basic principles apply across perhaps a dozen software, such as Resolume, Millennium, Heavy M, and Isadora. Each of these software has a range of features and capabilities, but the principles of projection are quite similar across all mapping processes.

A single projector is set as the target of our output. We can call this "projector 1," or give it a unique name such as "stage right," or something that helps us understand its practical placement.

To start with a single image, we can import an element we have designed: a movie file, a still image, or even some specialized shaders and patterns. First, we define a shape, such as a quad, triangle, or circle, which is then applied to any media element we have selected. We can also select a part or the whole of the media element with this shape. The shape we select is immediately placed in the projector's area, which we can modify in real time by moving points to the corners of something the projector is covering. We can "pin" a square image to the face of a box, literally in a few seconds.

THE PROJECTION WORKFLOW

The bottom strip of Figure 13.1 illustrates the projection workflow process:

Left image: Importing an element we have designed elsewhere.
Center image: Using a four-sided shape to define a section of the imported source image.
Right image: Pinning the selected area to the face of a box using the shape's corner points.

The basic process of selecting sources, applying shapes, and modifying these shapes in real time can create a variety of complex arrangements, often very quickly. Masks can be made or drawn to remove part of an image from being visible, and complex shapes can be developed by subdividing a shape with a user-defined mesh and adjusting this mesh within the process.

A designer can make almost any shape using these techniques and the creation of very flexible surface placement in complex, real-world environments.

Expanding the Canvas
Multiple projectors give the option for a vastly expanded canvas or even lighting of objects from multiple directions. Projectors can be added as outputs and lights to cover a larger surface. Because projectors appear next to each other in software (they do not have to be

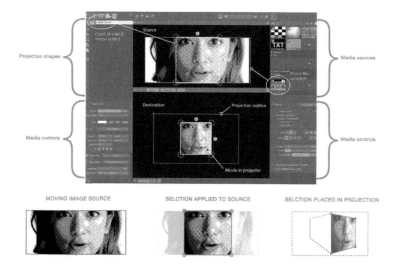

13.1
The MadMapper interface showing a source selected (top) and the shape of the source visible in the projector's area (bottom).

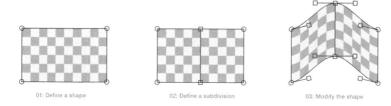

13.2
A shape with a single subdivision applied. This subdivision can be left as angular "corner" points or defined as a Bezier mesh to warp the image with curves into a particular shape. Multiple mesh points can be added to allow for further fine adjustment.

placed that way), they can be stacked, spread apart, or placed around an object to give a full-dimensional coverage of a physical object from all sides.

Working With Shaders in Projection

The development of efficient shading routines for game design has offered a range of new possibilities for 2D projection work. The Interactive Shader Format (ISF) is based on the Open GL Shader Language, a graphics language for programming image textures with code.

These "shaders" are very compact as files because the code that "describes" the file is very compressed, usually a few hundred lines of text. Unlike complex movie files, they often only require a few kilobytes of storage and are rendered to screen in real time using the video card on the host computer. The ISF format also allows for certain parameters of the shader to be exposed as *controls*, so that many parameters of the rendering process can also be adjusted in real time using simple sliders. ISF shaders can be found on the web (www.isf.video is a great place to start), and there are seemingly endless varieties because

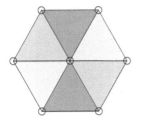

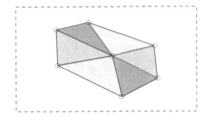

01: Multiple Source Shapes 02: Projected Placement

13.3
Multiple source shapes placed into a detailed arrangement in the projection surface.

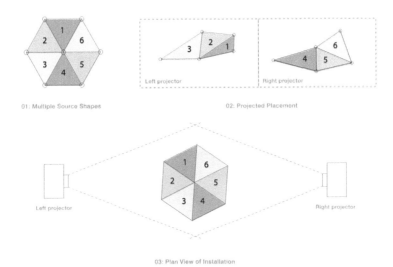

01: Multiple Source Shapes 02: Projected Placement

03: Plan View of Installation

13.4
Multiple source shapes can be spread across two or more projectors, which can then be directed to an object from different directions, offering coverage from all angles.

production of ISFs is an open project to which anyone can contribute. Even a casual user can browse single shaders on the web and either alter the parameters interactively or expose the code and make real-time adjustments to the underlying program. Files or modified versions are simple to download and will import quickly into mapping software.

The same principles apply when working with shaders or movie files rendered from a motion timeline, as they do in the development of projection work across different software platforms. Think of the inputs as being flexible, with areas being defined and then made into a virtual canvas. This canvas can be manipulated, layered, combined, and adjusted very flexibly into a final form, which is sent to the projector as the very last stage of the process.

Scanning the Real World
Other techniques can allow for the capture of images that correlate exactly to the "view" of a projector. One example of this is Structured Light Scanning, which allows a guide

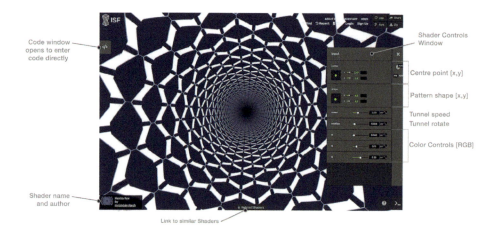

Code window opens to enter code directly

Shader Controls Window

Centre point [x,y]

Pattern shape [x,y]

Tunnel speed
Tunnel rotate

Color Controls [RGB]

Shader name and author

Link to similar Shaders

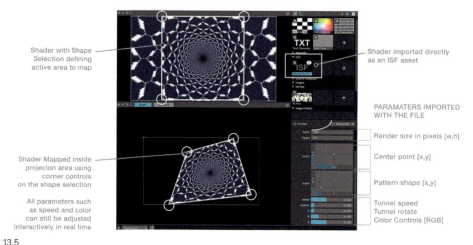

Shader with Shape Selection defining active area to map

Shader imported directly as an ISF asset

PARAMATERS IMPORTED WITH THE FILE

Render size in pixels [w,h]

Center point [x,y]

Shader Mapped inside projecion area using corner controls on the shape selection

Pattern shape [x,y]

All parameters such as speed and color can still be adjusted interactively in real time

Tunnel speed
Tunnel rotate
Color Controls [RGB]

13.5

(Above) A typical ISF shader, producing a rotating tunnel effect in the www.isf.video repository. The web-based interface allows for adjustment of the base code, or through specified parameters using interactive sliders. (Below) Downloading the shader allows it to be immediately imported and applied to shapes for mapping. All the interactive controls are imported and available for adjustment at any time.

image to be created by scanning a sample of the projector's output and rendering it as an image that shows the projector's "point of view." The image created in this way is a template or guide image, for use in other applications, such as Photoshop or After Effects, where it can be used to make sequences that are aligned to a given projector *without* using preset shapes. Structured light scanning needs only the mapping software and a camera, such as a good quality web camera, attached to the host computer.

The external camera is set close to the projector and should be set up to capture a little more than the area of view covered by the projector. Projecting a solid color makes this easy to align. To access the scanning process in MadMapper, use the Space Scanner item in the Tools Menu, confirm the camera you are using, and start the scan. The projector will spend a few minutes projecting images of black-and-white stripes, both horizontally and vertically, beginning with a half black, half white image, and gradually increasing the number of stripes

in each image until the scan is complete. The camera records each of these high-contrast images and the way that the stripes contour around any objects in the scene. This information is processed into a slightly grainy, black-and-white "image," which is the same resolution as the projector, and identifies the key outlines, contours, and edges of objects covered by the projector. It is, in short, what the projector "sees."

This image can be saved and opened in Photoshop to create mattes or outlines. These mattes can be processed into moving images in After Effects. Without changing the resolution of the base image or subsequent renders, any movie file produced this way will match the projector's output exactly. This technique can be used to create very organic maps of scenes, and the process does not require producing shapes to place onto the space while projecting. It will naturally match the scene, and so all the elements can be drawn and rendered in place.

Fulldome and Immersive Cinema Production

After Effects is not strictly limited to the development of images that fit into a four-sided frame. It can be adapted to a range of immersive techniques using advanced processes that build on the common principles a designer works with in other production settings.

One example of non-traditional framing is the production of fulldome films for display in immersive projection spaces, such as planetariums. This format is an expanding area of practice that is visible in art exhibitions, film festivals adapted specifically to this medium, and commissioned educational and cultural programs displayed in dome theaters. A fulldome film uses the domed projection space of the planetarium to present these programs on a screen that surrounds the audience. Immersive films of this type may involve 3D imagery, filmed scenes, stop motion, hand-drawn animations, or graphic media sequenced in other motion software. The image is projected into the theater from a mastered movie that is square in aspect, with a circular area in the frame corresponding to the area of the dome.

Filmed images from immersive cameras can also be adapted to dome projection, which can be thought of much like other moving images in traditional screen spaces. 3D software can also simply position a 180-degree, ultra-wide "fish-eye" camera in the viewing position to render an immersive scene for fulldome projection. The extreme fish-eye view naturally renders the required square frame with a circular insert. The 3D space is not simply a "camera" view in the traditional *cinematic* sense but a view of a range of animation *surrounding* the audience and forming a horizon in all directions. This format presents entirely new ways of working and thinking about production for the 3D designer and is quite similar to the considerations for developing immersive work for virtual reality headsets.

Working with 2D Motion Design in an immersive space presents new challenges. A simple approach is to take a wide, equirectangular (four-sided) image and *wrap* it into the shape of the dome. This technique creates some issues with distortion: the bottom of the image is wrapped around the perimeter of the dome, the horizon, without much apparent distortion. The upper parts of the image are gradually squeezed into what eventually becomes a *single pixel* at the very top, called the zenith of the dome, which can noticeably affect the legibility of the image if it is not accounted for in the design of the work.

So, an effective design using an image wrapped into a dome would need to allow for having few elements that would distort in this way, which can limit the creative possibilities of 2D imagery and animation.

13.6

Structured Light Scanning Progression. In a typical use of Structured Light Scanning, the site (top) is scanned automatically with a succession of sequentially more detailed black-and-white lines, to record, through contrast, the way light bends on the surface (images 3 and 4). The multiple scans are combined into a single image. Image 5 shows the image that is recorded by the scan. Image 6 shows it applied back to the building, with a few lines added, in Photoshop, to the edges of shapes, and played back through the projector. The lower two images are projections produced using this template. The projections were composited entirely in After Effects, using the scanned image as a guide. The resulting movie files correlate precisely to the projector being used.

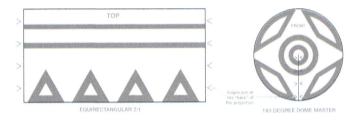

13.7
An equirectangular frame will wrap around the dome, joining its opposite edges at the rear of the projection and making full-width elements much more visually concentrated at the top of the dome.

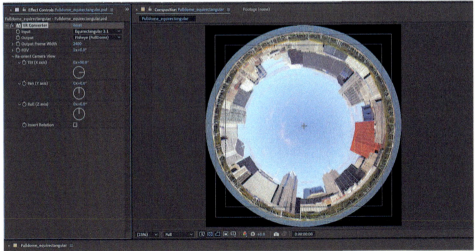

13.8
A low city skyline is an ideal image to work with in a dome projection, as the sky can blend into itself quite easily. In this image, the two opposing edges have been treated to allow for a seamless blend in the dome as they will "touch" each other once the image is wrapped.

Within these constraints, however, there are some strategies to consider for producing immersive media this way, which can be a great means of adapting illustration into the dome environment.

To begin, a starting composition is defined; in this case, the image begins in a 2:1 aspect ratio. The design needs to consider the top half of the space as a receding element because the entire top part of the frame will disappear into a single spot on the zenith. The work needs to make the most use of the horizon line, with the realization that the higher a design goes in the square frame, the more it will distort in the immersive space.

Designing in this manner means that the horizon is a good place to put different elements that will surround the audience. The two edges of the frame will join behind the audience in most cases. So, to avoid a seam in the image, the file should be blended to allow for a visually smooth joining as the edges touch each other.

The image is put into a new composition and is processed to a fulldome frame. The 2:1 image has the VR Converter plug-in applied and the Input set to *Equirectangular 2:1* and the Output set to *fish-eye (fulldome)*. The Re-orient Camera View setting will often need adjustment to place the zenith at the top of the dome image—usually a tilt adjustment of around 90 degrees.

The finished project will output a square movie with a circular inset that defines the live area of view. This movie will replay in a dome theater, using the circular part of the image and will produce an immersive point of view. The example here uses a photo-like image, although *any* animation created with these principles and set into a 2:1 aspect frame with sufficient resolution will convert using the same process.

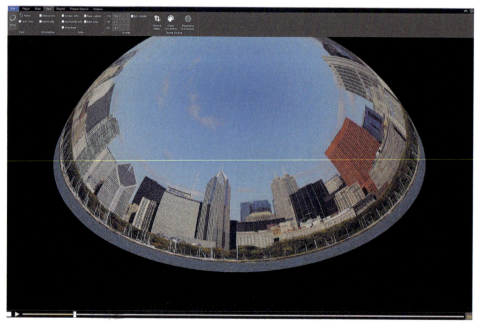

13.9

A dome preview in Amateras Dome Player (www.orihalcon.co.jp/amateras/domeplayer/en/), which allows the scene to be freely rotated and tilted as it plays. The view can also be sent within the software to a VR headset, for an immersive visualization.

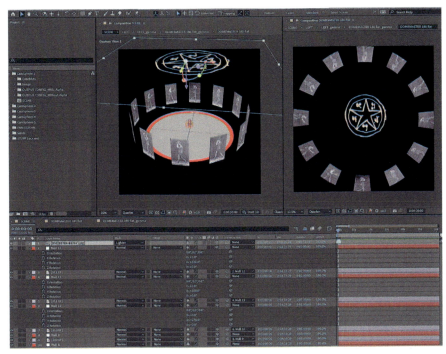

13.10
A dome projection using the Camsphere rig produced by the Société des Arts Technologiques in Quebec, Canada.

Footage recorded with an immersive or 360-degree camera can also be "unwrapped" by reversing this procedure. As this footage is natively recorded in the fulldome format, the circular image can be output to a 2:1 equirectangular frame for compositing, adding animation, rotoscoping, or other typical production processes.

The result can be viewed on a dome player software, such as the excellent Amateras Dome Player, which can not only preview the work as a domed view but also format it for real-time replay in a VR headset, such as an Oculus Rift. These options afford motion designers a simple way to either preview dome media they have created, or to use the VR headset to work with standalone VR spaces.

Motion designers can also make use of quite advanced camera rigs to work more freely in the immersive space. A multi-camera rig, where the views of each camera are "stitched" into a domed image without distortion, allows multiple cameras to each capture only one aspect of the total scene. The full scene is rendered using all their views stitched together.

In simple terms, this setup presents a six-camera rig at the viewer's eye position, which mimics similar multi-camera devices used to capture immersive 3D video. The six cameras address a 3D space around this central point of focus, which is the camera/audience viewpoint in the center of the dome. 2D objects and animations can be arranged in the space around this central point, offering quite a free placement of different elements. To move them in relation to the camera(s), however, they need to be carefully rigged.

This is a circumstance where the use of Nulls in 3D space to manage the position of elements becomes very useful. Each element is made into a 3D layer and moved in space.

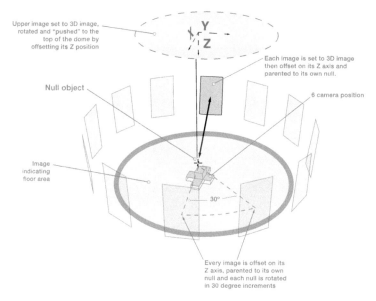

Upper image set to 3D image, rotated and "pushed" to the top of the dome by offsetting its Z position

Each image is set to 3D image then offset on its Z axis and parented to its own null.

Null object

6 camera position

Image indicating floor area

30°

Every image is offset on its Z axis, parented to its own null and each null is rotated in 30 degree increments

13.11
Each image element can be independent, such as the "sky" image that sits on the zenith of the dome. Images lower to the horizon can also be controlled through careful rigging and their use of nulls in 3D space, making After Effects a very creative immersive animation tool.

Parenting an image to a central null allows it to move on its own or in relation to the center of the scene. Groups of nulls can also be parented to a single "master" null object that could rotate multiple items as a group.

Taking small steps into immersive media is an ideal bridge for filmmakers and 2D artists to start thinking about these extended production opportunities. There are cameras and ultra-wide fish-eye lenses that can capture an immersive moving image that will conform to a dome projection. The resulting images can be incorporated into a production workflow just as they can in typical 2D work. Illustrations or graphics can be set into the immersive space, which may seem daunting at first, but is simply an extension of the same principles that apply across all areas of Motion Design. Once a designer is familiar with thinking, literally outside the box, the world of immersive media becomes an entirely new set of possibilities in the creative toolkit.

Chapter 14
Professional Practices

Skill: the ability to do something that comes from training, experience, or practice.[1]

HARD SKILLS AND SOFT SKILLS

Any professional practice requires a mix of both *hard* and *soft skills*. Examples of hard skills for a motion designer include creating design style frames, working with typography, masking, rigging, composing in Z space, working with cameras, editing, compositing, and animating across a range of techniques. A minimum level of proficiency with these hard skills is what makes you employable at a professional level.

Although soft skills are less tangible, they are just as important. Soft skills are the interpersonal skills required to effectively work with others. Motion Design is a collaborative practice, and even solo motion designers still need to interact with their clients. No matter how talented a designer is with their hard skills, a severe lack of soft skills makes working with them very difficult. Some examples of soft skills include clear communication, reliability, focus, time management, adaptability, and situational awareness (the ability to read the room).

Although we continue to refine and improve our hard and soft skills throughout our careers, we need to demonstrate our qualifications for entry-level positions or opportunities. Making the transition from student to professional, or even switching careers, is a pivotal time. The first step is getting one's foot in the door of a creative industry, which might look like an internship, a freelance booking, or a full-time staff position. Capturing the attention of a potential employer requires a *portfolio*, the traditional tool for creative professionals to showcase hard skills.

Portfolio

A portfolio contains a curated selection of projects that highlight your skills, interests, and creative strengths. A Motion Design portfolio typically consists of a *demo reel* and website. Because Motion Design is so varied in its outputs and creative roles, there are no fixed rules about what needs to be included in a portfolio. In fact, the only rule is that *there are no rules*. However, your portfolio does need to work for you, meaning that it opens doors to new opportunities.

Demo Reel

A demo reel is your portfolio in motion. The term originated with edits of analog film on a physical reel that directors used to showcase their work. As technology progressed, demo

reels were presented on VHS tapes, CDs, DVDs, and USB thumb drives. Today, the name persists despite our reels existing mostly as digital video files on websites or social media channels. Regardless, the demo reel serves as a tool to demonstrate one's Motion Design capabilities. The traditional ways for motion designers to craft their demo reels is a montage and/or a series of completed projects.

Montage

In the context of a demo reel, a montage combines the best shots and moments drawn from the entirety of your motion work, edited together with music. The main advantage of a montage is the ability to show the range of your strengths and interests in a short amount of time. Other benefits include showcasing your editing skills and your ability to curate work. A montage should only include the very best examples of your favorite projects and does not need to be exhaustive. In other words, keep it short and impactful. The purpose of a montage is to give the audience a brief taste of your work and leave them hungry for more. If your montage captures their attention, they will want to dig deeper into your website, check out your social media channels, and hopefully schedule an interview to get to know you better.

Students often ask how long a montage needs to be. Again, there are no rules, but shorter is often better, especially for junior artists. Fifteen to 30 seconds of solid work makes a stronger impression than a one-minute montage that starts to fall apart. Disparity in the quality of projects included in a montage raises questions about one's taste and ability to curate their own work. *Less is more*, as long as whatever you include is your best. As your career progresses and portfolio grows, a one-minute montage becomes more appropriate.

Editing a Montage

Students will sometimes save their very best shots for the end of their montages because they want to finish strong. However, if the viewer's attention is not captured immediately, they will not watch the entire edit. Ask yourself, "What projects would I feel most disappointed about the viewer not seeing?" Identify your top two or three shots, and lead the montage with those. Starting with your very best work will draw in the audience. Ideally, you will still finish strong because you have edited out any weaker projects.

Once you have a strong open to your montage, create further interest by varying the types of projects in your sequence. For instance, if you open with dynamic typography, follow that with something graphic or illustrative. Then show compositing of footage, or photography, or a character animation before coming back to typography. The goal is to create a compelling rhythm across the range of your work.

General Suggestions

When choosing shots to include in your montage, you may have projects that contain multiple exciting moments. In these instances, creating a mini montage from a larger project is an effective way to highlight the best scenes from a single piece.

When reviewing student montages, one thing we always look for is examples of kinetic typography. Nearly every commercial Motion Design project has some typography included and showing competency with typesetting and animation is an employable skill.

In the context of a montage, it might help to speed up shots to fit the cadence of the edit. Ultimately, the montage is a new piece comprising your work.

Iteration

Although the montage is a serious part of your portfolio, it is helpful to view it through the lens of iteration. In other words, do not be overly precious about your first edit or series of edits. Embrace the process of curation and creative editing of your work. In a class environment, students often cut three to five versions of their montage before it really starts to feel strong. The most important ingredient when crafting your montage is that you are enjoying the process. If you are having fun while making the edit, chances are the audience will enjoy themselves too. Also, the montage is like a living part of your portfolio, meaning it will improve as you evolve in your career.

AUTHOR'S REFLECTION: AUSTIN SHAW

My first portfolio was a combination of a demo reel on a VHS tape and a black leather book that contained examples of my graphic design and illustration work. The process of making a demo reel was challenging. Once I had an edit, I had to either pay a service bureau to transfer my reel onto VHS tapes or beg the IT folks who worked in machine rooms—climate-controlled rooms that housed computer servers and tape decks—at my internship to make copies of my reel when they were not too busy. I also made my own branded labels with my contact info and attached them to each VHS tape.

Making a professional design book was also expensive. Each image was professionally printed, and I always wanted to have two exact copies of my book. Sometimes when I contacted a studio, they would ask me to drop my book off for a week or two for their art directors to review. The last thing I wanted was to get a call to meet another employer or client and not be able to show them my portfolio. So, I paid to have two design books made—one for drop-offs and one to always have in hand, in case I needed it.

I networked for contacts and literally pounded the pavement of New York City, bringing my portfolio to different studios who employed motion designers. As time passed, I improved and worked on better projects. When I did enough new work to warrant recutting my reel, the process started all over again. Eventually, DVDs came out and became a better option for the demo reel. I bought DVDs in bulk, rebranded all my labels, and got familiar with a DVD authoring software called Toast (which often failed).

In the early 2000s, I got a website and started to showcase my design and motion work there as well. It was quite a few years before website builders became a thing, so I would need to have a friend help me build a site or hire someone when I wanted to update. Vimeo and WeTransfer did not exist yet, so managing videos on the web was difficult. Delivering projects to clients was often completed by sending a DVD or physical drive via FedEx overnight shipment.

A lot has changed over the last decade. Tools like WordPress and Squarespace have made constructing portfolio websites extremely easy. Instagram and Twitter provide supplementary if not alternative platforms for online portfolios. Although I still enjoy creating and showing tactile work, I cannot remember the last time I had to bring a reel or even a design book to a meeting. However, despite the changes in where my portfolio is seen, the fundamental principles of curation still apply. I show examples of my best work first that represents the kinds of projects I like to make.

Web Presence

The last few decades have revolutionized the way motion designers can present their work. Websites can contain the entirety of one's portfolio, accessible to anyone with an internet connection. Although learning how to build a website from scratch is useful, especially regarding understanding the fundamentals of coding, it is not necessary. All we need to know is how to interface with the website building tool of our choice. Today, a website can showcase all the elements of a portfolio including a demo reel and design book. How you structure your website depends on your creative interests. But like a demo reel, lead with your strongest work. The design of a portfolio website needs to be clean, simple, consistent, and above all else, support the creative work contained within.

Showcase Process

Websites offer the opportunity to show the creative process behind a project in addition to the finished outcome. Including process gives potential employers insight into how you think, come up with ideas, and develop design solutions. Sketches, mood boards, mind maps, style frames, design boards, and other forms of ideation help tell the story behind the project. Like everything related to a portfolio, the process you choose to show should also be curated.

Social Presence

Although it is not required, showing aspects of your portfolio on social media channels is extremely helpful. If a potential employer likes your portfolio website and demo reel, the next place they will investigate you further is on social media. Although many of the same suggestions about curation apply, many designers also use social media to show process and experimentation. The immediacy of posting and interactive nature of audiences and algorithms provide a different level of engagement than a portfolio website. Savvy social media users generate massive followings that lead to new business opportunities and exposure. We may not be too far away from some motion designers opting to forgo a website entirely for robust Instagram, Twitter, or TikTok accounts.

Interviewing

Once a motion designer crosses the threshold of required hard skills based on their portfolio, potential employers will request an interview. For entry level, new hire, or new contract positions, interviews are the initial test of soft skills. The interview process is how an

employer evaluates a candidate's personality to determine if they are a good fit for their current needs. A motion designer should look at the interview process in the same way: an opportunity to discover important qualities about the employer. Although interviews can be a nerve-wracking experience, an attitude of curiosity can help alleviate some of the fear.

Punctuality

Effective time management is an incredibly important soft skill in any profession. An interview is the first personal impression you will make with an employer; so, do everything in your power to show up on time. Confirm any appointment scheduled—in person, phone, or video—prior to the actual interview. Double check your time zones if your interviewer is in a different state or country. Give yourself plenty of time and space before the interview so you do not feel rushed. If you are a person who struggles with punctuality, set multiple alarms or alerts to ensure you arrive early.

Be Prepared to Talk About Yourself

Of course, you will talk about yourself in an interview. However, practicing the way you describe your creative skills and interests is a good idea. Some people are naturally very comfortable with self-promotion. For those who may be shy when it comes to championing your own talent and experience, rehearsing is always advised. You want to feel comfortable expressing your creative goals and abilities in a concise and confident manner.

Do Your Homework

In preparation for an interview, research the company. Be ready to talk about why you want to work with them. In addition to paying your salary and benefits, employers spend an incredible amount of time and energy in training new hires. Employers want to know that you are genuinely interested in being a part of their team. What do you like about their work? What specific projects do you admire? Questions about company culture demonstrate you are inquisitive about what it is like to work at a studio.

CULTURE

Company or studio culture is an important topic to consider when searching for a job. Culture includes the explicit and implicit values, customs, policies, and day-to-day activities of a work or studio environment. This idea of culture also extends to educational institutions, departments, and individual classes. Creative studios come in all shapes and sizes, and the culture of the workplace has a direct impact on what it is like to work there. Studio cultures can range from *boutique* (casual) to *corporate* (formal). When starting a job search, ask yourself what kind of culture is appealing to you?

Boutique

Boutique studio cultures tend to be smaller, independently owned and run companies. Many design studios start as boutique operations. The culture is shaped by the personal philosophies and professional ethos of an individual owner or small group of partners. In the best scenarios, boutiques offer exciting work because they tend to push creative boundaries in

order to elevate the studio's portfolio. This pursuit of excellence can come at a cost, though: demanding hours, a competitive atmosphere, and stressful expectations. The reward for working in this type of culture is an accelerated leveling up of one's hard skills, personal portfolio, and expanded professional network.

Corporate

On the other side of the spectrum from boutique is corporate culture. Creative studios that are more corporate tend to exist inside larger organizations, or corporations. Brands, companies, or services that employ many workers often have internal creative teams. The culture of these creative studios is influenced by the larger company within which they are nested. Employee handbooks, human resources departments, and defined work hours are a few of the more explicit aspects typically found in more corporate settings. Although the work at a more corporate setting might not be as challenging or groundbreaking as a boutique, there are often clearer boundaries around work and life balance.

Spectrums

The spectrum between studio cultures is not static, and most work environments blend qualities of both. The preceding descriptions are quite general, and there are always exceptions. Sometimes, boutique studios grow large and must start adopting some aspects of more corporate cultures. Alternatively, some creative studios within large corporations feel more boutique. There are pros and cons to every culture, and the most important factor for any motion designer is finding a studio that is good fit in terms of aligning with their interests, goals, and values.

Professional Perspectives

Peter Pak

Interview With Peter Pak

What is your background?

I am a Korean American from the Los Angeles area. Ever since I was young, I really liked drawing versus anything academic. My parents recognized that early on and got me art lessons. I had a very traditional art and design background, lots of still life and landscape paintings. I went to Otis College to study concept art, to do matte paintings. I took one class and was like, "Oh no, this is not for me." But I took a Motion Design class, and it was something so simple, starting with ball bounces. But seeing the possibility of things in motion really sparked my interest. Having the more traditional background helped me as an artist and designer later on, because the fundamentals are so important. Because I had an interest in concept art, I think that helped me when it came to designing style frames. How much story and concept can you fit into every frame? You have to utilize every trick in the book. I started very traditional and evolved, graduated from school, and have done Motion Design ever since. I equally enjoy both design and animation. There are some people that love just one or the other. But I like seeing things come to life. Working at a smaller studio helped me develop a wide skill set, because you have to create a lot of it, versus only doing one thing.

Were internships a part of your career path?

I did internships, but I can't say they were too helpful for me personally. There was a lot of "here's some work, figure it out." There was not a lot of guidance. They just needed extra hands rotoscoping and pulling keys on green screens. Which is why when we have interns, I try to involve them in the process. Because I did not have a fulfilling internship, I try to do a better job as a person from the other side.

Where did you find mentorship in your early career?

I graduated from Otis and spent a year freelancing. That was a difficult period for me because I was straight out of school, barely had any connections, and my portfolio was all school-work. That first year felt like I wasn't progressing too much. But then I got a permalance situation at Digital Kitchen, which became a full-time job. Because there was a lot of different types of work at the studio, it helped me get really comfortable with all types of jobs that needed to be done. One project might be cute and friendly; another project was sports or something scary or horror. It also helped that my creative director really wanted to involve us.

14.1
Helstrom, title sequence created by Sid Lee for Hulu. Art director: Peter Pak.

When I first started designing for pitches, I had creative directors who were like Don Draper. They were the star, loved going into meetings, and doing all the talking themselves. This creative director actually wanted us to pitch our design frames to the client. At first, it was very nerve-wracking. But I got comfortable doing that, little by little. I would try to pitch it, and he would come in afterwards to fill in the gaps that were necessary. Having a leader that cared about the growth of the artists was helpful. As time went on, I got more and more involved in the process.

What are your favorite kinds of projects?

I do enjoy main titles, but it's not the only type of stuff we work on. The company has to do other jobs to pay the bills. Main titles are more the fun and flashy stuff. I don't mind that because if I was on main titles constantly, that could burn someone out. Lately, we have been working on a lot of exterior and experiential stuff. It's different, you have to think about the actual space the work lives in. Screens can be different sizes and shapes. That has been interesting. I really like Motion Design because the skill set is flexible. My skills can be applied for almost anything. Each project is bespoke, and I am not just working on one thing forever.

Can you talk about the Helstrom *main titles?*

I directed that project and figured out the key compositions. We had some animators who did most of the frame-by-frame animations. It was a lot of frame by frame, and it was my job to try and streamline the process. What in this project can we try to do in After Effects? If we tried to draw everything, we would probably still be drawing right now! We would try to figure out how to transition from each moment defined by the style frames.

The childlike drawing concept was the wild card idea in the pitch. During a pitch, we present several different ideas. We usually come up with 3 or 4 concepts. There are concepts that are expected; that is the trend. The wild card is something that is completely different. It mixes things up a little bit. When I come up with pitches, I try not to think too much about what our capabilities are. If it's a cool concept, we will figure out how to do it. If we need to bring in freelancers, we will do that. That way, we can create something that is appropriate to the concept, not just limited to our skill set.

What do you think belongs in the motion designer's toolkit?

Being able to talk about your work is fundamental. If you can't talk about your work, then you don't know why you made those choices. We recognize when something looks beautiful; there is something primal that triggers in our brain. It is our job as designers to know why that speaks to us and to be able to talk about it. When you can talk about it, it means you know what you are doing versus throwing stuff at the wall and seeing what sticks. When you learn how to talk about it, that will help you pitch and sell your work.

If you can look at something objectively and break it down to basic design principles, and know why it works or doesn't work, then you can figure out next steps. What does in need? What does it lack? That will help you later on when you become an art director or creative director who has to give guidance. The worst type of leader is someone who doesn't know what they want but will know when they see it. Get comfortable talking about the principles.

Do you have suggestions for young designers?

Once you graduate from school, you are thrown into the deep end. If you are applying for a staff position without knowing anyone at the company, it's hard to figure out the culture. Working in the type of environment where there are no bad ideas, where you are not shamed for anything, has really helped me. But you still need a thick skin, where if an idea you really like gets rejected, it's time to move on and come up with something better.

Where do you find inspiration?

Beyond Instagram and Pinterest, something I look at are video essays. If there is a movie that I like, I can find someone online who breaks down the meaning and principles in a 20- or 30-minute video. Listening to video essays has helped me learn and talk about subject matter. Being able to think in greater depth opens possibilities for artists and designers. You need to do your research to know when your reference is appropriate to use.[2]

NOTES

1 Skill. Merriam-Webster. Merriam-Webster. Accessed November 14, 2021. https://www.merri-am-webster.com/dictionary/skill.
2 Pak, Peter, Zoom interview with author, November 4, 2021.

Chapter 15
Business Tools

Approaching production from a business point of view is different from working with a purely creative process in mind. Creatively, we break production into a two-part process: *design* and *production*, or *concept* and *execution*. In the first stage, design, we imagine the look and feel of a project. The second stage, production, involves all the practical work required to see that vision fleshed out.

This two-part process needs to be broken down and staged somewhat differently when you approach production from a business perspective. Business is not simply the act of doing creative work and getting paid for it. Rather, it is understanding how your work and the process around it meets the particular requirements of *someone else's business*.

It is a professional service, which takes your expertise and adapts it to a given problem. To make this practice effective, you need a managed and clearly understood process for working with the client. You also need to understand how to measure your progress through different points in a production.

The kind of work that motion designers can be involved with today ranges from traditional screen-based work to assisting with interface development, or even working on large public installations that may involve very broad and professionally diverse teams. With these factors in mind, we can expand design and production from *think* and *do* into a more detailed set of *stages* that make the process clear for everyone involved. This clarity is particularly important for clients who may not fully grasp the work involved in a given project or during given stages in a project. Each of these stages should be used to think through a project as it is being developed.

MEDIA AS SOFTWARE

Media is ultimately a type of software—it runs on a platform, is designed to do things in a particular way, and expresses an *underlying idea or purpose*. So, a robust model for Motion Design takes elements from a software production process and adapts them to produce media as software.

Figure 15.1 shows the stages of production in this process.

The two processes, design development and production, are still here, but each is advanced through different smaller stages, which help to define the work and clarify requirements before moving onto the next stage.

DOI: 10.4324/9781003200529-16

Design Development	Scope Specification Design
Production	Build Test
Distribution	Implement [master] Review Maintain

15.1
Production stages.

SCOPE

Scope is a survey of what a project entails, including the creative approach, delivery plat-forms, intended duration, and often different versions that may be required—in simple terms, "How much" of "What exactly?" Scope is perhaps the least considered part of pro-duction for designers because their natural instinct is to leap into design. Working on scope is important because it allows an extended conversation of how a project might develop. It also offers an important moment for the designer to integrate their professional experience into the process and how the work is matched to the creative brief.

Some scope discussions are simple. A 15-second TV commercial from a provided script is fairly straightforward, but it is still important to understand what a client intends to do with the work at this point. What assets are being developed, and where else might they be used? Is there a social media or print campaign involved? Are alternate versions required for non-broadcast screens, such as online video pre-rolls? Maybe there needs to be a 5-second version and so on.

Clarifying the different elements being created, particularly with respect to design con-straints, is essential for multi-platform delivery. Work that has multiple delivery formats will mean that the resolution or aspect ratio of graphic elements or text might be a critical con-sideration. Medium shots well on a cell phone but may be a little confronting on a larger TV. Text that works well across a widescreen TV might crowd a social media format or seem too small on a pillar box or vertically oriented screen.

For more complex projects, scope offers the opportunity to better understand a client's needs. A museum installation, for example, might require a longer discussion of curatorial requirements, visitor circulation patterns, and even the technical delivery and format of the exhibit. This type of project can be a great opportunity for an experienced creative to really help

define and clarify the scope of the work and to make suggestions that significantly enhance the final result.

> **I like to make works that are site-specific, and so the envelope for the work is non-traditional in format and usually aspect ratio. If you simply hang another screen in space—like a TV on a Greyhound bus or those ones, they have at the gas pump—it's just another screen. If you play around with the parameters, then you make something that is not like a TV or a browser, and immediately you have people's attention. But then this makes things hard to do; each one you make is its own prototype. And so, it requires care in the selection of hardware and the provision for future maintenance of the screen hardware, and so on.**
> *Michael Thomas Hill, Creative Director and Studio Principal, Lightwell*

Scope is a good time to discuss the delivery of production assets: project files, unique artwork, 3D models, or audio originals if these are required. Clients may not understand that they are paying for the final work—and that releasing production assets (usually referred to as a *buyout*) may require additional negotiation and a higher price. Be clear about the exact deliverables and what production elements are not included.

This discussion can actually be empowering for clients because they feel more involved and better informed about the work to be undertaken. It also gives the designer/producer the opportunity to highlight their professional expertise and its value for the project. Ideally, a client should feel a little more involved with planning the design, and the designer should feel a little more engaged with the client's needs after scope discussions.

Think of the scope process as a time to gain clarity and confidence and to collaborate at the start of a project through clear communication. The scope process may run from a half hour to a week or more depending on the project, its complexity, and its deadlines.

MAYBE WE COULD . . . ?

Scope is frequently open to revision and review: when a client comes to you with a project, there is often room to suggest a shift in scope that allows your subject matter and production expertise to add value to a project.

Clients often base project briefs on something that they have seen elsewhere, which offers the opportunity to make recommendations on project formats, creative and technical approaches, and even the scale, quantity, and format of work.

Advertising agencies will often have strong creative and media requirements, so the scope of the project is open to mainly creative and production advice.

Working with clients directly places a freelancer or studio in the role of both production provider and creative partner. Clients who bring work to you directly are generally more open to thoughtful suggestions about how to develop and deliver the work, so scope is often more open to a dialogue on how to make the work the best it can be.

One tendency we all struggle with these days is "brief-by-YouTube," where a client has seen a fantastic video online and wants to produce a similar thing. If we have been approached directly to deliver a concept, we always try and find something cool to do so we can stay ahead of the curve and try to push clients into something they might not have seen before. Within our production team, we have producers and designers and programmers, and each brings to a brainstorming session something they'd like to try, or a way to make things fresh.

Michael Thomas Hill, Creative Director and Studio Principal, Lightwell

SPECIFICATION

In software development, writing a *functional specification* requires clear documentation of all a product's *exact* attributes. In a complex website or a game design, these documents can run to hundreds or even thousands of pages; they serve as a reference how a user interacts with a work, what it looks like, how the components of the system are designed, and how they work together. A large production team will use this document as a guide for everything in later production.

For Motion Design, specification can be as simple as a set of deliverables, the resolution, compression requirements, duration, color space, and audio format of the work. An online video, for example, might be delivered with a particular set of compression requirements, such as an MP4 and as a separate master copy, without compression, as a project archive.

Deliverables that span multiple formats and platforms should include a documented list or *matrix of deliverables* and assets to define what is delivered at the end of the production. This overview should take the scope into a clear set of defined objectives and list the various versions and formats required.

So, think of this part of production as stepping back from the *doing* to make sure that all the parts you need are in place before you start the work.

DESIGN

Once the scope and detailed specification of a production are established, the designer is in their most natural element. The design process will make a detailed proof of concept that gives a sense of the look and feel of a project to a client and internally to a team of artists who may need to be briefed on the production. Scope and specification are for agreeing on *what* is being done. Design is how it should *look*.

Style frames might have been developed as part of a pitch to secure the work and to communicate your creative intentions for a project. Whereas *pitch* style frames are a way of getting the work in the door and building creative rapport with clients in the pitching process, *production* style frames should be more detailed to show *exactly* what a work will look like. These production frames might extend and clarify the ideas that won the pitch.

Making detailed frames *before* moving to production allows a client to see, ideally, exactly what a work should look like as a high-fidelity rendering, and importantly, to sign off

DELIVERABLE MATRIX

Campaign name / Year / Market sector			
Release Dates (Campaign Date begin : Date Concludes)			
Video Prerolls			
Platform	YouTube	Pandora	Twitch
Start Date	Oct 1st	Dec 1st	Dec 1st
Max File Size	1GB	50 MB	5,000 kb
Language	English	English	English
Dimensions	1920x1080	640x480 1280x720	1920x1080
Aspect Ratio	HD 16:9	HD 16:9	HD 16:9
Video Length	6s 15s 30s	30s	15s 30s
Submission Format	AVI ASF Quicktime Windows Media MP4 MPEG	Mov MP4	Mov MP4
Frame Rate	up to 30	24	up to 30
Bit Rate	15mbps minimum/video 192kpbs minimum/audio		
Audio	between -25db and-29db		
Drop Dead	Day/Month/date		

15.2
A deliverable matrix will not only outline intended platforms for versions of work, but will outline file and formatting requirements across multiple, often similar delivery platforms. A designer needs to keep these differences in mind when preparing to deliver a commercial campaign.

on the look and feel of each frame. The remark "That's not what I thought it would look like" is avoidable if detailed production frames are signed off at this early stage.

Making frames as *production ready* concepts may also integrate some of the later production work into this early part of the process; assets developed here can be used in the final production. Production ready assets are more useful for a team handling different parts of the production than a pure "look" that may be difficult to develop practically. At the same time, larger teams can push the boundaries by using a concept artist and working out how

to bring more complex, illustrative, and adventurous frames to life. It is important to let style frames work within your process. Making a "fake 3D" element in Photoshop to get approval on design only means that this element needs to be developed later from scratch. Making the 3D model for the style frame means that an asset that already exists is possibly ready for animation at the start of actual production.

Lower fidelity versions of work—animated thumbnail sketches, boardomatics, motion tests, or animatics—will help refine the production process and communicate this development work to a client if it is appropriate. These are discussed in detail in Chapter 10. Project stages are simply guides for refining a range of possibilities into a specific execution, so think flexibly about how these stages apply to your project.

For some projects, the process of development may be heavily research based, so the design phase may constitute *most* of the work. In the case of Motion Design for UX, a motion element on an app used by millions of people may have been through dozens of versions in the development phase. The final production requires refining the chosen candidate. In these cases, design and production will bounce back and forth as an integrated, evolving process.

In Figure 15.3, we see the Messenger Illustration System designed by Stephen Kelleher for Facebook. This project exemplifies a robust design system that integrates both Motion Design and UX on a global scale.

With over 1.3 billion users, Messenger has grown to become one of the largest communication platforms in the world. As a part of their global brand relaunch, they wanted to completely overhaul their in-app illustration system. The ask? To create a sophisticated, universally understandable language whilst establishing an ownable and versatile aesthetic. No problem!

Directing a small international team, we developed process guidelines as well as a complete suite of use-case illustrations both static and animated. Our starting point was to establish a conceptual basis for the illustrations; the integration of clear iconic imagery with the UI surface itself. From there, we formulated design and animation principles which not only reinforce concepts but improve overall user comprehension. This new system of process rules ensures a cohesive brand voice whilst helping users better understand content, features, and information.

Stephen Kelleher, Creative Director and Designer

CLIENT LIAISON

Working with clients is really about communicating your approach and what you need from them to meet their needs. This process applies particularly to revisions and communication for progress check-ins. Some clients like to see, or even need to see extensive process development. Other clients might suddenly say, "Is that what it will look like?"—mistaking a rough animatic for something closer to the finished project. Always be clear about exactly what you are showing and why. Try to let your client know ahead of time the range of feedback you are seeking at a particular meeting to avoid an open brief for change.

Some clients may want to alter or adapt the look of work once it is quite close to finished. *Late revisions* to a project—asking for a new idea or look late in the production

15.3
Messenger Illustration System, designed by Stephen Kelleher for Facebook. Creative director: Graham Hill.

process—call for an *additional* scope, as they are like a new "mini project" or even a complete restart, taking the work back to the early stages. Signing off on agreed design documents as the production progresses will help to clarify what is open to further review and what has been decided. Late additions will call for additional scope and a new fee proposal for the variation.

This *overage* will create either a new piece of work or, if the client does not want the additional expense, avoid the costs of revision (for the designer) late in the process. So, agreement on creative design is essential before heading into full production. Orient your clients in the stages of production so they understand why late revisions are not so simple. The design documentation should be matched with a clear schedule that builds clarity for everyone involved.

If a designer simply *designs* and *makes*, then there is a communication gap between the client and the designer. Each is living in their own world and working only from their own experience, which is not a great model for collaboration. Production stages should frame design as a creative service that provides a common language to make the design process coherent, so that everyone understands and values it.

Extended Design and Build

Some projects involve an extended design process. This circumstance is often true for work that may have a long public life cycle, like a permanent museum exhibit, motion as identity design, or design for UX that may roll out to a highly distributed audience of potentially millions of users.

In the example of the museum or similar public installations, the work will usually be developed in consultation with curators, public trustees, and other stakeholders. This style of production is usually undertaken with a very long development time factored in.

For longer, more complex projects of this type, the build phase may integrate ongoing design stages and prototypes as part of the project's development. These milestones in turn require additional presentation and review, so the project should have clearly planned reviews in advance. For extended timelines, these reviews could be bi-weekly.

In a different way, very public UX projects can mean a Motion Design team is involved with an extended period of client review and interaction, with the external (design) team working alongside an internal (client) team, each with multiple members.

UX work may involve multiple rounds of design, presentation, prototyping, and collaboration with project stakeholders. Even small adjustments to UX for online services may address massive audiences in a very public manner, so multiple designs may be put into small-scale user testing before build approval. For UX/UI projects, this iterative development and evaluation is, in a very practical sense, embedded into the work.

Iterative user testing is essential to integrate user feedback, and it is also important for a client's internal risk management. Prototyping and assessing options during design testing may be so extensive that the build is mostly integrated into the process, and at the end of the design phase, a particular *candidate* build is simply chosen for implementation. For these types of projects, the design process will involve constant short design sprints and progress reviews. Because of this dynamic, almost all a project's fee proposal may come from this extended period of design development and evaluation. So, these types of projects need to be budgeted with this consideration in mind.

LINEAR MOTION WORKS

For more traditional production processes, shooting schedules, crew bookings, production plans, and budgets are all parts of the "design" phase that make later stages of the production process more efficient and effective. Based on your production style, develop a checklist that answers the who, what, when, where, and why of your production plan.

A studio shoot with elements shot on a tabletop needs a particular set of equipment, specific physical space, lighting setup, camera, and a smaller crew compared to a shoot involving multiple people with sound recording, specialist camera support, and hair and makeup.

Make a checklist of:

Who (crew—who is doing what)
What (style of production and the resources needed)
When (schedule and dates)
Where (location or studio)
Why (how the work is used in the final production)

This checklist can help you plan effectively not only for the production but also for the break down and management of your own internal costs.

Combining studio days, minimizing the rental period of an expensive item, or scheduling the availability of key talent into single calls are all things that can have a major influence on production schedules and costs. So, they should be considered in pre-production. Using this staged model to understand production means that design is understood creatively *and* practically.

Design is a series of creative propositions mapped to a series of practical steps to make the best use of resources. The stages, timing, and requirements of the process must be communicated to everyone involved, which includes crew members, clients, and collaborators who may be part of an extended creative team.

PRODUCTION: BUILD

Think of the *build* stage as the start of actual production. Everything you consider in the design process is ready to be put into action.

If you were making a film, the build would start on the first day of shooting, when all the plans, schedules, crew detail, budgeting, production design, and script elements are in place. Cast, crew, and equipment, potentially involving dozens of people will be ready to turn up for the first day of a shoot. Shot lists are ready, and the script pages for the day's shoot are circulated to the cast and crew. Film production requires detailed planning and precise scheduling because there are so many people involved and so many variables in play.

Motion work also becomes more complex as projects, budgets, and teams get bigger. Although you may develop and integrate 2D and 3D elements for a project by yourself as an artist/designer, you may also be part of a team that works in a very specialized manner. In these situations, single assets come together as part of a complex composited frame, and finished shots and sequences are later edited into the final production.

Other elements, like audio integration and mixing, may involve the work of specialist collaborators. Sequencing and planning each phase, making bookings for facilities, and putting holds on the schedules of important freelancers has to be done before the build/production begins.

One of the best ways to imagine your toolkit here is building a house. Ideally, the scope (where it is located, what style of house, how many bedrooms and bathrooms) is taken into a detailed specification (a layout, exterior sketches, and a list of finishes), and then the detailed design (plans, drawings, and a construction schedule) are produced.

A single contractor can build a house, but they will almost always call on specialist tradespeople for specific expertise, or for cost efficiency, at key stages in the process. Most people can learn to lay drywall, but a specialist team can finish a project in a matter of days. So, even an experienced contractor will call in specialist help where it makes sense for cost and efficiency. Events during construction need to be scheduled so certain elements are in place before other parts of the build can start. A drywall team, for instance, needs not only framing, but electrical wiring and plumbing to be in place before they go to work.

In media production, specific skills like cinematography, hair and makeup, sound recording and mixing, music production, 3D animation, or even production management will often require specialist expertise. Every motion designer, and every studio, needs an inventory of their core skills and a set of reliable collaborators who can add additional expertise where it is appropriate. In the same way, as motion projects involve more people, the scheduling becomes more complex.

PRODUCTION SCHEDULES

A planning tool used in production management for construction and other industries is the Gantt chart, named after Henry Gantt. Developed in the early 20th century, this tool simply looks at time as a linear calendar. It is used to plan project stages and their dependencies—what things need to be complete before a new part of the process can begin. This outline is called a *waterfall* model, as each stage "flows into" the next part of the production process.

Production Schedule

15.4
Production mapped to a Gantt chart in the design phase will need awareness of what is dependent on other assets being completed. This outline is often called a "waterfall" model, and sequential processes flow, top to bottom, while the time each step is expected to take is mapped left to right. The format is easily adapted to any production process or style of production using a simple spreadsheet program.

Scheduling production with a Gantt chart will never be totally perfect because unexpected schedule overages or delays can happen, impacting the *flow on* effect, perhaps even stalling further progress. At the same time, some things can happen more quickly than expected, freeing up the schedule. What is important is the overall production "map" and visualizing production as a *plan* and making that plan into a schedule.

SHOT AND ASSET LISTS

On a film shoot, each day will have a running order and a shot list. The shot list will be posted during the shoot, and progress in finishing shots will be measured as the day progresses. Each day's shot list is a plan for the fast-moving process of production and outlines what needs to be done, where, by who, and in what sequence.

(A)

(B)

15.5

(A) Storyboard sequence: "Booby Health" by Stephanie Stromenger. (B) An animatic frame from the storyboards with frame numbers overlayed.

"Booby Birds" | PAL 1080p | 25fps / 16/48 Stereo

Shot	Storyboard frame	Frames	Background	Background animation	Character assets	Pencil test	Outlines inked	Fill / coloring
Shot 01 00000 :: 00051		52 frames						
Shot 02 00052 :: 00108		56 frames						
Shot 03 00109 :: 00148		39 frames						
Shot 04 00149_00200		51 frames						

15.6

The shot list as a matrix, showing each shot, the duration, and the stages of completion.

Motion work is itself like a film shoot, but each shot is produced from multiple elements and processes and may be produced completely in the digital environment. It makes the distinction between asset creation (shoot) and editing (post-production) more difficult to separate, but this tool still allows tracking of a project through a shot list.

Tracking progress in a shot list should start with the storyboard and an animatic of the work.

For example, making a rough boardomatic involves taking the frames (see Figure 15.5A), into a sequence of shots. At this stage it is useful to overlay *frame numbers* into a corner of the animatic (see Figure 15.5B). This process is the first stage in making a *shot list*.

Shot duration and the production stages required for each shot can be laid out in a simple matrix.

Figure 15.6 has a list of shots, the duration of each, and a process, left to right, for creating the assets and integrating them to complete every shot. The cells for these can be set to *red* for incomplete and changed to *green* once they are finished and ready for the next stage. Even though this work may take place over an extended period of time, and using a number of artists, the production matrix will serve as a shot list and progress tracker for the various stages of production.

TEST

During any production, there will be multiple stages of testing and refinement, from an artist assessing the success of a timeline adjustment or an edit to a team or client review of work in progress. Feedback is intended to make sure that everyone involved can make observations and suggestions on work so that it develops with a sense of participation and agreement in line with the design development. Production is always a process of development and refinement. Adjusting timing, edits, and other specific visual elements are all a part of any production process, so having agreement on these changes as the project develops is essential.

Once you reach completion of the build phase there is usually a formal review process where the final work is presented to the client. For these final reviews, try to outline *what*

15.7
A sample workflow for revisions and approvals.

is and *what is not* open to change. Set an agenda for this meeting of the feedback you are looking for (and what the client will decide on) ahead of time. If your client has signed off on style frames, and you have completed some basic motion tests and integrated client feedback progressively into the work in progress, there should be no surprises.

A good idea at this stage is to outline a couple of questions, possibly with a choice of options, to give the client a starting point, and a boundary, for the review. Projects can take so many forms that the process of revision is sometimes a matter of interpretation. Some clients insist on it because it raises their importance and status in the project, bringing them back in control of its development. Other clients are easier going or trusting of the collaboration process, so may be less inclined to make changes. Developing set ideas for *what* to review makes client's input valuable, but also specific, at later stages. Set clear grounds for collaboration and feedback.

DELIVERY: IMPLEMENT, REVIEW, AND MAINTAIN

Project completion is always defined by the delivery of the final "gold master," or the set of deliverables outlined in the specification stage of development. Projects that are well received are often extended and adapted, so there are frequent opportunities for additional work as you review and maintain a project.

To maintain a piece, you might make regional adjustments, alternate versions, or even launch entirely new campaigns based on existing work. Often templates or assets used in a particular piece assist with the rapid development of a follow-on project. These extensions of existing work are opportunities to earn additional fees with much of the "heavy lifting" already done. Design, client feedback, and even assets are all in place. So, the process for making another piece of work should be faster and a little cheaper for the client, but not too much cheaper. Extensions of existing work are great opportunities to save the client a little money, but also afford a very efficient production process for the designer! These follow-on works are often very profitable projects for a studio for the time involved.

Think of the broader economy. There are opportunities to sell products, and opportunities to sell services. Most motion work is a service, like other professional services such as lawyers, accountants, media practitioners, or personal care services. These examples involve paying someone with very specific expertise to deliver a service or to solve a problem. Other sales involve products, which are more likely to be mass-produced to some extent, to be competing with similar products based on perceived value, and to address an apparent need for the buyer.

Product	Service
Produced in quantity	Produced through applied expertise
Needs to differentiate itself from competitors	Needs to differentiate itself on experience
Perceived value	Value realized in solution
Solves a perceived need	Solved a perceived problem
Economies of scale	Economies of scope

Products have different prices and may involve smaller niches that compete on a perceived value (perhaps prestige) and not on price. Mass-market products will typically be more subject to price competition, so they use branding to increase the perceived value of the product because they are competing for economies of *scale*. It does not matter if the product is soda pop or luxury handbags—each will look to maximize the number of sales in its niche.

By contrast, the service-based business makes the experience of the work, the relationships involved, and the quality of the solution to the problem part of its competitive edge. Getting more work, and more attractive work, is maximizing the economy of *scope*. Because most production work is in the services category, it is very difficult to think in terms of scale.

The opportunity to make serial versions of a work may not be a design challenge, but it offers one of the few access points where a creative business has something resembling mass production. The work will still retain some of the assumed value of production itself, and so it is a good idea to develop these opportunities when they present themselves, as they can be very profitable.

TEAM MANAGEMENT

As projects scale and become more complex, teams also become larger, more complex, and potentially more specialized in their composition. For example, some workflows in social media projects can be completed by a single designer liaising directly with a client. However, once work reaches any larger commercial scale, there will usually be multiple people involved on both the client team and the design and production team.

Planning the stages that take a design from idea to implementation and tracking these through production becomes important on any project, from a student's final capstone production to a fast-moving studio production involving multiple team members and freelance production crew. Complex projects with multiple stakeholders and high client involvement will usually benefit from the establishment of a group chat or communication platform

devoted to the project. Instant messaging, file sharing, and progressive approvals can take place very effectively even with a widely distributed or very complex team, making the need for physical meetings or even physical proximity less of an issue.

TRACKING MILESTONES

Milestones are points in a production that indicate that a stage is complete, or a given time has elapsed. Milestones are important not only to track production but also to meet agreed terms of payment with a client.

Payment on completion is never advisable for two main reasons. The simplest is that you work without cash flow to manage expenses, which is never a good practice. The less obvious issue is that you have not exchanged anything with the client; you have simply started to work, which removes obligation from their side. *Using milestones to trigger payment is important to register an exchange of value (consideration, in legal terms) and to align the work and payment into an agreed schedule.*

Many commercial projects are simply started and completed within an agreed time, which makes payment a simple matter. If you use the staged/software model of production, you can usually break your payments into two stages: one on commencement (the start of the process) and one on completion, usually due on delivery of the final master.

So, it is easier to ask for a "commencement payment" than "money up front." The first sounds like you are starting work, whereas money up front sounds shady. Many times, scope can be dealt with in an initial meeting, and it is good to clarify the details of your understanding in writing to the client after this first meeting. In this communication, you can let them know that the next stages also call for a commencement payment. The exact timing of this negotiation is open. However, as a rule of thumb, if you need to extend your professional engagement beyond one or two meetings and some pitch development, you need to request a commencement payment, or to request a suitable fee for an extended pitching process.

Asking for 50% of the budget for the initial payment is quite reasonable, as you should be productively engaged with your client by this stage of the process. By comparison, waiting for a *completion* payment of the entire project budget gives a client unnecessary leverage over the final work, allowing them in some cases to force changes or hold the payment back for a variety of reasons. It also makes your cash flow more precarious, and so staging payments and outlining clearly when payments are expected helps moderate these issues.

There are clients, particularly ones you have worked with repeatedly, that may be good candidates for a final and full payment on completion. You will usually know these clients well enough to have the trust and engagement issues in production and payment worked out well in advance from previous work.

Some work that happens for extended periods will require multiple, staged payments. Examples include true design development–focused projects, or larger, team-based public installations, where the process could stretch out for six months to a year. In these instances, the budget and scope of work may involve numerous subcontractors who need to be paid. In these scenarios, break the process into multiple smaller deliverables or time periods, such as a monthly payment. A Gantt chart can be useful to outline this timeline. Clients working

on these larger scale projects have the budget allocated for the work and will usually be quite agreeable to multiple milestone payments at the completion of key phases of production.

CONTRACTS AND AGREEMENTS

As noted above, a *contract* is legally formed when two parties exchange something of value, which in legal terms is referred to as *consideration*. A contract only needs an offer, and acceptance of that offer, along with the exchange of consideration to form. Consideration might be specified work for an agreed amount of money, or an agreed amount of money for a car. Legal issues with contracts arise when someone does not fulfill their obligation to provide the consideration they agreed to, but it is also worthwhile noting that most legal issues are avoidable with clear agreements in place.

The various written documents that people sign to outline different terms of a contract are really just the written record of terms: they are a *record of agreement*. These documents state in usually quite precise language exactly how much of what is to be exchanged and are signed to recognize the acceptance of the terms they set out. Verbal agreements can have all the weight of a written agreement in forming a contract, but unless there is a record of what was said, the details may be ambiguous.

So, written agreements (to form contracts) are useful to outline terms, details, and each party's acceptance of the terms. It is good to formally note your agreement with clients about the scope of work and the terms of payment in a written document, which can also highlight a range of things such as the agreed review process, when milestone payments are due, and even where and how work might be completed.

It is worth noting that these terms can also be exchanged and recorded through an email conversation where the offer from each party is made clear and acknowledged by the other party. For many smaller projects, this email exchange is entirely sufficient. However, for larger, more involved projects, there is usually a written agreement signed.

Short form contracts for motion designers can be found in many places, and the Graphic Artists Guild *Handbook of Pricing and Ethical Guidelines*, updated annually, is a great place to start for sample agreements for graphic artwork and production, as well as a range of other useful resources. It is usually a producer or business principal's role to execute agreements in larger productions, but the individual designer or smaller studio should be aware of this process as a tool for managing their business effectively.

COPYRIGHT, INTELLECTUAL PROPERTY, AND WORK FOR HIRE

Copyright is often misunderstood because it is quite specific in what it does and is also important when you are working in a creative field. Copyright protects the concrete expression of an idea, not the idea itself. Everyone can use ideas, as they form the basis of culture at large, but the rendering of that idea into a specific form through creative activity—a performance, an image, a script, or written work—leads to the automatic formation of copyright.

Creative people automatically own the copyright to their creative works. This fact divides the underlying process from the work itself. Ideas and processes are common property, but their original and unique expression in a tangible form is not.

In the same way, *patents* protect specific novel technical processes or inventions. You cannot patent a "robot" because that idea exists broadly in the cultural imagination. But a specific engineering innovation in robotics, that can be defined, and is registered with the US Patent Office, can be a unique piece of intellectual property. Patents, unlike copyright, must be novel or unique processes, and they are clearly defined, documented, and must be registered.

So, for the creative person, *every* unique creative act is in and of itself a production of copyright. If you take a photograph, the resulting image is a unique and singular creative act. You cannot copyright the subject, your technique, or the "idea" of the work, only the image itself.

Intellectual property and the way it is understood is such a wide area that it sustains countless legal careers around the world, so its interpretation will not be settled here. What is important is how this principle applies to motion designers. Motion Design naturally produces work that is the copyright property of the designer. There are two important exceptions to this rule:

1 When you work for someone full time, it is understood that the work you do for them is subject to their immediate ownership. If you work on salary full time for a production studio, they automatically own the copyright to your work
2 You are contracted to work under a *work for hire* agreement. This type of agreement notes that the work you undertake, as a freelancer for example, is considered work for hire. Under this type of agreement, your work, including any intellectual property arising from that work, has its rights assigned to your employer, in full, as part of your contract.

This type of agreement is *everywhere* in creative freelancing, so expect to see it (or use it) as a normal part of your work.

THE FREELANCE INCENTIVE

Most studios have a roster of core creative talent and a pool of freelancers they cultivate to allow for production flexibility. Key personnel give a studio its creative core, but they are also *fixed costs*. Their salary, benefits, and the cost of their equipment are all expenses that need to be met every month. As work cycles through busy periods, they may be overwhelmed with work. In quieter times, they may be working on in-house projects for a period.

Freelancers allow a studio to do three things: (1) they allow for additional production capacity as it is needed when there is a surplus of work; (2) they allow specialist skills to be integrated into a project; and (3) they provide new creative perspectives and skills.

Some studios, for example, have little call for 3D work, yet they can often hire in an expert for specific jobs, making this skill set a part of their offering, but only as needed. The higher daily cost of the freelancer is justified by the value they bring to a specific project. In some cases, freelancers who are great generalists can add extra capacity simply because there is a lot of work in the pipeline.

Many seasoned designers, such as experienced concept artists, will be called in to produce style frames when pitching for new business. Sometimes a different creative vision

and a fresh set of eyes can develop an idea that expands the creative palette of a studio, and the highly developed design aesthetic in a unique pitch book will make the difference in winning an important bid.

So, freelance is not only part of studio life but also part of the working life of most designers who may enter the industry on a freelance basis and may work in this capacity several times during their career.

THE HOLD SYSTEM

As studios approach upcoming work and prepare for bids, they will want to secure the right people for bigger projects. Freelancers are booked and contracted for work. However, for work that is not yet confirmed, a studio will put the artist "on hold." The hold system is based on an option for work, but it is not a guarantee. An artist may be asked to be placed on a *first hold* for a job, which is pending. A second studio may put the artist on hold for the same period, but this is the *second hold*. If the second hold is confirmed, and the work is going ahead, the artist must seek a release from the first hold. The first hold studio may still want to carry the option to hire the artist for the job, and so they confirm the booking. In the meantime, the studio with the second hold needs to find another artist to book. Some freelancers may accept first, second, third, or even more holds on their time.

In some cases, the work for the first hold never materializes, and so the artist is left with no work for the period. Because of this possibility, many freelancers always *put a first hold on themselves*, and they can "release themselves" to the best work that appears at the time. *This flexibility is very important but comes with the vital provision that the "self-hold" is never disclosed to clients.* Client's holds should be booked in a calendar, with the second and third holds clearly marked, to see at a glance what work is upcoming, to decide which work to take as it is offered, and most importantly, to avoid double booking.

Freelancing, as a natural part of the working landscape, touches all motion designers. In arts-based commissioned works, these types of projects are inherently freelance. They are always on an as-needed basis, but the creative rewards are extremely high. For some designers, freelancing allows them to work remotely and set their own hours. For others, they have a skill set that is in demand, and they can work as much as they need to, at a higher rate, as a freelancer.

Whether an individual, studio, or business, in some ways everyone is a freelancer pitching for work, proposing projects, and looking for new opportunities. The business of Motion Design needs a clear appreciation of structure, process, management skill to communicate with clients, and to complete work effectively. At the same time, the constant development of new projects and opportunities requires creativity, flexibility, and imagination. A good business toolkit allows for a little of both approaches: a solid structure combined with creative flexibility.

BUILDING REPUTATION

Reputation is the currency of a career. There is no form of marketing, promotion, or demonstration of your capability that will secure work more easily than positive experience from people with whom you have already worked. The easiest job to get hired is the second job from an

existing client. If a positive experience results from working with someone, they will hire you again because the alternative—working with someone untested and untried—is a risk.

Risk, as a principle, also guides people's thinking and action in commercial contexts. Nobody says "let's take a chance" when their money, reputation, and job is focused on the result (unless of course it is a "low-risk" scenario). Most of what you will be called on to do as a designer or studio is based on removing as much risk from the outcome as possible.

Again, reputation makes a difference. When you are booked by a new client, they have usually assessed that you are a good choice for the work at hand. Often, they will have asked someone else you have worked with or done some other type of investigation to make sure they feel comfortable with your work.

Professional Perspectives

Erin Sarofsky

Interview With Erin Sarofsky

What are your thoughts on the state of creative industries?
Well, the lines are blurred now, that's for sure. Even though there are still generalist designers out there, there is more specialization than ever. That's because the industry has grown in scale enough to accommodate artists and studios working exclusively in specific styles and techniques.

Also, with the high demand for Motion Design artists and the growing number of working artists, companies are bringing that capability in-house. So, although boutique studios might attract the highest levels of design talent in their marketplace, there are still plenty of talented motion designers out there making great content for business directly.

What do you mean when you describe Sarofsky as a "generalist studio"?
For me, being a generalist studio means that we are design led. We don't have a preconceived notion about what a project should be based on our house style or what is popular at the time. We allow the brief to present the problem and use design to solve it.

How does someone who is interested in Motion Design build a mix between generalization and specialization?
I think it is really about the core of the person. Generalists are people that are really good at exploring a range of things, including working in a variety of different styles and environments.

They are not afraid to dig into something unexpected and opened minded about where that is going to lead them. I think specialization is like "I really like Houdini, so I am going to know everything about that software." Or even more granular, "I really like doing mist and smoke in Houdini, so I am going to learn everything about that." Those people are specialists. They tend to be much more focused, even from the beginning of their careers.

Generally speaking, I think generalists are more rooted in design, whereas specialists are more rooted in technology. Traditionally trained designers tend to be better generalists because they are problem solvers on a conceptual and stylistic level. Specialization is really learning how the tools work to get a desired effect.

We need both of those types of people in the industry. Sometimes you just need the person who knows everything about mist and smoke and sometimes you need an animator to make something cool out of some type and stock elements. That's what cool about the industry right now: we have so much talent out there and so much opportunity.

15.8
In the Year 2525, title sequence for FITC. Created by Sarofsky.

What do students need to know about the business of Motion Design?

To start, students should know about producers. A producer is the person who manages the client, sets expectations, and makes sure the budget and schedule are adhered to . . . well, as close as possible. You and your peers will be working very closely with a producer. Think of them as the quarterback. . . . while the coach is your creative director.

Also, the infrastructure required to operate is far bigger than students typically realize. Yes, we have workstations, software, plugins, fonts, comfortable chairs, and the mainte-nance of all that. But a studio needs so much more infrastructure than that: security, a proper

backup system, firewalls, storage, battery backups, communication tools, resources and software for staffing, HR, bidding, scheduling. . . . all sorts of things. It's important to know that you and your work are important, but so are many other things.

How do you approach project scope?

When a client says, "Hey, we have a project"—that always looks different. Sometimes they send fully fleshed-out boards with a schedule attached, and a budget, and some stock footage they think could be appropriate. Those people are super-buttoned up. But. . . . sometimes, people say "Hey, can we get on a call?" They screen share and show some YouTube examples. Every client is different, and the brief can come in a bunch of different ways.

We digest the information and, if we are interested in perusing the job, build a bid and a schedule. We do that before we do any creative work. We talk internally about how many people it's going to take and how much time we need. Then we get back to them with the topline of what we've distilled—how many people it's going to take, how long, how much it will cost, and the deliverables based on that. With that comes the scope. So, if they change the creative on us, or add deliverables, we have a paradigm in which we can charge overages. It creates a real clear menu, so to speak, of what they are getting for their money.

How does your studio approach creative explorations for clients?

Everything is different. It depends on who the client is, and what their client needs to see to feel comfortable moving forward with you as a partner. Motion tests, style frames, illustrated storyboards, or a shot list may be appropriate. A lot of writing, people read more than you think.

If I were going to encourage students to do anything, I would say take some writing classes: the ability to put in a couple of sentences in an email, what your idea is, how it will be executed, and what the client can expect from it.

Can you talk about triple bids?

Typically, a client gets three companies to make competitive bids (a bid being an estimate of the cost). So, we will do a bid and a schedule, and two other companies will do the same. Sometimes they just ask for bids, and not creative treatments. But often it's a full bid package, which also includes creative design treatments (style frames) and/or motion tests. That's when you wat to do a really killer presentation. Usually, those jobs have nice budgets, otherwise why would you bid competitively?

How have deliverables shifted in the last few years?

The twist was social, which mandated a variety of ratios, including the wildly problematic vertical, 9 × 16. Our studio is still called to produce big broadcast commercials, which is the 16 × 9 format, but now everyone typically needs a variety of social deliverables along with it. So, they want the pie, and they also want us to cut up the pie into 50 different slices. When we build for broadcast, we build at 16:9, and clients think it will just work in all the different ways and sizes. But usually, you need to reconfigure the layouts, especially if it needs to be delivered 9 × 16 as well. And, if you are shooting live action, you have to shoot differently for 9:16 then 16:9. That's why you really need a spec sheet before you start working on the job.

Additionally, not that you asked, but as a motion designer you also need to know what finishing really means. Broadly speaking, students in school studying Motion Design are not taught about finishing. How to slate work, compressions, bitrates, and how to deliver an After Effects file as a toolkit. I think students should be graded not just on the outcomes but on the file itself. Because in a production pipeline, you have to be organized. You have to use a folder structure and it has to make some amount of sense, so if another artist needs to go in there, they can make revisions. I think students are shocked when they come into the industry and see how specific, rigid and complex each studios pipeline is.

How do you manage client feedback?

Every studio manages and addresses feedback differently. It's really based on the creative director, the producer, and the client. There are so many variables there that impact the dynamic. But the thing we notice with students transitioning to professionals is—feedback isn't a suggestion, it's a mandate. When somebody gives you a note, you have to address it. How you interpret that note is essentially the creative process. I always say "How do you know when a job is done? When a client runs out of time and money." That's not a joke. If you show something to a client that is a masterpiece first thing out of the gate, they are going to come up with 15 things to say about. In addition to the final result, they bought your time and attention for a specified amount of time. Our job is to make sure the work stays great through the feedback process. My advice is simple, work with integrity, listen to the feedback as it comes, and address it. Don't take it personally, because there is always so many things in play that has nothing to do with the actual work.

Can you talk about what a schedule looks like?'

The schedule dictates the amount of reviews the client gets and the project's major milestones. . . . which is defining where we need to be in the process to make the deadline. That is our roadmap. It's important to have those milestones because that's where we get approvals. We may need approval on boards, models, lighting, or animatics. There are all these points in the process where if they miss something, whoever's fault it is, it's an overage because changes will ripple forward.

What belongs in the motion designer's toolkit?

Well toolkits are different to everyone, but I feel strongly that for a Motion Design toolkit it should include principles that are intertangle to understanding After Effects and even a little bit of Cinema 4D. It should also cover core design skills: typography, composition, color, and consistency. Part of what you are trusting with a motion designer is their "eye" as a designer first and foremost. We also look for their ability to edit and curate their own work and to have some of soft skills, like basic communication, developed.

How important are soft skills?

Soft skills are so important, maybe more important than talent. The worst thing you want is to give someone feedback, and they just ignore it. You can't change someone's personality no matter how talented they are. You have to be able to accept that some jobs are not going

15.9
Community, title sequence for NBC and Sony. Created by Sarofsky.

to go the way you want them to, but still be professional and make it the best you can. Not everything is going to be the *Mona Lisa*.

I have a philosophy of how to make things go smoothly. My job as a creative director is make everyone feel like they have ownership, that they have influenced the outcome. Artists need to feel like there work is appreciated and essential. I wasn't just telling them exactly what to do, I was saying something like "emphasize the logo more," not just "make it bigger." They get to solve that problem. With my client, I am saying things like "that is a great idea, we are going to integrate that" even if it just means I understand what is informing the note and we address that in our own way. Everyone needs to feel like they have affected the outcome. If all of that happens, then I can feel ownership over it, because I owned the process.

What does a creative business owner need to know?

You need to understand healthcare, 401(k)s, payroll, scheduling software, promotion and PR, and recruiting. A lot of that stuff falls under what would be a human resources department, but as a small studio owner, you own those responsibilities. As you grow, you have to identify when is it appropriate to have an HR department, finances, and operations. It's layers and layers of jobs that starts as all your job, and if you don't parse it out, as you grow, you will get crushed by the weight of it. Regarding the financial side of it, you have to understand what cash flow is, how to manage that, and of course how to handle all the financial day-to-days. I did not know any of that when I started. It requires patience, resilience, constant learning, and being open to evolution.[1]

Can you tell us about the titles for the show Community?

You remember cootie catchers, those paper fortune tellers you'd make and fold over your fingers. Your friends would pick a number and you'd flip them open to show the hidden message you'd written there. I thought they were the perfect metaphor for the show and its group of misfit characters. The show runners thought so too. Show creator Dan Harmon and executive producers/directors the Russo Brothers loved the idea, and both NBC and Sony Pictures signed off swiftly.

Running with the theme, our fast-moving sequence opens with the four-pointed star of a cootie catcher, flipping and turning to a bouncy track of "At Least It Was Here," by *The 88*. With each musical shift, flaps lift to reveal titles: Joel McHale with a Kilroy doodle, Danny Pudi in a game of hangman, Yvette Nicole Brown with a knife-slashed birthday cake, and Donald Glover with dueling bumblebees.

The Russo Brothers were so pleased with the *Community* title sequence, it became the start of our great, and ongoing, collaborative relationship.

NOTE

1 Sarofsky, Erin, Zoom interview with author, April 12, 2021.

Index

9781032060576